ASIATIC INFLUENCES IN PRE-COLUMBIAN AMERICAN ART

Asiatic Influences in

Pre-Columbian American Art

PAUL SHAO

THE IOWA STATE UNIVERSITY PRESS / AMES, IOWA / 1 9 7 6

PAUL SHAO is Associate Professor of Architecture, Iowa State University.

© 1976 Paul Shao

All rights reserved

Layout by Paul Shao

Composed and printed by the Iowa State University Press

First edition, 1976

Library of Congress Cataloging in Publication Data

Shao, Paul 1940—
 Asiatic influences in pre-Columbian American art.

 Includes bibliographies.
 1. Indians of Mexico—Art. 2. Indians of
Central America—Art. 3. Indians—Transpacific
influences. 4. Indians—Chinese influences.
I. Title.
F1219.3.A7S52 709'.01'1 76-22631
ISBN 0-8138-1855-9

TO MY FATHER

C O N T E N T S

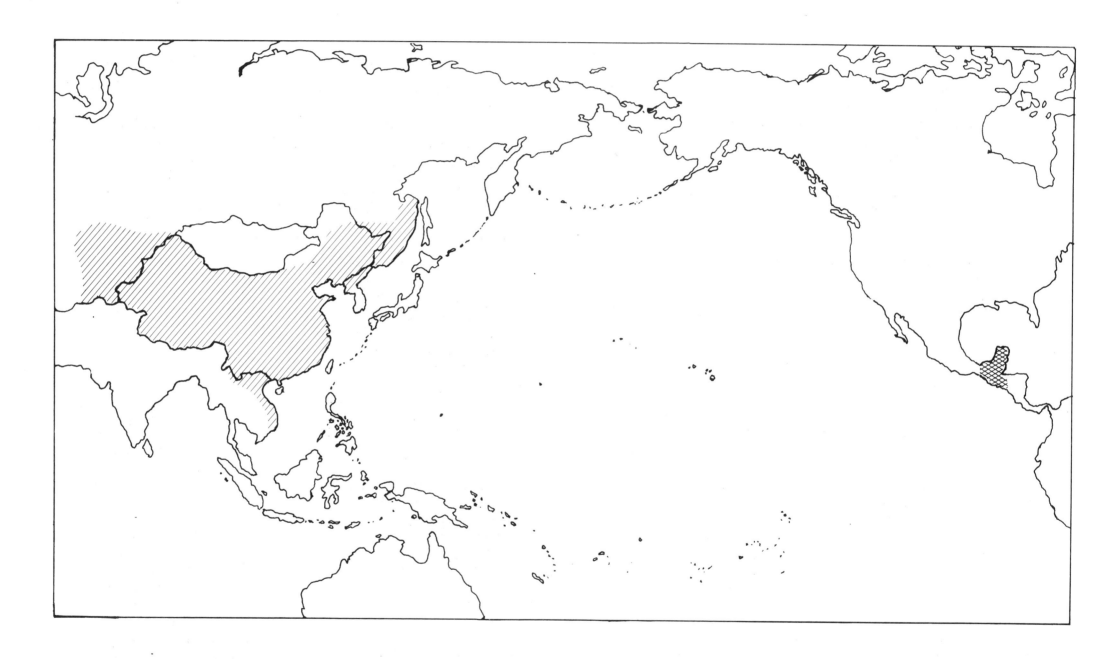

CHINA,
TANG DYNASTY MAYA AREA
(A.D. 618—907) (A.D. 600—900)

I AM NOT a typical looking Southern Chinese. While in primary school in Kwangchou, Kwangtung, China, I was often teased by my classmates about my appearance. One day after school I asked my grandmother about it. She told me our ancestors were not natives of Kwangchou but were immigrants from "another place." As to the whereabouts of this "other place" she could not tell me, nor could my parents. Since then I have been fascinated by stories of histories about the migration of people in China as well as abroad. My interest in the comparative study of Asian and Meso-American art and architecture was sparked by a chance encounter, nine years ago, with A. P. Maudslay's huge, superbly illustrated *Biologia Centrali Americana.* I was immediately impressed by the structural and formal similarities between what was in front of me and what I had seen and studied when I was in China. I thought naively that I was the first one to notice such resemblances. Upon further research I was intrigued by the amount and variety of speculation on the subject, but I was disappointed that most of it led to superficial conclusions based on circumstantial evidence.

My enthusiasm diminished and I was distracted by other projects. Then, four years ago, on my second trip back to Asia, I had an opportunity to study at the Palace Museum and the Academia Sinica in Taiwan, China. At once my interest in Meso-American art and architecture was rekindled; it took me, in the next few years, to the major museums and archives in America, East Asia, and Europe, and to most of the important sites and museums in Central America. The undertaking has been most exciting and fulfilling. Many times, in the middle of the night, I would wake up with an idea, immediately dash to my office and discover after checking my research materials that it was as I suspected: the motifs I had studied during the daytime, the previous day, previous week, and sometimes the previous month, showed up in my dreams and made sense by themselves. Often while I was taking a walk, doing my laundry, shopping, or eating my dinner, an image would flash through my mind—click, click—and all the pieces of the puzzle which I had struggled for days to put together would fall into their places. I have never enjoyed any research project so much as this one.

As I studied the subject, I was overwhelmed and awed by the great achievements of the ancient American Indians and the mechanics that brought them about. A new approach to the problem had to be sought— one built on a broad base of tangible, coherent, and comprehensive evidence that could withstand scholarly scrutiny. My direct first-hand contacts with major artifacts of both ancient East Asia and Meso-America gave me an advantage over most scholars. I carefully studied and photographed all relevant art works on every site and in every museum I visited. I took over 5,000 photographs and purchased another 800 from various archives and museums.

The illustrations contained in this book represent approximately one-twentieth of the motifs for which I have established correlations. This book does not undertake to examine the process and the mechanics through which the postulated transpacific contacts came about; it confines itself to a comparison of a number of general trait-complexes from ancient East Asia and Meso-America as an introduction to the problem of transpacific cultural diffusion. More conclusive and detailed treatment of specialized areas will be found in three manuscripts under preparation: *The Origin of Ancient American Civilization: A Study of the Olmec, the Chavin, and the Chinese Arts, Asiatic Influences in Meso-American Architecture,* and *The Life-Death Tree.*

I would like to take this opportunity to thank Professor Kao Hua-Cheng, Director General of Academia Sinica, and Professor Chu Wan-Li, Director, Institute of History and Philology, Academia Sinica, Taiwan, for their kind support and cooperation. I am indebted to Mrs. Katherina Edsall, Peabody Museum, Harvard University, for her encouragement and patient assistance. I am deeply grateful to Harvard University for the use of their magnificent Peabody Archive and the Archive of the Carnegie Institution of Washington.

To the following institutions I would like to express my indebtedness for granting me access to the artifacts in their collections or else supplying me with photographs of their art works: The National Institute of Anthropology and History and the National Museum of Anthropology, Mexico City; the Regional Museum of Mayan Archaeology, Copan; the Museum of Palenque; the Frissell Museum, Mitla; the National Museum of Guatemala, Guatemala City; the Regional Museum of Villahermosa; the University of Veracruz Museum, Jalapa; the American Museum of Natural History, the Museum of the American Indian, the Museum of

Primitive Art and the Brooklyn Museum, New York City; the University Museum, Philadelphia; the Dumbarton Oaks, Washington, D.C.; the Stendahl Galleries, Hollywood; the Metropolitan Museum, New York City; the Cleveland Museum of Art; the Minneapolis Institute of Arts; the Art Institute of Chicago; the William Rockhill Nelson Gallery of Art, Kansas City; the Freer Gallery of Art, Washington, D.C.; Boston Museum of Fine Arts and the Fogg Museum of Art, Cambridge; the Djakarta Museum and the Archaeological Service of Indonesia; the National Museum, Bangkok; the National Museum, Phnom-Penh; the National Palace Museum, Taipei; the National Museum of Korea, Seoul; the Tokyo National Museum and the Eisei Bunko Foundation, Tokyo; the British Museum; the Museum of Mankind and the Victoria and Albert Museum, London; the Museum Guimet and the Museum Cernuschi, Paris; the National Institute for the Tropic and the Tropic Museum, Amsterdam.

I am grateful to Dr. Daniel Zaffarano and Dr. Paul Peterson without whose generous support this book would not have been possible. I thank my friends, Heide Exner, Laurie Hansen, Daniel Kohl, and Jon Theim for their help in preparing and reading the manuscript. I am especially indebted to Professor M.J. Kitzman for his constant encouragement and advice.

I also wish to thank Merritt Bailey, Ray Fassel, Rowena James, and Mary Adams of the Iowa State University Press for their patient assistance and may valuable suggestions.

Finally, I convey my deep appreciation to the Iowa State University Graduate School, the Research Foundation, and the Engineering Research Institute for their generous support.

MEN WITHIN FOUR SEAS ARE BROTHERS

The Sayings of Confucius (Lun Yu), Book 12, Chapter 5, Stanza 4, ca. 450 B.C.

ONE OF THE most challenging problems confronting archaeologists and ethnologists today is the origin of ancient American civilization. Soon after it was recognized that the land Columbus "discovered" was not India, speculations regarding what gave birth to Meso-American culture sprang up like grass after rain in the summer. The sources on which scholars all over the world have based their conjectures since the early sixteenth century generally can be divided into three major categories: Greek, Hebrew, and Chinese.

One of the earliest and most persistent theories ascribed the source of the New World civilization to the sunken continent, Atlantis. According to Plato's descriptions in the *Timaeus* and *Critias,* Atlantis was a gigantic island in the middle of the sea west of the Pillars of Hercules. The island, thought to be larger than Asia and Africa put together, was supposedly inhabited by a highly civilized people whose king had once invaded Europe and Egypt.[1]

The Atlantian theory was first put forth by Giralamo Fracastoro in 1530 and championed by Gonzalo Fernandez de Oviedo y Valdés in 1535. Since then it has been maintained and expounded upon by numerous other scholars. As recently as 1966, Cyrus Gordon wrote, "Greek classics independently and repeatedly attest transatlantic contacts between the Mediterranean and America."[2] Few proponents of this theory, however, have mentioned that, according to the *Timaeus,* Plato learned of Atlantis from Solon who heard of it from an Egyptian priest who explicitly stated that Atlantis had sunk 9,000 years prior to Plato's time. This theory is ruled out by the fact that civilization did not emerge in America until the late second millenium or early first millenium, B.C.

The tenet of another major speculative theory concerning the roots of ancient American culture was best expressed by Joseph de Acosta in his *The Natural and Moral History of the Indies* published in 1590:

> The reason that inforceth us to yeeld that the first men of the Indies are come from Europe or Asia, is the testimonie of the holy scripture, which teacheth us plainely that all men came from Adam. We can therefore give no other beginning to those at the Indies, seeing the holy

scripture saieth that all beasts and creatures of the earth perished but such as were reserved in the Arke of Noe, for the multiplication and maintenance of their kinde; so as we must necessarily referre the multiplication of all beasts to those which came out of the Arke of Noe, on the mountaines of Ararat, where it staied. And by this meanes we must seeke out both for men and beasts the way whereby they might passe from the old world to this new.[3]

One school of this theory—with Diego Duran,[4] James Adair,[5] and Edward King (better known as Lord Kingsborough)[6] as its devoted advocates—argues that the ten lost tribes of Israel were ancestors of the Indians of Central America. Another school, mostly consisting of Mormons claiming analogies between their sacred book (*The Book of Mormon*) and that of the Central American Indians, seeks to prove that the Hebrews were responsible for the civilization of Meso-America. In Article 8, Chapter 15, of the *Articles of Faith for the Book of Mormon,*[7] it is asserted that the Jaredites mentioned in Genesis left the site of the Tower of Babel and settled in America. In the second century B.C. they supposedly became extinct as a result of natural calamities, but another group, headed by Lehi, had left the Holy Land for the New World around 600 B.C. A portion of this group, the Nephites, established civilized communities in Central America and the Andes while the other portion— the Lamanites—headed north and became the North American Indians of our time. Some influential Mormons also believe that the Mexican deity, Quetzalcoatl, depicted in legend and Indian artifacts, can be identified as Christ. It is true that one of the earliest narrations regarding the Mexican deity contained in Bishop Landa's *Relacion de las Cosas de Yucatan* published in 1566, portrays a benevolent Quetzalcoatl:

> It is believed among the Indians that with the Itzas who occupied Chichen Itza there reigned a great lord, named Kukulcan, and that the

1. For more detailed discussion of the sunken continent theories see: Robert Wauchope, *Lost Tribes and Sunken Continents,* University of Chicago Press: Chicago, 1962.

2. Cyrus Gordon, *Before Columbus,* Crown Publishers: New York, 1966, p. 49.

3. Joseph de Acosta, *The Natural and Moral History of the Indies,* translated by Edward Grimston in 1604, Burt Franklin: New York, 1970 reprint, p. 57.

4. See Diego Duran, *Historia de las Indias de Nueva Espana* (The History of the Indies of New Spain) first published in 1585. Translated in English by Heyden and Horcasitas, Orion Press: New York, 1964.

5. See James Adair, *The History of American Indians,* Dilly: London, 1775.

6. See Edward Kingsborough, *Antiquities of Mexico,* London, 1831-1848.

7. Wauchope, *Lost Tribes,* p. 59.

principal building, which is called Kukulcan shows this to be true. They say that he arrived from the west; but they differ among themselves as to whether he arrived before or after the Itzas or with them. They say that he was favorably disposed, and had no wife or children, and that after his return he was regarded in Mexico as one of their gods and called Quetzalcoatl; and they also considered him a god in Yucatan on account of his being a just statesman.[8]

However, from the description of other early Spanish writers, including Herrera, the official historian of the Indies for the Crown of Spain, Quetzalcoatl was associated with human sacrifice. This and the fact that Chichen was not occupied by the Itzas until almost ten centuries after Christ's death,[9] make the Christ-Quetzalcoatl theory highly improbable.

> The old men of the provinces (Yucatan) say that anciently, near to eight hundred years ago, idolatry was not practiced, and afterwards when the Mexicans entered it and took possession of it, a captain, who was called Quetzalquat (Quetzalcoatl) in the Mexican language, which is to say in ours, plumage of the serpent, . . . introduced idolatry into this land and the use of idols for gods, which he had made of wood, of clay and of stone. And he made them (the Maya) worship these idols and they offered many things of the hunt, of merchandise and above all the blood of their

nostrils and ears, and the hearts of those whom they sacrificed in his services. . . . They say that the first inhabitants of Chichenyza (Chichen Itza) were not idolators, until a Mexican captain Ku Kalcan (Kukulcan) entered into these parts, who taught idolatry, and the necessity, so they say, to teach and practice it.[10]

Archaeological finds of recent decades support these historians' descriptions of the bloody religious ceremony practiced by the Meso-Americans. A stela at Piedras Negras,[11] Peten, Guatemala, dated 751 A.D., clearly depicts a scene of human sacrifice. At the bottom of the stela, the victim was placed on top of a basketlike altar. Under the watchful eyes of Quetzalcoatl, his stomach was opened by a heart-shaped object with feathers attached to the top.

The believers of the Bible-related theories concerning the ancestry of the American Indians differ from the Atlantian theorists and are generally more dedicated; the Mormons have spared few resources in the search for physical evidence in support of their contentions, but I believe most of their efforts have been misdirected. In my book manuscript, *The Life-Death Tree,* I attempt to document the thesis that the cross motifs of Palenque, which Mormon scholars identify as Christ's cross, are of direct Hindu-Buddhist-Taoist derivation.

8. Sylvanus G. Morley, *The Ancient Mayan,* Stanford University Press: Palo Alto, 1946, p. 85.

9. According to the Mayan natives at the time of the Spanish conquest, Kukulcan (Quetzalcoatl) entered the Yucatan region between 987 and 1000 A.D. He first settled in Mayanpan and later in Chichen Itza.

10. Morley, *The Ancient Mayan,* p. 211.

11. See Fig. 52c. of Tatiana Proskouriakoff's *A Study of Maya Sculpture,* Carnegie Institution of Washington: Washington, D.C., 1950.

THE SPECULATIVE THEORIES of Buddhist influence on pre-Columbian American civilization center around an account of a voyage taken by five monks from Afghanistan to the Fu-Sang Kuo (Country of the Extreme East) recorded in the "Chu I Chuan" ("Record of the Barbarians") of *Liang Shu*[1] (The History of the Liang Dynasty).

The story of the voyage was told in the first year of Yung Yuan of the Chi Dynasty (A.D. 499) by a shaman named Hui Shen. It was related that in the second year of Ta Ming of the Sung[2] Dynasty (A.D. 458), five monks of Chi-Pin (Cophen[3]—an early Buddhist center—present day Kabul, capital of Afghanistan) wandered into the country of Fu-Sang, which was supposedly thirty-two thousand Chinese miles east of Japan (three Chinese miles equal one American mile). The monks preached Buddhism, distributed religious writings and drawings, and succeeded in reforming the customs of that country.

Following is a translation of the Fu-Sang episode recorded in *Liang Shu:*

> In the first year of the reign of Yung-Yuan of the Tung Heun, Chi Dynasty [A.D. 499], a Shaman priest named Hui-Shen arrived at Ching-Chou from Fu-Sang and related the following account regarding the country of Fu-Sang.

> Fu-Sang lies east of the kingdom of Ta-Han more than twenty thousand li [Chinese miles]; it is also to the east of the Middle Kingdom [China]. It produces many fu-sang trees, from which it derives its name. The leaves of the fu-sang resemble those of the tung tree. It sprouts forth like the bamboo, and the inhabitants of the country eat the shoots. Its fruit resembles the pear, but is red; the bark is spun into cloth for dresses; and woven into finer fabrics. The houses are made of slabs. There are no walled cities. The people have written characters and make paper from the bark of the fu-sang. They have no soldiers, no armour, and do not wage war.

> According to the laws of the country, there exists a northern prison and a southern prison. Those who have committed crimes of little gravity are sent to the southern prison, while the great criminals are confined in the northern prison. If there is a general pardon, those in the south prison are let out and those in the north remain. The men and women of the north prison are allowed to marry one another. The children which are born of these unions become slaves, the boys at age of eight years, and the girls at the age of nine years. Convicted criminals are not allowed to leave their prison while alive.

> When a nobleman has been convicted of crime the people of the kingdom assemble in great numbers and place the criminal in a ditch. They wine and dine with him as if he is departing for good—then he is surrounded with ashes. If the crime is only one of the first degree, the criminal alone is punished; if the crime is of the second degree, his children and grandchildren are punished with him; and, finally, if the crime is of the third degree, the punishment is extended to the seventh generation.

> The king is called I-Chi. The nobility of the first class are called Tui-Lu; those of the second class, little Tui-Lu; and those of the third class, Na-To-Sha. When the king takes a trip he is preceded and followed by drummers and horn trumpeters. The color of his robes changes in accordance with a ten year cycle. The first two years, green; the third and fourth, red; the fifth and sixth years, yellow; the seventh and eighth years, white; and the ninth and tenth years, black.

> They have long ox horns which they use as containers to hold over twenty "Hu" of grain. They have horse carts, cattle carts, and deer carts. The people of the country raise deer as cattle are raised in the Middle Kingdom and a creamy substance is made out of their milk. The people have red pears which will keep throughout the year without spoiling; they also have many grapes. This land has no iron, but contains copper. Gold and silver are not treasured. In the markets no taxes are assessed.

> In regard to marital customs, the suiter constructs a dwelling place in front of the house of the maiden he seeks. Morning after morning, evening after evening, he sprinkles the ground and sweeps. After one year elapses if the young woman does not like him, she sends him away and if she does like him they will get married. The marriage ceremonies are, for the most part, identical with those of China.

> A fast of seven days is observed for parents at their death, five for grand-parents, and three days for brothers, sisters, uncles, and aunts. Images to represent their spirits are set up, before which they make their offerings and pay their respect morning and evening. They do not wear mourning garments. As a token of reverence the successor of the deceased king does not attend government affairs for the first three years.

> In former times they knew nothing of the Buddhist religion, but in the

1. Liang was a southern kingdom succeeding Chi Dynasty in A.D. 502 and lasted to A.D. 556. Its first king, Liang Wu-Ti, was a well-known patron of Buddhism. The *Liang Shu* was written during the first half of the Seventh Century.

2. Liu Sung Dynasty (A.D. 420-447) of the South-North Epoch, not to be confused with Sung Dynasty of A.D. 960-1126.

3. This name was mentioned by both Caius Plinius (*Pliny* VI.23) and Stephanus Byzantinus (*Arachotus*). It bears phonetic similarity to that of the important Mayan cultural center—Copan, Honduras.

second year of Ta-Ming of Sung Dynasty [485 A.D.], five monks from Chi-Pin traveled by ship to that country. They propagated Buddhist doctrines, circulated scriptures and drawings, and advised the people to relinquish worldly attachments. As a result, the customs of Fu-Sang changed.

The Fu-Sang hypothesis has been passionately discussed by numerous scholars since the mid-eighteenth century. The earliest exposition regarding the story of Fu-Sang appeared in Phillippe Buache's ''Considérations géographiques et physiques sur les nouvelles descouvertes au nord de la Grande Mer,'' in 1753. In this article he pointed out the existence of what was later to be known as the Bering Strait and contended that the Chinese Buddhists had established a colony in California in the fifth century. In 1761, an article[4] entitled ''Investigation of the Navigations of the Chinese to the Coast of America, and as to Some Tribes Situated at the Eastern Extremity of Asia'' was published by a well-known French scholar, M. de Guignes, who argued that Wen-Shen Kuo[5] (Country of the Tattooed Body) should be identified as Hokkaido in northern Japan and Ta-Han Kuo (Country of Great Han) as the Kamchatka Peninsula. He concluded accordingly that Fu-Sang Kuo (Country of the Extreme East) could only be North America.

Another distinguished scholar of the time, J. J. Klaproth, argued against de Guignes' hypothesis in an article published in 1831, entitled ''Researches Regarding the Country of Fu-Sang, Mentioned in Chinese Books, and Erroneously Supposed to be a Part of America.'' Citing that horses and grapes mentioned in *Liang Shu* were not native to America but were imported by the Spaniards, Klaproth concluded that the country of Ta-Han was merely Sakhalin and the country of Fu-Sang none other than Japan.

Karl Neumann disagreed. Armed with many Chinese historical records, he concluded in ''Eastern Asia and Western America, According to Chinese Authorities of Fifth, Sixth, and Seventh Centuries'' that the country of ''Picture People'' (Tattooed Body) lay probably in the Aleutian Islands. He further asserted that five thousand Chinese miles east of these islands, ''The distance and direction lead us to the great peninsula of Alaska,'' which he identified as Ta-Han. Differing from de Guignes, who situated Fu-Sang in the northwestern part of the American continent, Neumann pushed Fu-Sang farther south into Central America.

His hypothesis was given a strong boost in 1885 with the publication

4. For more detailed discussions of literature on Fu-Sang prior to 1885, see Edward P. Vining, *An Inglorious Columbus,* Appleton and Company: New York, 1885.

5. Both the country of Tattooed Body and Great Han were described in ''Chu I Chuan'' of *Liang Shu.* The country of Great Han was said to be located five thousand Chinese miles east of the country of Tattooed Body which was supposed to be situated more than twenty thousand Chinese miles west of Fu-Sang.

of Edward Vining's *An Inglorious Columbus.* A multitude of alleged similarities of customs between Mexico and Fu-Sang described in *Liang Shu* was added, among them the making of cloth and paper from the bark of the fu-sang, changing the color of garments according to ten-year cycle, the procession of drummers and trumpeters accompanying the king on a trip, and the ceremonies for marriage and mourning. Based partially on the works of other scholars of his time—notably de Paraley, Neumann, Deichthal, Humboldt, Leland, d'Hervey, de Saint-Denys, and Lobscheid—Vining listed the following as positive proofs that the country of Fu-Sang depicted by Hui-Shen was indeed Mexico.[6]

1. The existence of monasteries and nunneries said to have been founded by Quetzalcoatl, the ''Revered Visitor.''
2. The vows of continence taken by their inmates.
3. The fact that these vows were not necessarily for life.
4. The daily routine of life of these ascetics, consisting of watching, of chanting hymns to the gods, of sweeping the temples and their yards, etc.
5. These priests were the educators of the children.
6. They were divided into orders, and some were of superior rank and governed the others.
7. They lived on alms.
8. They occasionally retired alone into the desert to lead a life of prayer and penance in solitude.
9. They were known by the title Tlamascazque or Tlama, corresponding to the title of Lama given to the Buddhist priests of Asia.
10. It was thought best to eat but once a day and then at noon.
11. They celebrated once each year a ''feast of the dead,'' at which they supposed that the hungry spirits of their deceased friends returned to be fed.
12. They worshipped upon large, truncated earthen pyramids.
13. These were covered with a layer of stone or brick, and the whole covered with plaster or stucco.
14. They used the false arch of overlapping stones, but not the true arch.
15. The inner walls of their temples were coated with stucco or plaster, which was ornamented with grotesque paintings.
16. A seated, cross-legged figure was found in one of their temples, resembling in its attitude, in the lion-headed couch upon which it was seated, in the niche in which it was found, and in its position in the temple, the statues of Buddha found in Buddhist temples.
17. The tradition of the conception of Huitzilopochtli closely resembles the Asiatic stories of the conception of Buddha.
18. They represented one of their gods as holding a mirror in his hand, in which he saw all the actions of men.
19. They believed that the inhabitants of the world had been four times destroyed—by water, by winds, by earthquakes, and by fire—and recreated after each destruction.

6. Edward P. Vining, *Inglorious Columbus,* pp. 706-8.

20. They had the custom of placing the walls of their temples facing the four cardinal points and of decorating each wall with a distinctive color.
21. They buried a small green stone with corpses.
22. Their idols were always clothed and were never offensive to modesty.
23. The custom of tying the corners of the garments of the bride and groom together constituted one of the most important of the marriage ceremonies.
24. Marriage was not consummated until the fourth day after the ceremony.
25. They placed in the hands of young children, a few days after their birth, toys symbolical of the instruments of craft or of household labor which it was expected that they would use during afterlife.
26. The long band of cloth worn about their waist was precisely like that worn by the natives of India.
27. They wore quilted cotton armour similar to that worn in Asia.
28. Their cakes of meal were similar to those made in India.
29. Their books were folded back and forth like those of Siam.
30. They played a game called *patolli,* which seems to have been substantially like the *pachisi* of the Hindoos.
31. They understood the arts of melting and casting precious metals and of working jewels, attributing their knowledge to Quetzalcoatl.
32. But they knew nothing of the use of milk or of any food prepared from it.
33. Their anchors were like those used in Asia, with four hooks without a barb.
34. They understood the art of constructing suspension bridges, and
35. Their calendar showed so many resemblances to that used by many nations of Asia, that from this fact alone Humboldt[7] was convinced that there was some connection between the civilizations of these two regions.

Speculations on the Fu-Sang episode have been surfacing sporadically since Vining's meticulous work. These later works only damaged further the credibility of the circumtranspacific cultural diffusion theory. It is sufficient to mention only two of the more bizarre ones.

In 1970, a book entitled *Chung-Kuo Ku Tai Yu Mei-Chou Chiao Tung Kao (China and America; a Study of Ancient Communication between the Two Lands]* was published by Wei Chu-Hsien in Hong Kong. A Taoist as well as a Confucian, Wei has published widely on Chinese archaeology and sociology. In his book, he related that a Mexican statue discovered by a friend of his bore the inscription of three Chinese characters: *Wu Tang Shan* (a Taoist center located in Wu-Tang Mountain). Furthermore, he claimed that both Confucius and Li Tai-Po

(the famed Tang poet) had visited America—the former in 484 B.C., the latter in A.D. 725.

No less fanciful is Henriette Mertz's *Pale Ink,* first published in 1958, with a second, revised edition published in 1972. The title of her work is derived from a saying of Confucius, ''Pale ink is better than the most retentive memory.'' It appears, however, that another equally famed passage in the Confucian classics has escaped Mertz's scrutiny. Book 5, Part 1, Chapter 4, Stanza 2, of *Meng Tzu* (Mencius) reads as follows:

> One should not arbitrarily insist on one phrase so as to do violence to a sentence, nor should one twist the meaning of a sentence to do injustice to the general spirit of a paper. One must attempt, with one's intelligence and knowledge, to interpret the general spirit. Then one can gain real insight.

In *Pale Ink* Mertz acclaimed Hui-Shen of the Fu-Sang story in *Liang Shu* as one of the ''greatest'' missionaries the world has ever known. In addition to ''converting an entire country,'' Mexico, Mertz contended that Hui-Shen brought ''a better life'' to the Mexican people and taught them ''advanced methods of agriculture,'' weaving, ceramics, metallurgy, astronomy, and the calendar[8]—single-handedly.

In a similar vein to the Mormons who associated Quetzalcoatl with Christ, Mertz defined Hui-Shen as ''Quetzalcoatl, Kukulcan and Wixipecocha.''[9]

> Fu-Sang is no geographical myth. It is real. In the Fifth Century, it was a vital strategic spot—Hwui Shan's visit there changed the entire course of its history. It was he who was instrumental in creating in it a magnificently brilliant civilization—the like of which the world has never seen.[10]

But this is not all. In the second part of her book Mertz ventured into fabulous territory no informed Chinese scholar has seriously considered, not even the Grand Imperial Historian, Szu-Ma Chien of the Han Dynasty.[11] She claimed that the legendary emperor Yu sent out a Chinese exploration team to America in 2250 B.C.,[12] and, after his men came back, compiled the ''world's oldest geography''[13]—the *Shan Hai*

7. For a detailed discussion of the calendrical similarities, see Alexander von Humboldt, ''Views of the Cordilleras and Monuments of the Indigenous Nations of America,'' Vining, ibid., pp. 142-55.

8. Henriette Mertz, *Pale Ink, Two Ancient Records of Chinese Exploration in America,* Swallow Press: Chicago, 1972, p. 82.
9. Ibid., p. 83.
10. Ibid., p. 2.
11. Szu-Ma Chien remarked in *Shih Chi* that the *Shan Ching* contained so many strange and fictitious things, he would not speak of them.
12. Mertz, *Pale Ink,* pp. 110 and 159.
13. Ibid., p. 104.

Ching[14]—which contained accurate and detailed descriptions of America:

> This instant document was written in the time of Yu, 2250 B.C., 2700 years before the time of Hwui Shan. At that early date, the Chinese had identified ''Fu-Sang.'' This is within 30 miles of the identical spot where I had previously calculated that Hwui Shan landed, at Point Heuneme [California]. . . . Hwui Shan, without question, studied these ancient records and knew precisely where he was going before he started out. He came within 30 miles of the spot identified in Yu's record as Fu-Sang, . . .[15]

Thus, according to Mertz, the ''Shu-Chu'' Mountain mentioned in Shan Hai Ching can be identifed as a peak near Casper, Wyoming; ''Keuch-Wang'' Mountain, Long's Peak, Colorado; the ''Wu-Kao'' Mountain, a hill near Santa Barbara; and ''Wei-Shi'' Mountain, a peak near Madera, in the state of Chihuahua, Mexico.[16]

> It is my belief that from those ancient Chinese documents we have the answers to the problems that have perplexed us for years and for which we have had no solution. These two records have taught us:
> That Fu-Sang was no ''geographical myth . . . figment of the Buddhist imagination''—that the plant ''Fu-Sang'' was corn, and the country ''Fu-Sang'' was Southwestern United States and Mexico.

More than five hundred years have elapsed since man's first attempt to explain the splendid achievements of the ancient American-Indian culture. A multitude of theories have been proposed and expounded upon; but all have failed to document a satisfactory answer concerning the origin of the Meso-American civilization. The transpacific cultural diffusion theory is no exception. Gordon Willey, an authority on American archaeology, wrote as recently as 1974:

> More dubious and debatable have been the claims for transpacific relations between Asia and America in relatively late pre-Columbian times. The Austrian ethnologist-archaeologist, Robert von Heine-Geldern, had long been the spokesman for the importance of such diffusion in the rise of the New World Meso-American and Peruvian civilizations, and he continued to argue his case in the 1950's and 1960's. Generally, American archaeologists were not convinced, citing difficulties in finding proper Asiatic antecedents with proper dating and arguing for the more likely possibility of independent development and evolution.[17]

The East Asians probably have played an important role in the blossoming of ancient American culture. Why is it then, that for five centuries no one has been able to convincingly establish that fact? There are four major reasons. First, the problem of cultural diffusion is complex and full of pitfalls; it involves not only a trait-generator, a trait-transmitter (the former and the latter can sometimes be the same entity), but also a trait-receiver and a trait-adapter (a receiver is not necessarily always the adapter). A trait in the process of transmission may sometimes be forced upon the trait-receiver or be adopted readily and voluntarily. An imported trait may be adapted immediately and at other times have a period of hibernation only to resurface and be adapted at a later time when the environmental-social-economical conditions change. This is not to mention the difficulties in deciding whether a trait was diffused or independently invented, as diffused traits are frequently disguised and intermingled with indigenous ones.

The second major reason for the transpacific or circumpacific diffusionists' failure to firmly establish their claims is their propensity for false analogies, forced associations, and narrow-minded, distorted textual interpretation of historical writings. Their lack of firsthand, in-depth knowledge of Asian culture in general and Chinese culture in particular also prevents productive advancement of the hypothesis.

Let us begin with de Guignes, the precursor of the Fu-Sang diffusionist theory. In *Liang Shu* (The History of Liang Dynasty), it was mentioned specifically that Hui-Shen was a shaman of the country of Fu-Sang and that the five monks who brought Buddhism to Fu-Sang in the fifth century were natives of Chi-Pin (the ancient Buddhist center in present-day Afghanistan). In his translation of the Fu-Sang episode, de Guignes conveniently omitted the statement concerning Hui-Shen's nationality and claimed that the five monks were Chinese—and the Chinese, he asserted in another article, were colonial subjects of the ancient Egyptians.[18]

Edward Vining, another proponent of the Fu-Sang theory, was more accurate. To establish the validity of the Fu-Sang story, he endeavored word by word and sentence by sentence, to find a Mexican parallel for everything about Fu-Sang mentioned in *Liang Shu*. Thus, he asserts Fu-Sang Kuo (the Country of Fu-Sang) is related both phonetically and semantically to the word Mexico; ''tui-lu'' (first rank nobleman) is identical to the American Indian word ''tecuhtli'' (soldier of high honor), while ''nah-to-sha'' becomes the Indian word ''tlatoque.'' According to Vining,[19] ''to-pu-tao'' is analogous to tomato—Indian ''tomatl.'' The truth is that ''to'' was used in the Chinese Fu-Sang text

14. *Shan Hai Ching* (The Book of Mountain and Sea) was based on an earlier work—*Shan Ching* (The Book of Mountain) of pre-Han period. It is generally regarded by authentic Chinese scholars as a Taoist fiction of Han (206 B.C.-A.D. 220) or later period.

15. Mertz, *Pale Ink*, pp. 132-33.

16. Ibid., pp. 114, 115, 132, 126, and 158.

17. Gordon Willey, *A History of American Archaeology*, Thames and Hudson: London, 1974, pp. 172-74.

18. Joseph Needham, *Science and Civilization in China*, Vol. 4, Cambridge University Press: Cambridge, 1971, p. 540.

19. Vining, *Inglorious Columbus*, p. 697.

as an adjective meaning "many," modifying a noun "pu-tao" meaning grapes. Vining arbitrarily put the adjective and the noun together as a phonetic unit "to-pu-tao" and literally turned many grapes into a tomato. In spite of these errors, Vining's book has value for western readers interested in Asian—Meso-American contacts. In addition to a Chinese text of the Fu-Sang episode in *Liang Shu,* Vining carefully translated and summarized works about Fu-Sang by many scholars of various nationalities.

There seems to be a vicious cycle operating here; without an aptitude for association, one will not become a diffusionist in the first place. Yet a person gifted with this quality is likely to perceive connections where none exist.

Mertz, who based a large part of her book, *Pale Ink,* on Vining's work, strived to link *Shan Hai Ching,* a Taoist counterpart of the Buddhist *Hsi Yu Chi*[20] (Record of a Journey to the West), to Hui-Shen's Fu-Sang story. Like some Chinese Taoist writers, she put words into both Confucius's and the Grand Historian Szu-Ma Chien's mouth[21] and claimed that both mentioned *Shan Hai Ching* and attributed it to Yu, a legendary emperor who ruled from 2205-2197 B.C.

A careful study of Szu-Ma Chien's *Shih-Chi* (Historical Records) and the Confucian *Chia-Yu* (The Family Sayings of Confucius) reveals that neither Confucius and his disciples nor Szu-Ma Chien had ever spoken of *Shan Hai Ching,* let alone of its having been compiled by Yu. Mertz has confused the *Shan Ching* (The Book of Mountain) with the *Shan Hai Ching* (The Book of Mountain and Sea).

The chief flaw of Mertz's treatment of *Shan Hai Ching* was her method of relating the mountains and rivers mentioned in the *Shan Hai Ching* to those in western America. She was not aware of the following:

1. The *Shan Hai Ching* never mentioned anyone having taken a journey from a definitive place.
2. The *Shan Hai Ching* made statements only to the effect that approximately so many miles from a certain "shan" (mountain or hill) there was a another "shan," and so many miles from such a peak was a river.
3. Chinese miles differed from Western miles and were frequently exaggerated in ancient Chinese books for there was no accurate means for measurement and the length of a mile changed sometimes from dynasty to dynasty. This practice remains even in modern times. For example, the Great Wall is called in China "The Wall of Ten Thousand Miles" when it is actually 1400 miles long, and the Chinese

Red Army's famed Long March is commonly known in China as the "Twenty-Five Thousand Miles Long March" when it was actually one of less than 6000 miles.
4. The Chinese term "shan" can mean a towering mountain or merely a hill.
5. It is not difficult to fit the description in *Shan Hai Ching* to any extended mountainous region—whether it is in Europe, Asia, or America—as long as one is at liberty to arbitrarily choose a starting point. Mertz did just that:

> There may be some indication in the untranslated portions that I do not have that told how the Chinese got across the Eastern Sea to the Eastern Mountains [There is no such indication in the untranslated portion]. Since it is not available, to decide independently how they got there would only be pulling a conclusion out of thin air. Therefore, with no apology, we shall jump across and only try to solve the geographical problems that we actually have.
>
> The opening sentence of the section started out by saying that "Suh-Chu Mountain" on its northern side adjoined the "Sunless Mountain" and that drinkable water was found in a river flowing northeasterly. I chased up and down a dozen or more times on my map, from Canada to Mexico, and each time examined every peak without even a flicker of a clue. Being unable to locate "Suh-Chu Mountain" or the good drinking water, I finally passed it over. The second peak had to be passed over for the same reason. The third one "rang a bell." The Chinese had named it "Aspen Mountain." "Aspen," to me, meant only one thing—Estes Park, Colorado. Taking a chance that the third peak was somewhere in Colorado, I pinpointed it there. From that point, I worked both forward and backward. Going backward to peak number one, "Suh-Chu Mountain," I found myself looking at Sweetwater River, in Wyoming, flowing northeast—good drinking water. Working my way down the map, the shifting sand, the sand that had eliminated the Andean range, was found precisely on the spot where the Chinese had placed it—and today, we have commemorated that spot, unknowingly insofar as the Chinese were concerned, with our Great Sand Dunes National Monument. From then on, peak after peak tallied. It seemed unbelievable at first—but it worked. If the first one worked, the others would have to do so.[22]

As in de Guignes's translation of the Fu-Sang story, Mertz also left out the statement in the original Chinese text that Hui-Shen was from the country of Fu-Sang. She alleged that Hui-Shen, a Chinese following the footsteps of Yu's explorers, reached Fu-Sang in A.D. 458 and civilized it. She outperformed her predecessors by contending that cultural influence was "a two-way street"—the Chinese first learned the use of arrowheads from the American Indians during the former's expedition to America in the twenty-third century B.C.[23]

20. *Hsi Yu Chi,* A fabulous version of a journey to India taken by a Chinese priest, Tang San-Chuang, accompanied by a monkey king and a pig-headed monster. "Hsi-yu-chi" is today popularly used as a slang in China similar in meaning to America's "baloney"!
21. Mertz, *Pale Ink,* p. 107.

22. Mertz, ibid., pp. 111-13.
23. Mertz, ibid., p. 100.

The *Shan Hai King* made sense. It was a simple and sincere statement of a place visited and a distance measured by a man who had been there—short notes jotted down in a little bamboo notebook.[24]

Transforming many grapes into a tomato was quite an exploit, but converting a Chinese Homeric Odyssey into a factual "bamboo chronicle" bearing the date of 2300 B.C. is a feat possible only by Zeus—not by a mortal.

The foregoing are only a few examples of excesses by some diffusionists who believed in the Asiatic origin of Meso-American culture. When a theory contains such improbable conjectures, the Asiatic hypothesis receives only meager support from the public and academia alike.

The third main reason for the transpacific diffusionists's unsuccessful attempts to establish their hypotheses is that practically all of the most important Mayan historical documents were destroyed by the conquerors of Central America during the colonial period—a time when it was considered a righteous undertaking to eradicate infidel cultures. Thus the famed (or notorious) Diego de Landa (1524-1579), Bishop of Yucatan, wrote:

These people also made use of certain characters or letters, with which they wrote in their *books their ancient matters* and their sciences, and by these and by drawings and by certain signs in these drawings, they understood their affairs and made others understand them and taught them. We found a large number of books in these characters and, as they contained nothing in which there were not to be seen superstition and lies of the devil, *we burned them all,* which they regretted to an amazing degree, and which caused them much affliction.[25]

Other noted Spanish historians also recorded the book burning incidents.[26] Antonio de Ciudad Real narrated in 1588:

but because in these books were mixed many things of idolatry, they burned almost all of them, and thus was lost the knowledge of many ancient matters of that land which by them could have been known.[27]

In 1590, Jose de Acosta gave the following account:

In the province of Iucatan, where is the so-called Bishopric of Honduras, there used to exist some books of leaves, bound or folded after a fashion, in which the learned Indians kept the distribution of their times and the knowledge of plants, animals, and other things of nature and the ancient customs, in a way of great neatness and carefulness. It appeared to a teacher of doctrine that all this must be to make witchcraft and magic art; he contended that they should be burned and those books were burned and afterwards not only the Indians but many eager-minded Spaniards who desired to know the secrets of that land felt badly.[28]

In 1633, Bernardo de Lizana reported in his *Historia de Yucatan:*

Thus he collected the books and the ancient writing and he commanded them burned and tied up. They burned many historical books of the ancient Yucatan which told of its beginning and history.[29]

In 1688, Diego Cogolludo wrote:

they collected all the books and ancient writings which the Indians had and in order to erase all the danger and memory of their ancient rites, as many as they were able to find were burned publicly on the day of the auto and at the same time with these (were destroyed) the history of their antiquities.[30]

In addition to stamping out Mayan historical records and other books, the Spanish priests also destroyed a large quantity of Indian artifacts:

From some notes of D. Pablo Moreno and from a letter of a Yucatecan Jesuit, D. Domingo Rodriquez to Illmo. Sr. Estevez, dated Bologna, March 20, 1805 we are able without other authority to offer to our readers the following annotation of the objects some of which were destroyed and others burned:
5000 idols of different form and dimension,
13 great stones which served as altars,
22 small stones of various forms,
27 rolls of signs and hieroglyphics on deer skin,
197 vases of all sizes and shapes.[31]

Other accounts of similar incidents are related in the following:

The Bishop Marroquin in the said city of Guatemala made a public auto in the presence of the Senores of the Audiencia . . . 'in which they burned

24. Mertz, ibid., p. 109.
25. Diego de Landa, *Relación de las Cosas de Yucatan,* edited with notes by Alfred Tozzer, *Papers of the Peabody Museum of American Archaeology and Ethnology,* Harvard University, Cambridge, Massachusetts, 1941 (1966 Reprint), Vol XVIII, p. 169.
26. Ibid., p. 78.
27. Antonio de Ciudad Real, *Fray Alonso Ponce on Yucatan,* translated and annotated by Ernest Noyes, *Middle American Research Series,* Tulane University Press: New Orleans, 1932, Vol. 4, p. 314.

28. Jose de Acosta, *Historia natural y moral de las Indias, en que se tratan las cosas notables del cielo, elementos, metales, plantas, y animales de ellos; y los ritos, ceremonias, leyes, gobierno de los Indios,* Seville, 1950, Part 6, chapter VI. See Landa's *Relación,* p. 78.
29. Bernardo de Lizana, *Historia de Yucatan,* Mexico, 1893, Book 1, chapter VI.
30. Diego Lopez Cogolludo, *Historia de Yucatan,* Madrid, 1688, Book 6, chapter I.
31. Diego Cogolludo, *Historia de Yucatan,* 2nd Edition, Campeche, 1842, Appendix by Justo Sierra, Vol. 1, p. 479. See Landa's *Relación,* p. 78 and *The Inscriptions at Copan,* by Morley, p. 44.

and broke a very large number of idols.' This would seem to show, as already pointed out, that most of the idols were of wood or clay.[32]

And after the above, the said auto was preached to the said Indians in their language and said interpreter (Gaspar Antonio Chi) read and stated the sentence of each delinquent and they were executed on their persons; and some were condemned to wear sambenitos, as has been said, and besides that to personal service for a certain number of years, some many, others less, and to be shorn and whipped and to burn statues and bones, . . . the said friars suspend many Indians by their arms, and some of them by the feet, and hang stones from their feet, and whip them and spatter them with tapers of burning wax, and mistreat them grievously in such a way that afterwards, at the said time when, as he has said, they were given penance and brought forth in the said public auto (de fe), there was not a sound place on their bodies where they could be whipped again in accordance with the sentences.[33]

The lack of reliable Asian historical records concerning transpacific voyages provides the fourth major stumbling block for the transpacific diffusionist. This is due to the following factors:

1. Situated on the crossroads between the East and the West, and suffering from cultural heterogeneity and discontinuity, India and other Southeast Asian countries, unlike China, do not have systematic, comprehensive, and uninterrupted historical records.

2. Unlike Spain, Portugal, England, and other mercantile countries in Europe, whose natural environments and limited resources encouraged government-sponsored overseas ventures, China, always an agrarian country, never has had pressing economic need to launch large-scale maritime exploration.

3. In ancient China most of the distant seafaring activities were largely conducted by private religious establishments, small groups of traders in the semi-"barbarous" states (provinces on the southern coast of China), the minority tribes who were driven out of China by the southward expanding Han Chinese, and the social outcasts (rebels and other criminals). The official historians (who were usually Confucians) of all the Chinese dynasties, with a few exceptions, did not record these nonofficial undertakings.

4. Confucianism, the dominant binding force of Chinese culture from the fifth century B.C. to as late as the early twentieth century A.D., disapproves of profit-seeking or religious overseas ventures:

Confucius said: While his parents are alive, the son may not take a distant voyage abroad. If he has to take such a voyage, his destination must be known.[34]

Confucius said: The mind of a superior man dwells on righteousness; the mind of a little man [mean man] dwells on profit.[35]

Fan Chih [a disciple] asked what constituted wisdom. Confucius answered: To shoulder the responsibility of righteousness for the people; while respectful, keep away from things dealing with demons and gods.[36]

Chi Lu [a disciple] asked about serving the spirits. Confucius replied: While unable to serve humans, how can one serve the spirits? Chi Lu then respectfully asked about death. Confucius answered: While man does not know enough about life, how can he expect to know about death?[37]

5. It is not surprising that among the few distant overseas ventures mentioned in official Chinese historical records, most of them were associated with infamous rulers:

In the years before the Han dynasty the First Emperor of the Chin abandoned the way of the sages, killed the practitioners of the Way [Righteous Tao], burned the *Odes* and *Documents* [Confucian Classics], and cast aside the principles of correct behavior, honoring deceit and physical force instead and trusting to harsh punishments. He had grain transported from the seacoast all the way to the upper reaches of the Yellow River, but at that time, although the men worked the fields as hard as they could, they could not scrape together enough to make a meal of chaff and dregs, and though the women wove and spun, they had not enough cloth left to cover their bodies. . . . Then the First Emperor of the Chin sent Hsu Fu to sail over the sea in search of the spirits, and he returned and lied to the emperor, saying, "In the midst of the sea I met a great spirit who asked me if I were the envoy from the Emperor of the West. When I answered that I was, he asked me what I was seeking for. 'I am looking for the medicine which increases one's years and brings long life,' I said. 'Your king of Chin,' replied the spirit, 'is too stingy with his courtesy! You may see the medicine, but you cannot take it back with you!' Then he led me to the southeast, to the mountain of Peng-lai, where I saw palaces and towers surrounded by lawns of grass. There was a messenger there, copper-colored and shaped like a dragon, with streams of light pouring from his body and lighting up the sky. When I saw him I bowed before him twice and asked, 'What sort of offerings should I bring?' and the Sea God (for that was what he was) replied, 'If you will bring me the

32. France Scholes and Eleanor Adams, *Don Diego Quijada, Alcalde Mayor de Yucatan, 1561-1565. Documentos sacados de los archivos de Espana*, Mexico, 1938, Vol. 1, p. xli and Vol. 2, pp. 54-5. See Tozzer, op. cit., p. 108.

33. Ibid., Document X, pp. 65-66; Tozzer, p. 77.

34. *Lun-Yu*, Book 4, chapter 19. *Lun-Yu* (The Confucian Analects—sometimes referred to as the Sayings of Confucius) is one of the Four Classics) *Lun-Yu, Ta-Hsueh, Chung-Yung,* and *Meng-Tzu*) which are to the Confucian as the Bible is to the Christian. *Lun-Yu* was compiled by the disciples of Confucius, ca. 450 B.C.

35. Ibid., Book 4, chapter 16.

36. Ibid., Book 6, chapter 20. Confucianism emphasizes man and his relationship to the society—a doctrine stressing the "this world" aspect against the "other world" aspect of things.

37. Ibid., Book 11, chapter 11.

sons of good families, and beautiful maidens, along with the products of your various craftsmen, then you may have the medicine!' '' When the First Emperor heard this, he was overjoyed and immediately sent Hsu Fu back east again, accompanied by three thousand boys and girls of good families and bearing presents of seeds of five types of grains and articles produced by the various craftsmen. But when Hsu Fu reached Ping-yuan and Kuang-tse, he halted his journey, made himself king of the region, and never returned to the Chin. With this, the people were filled with sorrow and bitterness and six families out of every ten favored revolt.[38]

38. *Shih Chi,* (The Historical Records), by Szu-Ma Chien and Szu-Ma Tan, ca. A.D. 90. Translated by Burton Watson in *Records of the Grand Historian of China,* Columbia University Press: New York, 1961, Vol. II, pp. 374-75.

It appears that if any Chinese did manage to cross the Pacific, they were probably fleeing China with no intention of returning because of political or religious persecution. Otherwise they probably were Buddhist propagators or Taoists in search of longevity drugs or fairylands. The probability that those people who survived the inadvertent crossing of the vast Pacific found their way back to China seems extremely slim. Thus the absence of reliable historical records.

This is only one of the possible speculative and highly simplified answers. I attach only minor significance to unverifiable literature and I wish to emphasize only tangible evidence, so I will proceed directly to comparisons of arbitrary trait-complexes.

III. SPECULATIONS BASED ON RESEMBLANCES BETWEEN ARTIFACTS OF THE OLD AND NEW WORLD

AS MORE ancient American artifacts came to light in the nineteenth and early twentieth centuries, some scholars speculated on possible Asiatic contacts because of similarities between art motifs of the Mayan culture and those of East Asian culture. One of the earliest, most hotly debated items was the elephant snout motif on Stela B in Copan, West Honduras.

John Lloyd Stephens, in his famous *Incidents of Travel in Central America, Chiapas, and Yucatan* published in 1841, first noted the resemblance of the two long-nosed elements (on top of Stela B) to elephant trunks. Twenty-five years later, in 1865, G. B. Taylor made an elaborate argument for the recognition of the Indian elephant as the subject matter depicted on the stela in a book entitled *Research into the Early History of Mankind*. Although noting the resemblance of the principal figure to an oriental one, Alfred Maudslay, a distinguished English scholar of Mayan archaeology, believed that the two heads with trunks on top of the stela could have been tapirs:

> The principal figure on the front of the stela has much the appearance of a Chinaman. The face is bearded and has what appears to be a moustache joined into a curious ornament. . . . The headdress bears a strong resemblance to a turban. . . . Above the turban is a complicated ornament. . . . The great curved teeth are, however, common to this head and to the heads which bear some resemblance to those of elephants occupying the top corners of the stela.
>
> The elephant-like appearance of those heads has been the subject of much discussion, but I fail to see any reason why the form may not have been taken from the head of the tapir, an animal still commonly found in the neighborhood.[1]

Alexander von Humboldt, whose earlier work *Views of the Cordilleras and Monuments of the Indigenous Nations of America* documented parallels between ancient American and Asian zodiacs and myths, also felt that the long-nosed animals described in Mexican codices were probably native animals of America.

In 1909, G. B. Gordon, who was in charge of the fourth expedition

(1894-95) at Copan, published an article entitled ''Conventionalism and Realism in Mayan Art in Copan,'' which first identified the two animal heads as local blue macaws. This view received immediate support from Alfred Tozzer,[2] then curator of Middle American Archaeology and Ethnology, Peabody Museum, Harvard University, and Herbert Spinden,[3] an American authority on Mayan art, then associated with the American Museum of Natural History in New York City. A fierce battle between the elephant and the macaw advocates ensued.

Elliot Smith, the champion of the British heliolithic school, challenged the Harvard-centered authorities in his ''Pre-Columbian Representations of the Elephant in America'' in 1915:

> No one who looks at the accompanying tracing, which I have taken from Dr. A. P. Maudslay's magnificent atlas of photographs and drawings of the central American monuments should have any doubt about the justification for Stephens' comment. Moreover, the outline of the head is so accurately drawn as to enable the zoologist to identify the original model for the design as an Indian species of the elephant.[4]

Tozzer and Spinden instantly responded with two separate letters to the editor of *Nature* magazine, Spinden saying:

> There appeared to be little doubt that these heads under discussion on Stela B at Copan are intended to represent the blue macaw. . . .
>
> It is not a mere difference of opinion upon rather minor details of archaeology that prompts this reply to Dr. G. Elliot Smith's communication. It is because he ventures to draw conclusions of great importance as regards cultural connection between China and Mexico in ancient times from this tainted evidence. In dealing with the hydra-headed fallacy of Old World origins for New World civilizations it is necessary to cut off each head in turn with a searing sword.[5]

1. Alfred Maudslay, *Biologia Centrali Americana*, Porter and Dulay: London, 1889-1920, Vol. 1, p. 42. This is still the best book ever published on Mayan art, with one volume of text and four huge volumes of superb illustrations.

2. Alfred Tozzer, ''The Animal Figures in Mayan Codices,'' *Peabody Museum Papers*, Harvard University Press: Cambridge, Vol. IV, No. 3, 1910, p. 343.

3. Herbert Spinden, ''A Study of Mayan Art,'' *Memoirs of the Peabody Museum*, Harvard University Press: Cambridge, Vol. VI, 1913, p. 79.

4. Elliot Smith, ''Pre-Columbian Representations of Elephants in America,'' *Nature*, Macmillan: London, No. 2404, Vol. 96, November 25, 1915, p. 340.

5. Herbert Spinden, *Nature*, No. 2413, Vol. 96, January 27, 1916, p. 593.

Tozzer commented:

> If Prof. Smith will look on the back of the monument on which his figure is found he will note at the bottom the drawing of the glyph referred to in the quotation. This is unmistakably a macaw. [6]

Undaunted, Smith countered:

> The account given in my memoir sheds a remarkable light upon the psychology of Americans, both ancient and modern, and especially upon the ethnological "Monroe Doctrine" which demands that everything American belongs to America, and must have been wholly invented there. The Maya civilization was American in origin only in the same sense that Harvard University is—immigrants from the Old World supplied the ideas and the technical knowledge, which enabled an institution to be built up, no doubt with certain modifications prompted by local conditions and the contact of a variety of cultural influences.
>
> Dr. Spinden's refusal to admit that the Copan sculptures represent elephants becomes more intelligible when one reads the statement in his monograph on "Maya Art" that "he does not care to dignify by refutation the numerous empty theories of ethnic connections between Central America and the Old World (p. 231). This is the attitude of mind not of the scientific investigator, but of the medieval theologian appealing to the emotions in defense of some dogma which is indefensible by reason. [7]

In 1920, another well-known American Mayan scholar, Sylvanus Morley, entered the battlefield and declared war on Smith.

> More recently Elliot Smith has revived this highly improbable identification finding detailed anatomical similarities between this decorative element on Stela B and the trunk of an elephant. He has been ably answered, however, by Tozzer, Spinden, and Means.
>
> It is hardly necessary to point out that any attempt which seeks to establish direct cultural connection between the Maya and any old-world civilization, either Egyptian or Mongolian, is quite at variance with the results of modern research in this field. And yet the superficial similarities of the Maya to these civilizations are such as to win for this now exploded hypothesis new adherents from time to time. [8]

His convictions unshaken despite overwhelming opposition, Smith published in 1924 a book titled *Elephants and Ethnologists* in which he retorted:

> The sole reason for the refusal to admit that the Copan sculptures and the pictures on the Maya codices are Indian elephants is due to the fact that such an admission would destroy the whole foundation of the doctrine of the independent evolution of American culture. I am not claiming that ethnologists on the two sides of the Atlantic are wittingly guilty of this deception; it is a case of the unconscious repression of an awkward fact. Having adopted as a rigid dogma, to which they cling with quasi-theological fervour, the belief that the civilization of the New World was developed without any help or even prompting from the Old World, it is clearly impossible for them seriously to consider even the possibility of an Indian elephant being represented on American monuments. Therefore, without even examining the evidence that is fatal to their creed they simply shut their eyes to it and refuse to admit a patent fact. [9]

That the American authorities, after years of painstaking on-site research, were outraged is understandable. An amateur (he was a professor in medicine), Smith was notorious for his fantastic heliolithic theory that the origin of all major cultures could be traced to ancient Egypt.[10] Smith had never visited Copan or any Mayan site and had based his speculations regarding Stela B mainly on a secondary source, Maudslay's illustrations in *Biologia Centrali Americana*.

An outsider who had neither formal training in American archaeology nor direct access to Meso-American artifacts, he challenged an academic cartel of distinguished professionals associated with such prestigious scholarly institutions as Harvard University, the Carnegie Institution of Washington, and the American Museum of Natural History. After Smith's death, his elephant theory was never heard of again.

In Chapter IV, section 5, I attempt to demonstrate with the new materials I found at Copan[11] that the explanations offered by Tozzer, Spinden, and Morley regarding the two long-nosed animals were just as defective as Smith's. It appears they all failed to recognize that the ancient Mayans were masters of zoomorphic synthesis, skillful in combining attributes of different animals into a single entity. The two long-nosed creatures, in my opinion, are neither macaws nor elephants. As Chapter IV will demonstrate, they appear to be an artistic hybrid of a liaison between a naughty Asian elephant and a swinging American macaw.

Other resemblances between Meso-American artifacts and those of Southeast Asia have been observed by a number of other scholars. Channing Arnold and Frederick Frost, in their *American Egypt* (1909), first pointed out the similarities in the water lily, Makara, cross, animal throne, and sitting posture motifs.[12] They were unable to produce any

6. Alfred Tozzer, ibid., p. 593.

7. Elliot Smith, ibid., pp. 593-95.

8. Sylvanus Morley, *The Inscriptions at Copan*, Carnegie Institution of Washington: Washington, 1920, p. 224.

9. Elliot Smith, *Elephants and Ethnologists*, E. P. Dutton and Co.: New York, 1924, p. 109.

10. Elliott Smith, *The Diffusion of Culture*, Watts and Co.: London, 1933.

11. These motifs had obviously escaped the attentions of all the scholars involved in the elephant controversy.

12. Channing Arnold and Frederick Frost. *The American Egypt: A Record of Travel in Yucatan*. Doubleday, Pageant Company: New York, 1909, pp. 269-73.

documentation, using the excuse that "archaeology is not such a popular and paying science as will allow those without large means at their disposal to follow up their theories."[13] This drew fierce attacks from Morley:

> The front of Stela B is sculptured with a human figure of heroic size whose somewhat Mongoloid cast of countenance has given rise to a flood of ill-considered speculations regarding the possible Asiatic origin of the Mayan civilization. One of the more recent supporters of this extravagant hypothesis, long since relegated to the rubbish pile of scientific discards, is Arnold.[14]

Added to Arnold and Frost's list of similarities in sculpture motifs of East Asia and Meso-America are the double-headed monster, the Kirtimukha motif (large frontal mask flanked by a profile on each side), and the animal headdress by Elliot Smith;[15] the wheeled toys[16] and tripod vessels[17] by Gordon Ekholm; the vertically stacked masks, the "Hockers," and the alterego motifs by Miguel Covarrubias;[18] the overlapping scroll motifs by Robert Heine-Geldern;[19] and the Jomon

motifs by Estrada, Meggers, and Evans.[20] Nevertheless, none of these scholars succeeded in breaching the defense line of the old guard which advocated the indigenous origin of ancient American culture. Hence the frustration of Ekholm, curator of Middle American archaeology of the American Museum of Natural History and a leading transpacific cultural diffusionist, who concluded in 1971, "Finally, and as a summary, we might come back to the question of transpacific contacts. I admit that there is no hard evidence of such contacts."[21]

Though I have great respect for Dr. Ekholm's scholarship, I disagree. The problem, in my opinion, is not so much the lack of hard evidence as the lack of adequate knowledge and pertinent tactics in discerning, structuring, and presenting such evidence. Tangible evidence favoring transpacific contacts abound. Wanting is a diachronic[22] and synchronic[23] matrix which correlates arbitrary trait-compexes of the Old and the New World instead of single and simple traits. An arbitrary trait-complex is defined here as being composed of a number of highly stylized motifs arranged in an arbitrary manner to form a whole (a new configuration—or a complex), which is usually symbolic in content and is not directly attributable to structural and functional limitations.

13. Ibid., p. viii.

14. Morley, *The Inscriptions at Copan,* p. 224.

15. Elliot Smith, *The Diffusion of Culture,* Plates 13, 14, 21, 22, 23, 28, 36, 39, 41, and 42.

16. Gordon Ekholm, "Wheeled Toys in Mexico," *American Antiquity,* 1946, Vol. II, pp. 222-28.

17. Gordon Ekholm, "Transpacific Contacts," *Pre-Historic Man in the New World,* edited by J. D. Jennings and Edward Norbeck, University of Chicago Press: Chicago, 1964, pp. 489-510.

18. Miguel Covarrubias, *The Eagle, the Jaguar and the Serpent,* Alfred A. Knopf: New York, 1954, pp. 34-60.

19. Robert Heine-Geldern, "The Problem of Transpacific Influences in Meso-America," *Handbook of Middle American Indians,* Vol. 4, University of Texas Press: Austin, 1966, pp. 277-95.

20. Betty Meggers, Clifford Evans, and Emilio Estrada, *Early Formative Period of Coastal Ecuador,* Smithsonian Contributions to Anthropology, Washington, D.C., 1965, Vol. 1.

21. Gordon Ekholm, "Diffusion and Archaeological Evidence," *Man Across the Sea,* edited by Carroll Riley, J. C. Kelley, C. W. Pennington and R. S. L. Rands, University of Texas Press: Austin, 1971, p. 59.

22. An evolutionary, historical approach to cultural study dealing vertically with cultural changes through time sequence.

23. A nonhistorical approach to cultural study, dealing horizontally with coexisting cultures at a single moment in time.

IV. COMPARISON OF ARBITRARY TRAIT-COMPLEXES

THE EXISTENCE of similar cultural motifs occurring in widely separated civilizations has given rise to two seemingly opposed, anthro-archaeological theories. One school believes that resemblance between cultures is basically the result of independent invention or parallel evolution; the other argues that it is mainly due to cultural contacts.

Evolution, the process of continuous change from a lower, simpler stage to a higher, more complex stage, was established as a theory with the publication of Darwin's *Origin of the Species* in 1859. His hypothesis was cross-fertilized with that of Herbert Spencer[1] and further developed by Edward Tylor[2] and Lewis Morgan[3] into a doctrine commonly known as cultural evolutionism. It asserts that there is a necessary and predetermined scheme—a universal law—underlying all stages of progressive development of culture.

Another famed evolutionist, Adolf Bastian,[4] used the concept of "psychic unity" or "overinventiveness" to explain resemblance between cultures. If different cultures advance through similar sequences and all human minds are essentially alike, resulting in similar "elementary concepts," it is only natural that parallel cultural achievements can be attained independently by unrelated civilizations.

Morgan expressed the idea of "psychic unity" as follows:

> The remote ancestors of the Aryan nations presumptively passed through an experience similar to that of existing barbarous and savage tribes. . . .
>
> It may be remarked finally that the experience of mankind has run in nearly uniform channels; that human necessities in similar condition have been substantially the same and that the operations of the mental principle have been uniform in virtue of the specific identity of the brain of all races of mankind.[5]

Departing from Bastian's "psychic unity" and negating Morgan's rigid "historical sequence" ("uniform channels" of progressive development), Franz Boas[6] believes that each culture is composed of a number of individual traits brought about by historical accidents, particular or specific events. He emphasizes these events and the need for exhaustive research on carefully defined problems of limited scope with strictly controlled variables. Unlike Bastian, who ascribed a subordinate, dispensable role to diffusion, Boas contends that although a culture may possess a few independently invented traits, its main components are of divergent, imported origins.

The German school of diffusionists led by Graebner[7] and Schmidt[8] was more extreme than Boas: their "Kulturkreislehre" contended that cultural similarities were solely the result of diffusion. Both Graebner and Schmidt underscored the "uninventiveness" of man and the concept of "kulturkreis" (cultural circle)—a scheme which assumed a number of original cultural centers from which "cultural circles" were diffused, in part or in whole, to all the lesser ones in the world.

Their counterpart in England, the heliolithic school led by Elliot Smith, W. H. R. Rivers, and W. J. Perry, went one step further. Robert Lowie summarized its tenets as follows:

(1) Man is uninventive; hence, culture arises only in exceptionally favorable circumstances, practically never twice independently.
(2) Such circumstances existed only in ancient Egypt; hence elsewhere culture, except some of the simplest elements, must have spread from Egypt with the rise of navigation.
(3) Civilization is naturally diluted as it spreads to outposts; hence, decadence has played a tremendous role in human history.[9]

The fallacy of the extreme diffusionist and the parallel evolutionist is evident. As pointed out by Tylor, similar stages of culture succeeding

1. Herbert Spencer, *Social Statics,* D. Appleton: New York, 1883 (orig. 1850); *Principles of Sociology,* D. Appleton: New York, 1896 (orig. 1876).

2. Edward Tylor, *Researches into the Early History of Mankind and the Development of Civilization,* Henry Holt: New York, 1878 (orig. 1865); *Primitive Culture,* Harper Torchbook: New York, 1958 (orig. 1871).

3. Lewis Morgan, *Ancient Society,* Henry Holt: New York, 1878.

4. Adolf Bastian, *Die Völker des Östlichen Asien,* Leipzig, 1869; *Der Völkergedanke im Aufbau einer Wissenschaft vom Menschen und seine Begründung auf Ethnologische Sammlungen,* Berlin, 1881.

5. Morgan, *Ancient Society,* p. 8.

6. Franz Boas, *Race, Language and Culture,* Macmillan: New York, 1940.

7. Fritz Graebner, "Kulturkreise und Kulturschichten in Ozeanien," *Zeitschrift für Ethnologie,* 1905, Vol. 37, pp. 28-53.

8. Wilhelm Schmidt, *The Culture Historical Method of Ethnology,* S. A. Sieber, Trans., Fortuny's: New York, 1939.

9. Robert Lowie, *The History of Ethnological Theory,* Holt, Reinhart, and Winston: New York, 1966, p. 161.

each other in substantially uniform fashion do not necessarily require the separation of independent traits from borrowed ones:

> In the first place, the facts collected seem to favor the view that the wide differences in the civilization and mental state of the various races of mankind are rather differences of development than of origin, rather of degree than of kind . . . wherever the occurrence of any art of knowledge in two places can be confidently ascribed to independent invention, as for instance, when we find the dwellers in the ancient lake-habitations of Switzerland, and the Modern New Zealanders, adopting a like construction in their curious fabrics of tied bundles of fibre, the similar step thus made in different times and places tends to prove the similarity of minds that made it. Moreover, to take a somewhat weaker line of argument, the uniformity with which like stages in the development of art and science are found among the most unlike races, may be adduced as evidence on the same side, in spite of the constant difficulty in deciding whether any particular development is due to independent invention, or to transmission from some other people to those among whom it is found. For if the similar thing has been produced in two places by independent invention, then, as has just been said, it is direct evidence of similarity of mind. And on the other hand, if it was carried from the one place to the other, or from a third to both, by mere transmission from people to people, then the smallness of the change it has suffered in transplanting is still evidence of the like nature of the soil wherever it is found.[10]

The very assumption of diffusion, therefore, predicates ''psychic unity.'' The fact that a trait is transmitted through cultural contacts does not assure that it will be appreciated and then appropriated by the receiving culture. If the trait is adapted, it merely provides evidence that human minds are essentially the same.

It is clear from the above discussion that diffusion as well as parallel evolution (independent invention) are both manifestations of ''psychic unity''—aspects of the same processes. Both are important factors affecting cultural change, although their respective roles may vary depending on the case under study. Generally speaking:

1. The simpler a cultural trait, the easier for it to be independently invented or evolved.
2. The more functionally and structurally oriented a trait, the greater the probability of independent invention.
3. Conversely, the more complex, arbitrary, and stylized a correlated trait, the higher likelihood of its being borrowed from a more advanced culture, particularly if these highly complex traits appear suddenly without traceable developmental precedence (like some of the Olmec and Mayan motifs).

4. The probability of cultural contact increases if resemblance occurs not only between individual traits of the two cultures, but also between trait-complexes—a trait-complex is composed of several traits arranged in a particular juxtaposition.
5. The probability of diffusion is positively related to the number of arbitrary trait-complexes for which counterparts in another culture can be isolated.
6. The significance of the similarities between arbitrary trait-complexes of the cultures multiplies if the resemblances can be correlated not only in motif-substance but also in time sequence.
7. The case for diffusion becomes more convincing if the correlated arbitrary trait-complexes are unique to the two cultures being investigated.

In comparing the following artifacts of Meso-America and East Asia, I have been careful to avoid comparisons of simple traits which can be easily attributed to congruences in primal human preceptual behaviors and their actualization under similar environmental stimuli. Also avoided, where possible, are motifs which have developed primarily as a result of functional and structural constraints. One rarely sees a square tripod vase. Round vessels supported on legs are, in most cases, designed with three legs because a fourth will add neither stability nor beauty, but will only create more problems of balance for the potter. Clay pots, whether a potter possesses the knowledge of the wheel or not, are usually round because they are structurally stronger, not as susceptible to chipping as square ones, and can be held more easily. Thus, if the form of one pot appears similar to another of a different culture, this cannot necessarily be considered as evidence of cultural contact.

Similarly, contacts cannot be deduced merely because the two cultures under study employ the same simple geometric motifs in decorating their art works. A good case in point is Heine-Geldern's contention of Hallstatt influence on late Chou Chinese and Dongson border designs, citing saw-tooth motifs, tangent-circle and the Greek meander as significant proofs.[11] The fact is that the tangent-circle and the saw-tooth motifs had already been employed in Chinese bronze works as early as the fifteenth century B.C. These border design motifs were so simple and universal that they could easily have been invented independently.[12]

In short, this study attaches little significance to resemblance of

10. Edward Tylor, *Researches into the Early History of Mankind and the Development of Civilization,* pp. 372-75.

11. See Robert Heine-Geldern, ''Some Tribal Art Styles of Southeast Asia: An Experiment in Art History,'' *The Many Faces of Primitive Art,* by Douglas Fraser, Prentice-Hall: Englewood Cliffs, 1966, p. 181. Heine-Geldern was one of the leading transpacific diffusionists.

12. See Wu Shan, ''On Paleolithic Decorative Design of the Huang River, Chang River, and the South China Region,'' *Wen Wu* [Cultural Relics], 1975, Vol. 5, p. 72, Figure 23.

"one-shot," simple, primal, universal and functionally oriented traits. Emphasis, rather, has been placed on the correlations of complicated and highly stylized trait-complexes, unique to Meso-America and East Asia, with distinctly arbitrary motifs and motif-schematizations in spatial and temporal contexts.

Section 1 of the following plates studies the similarities in ceremonial postures and attires portrayed in Mayan and Asian art works. In section 2, various multiple-headed motifs of the two cultures are examined. In section 3, a number of distinct iconographic attributes of seated figures in East Asia and Meso-America are compared. Section 4 examines the trait-complex of priest-king holding ceremonial objects and standing on a slave-demon in various positions. In section 5, I attempt to document that the two controversial animal heads on top of the Stela B at Copan are composite imageries created by the Mayan artists probably under Asiatic stimulus. Finally, in section 6, a series of highly unique ceremonial gestures depicted by the Mayan and East Asian artists are correlated.

1. STANDING FIGURE HOLDING DOUBLE-HEADED SERPENT BAR (PLATES I-80A)

Before proceeding directly to the comparison of Mayan and Asian artifacts, perhaps a brief examination of two classic "old-world" statues will help clarify the basic concept underlying the approach employed in this study. The Greek Kouros and the Egyptian figure shown in Plates 1 and 2 share the following attributes:

1) beaded-hair stylization
2) stiff arms pressed to the sides of the body
3) clenched fists
4) left foot forward in a striding position.

Now let us suppose:

1) that we have not yet deciphered the Egyptian hieroglyphics
2) that neither Diodorus nor any of his countrymen recorded in writing the Egyptian canon of art or, for that matter, the existence of Egypt
3) that Greece is in America rather than in Europe
4) that no bona fide artifact of one country has ever been found in the other and vice versa.

Will an art historian be in a position to deduce cultural contacts between the two countries in question, based on resemblances in artifacts alone? A hard-core "independent evolutionist" or "inventionist" will probably say no; and a so-called "diffusionist" will probably say yes. A more candid student of the subject will probably withhold his conclusion pending a more thorough examination of both the quality and quantity of the parallels which occurred between the two cultures under study. Beaded hair alone, for instance, will prove nothing. The "left foot forward" motif requires more attention because in order to accomplish it, a sculptor has to carve away such a great quantity of stone that throughout the ages, stone sculptors of most cultures—primitive or civilized—have predominately favored the standing pose with feet placed side by side rather than one in front of the other. Nevertheless, the motif of "left foot forward" alone will testify little for cultural contact. However, the left foot forward striding position, beaded hair, and clenched fists close to the sides, together as a trait-complex, will make an interesting case (because the combination of traits within the complex is quite arbitrary thus making it less likely to have been independently invented), but will still not be enough to argue convincingly for diffusion. On the contrary, if there are not just a few but hundreds and hundreds of parallels in arbitrary trait-complexes, then a case of cultural contact between the two countires under study can be strongly supported—especially if these parallels occurred in chronological sequence.

It is within this methodological framework of multiple parallels in arbitrary trait-complexes that the problem of Asiatic influence in Meso-American art is approached in the following pages.

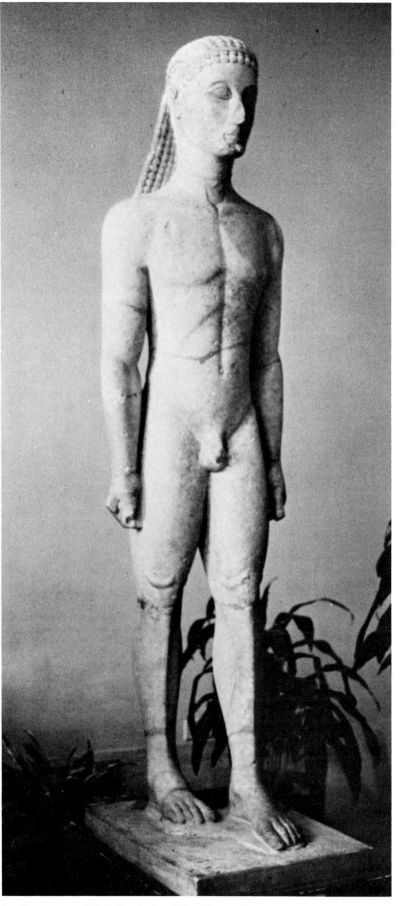

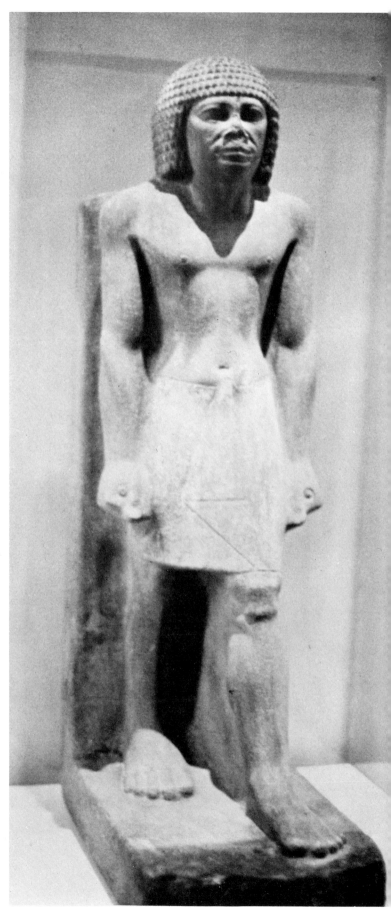

1 Kouros, ca. 620 B.C., Attica (The Metropolitan
Museum of Art, Fletcher Fund, 1932).

2 Egyptian Figure, ca. Second millennium B.C.,
Egypt (Collection of the Metropolitan Museum of Art,
New York City).

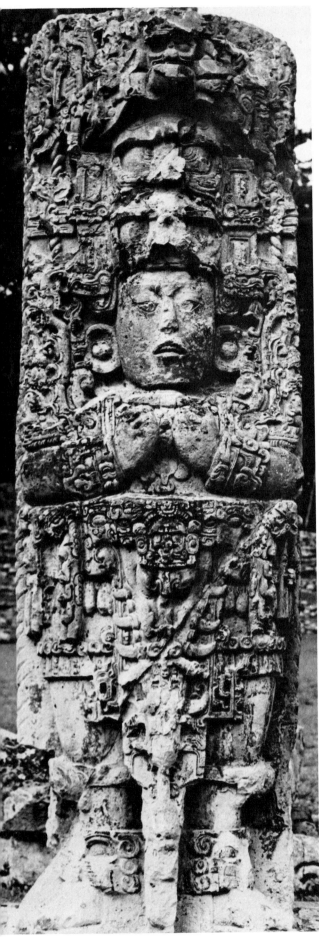

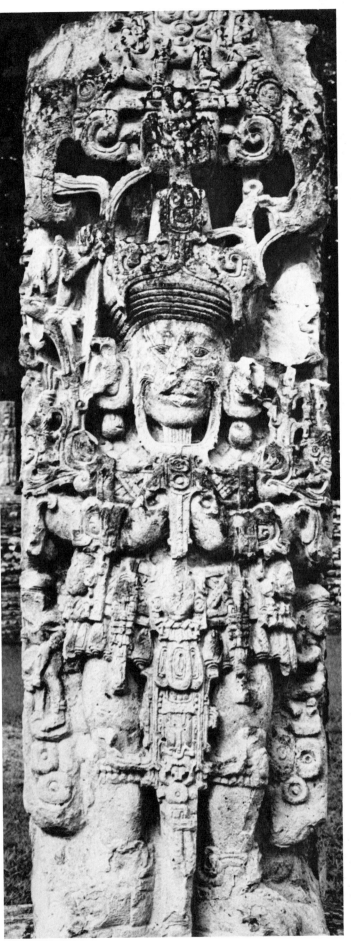

Nowhere in Central America is there a Mayan cultural center which achieved as high a level of artistic sophistication as Copan. Quite a number of the exquisitely carved stone stelae survive at this Mayan site. No sooner had I placed myself among them than I was overpowered by their majestic imageries, delicate craftsmanship, and an indescribable sense of kinship. Without exception, all the priest-kings depicted on these stelae were modelled with arms held horizontally in front of the breasts, feet placed open in a wide V, and heads capped by monster-masks (from which the heads appear to have emerged). In the next few plates the remarkable resemblances between these figures and those of the Chinese will be examined in detail.

3 Stela C, East Side, Dated 9.17.12.0.0—4 Ahau 18 Muan (A.D. 782), Copan, Honduras

4 Stela B, Dated 9.15.0.0.0—4 Ahau 13 Yax (A.D. 731), Copan, Honduras.

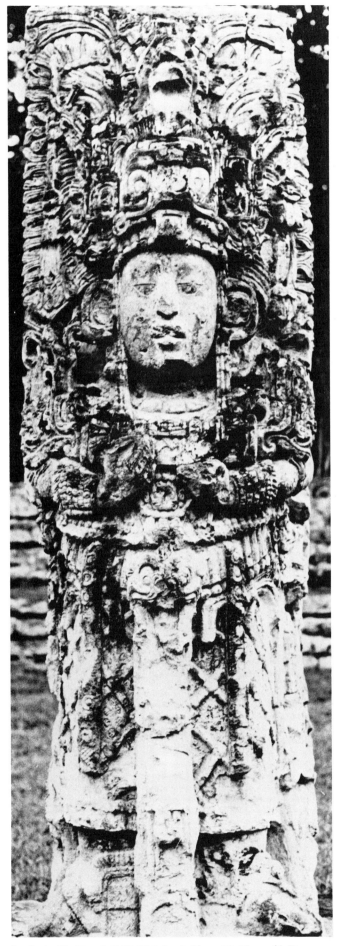

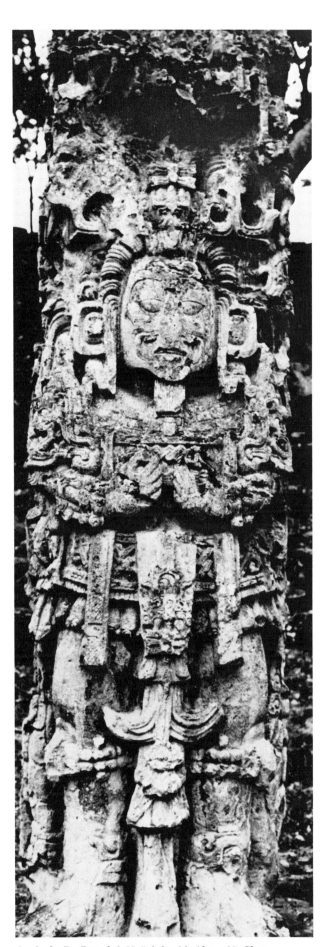

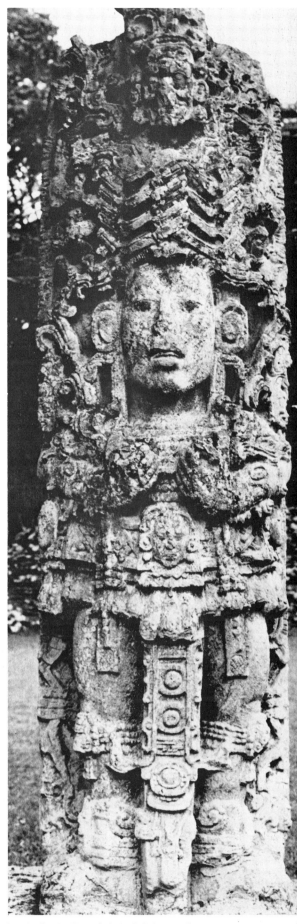

5 Stela H, Dated 9.17.12.0.0—4 Ahau 18 Muan (A.D. 782), Copan, Honduras.

6 Stela D, Dated 9.15.5.0.0—10 Ahau 15 Chen (A.D. 736), Copan, Honduras.

7 Stela A, Dated 9.15.0.0.0—4 Ahau 13 Yax (A.D. 731), Copan, Honduras.

8 Mongolian Lamas (Courtesy of the American
Museum of Natural History).

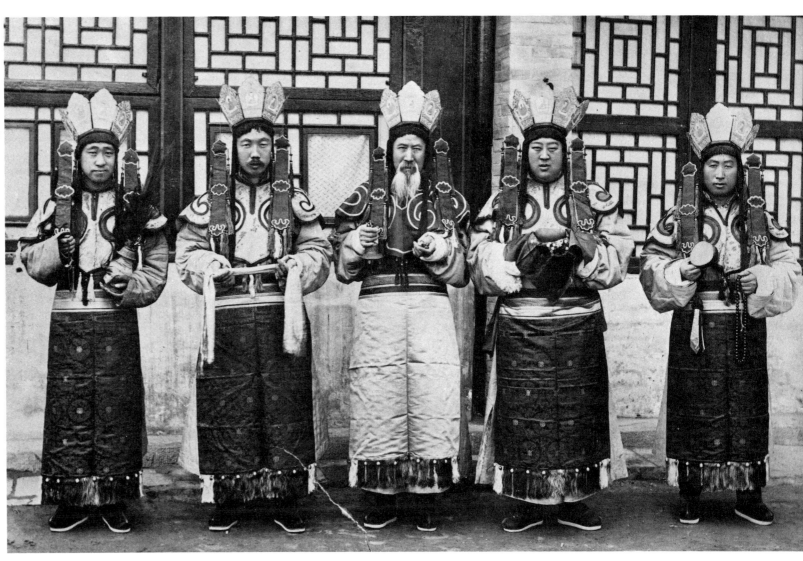

9 Mongolian Lamas (Courtesy of the American
Museum of Natural History).

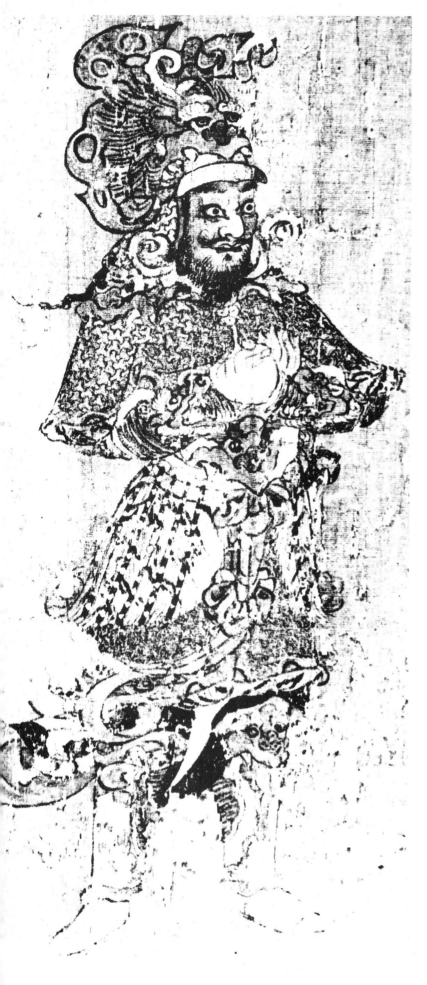

The stylization of the human figure in Chinese art differs markedly from dynasty to dynasty. Significantly the period when the representation of the human figure exhibits the strongest correspondence with those of the Mayan is the Tang (A.D. 618-907). Founded by Li Yuan and his son, Li Shih-Min (better known as Tang Tai-Tsung), the Tang era is generally regarded by the Chinese as the most glorious in their history on account of its extensive domain and high achievements in art and literature. (To this date, all the overseas Chinese still proudly call themselves "Tang-Jen"—literally the people of Tang, and "China Town" is, without exception, referred to by the Chinese as "Tang-Jen-Chieh"—the streets of the Tang people.)

The domain of the Tang empire extended east-west from the Yellow Sea to the Aral Sea and north-south from Mongolia to Indo-China. It was during this period when Japan imported, en masse, the Chinese culture and turned it into the essential elements of her own. It was during this period that the Sassanian King, Yzdegerd, submitted himself to Tang Tai-Tsung and sought his protection. The Greek emperor, Theodosius, sent an envoy to Chang-An, the Tang capital, to pay tribute to the Chinese emperor. Fleets of Chinese junks sailed into the Persian Gulf and a great number of Ta-Shih "Barbarians" (Arabs) settled in China (notably in Hangchou and Chuanchou—east coastal cities) to carry on the flourishing trade between the two countries.

It is most interesting to observe that the three centuries of the expansive Tang coincides with the Copan Classic Period when Mayan three-dimensional modeling in monuments attained its highest articulation. The following photographs illustrate a few of the dramatic similarities between the Tang and Mayan human stylizations.

10 Portrait of Chang Sun Sung—A General of Early Northern Wei Dynasty. During the Reign of Ming-Yuan Emperor (A.D. 409-424), Attributed to Chen Hung of Tang Dynasty (ca. A.D. 730), China (Collection of the Nelson Gallery and Atkins Museum of Fine Arts, Kansas City).

11 Same as Plate 10 with Irrelevant Details Eliminated.

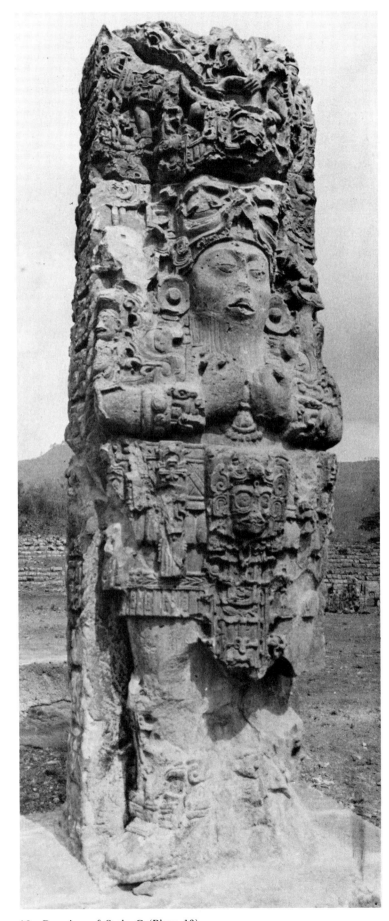

12 Drawing of Stela C (Plate 13) with irrelevant details deleted.

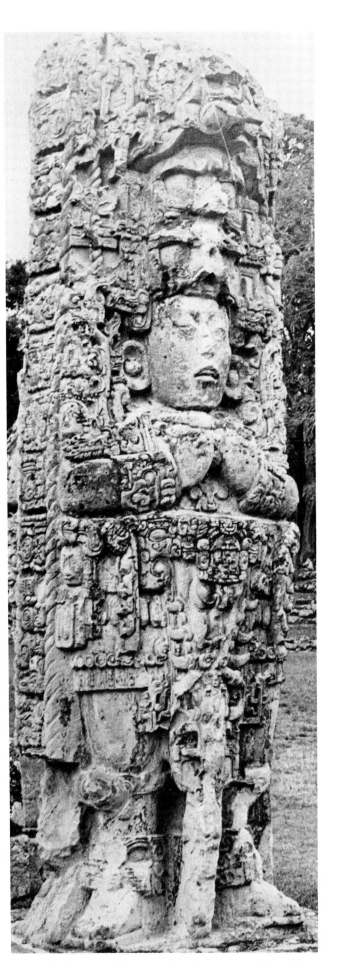

13 Stela C. West Side. Dated 9.17.12.0.0—4 Ahau 18 Muan (A.D. 782), Honduras.

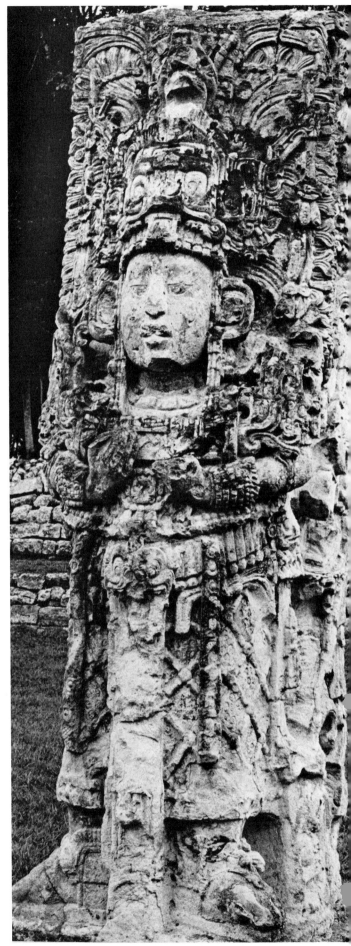

14 Stela H, Dated 9.17.12.0.0—4 Ahau 18 Muan (A.D. 782), Copan, Honduras.

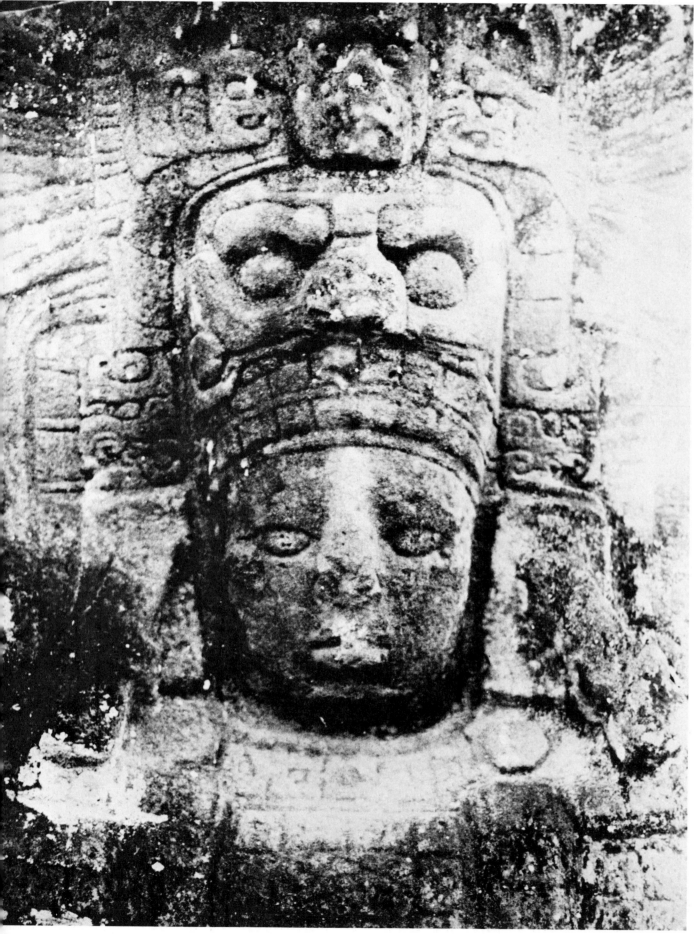

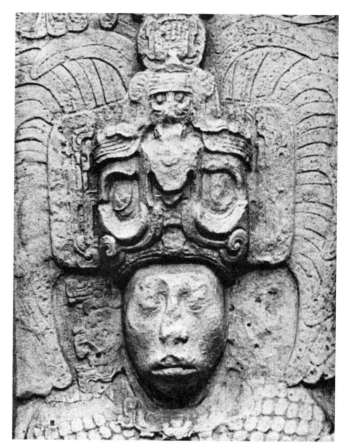

16 Feathered Monster-Head Headdress, Stela 6, Dated 9.12.15.0.0—2 Ahau 13 Zip (A.D. 687), Piedras Negras, Peten, Guatemala.

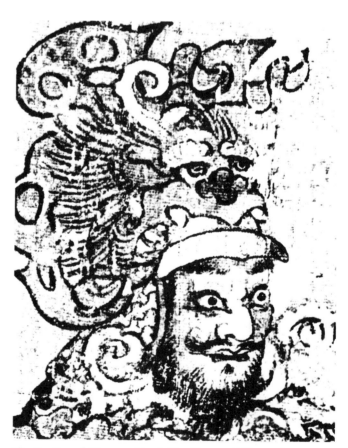

17 Feathered Monster-Head Headdress of Chang Sun Sung (Detail of Plate 10) (ca. A.D. 730), China.

15 Feathered Monster-Head Headdress, Classic Period, ca. Eighth Century A.D., Quirigua,,

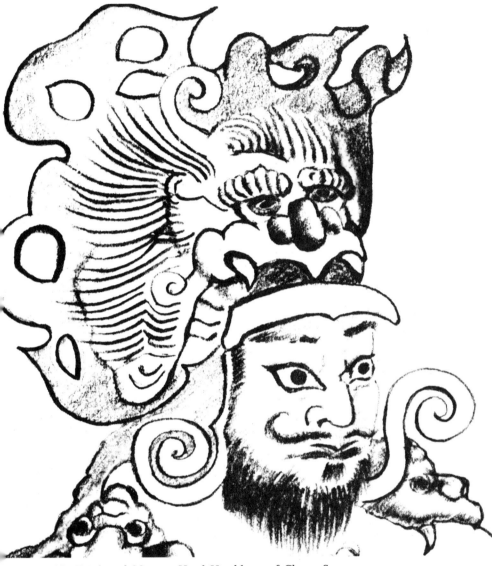

18 Feathered Monster-Head Headdress of Chang Sun Sung (See Plate 17) (ca. A.D. 730), China.

The chinless monster-head headdress with feathers (Plates 15-19) is a common feature of both Meso-American and ancient Chinese costumes.

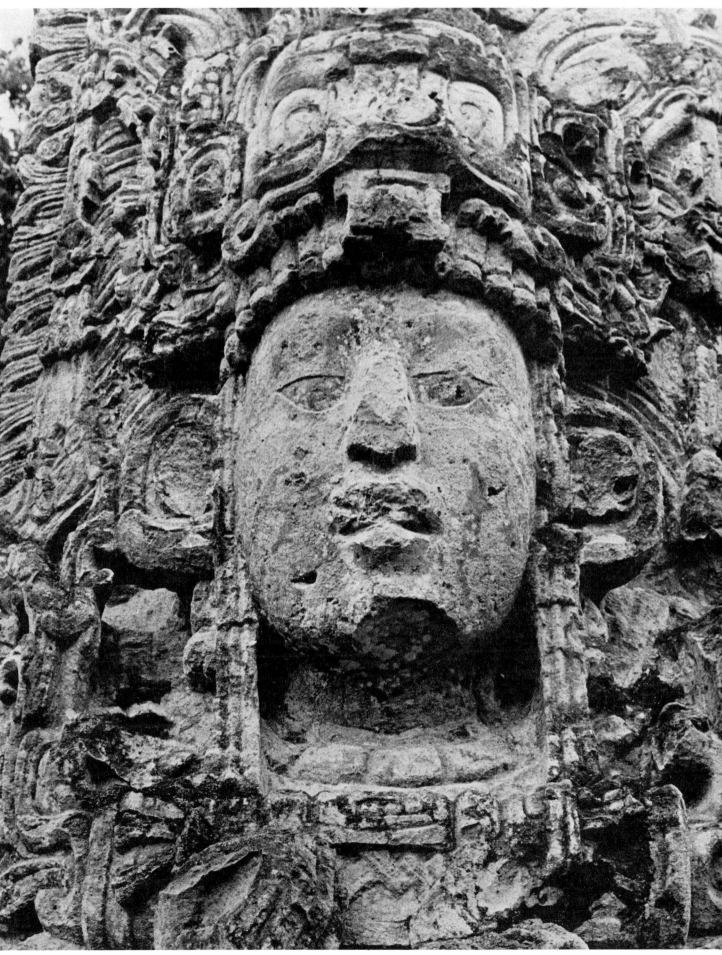

19 Feathered Monster-Head Headdress (Detail of Stela H), Dated A.D. 782, Copan, Honduras.

20 Headdress of an Empress, Sung Dynasty (A.D. 960-1278), China.

The female figure on Stela H (Plate 19) wears a headdress, the bottom of which is lined with beads, similiar to that of the headdress in Plate 20. The portion of the headdress immediately next to the temples of the head is decorated with birdlike elements (Plates 21 and 23).

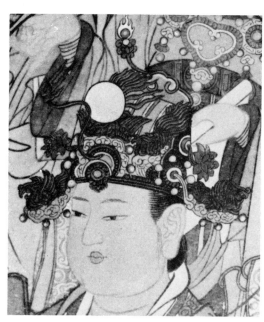

21 Headdress of a Taoist Goddess, Yuan Dynasty (Thirteenth Century) in Tang (A.D. 618-907) Style, Detail of a Mural in Yung-Lo Kung, Shansi, China.

Flanking the face are tassel-like elements attached to the headdress (see Plates 245-247, 9, 19, and 22).

22 Opera Actors in Ancient Chinese Costumes (Courtesy of the American Museum of Natural History).

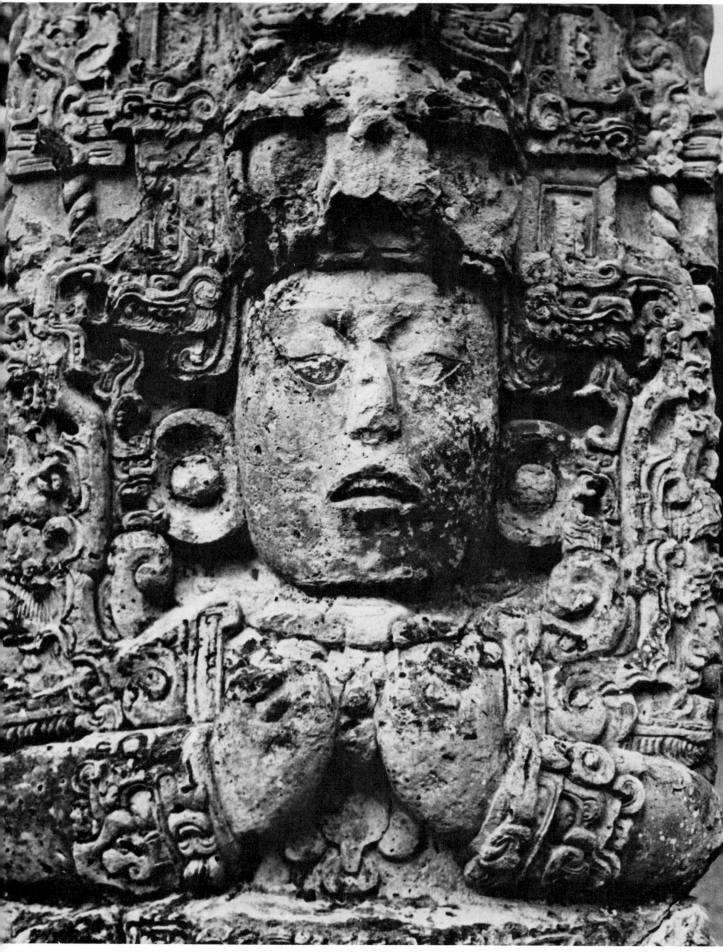

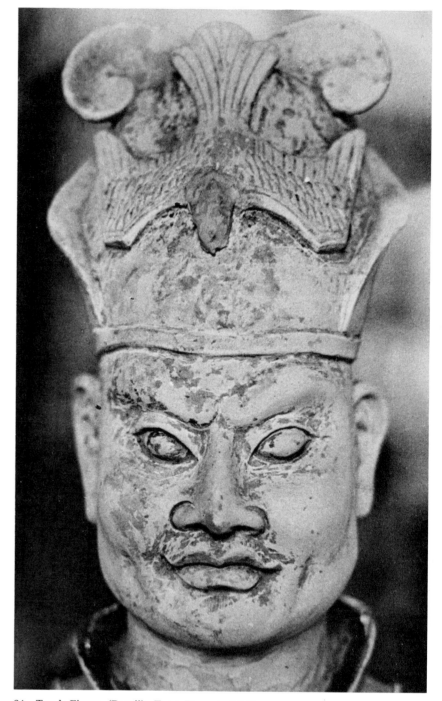

24 Tomb Figure (Detail), Tang Dynasty (A.D. 618-907), China (Collection of the British Museum, London).

23 Stela C (Detail), Dated A.D. 782. Copan, Honduras.

25 Wrist Decoration, Stela N, Dated A.D. 761, Copan, Honduras (See Plate 243).

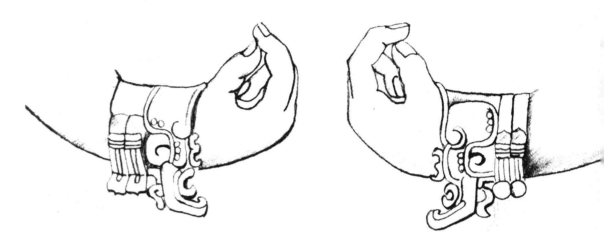

The wrists in Plates 25 and 26 are adorned with wristlets stylized in such a manner as to suggest that the hand emerges from the mouth of an animal head (a bird's head in Plate 25 and a dragon's head in Plate 26).

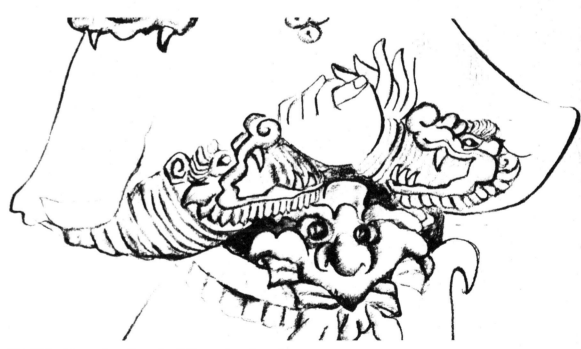

26 Wrist Decoration, Portrait of Chang Sun Sung (ca. A.D. 730), China (See Plate 9).

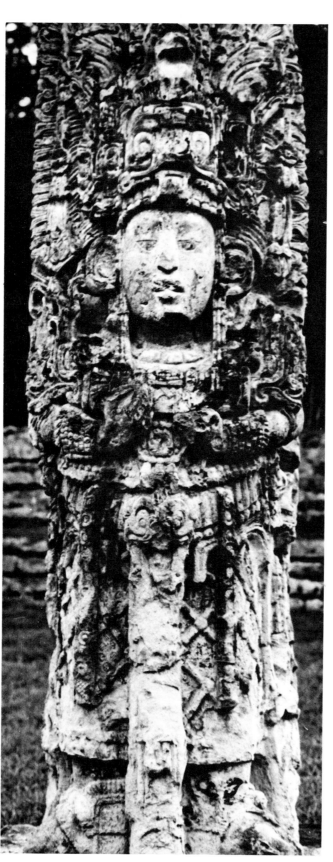

27 Traditional Tibetan Diamond Pattern, Beaded
Ceremonial Skirt, ca. Nineteenth Century, China
(Courtesy of the American Museum of Natural
History).

28 Stela H, Dated 9.17.12.0.0—4 Ahau 14 Muan (A.D.
782), Copan, Honduras.

The diamond patterned, beaded ceremonial skirts that appeared in Mayan art works (Plates 28, 29, and 31) are akin to those worn by Tibetan priests as late as the early twentieth century (Plate 27).

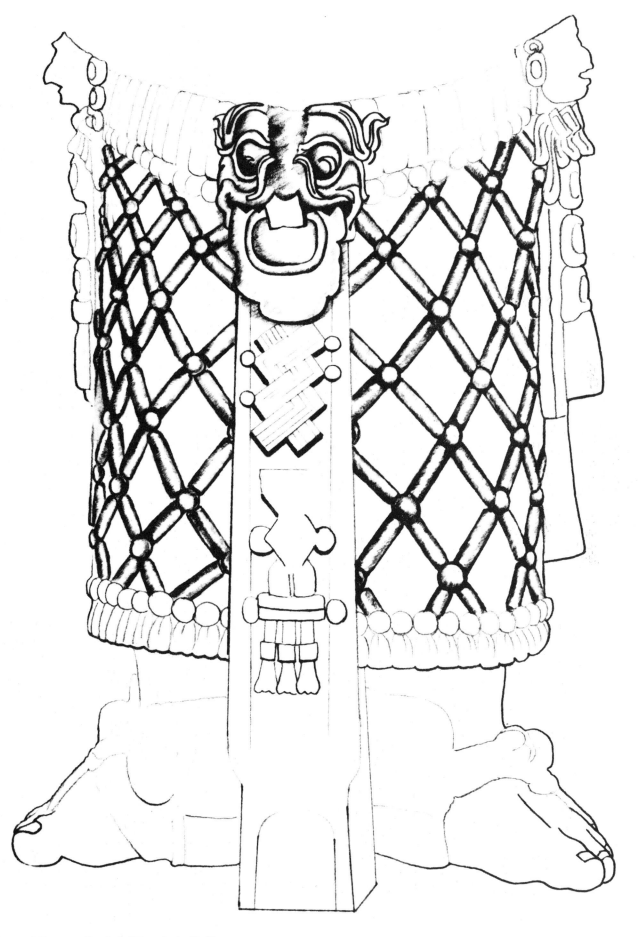

29 Diamond Pattern, Beaded Skirt, Stela H (See Plate 28), Copan, Honduras.

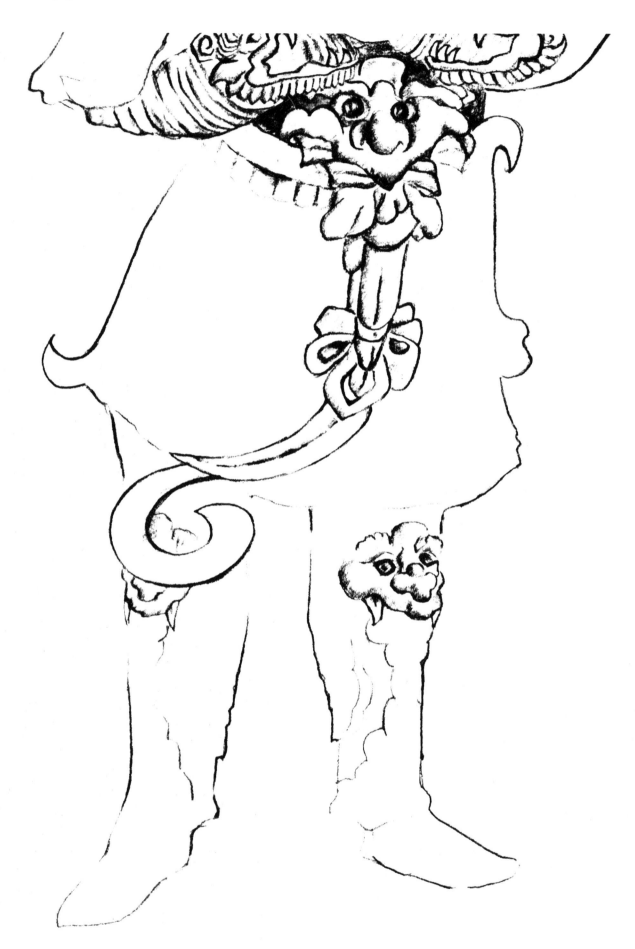

The loincloth apron worn by the Chinese general (Plate 30), the Bodhisattva (Plate 35) and the guardian king (Plates 37, 79, and 81) is composed of a monster mask with the apron hanging from the mouth. The same treatment of the loincloth apron can be observed on Mayan figures (Plates 31-34 and 36).

30 Loincloth Apron, Portrait of Chang Sun Sung (A General of Fifth Century A.D.) (ca. A.D. 730), China (See Plate 10).

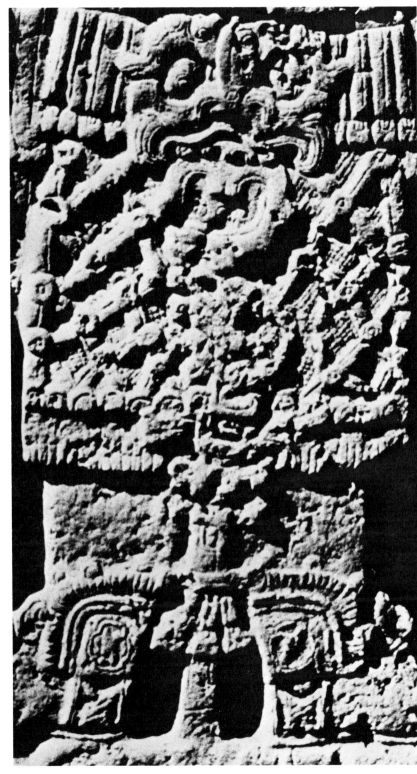

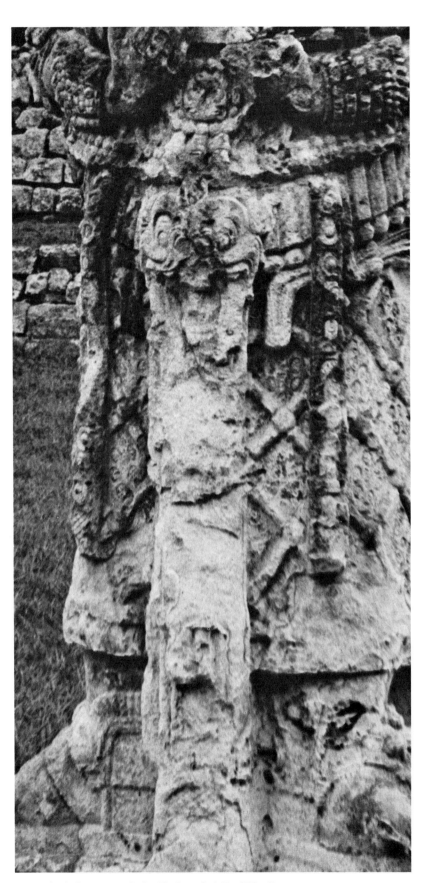

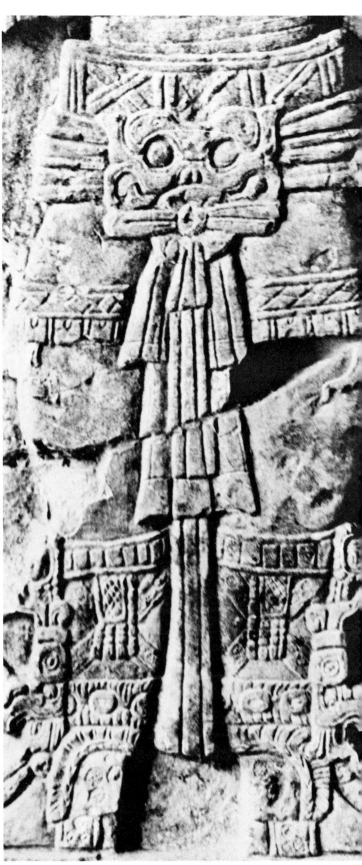

31 Loincloth Apron, Stela 24, Dated 9.12.10.5.12—4 Eb
10 Yax (ca. A.D. 690), Naranjo, Peten, Guatemala.

32 Loincloth Apron, Stela H, Dated A.D. 782, Copan,
Honduras (See Plate 28).

33 Loincloth Apron, Detail of Figure on North Lintel,
House L (ca. A.D. 720), Yaxchilan, Chiapas, Mexico
(See Plate 80).

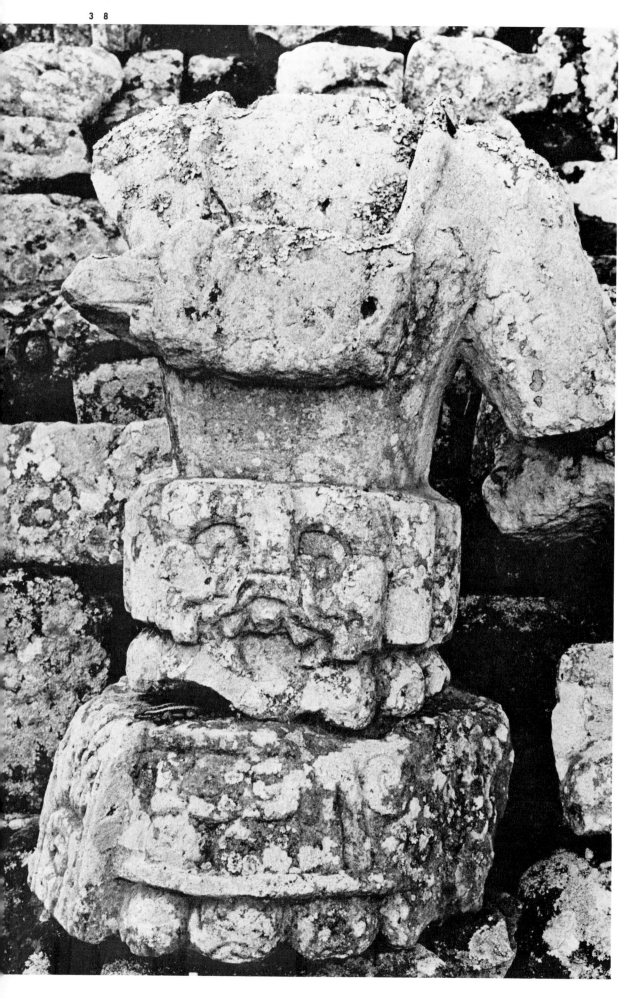

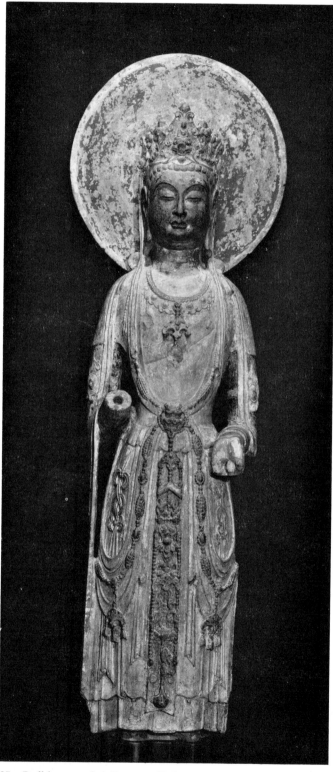

34 Torso, Dated Classic Period
(ca. A.D. 750), Copan, Honduras
(Note live lizard on left side of waist).

35 Bodhisattva, Sui Dynasty (A.D. 589-618), China
(Courtesy of the Smithsonian Institution, Freer
Gallery of Art, Washington, D.C.).

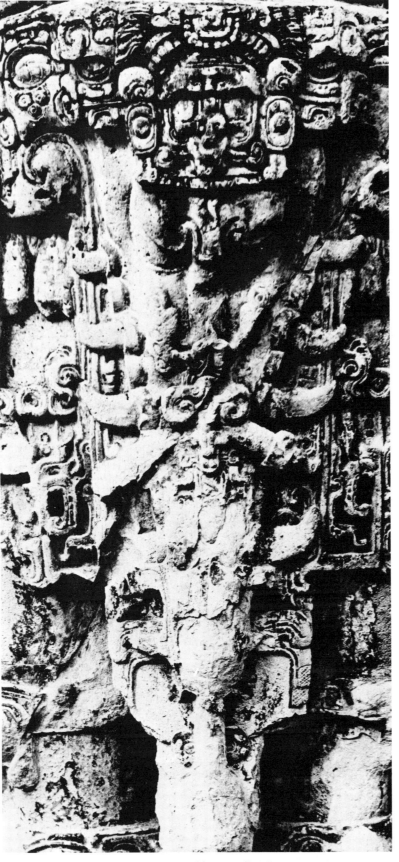

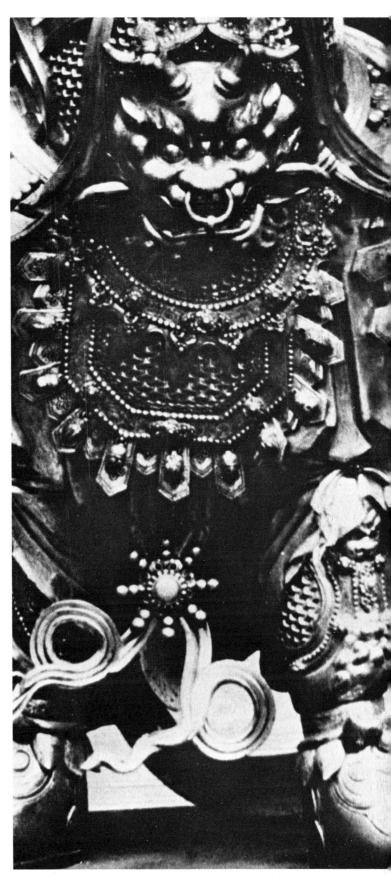

36 Loincloth Apron, Stela C, East Side, Dated A.D.
782. Copan, Honduras (See Plate 3).

37 Loincloth Apron, Guardian King, Ming Dynasty,
ca. Fourteenth Century, China, Detail of Plate 184
(Collection of Seattle Art Museum, Seattle).

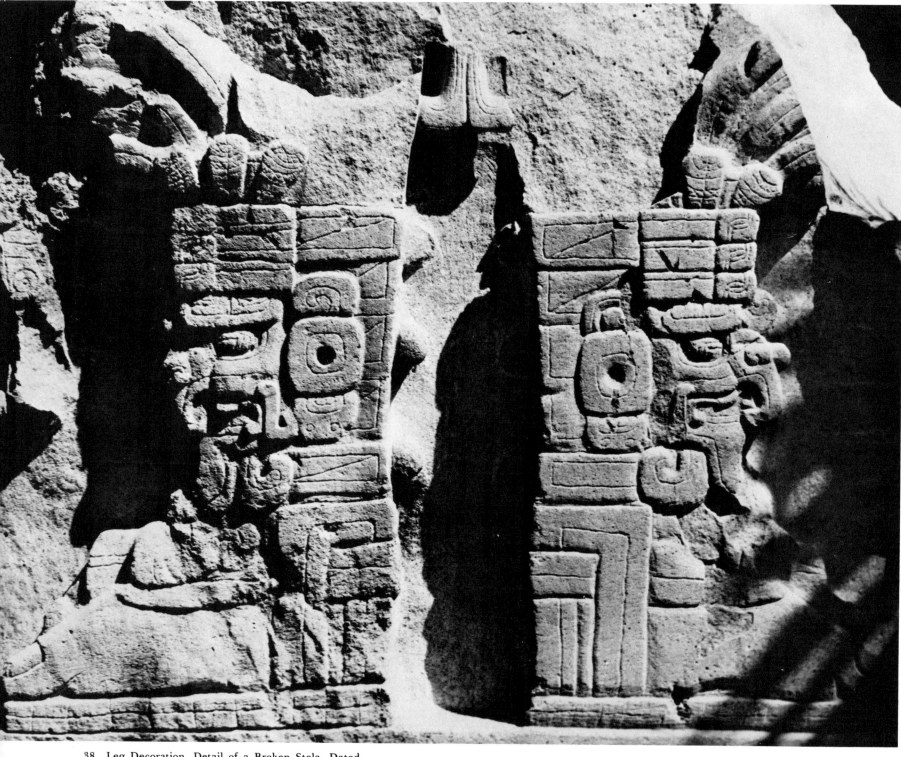

38 Leg Decoration, Detail of a Broken Stela, Dated
Classic Period (ca. A.D. 700-800), The Great Plaza,
Tikal, Peten, Guatemala.

The knees and legs of both the Mayan and the ancient Chinese figures were often adorned with chinless monster masks.

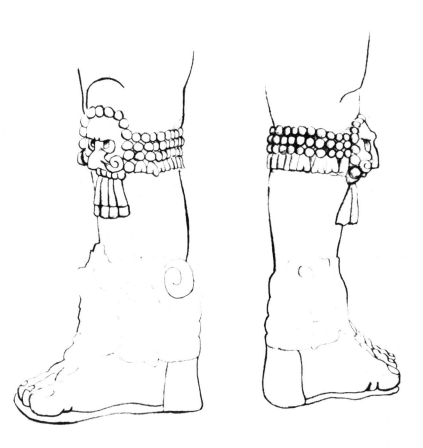

39 Knee Decoration, Stela A, Dated A.D. 731, Copan, Honduras (See Plate 7).

40 Knee Decoration, Portrait of Chang Sun Sung (A General of Fifth Century A.D.) (ca. A.D. 730), China (See Plate 10).

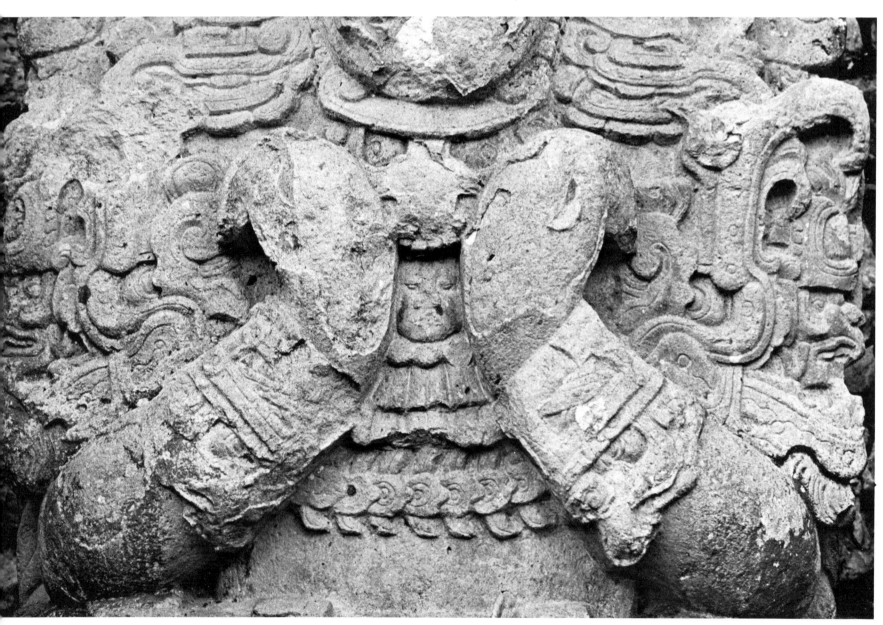

41 Stela I (Detail), Copan, Honduras.

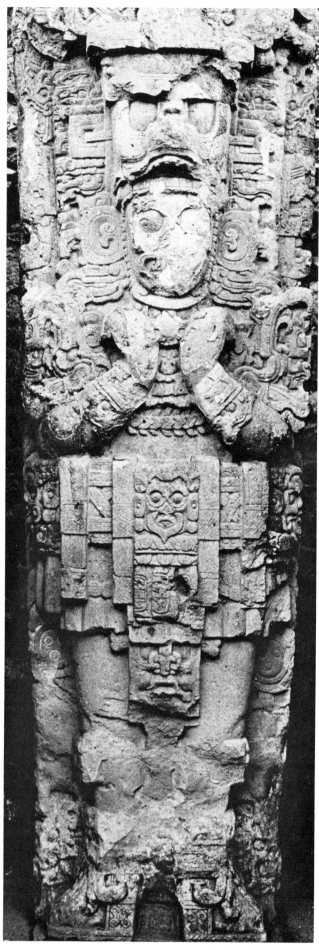

42 Stela I, Dated 9.12.3.14.0−5 Ahau 8 Uo (A.D. 676), Copan, Honduras.

The double-headed serpent bar held, without exception, horizontally in front of the breast of every principal figure on the Copan stelae (Plates 3-7, 41, 47, and 48, 50) appears to be closely related to the double-headed dragon shoulder decoration of the Tang funerary figure (Plates 43, 45, and 46). Plates 180-185 illustrate the striking similarities between the Mayan double-headed serpent and the Asian double-headed dragon. Both the dragon and the serpent share the following attributes: open mouth, *spiral markings in the eye* (Plates 44, 49, 51, and 52), *long beard under the lower jaw* (Plates 3, 5, 6, 23, 41, 47, 49-51, and 53), *hornlike element above the eye* (Plates 44-53). The motif of long-snouted dragon with horn and beard first made its appearance in Chinese artworks during the late Chou, early Han period (fifth to second century B.C.), and was adopted by both the Korean and the Japanese in subsequent periods. The examples contained in this chapter only introduce the many correlations I have found regarding this important motif. A more detailed discussion is found in another of my books under preparation, *The Life-Death Tree*.

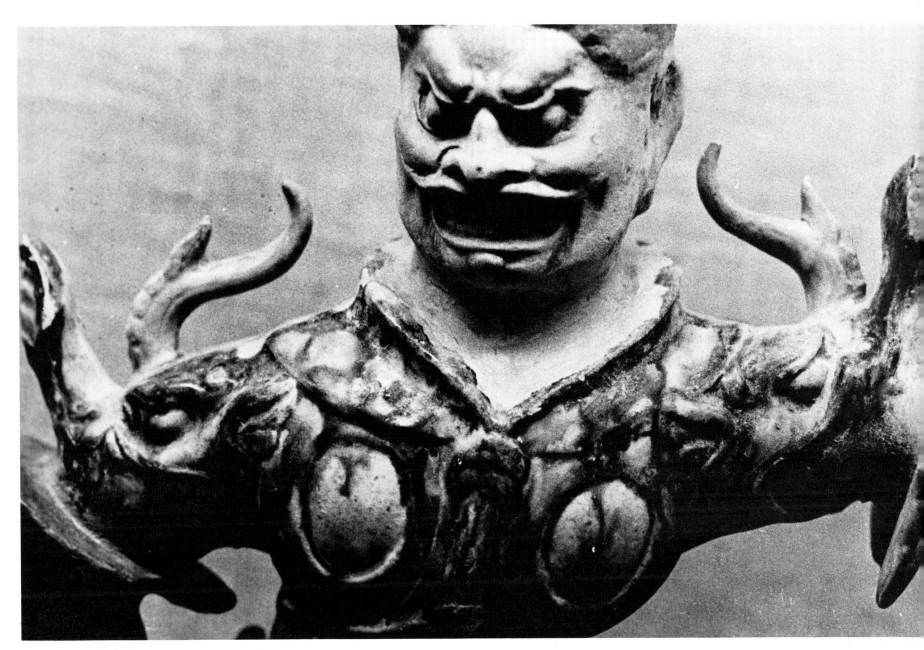

43 Shoulder Decoration, Guardian King, Tang Dynasty (A.D. 618-907), China (Collection of the National Museum of History, Taipei).

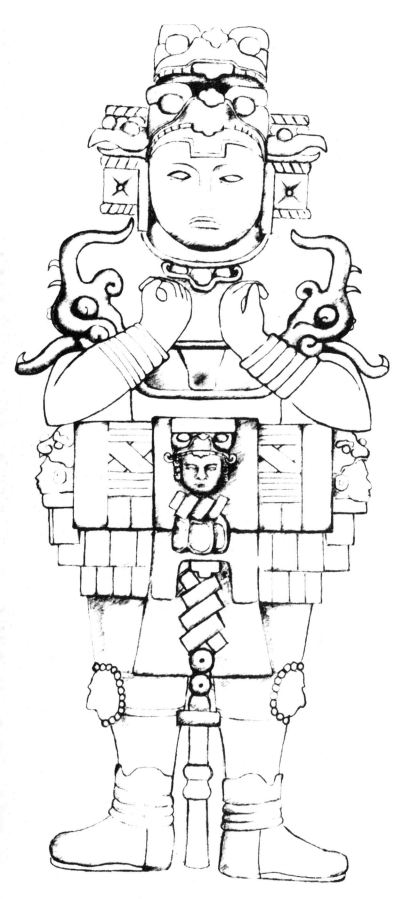

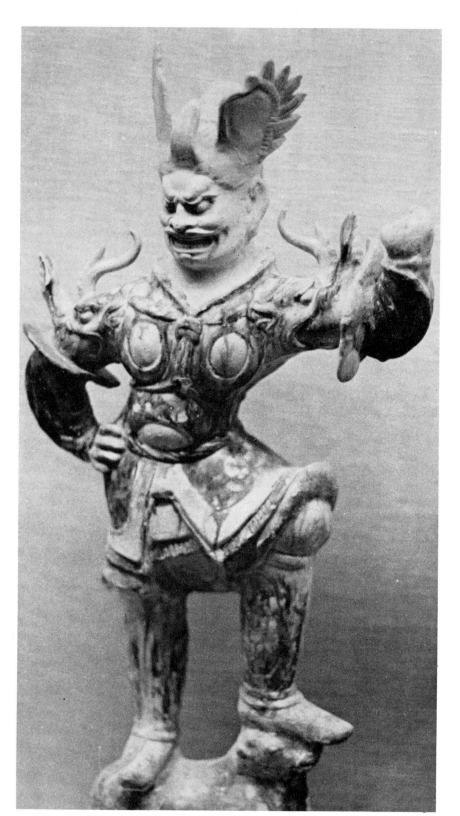

The double-headed serpent depicted on the east side of Stela 5 (Plates 44 and 47) at Copan exhibits particularly conspicuous likeness to that of the Tang Chinese: the upward undulating long snout, the wide open mouth with lower jaw much shorter than the upper, the hornlike element above the eye, and the spiral marking in the eye.

45 Guardian King, Tang Dynasty (A.D. 618-907), China (Collection of the National Museum of History, Taipei).

44 Stela 5, East Side (ca. A.D. 706), Copan, Honduras (See Plate 47).

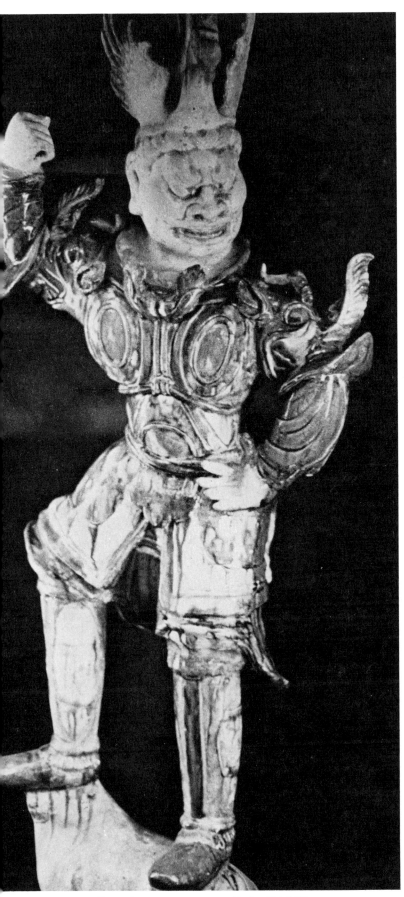

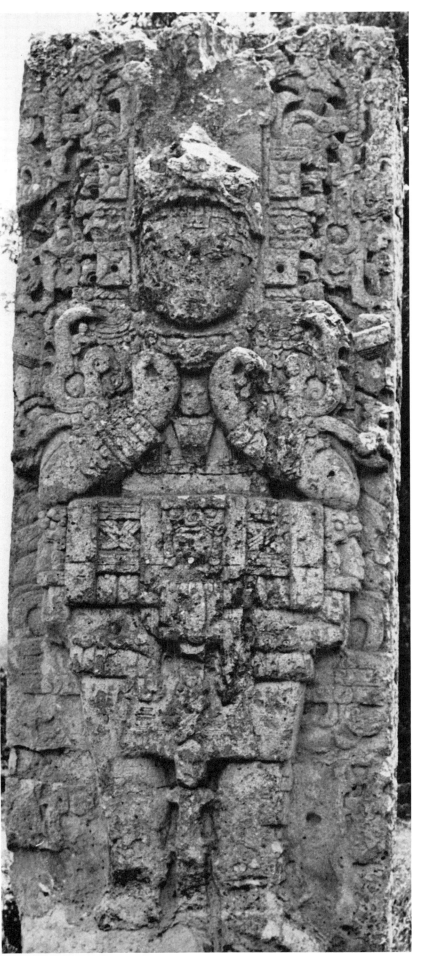

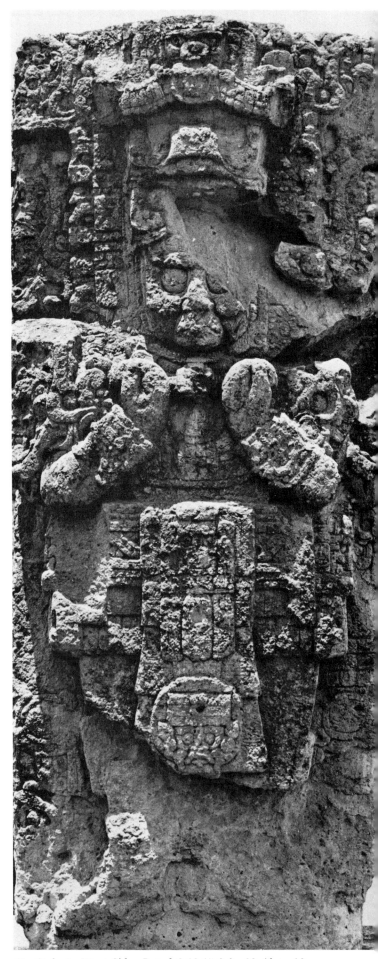

46 Guardian King, Tang Dynasty (A.D. 618-907), China (Courtesy of the Victoria and Albert Museum).

47 Stela 5, East Side, Dated 9.13.15.0.0 — 13 Ahau 18 Pax (ca. A.D. 706) Copan, Honduras.

48 Stela 5, West Side, Dated 9.13.15.0.0 — 13 Ahau 18 Pax (ca. A.D. 706), Copan, Honduras.

In addition to the just mentioned similarities, a variation of the double-headed serpent bar shown in Plate 49 (see also Plate 51) displays another totally arbitrary attribute—"Ho Chi-Minh beard" which was also a common feature of Chinese dragons (Plates 52 and 53).

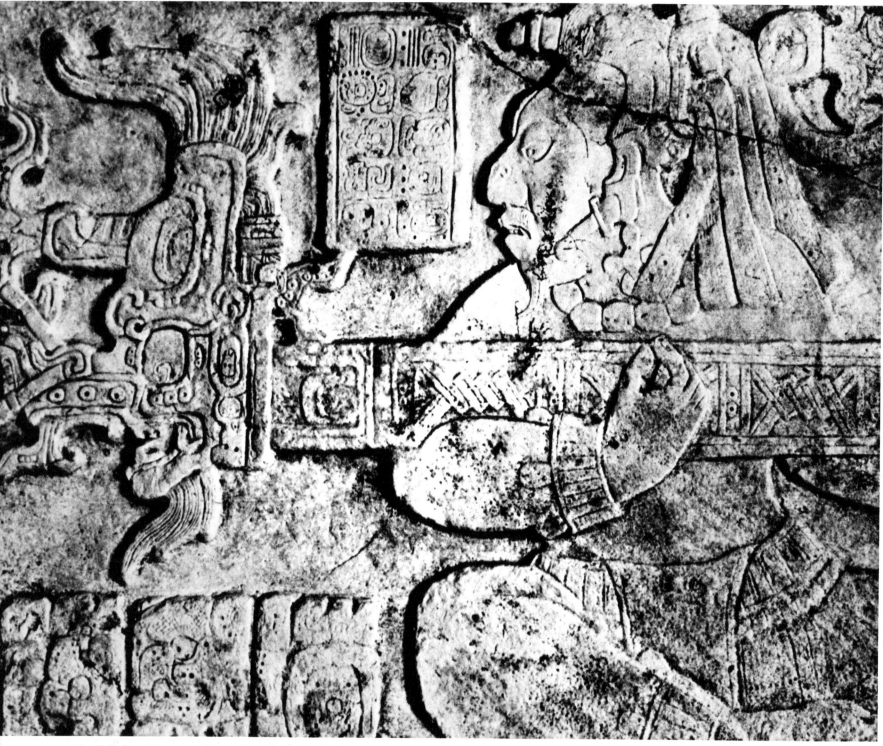

49 Relief on Limestone Lintel (Detail), Late Classic Period (ca. A.D. 800), Chiapas, Mexico (The Robert Woods Bliss Collection, Dumbarton Oaks).

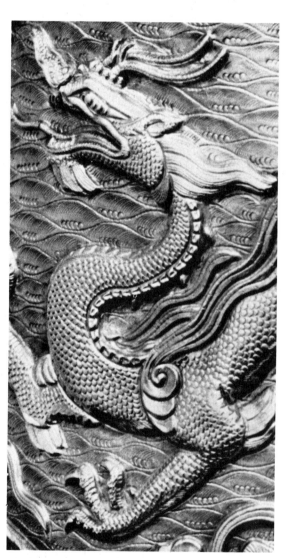

50 Dragon, Detail of a Crown, Liao Dynasty (A.D. 907-1125), China (Courtesy Museum of Fine Arts, Boston).

52 Long-Snouted Dragon Head, Shoulder Decoration of a Guardian King, Tang Dynasty (A.D. 618-907), China (Collection of the British Museum, London).

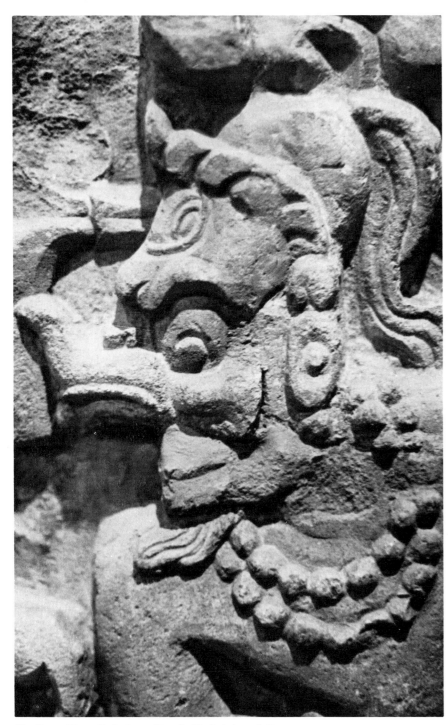

51 Long-Nose God, Late Classic Period (ca. A.D. 800), Chiapas, Mexico (Collection of the Museum of Mankind, London).

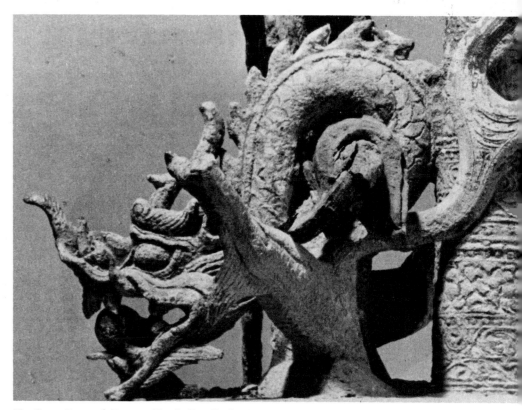

53 Long-Snouted Dragon Head, Detail of a Bronze Bell, Koryo Period (A.D. 1048), Kyonggi-Do, Korea (Collection of the National Museum of Korea).

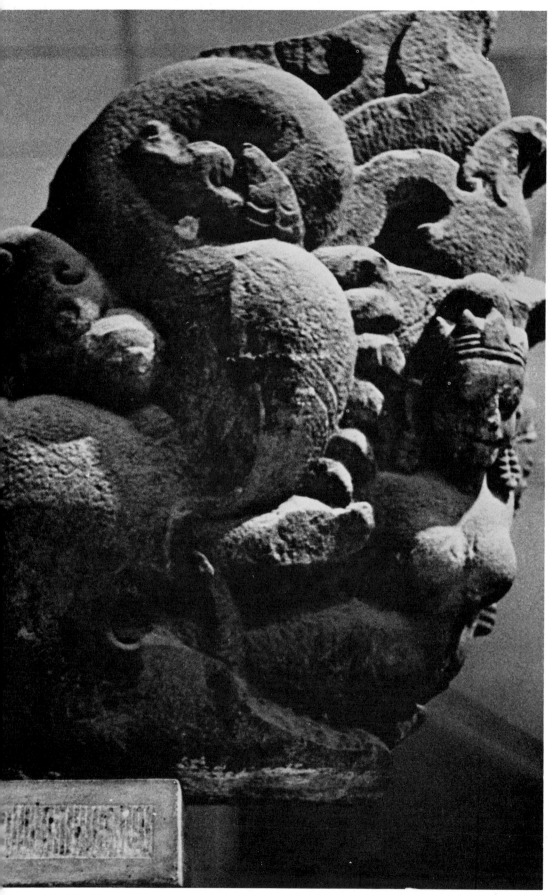

54 Makara, ca. Thirteenth Century A.D., Java
(Collection of the Musee Guimet, Paris).

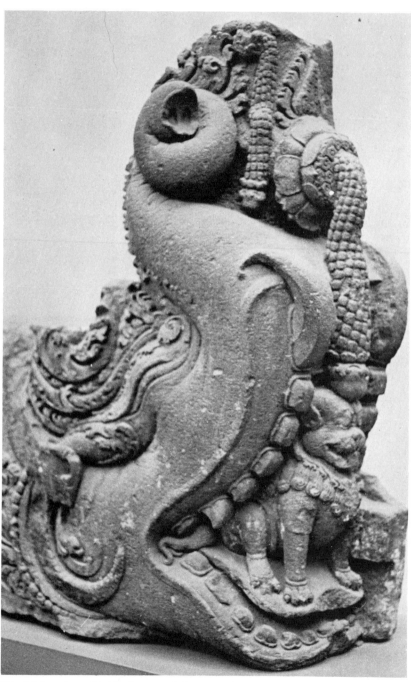

55 Makara, ca. Tenth Century A.D., Prambanan,
Java (Collection of the Rijksmuseum, Amsterdam).

Another markedly
Asiatic trait,
an anthropomor-
phic creature
emerging from
the mouth of a
long-snouted,
often double-
headed creature
(Plates 55, 56,
64, 67, and 68),
was also exten-
sively employed
in Mayan art
(Plates 56-58
and 60; see also
Plate 41).

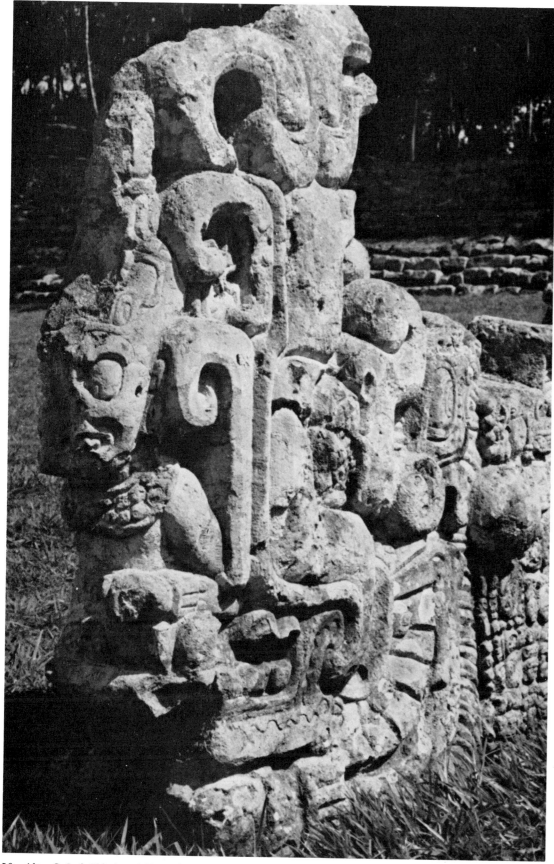

56 Altar G, Left Side (ca. A.D. 800), Copan,
Honduras.

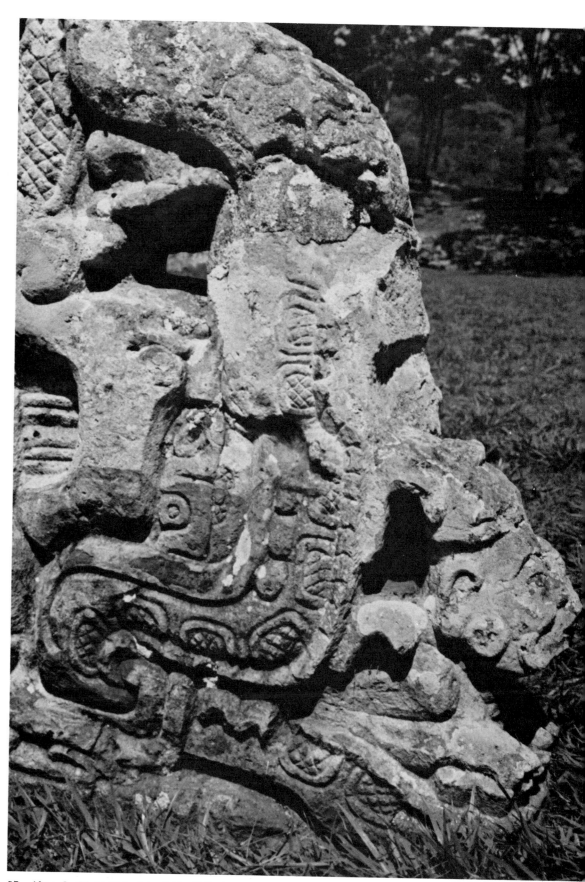

57 Altar G, Right Side (ca. A.D. 800), Copan,
Honduras.

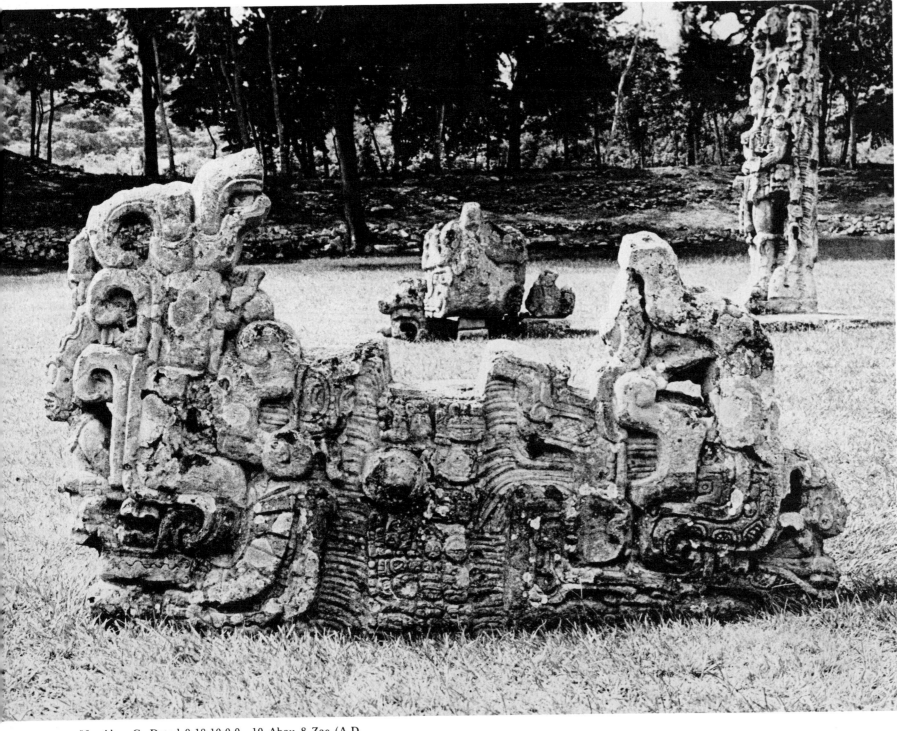

58 Altar G, Dated 9.18.10.0.0 — 10 Ahau 8 Zac (A.D. 800), Copan, Honduras.

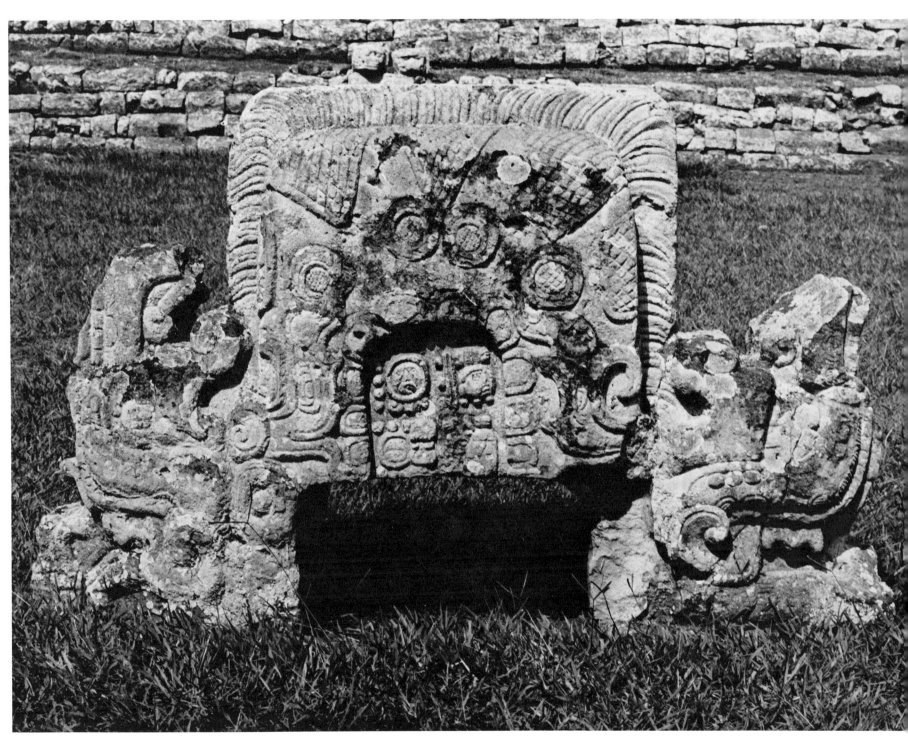

59 Altar G1, Dated 9.17.0.0.0—4 Ahau 13 Ceh (A.D.
771), Copan, Honduras.

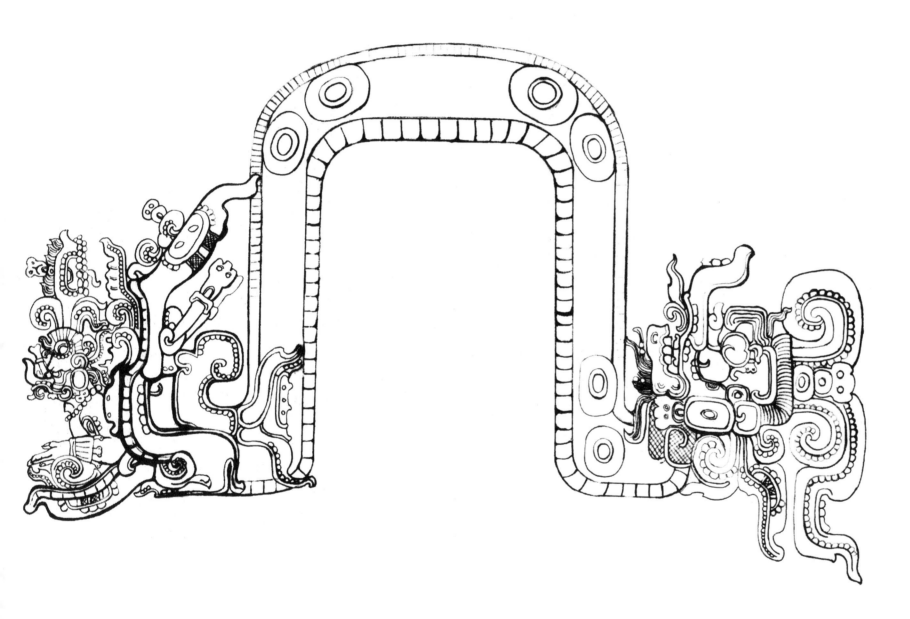

60 Double-Headed Dragon on Wooden Lintel of Temple IV with Irrelevant Elements Deleted (ca. A.D. 600-800), Tikal, Peten, Guatemala.

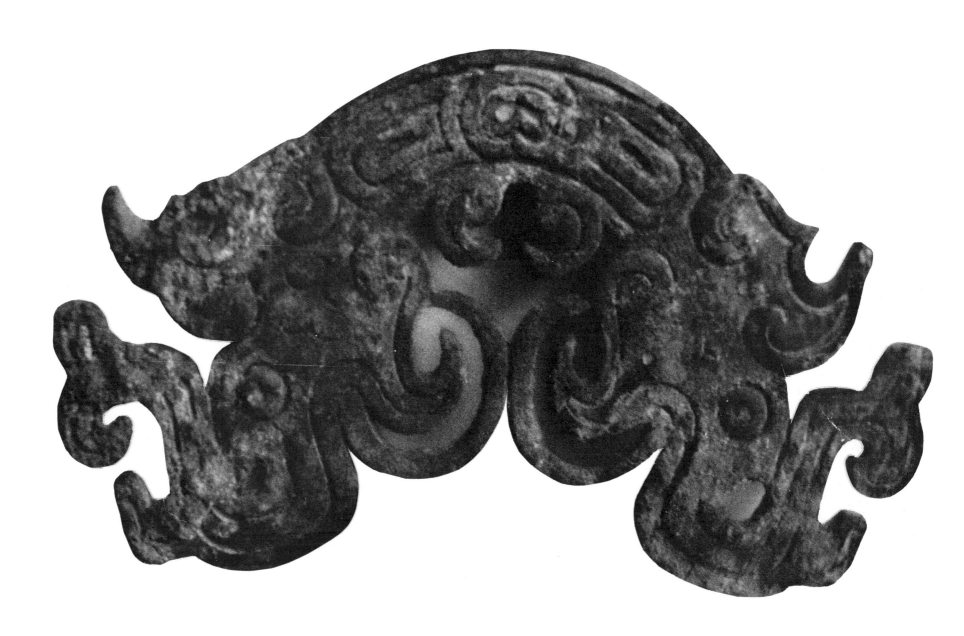

61 Double-Headed Dragon Bronze Plate, Chou
Dynasty (ca. 500 B.C.), China (Collection of the
Rijksmuseum, Amsterdam).

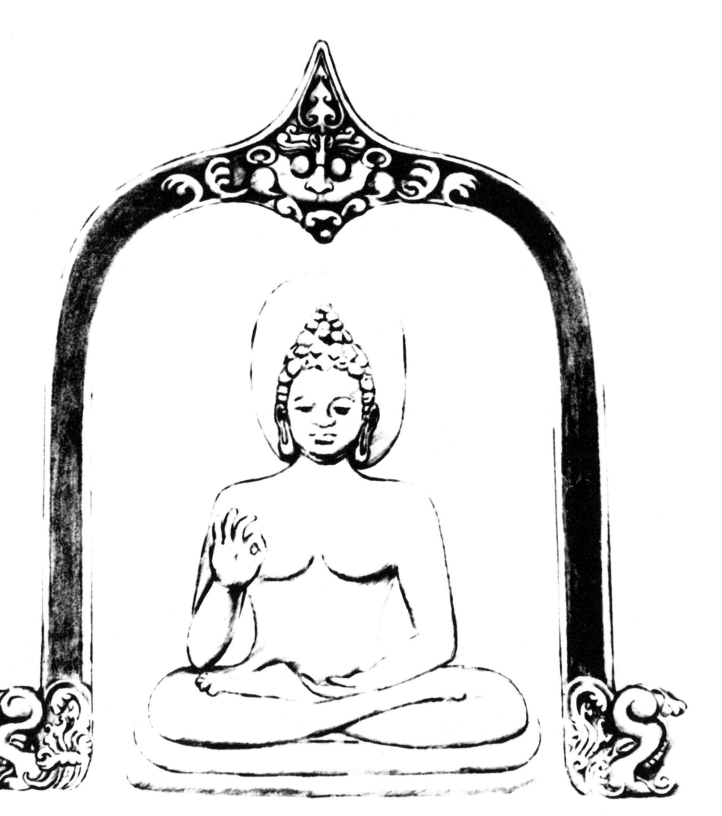

62 Double-Headed Makara (Irrelevant Elements Deleted), Stone Relief on Terrace of Borobudur (ca. A.D. 800-900), Java.

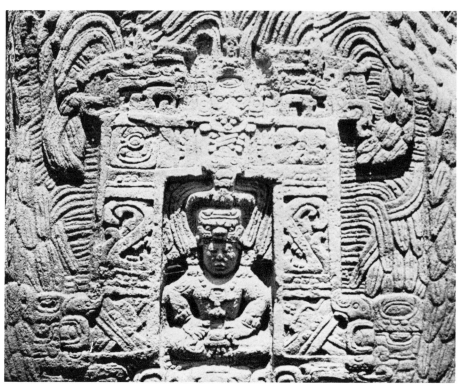

63 Detail of Stela I, Back Side, Dated 9.18.10.0.0 — 10 Ahau 8 Zac (ca. A.D. 800), Quirigua, Guatemala.

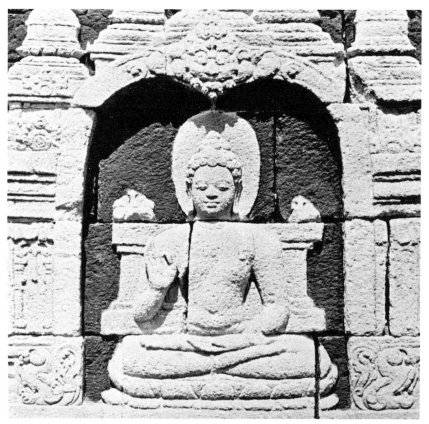

64 Stone Relief on Terrace of Borobudur (ca. A.D. 800-900), Java.

The double-headed dragon in Plate 65 is a reconstructed view of the double-headed serpent arch appearing on Stela I at Quirigua (about 35 miles from Copan). The serpent head is partially based on similar motifs illustrated in Maudslay's *Biologia Centrali Americana,* Plate Volume 1, Plate 9 and Spinden's *Mayan Art and Civilization,* Fig. 93. The Asiatic double-headed makaras (water animal) arch corresponds with the Mayan double-headed serpent arch not only in total concept and composition but also in detailed elements: on top of both the double-headed serpent arch and the double-headed makaras arch is an anthropomorphic mask from the corners of whose mouth vinelike elements come out. A cross-legged figure with round face is seated inside the arch.

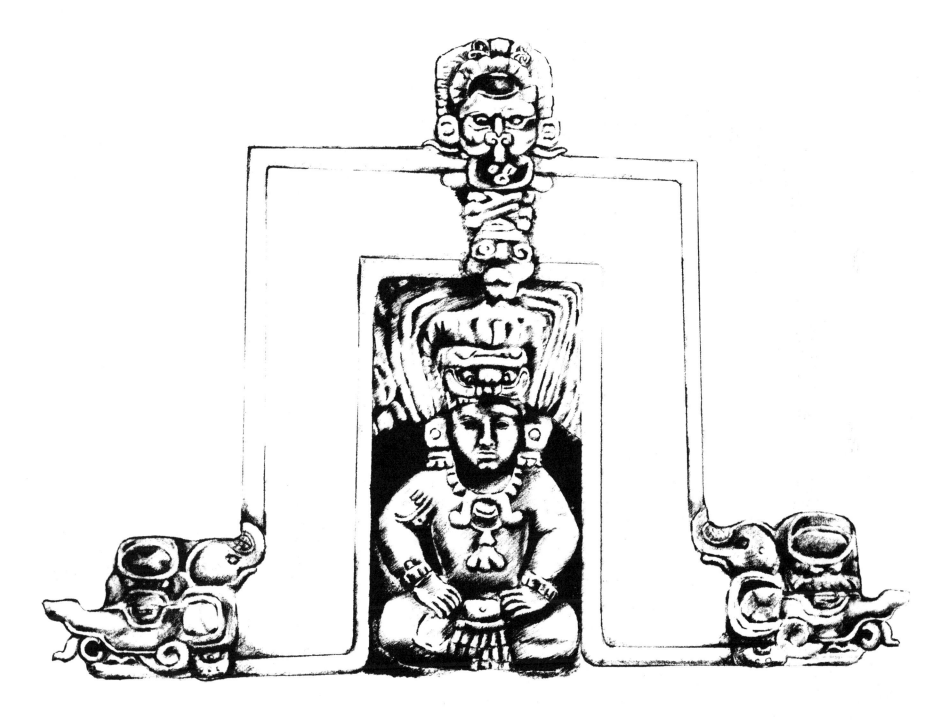

65 Double-Headed Dragon on Stela I (ca. A.D. 800), with Irrelevant Elements Deleted, Quirigua, Guatemala.

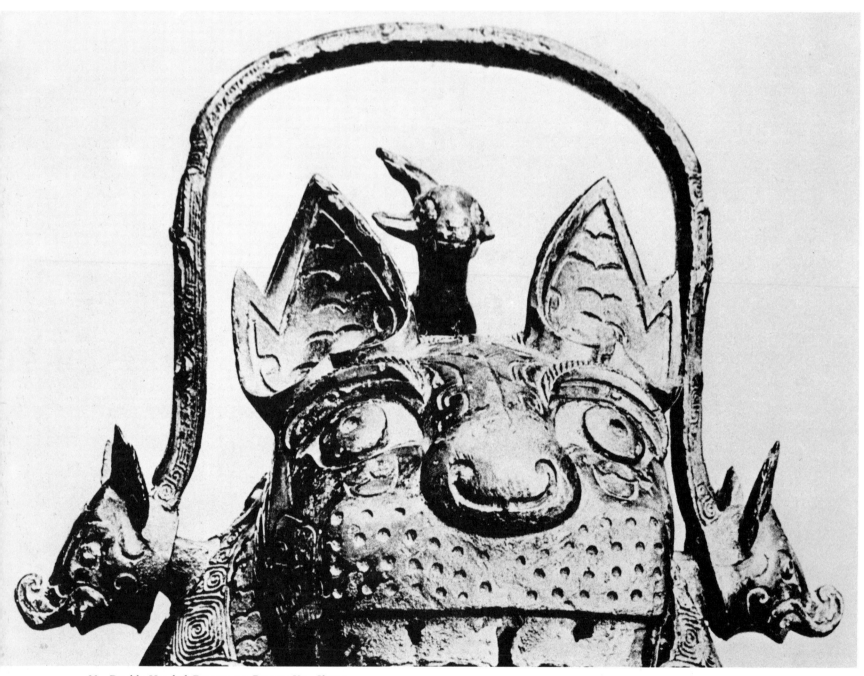

The Chinese double-headed dragon motif and the "man emerging from the mouth of animal" motif can be traced as far back as the Shang Dynasty (Plates 66 and 68).

66 Double-Headed Dragon on Bronze Yu, Shang Dynasty (1766-1154 B.C.), China (Collection of Musee Cernuschi, Paris).

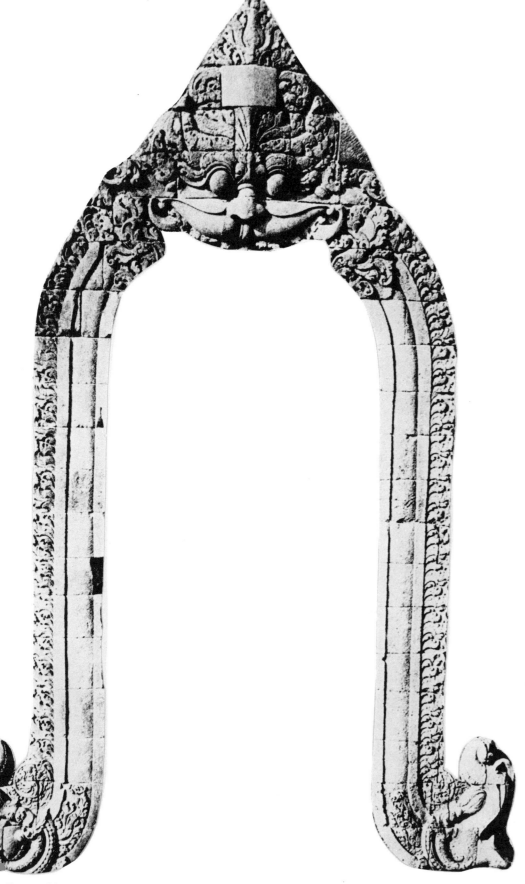

67 Double-Headed Makara, Gateway in the Fourth
Gallery (ca. A.D. 800-900), Borobudur, Java.

68 Human Head Emerging from the Mouths of Two
Tigers, Rubbing from a Fang Ting (Square Cauldron
Dedicated to King Wen Ting's Mother, Muwu) of
Shang Dynasty (1766-1154 B.C.), Honan, China
(Collection of the People's Republic of China).

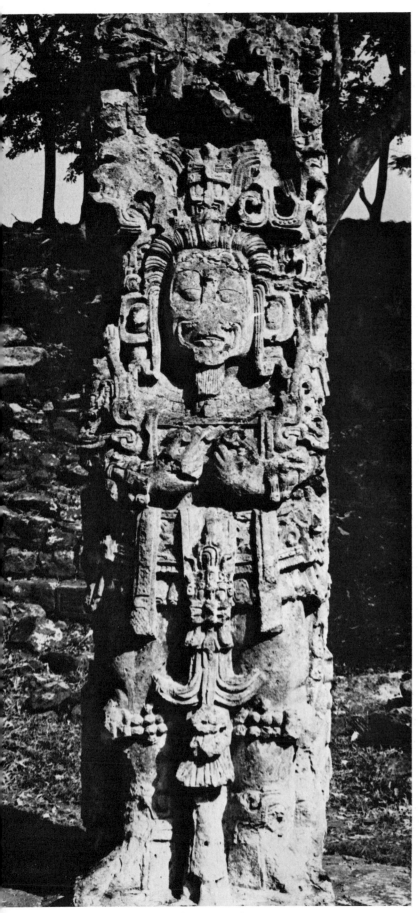

The extensively portrayed "horizontal ceremonial bar in front of the breast" pose in Mayan art was also a favorite of the East Asians. It appeared in Chinese artworks as early as the Han Dynasty (206 B.C.-A.D. 221). Note also the "180 degrees open feet" motif in Plates 70, 72, and 81.

69 Stela D, Dated 9.15.5.0.0—10 Ahau 15 Chen (A.D. 736), Copan, Honduras.

70 Tibetan Deity, ca. Nineteenth Century A.D., China.

59

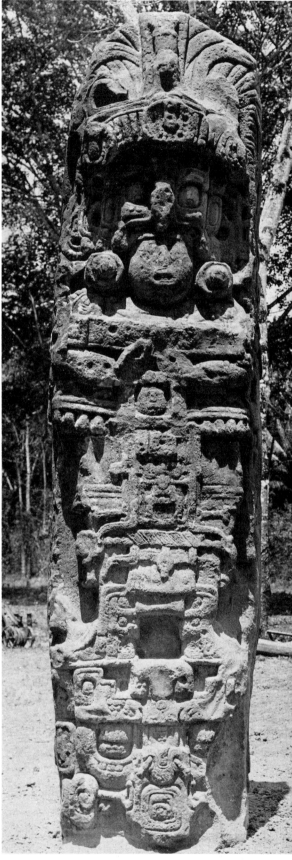

71 Figure on a Han Relief (ca. A.D. 100),
China.

72 Black Deity, ca. Nineteenth Century
A.D., Tibet, China.

73 Stela H, Dated 9.16.0.0.0−2 Ahau 13
Tzec (A.D. 751), Quirigua, Guatemala
(Courtesy Peabody Museum, Harvard
University).

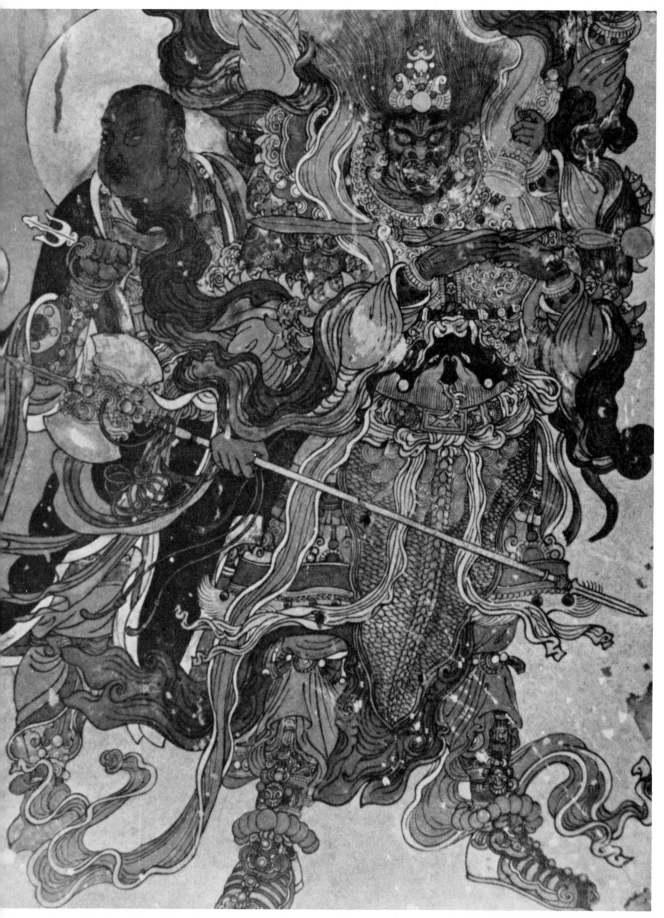

74 Guardian King, Yuan Dynasty (Thirteenth
Century), Detail of a Mural in Yung-Lo Kung, Shansi, China.

Both the "long-thin" variety (Plates 71, 74-76) and the "short-thick" variety (Plates 72-74) of the horizontal bar occurred in Mayan and Chinese art.

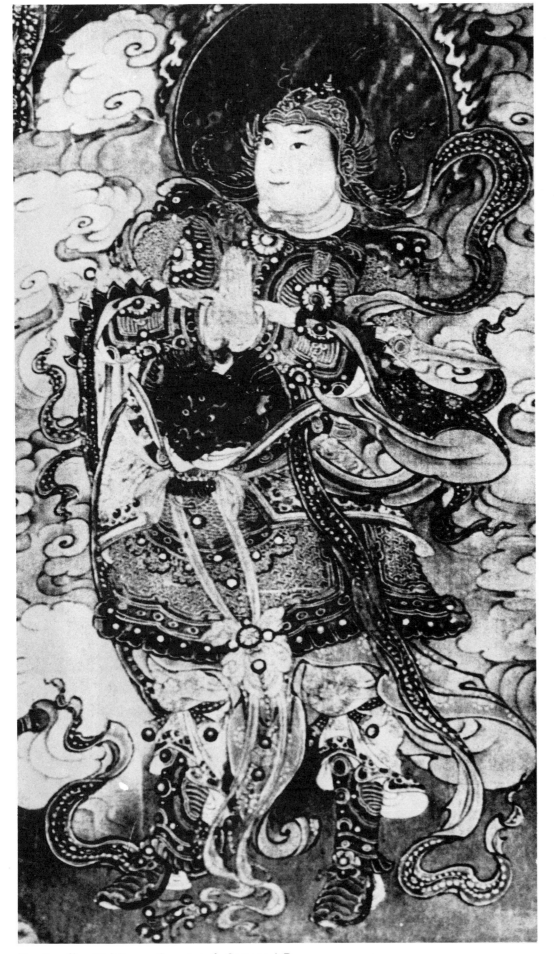

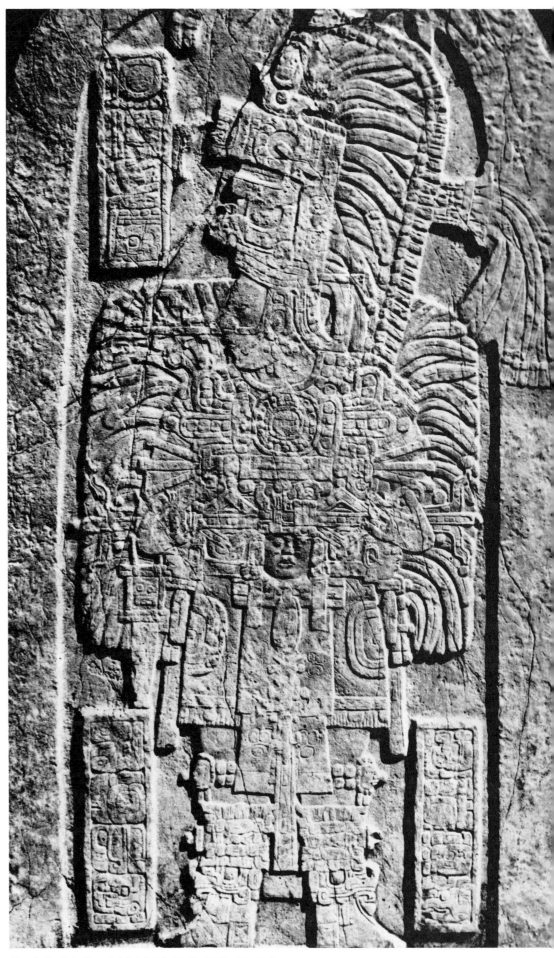

75 Guardian Wei-To, ca. Seventeenth Century A.D.,
China (Courtesy of the Museum of Fine Arts, Boston).

76 Stela 16, Dated 9.14.0.0.0 (A.D. 711), Tikal, Peten,
Guatemala.

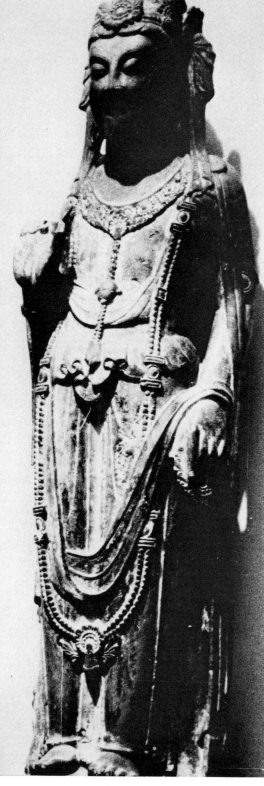

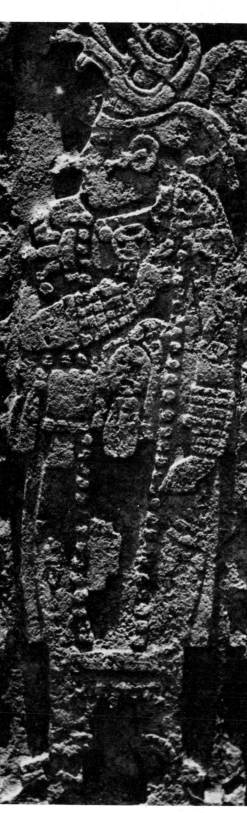

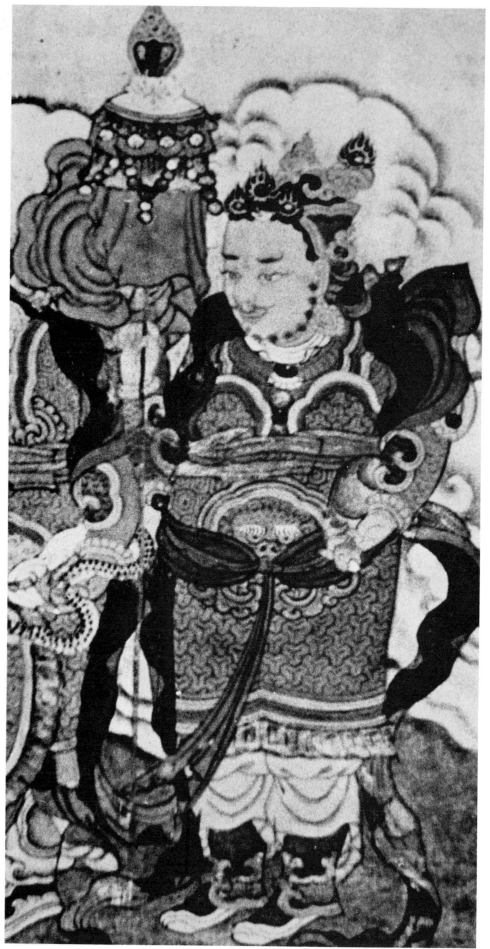

77 Avalokitesvara, Sixth Century A.D., China (Courtesy of the Metropolitan Museum of Art, New York).

78 Figure on South Lintel of Structure 3C10, Late Classic Period (ca. A.D. 800), Oxkintok, Yucatan, Mexico (Courtesy of the Peabody Museum, Harvard University).

79 Guardian King, Detail of a Buddhist Painting in Tang (A.D. 618-907) Style, ca. Thirteenth Century A.D., China.

ther ceremonial
ardwares of the Mayan
nd Chinese religious
ersonages: knee-
ngth beads, um-
rellalike staff, and
onster-mask belt-
pron also match
urprisingly well. Plates
7 and 78 portray
gures each wearing a
ecklace of beads which
eaches as far down as
lightly below the
nees.

he figure in both Plates
0 and 80A holds a short
bject in his left hand
nd an umbrellalike
eremonial staff in his
ight hand. The animal-
nask loincloth aprons,
nore decorative than
unctional, are both
ashioned in such a
nanner as to suggest
hat the animal-mask is
olding the ribbonlike
pron in its mouth.

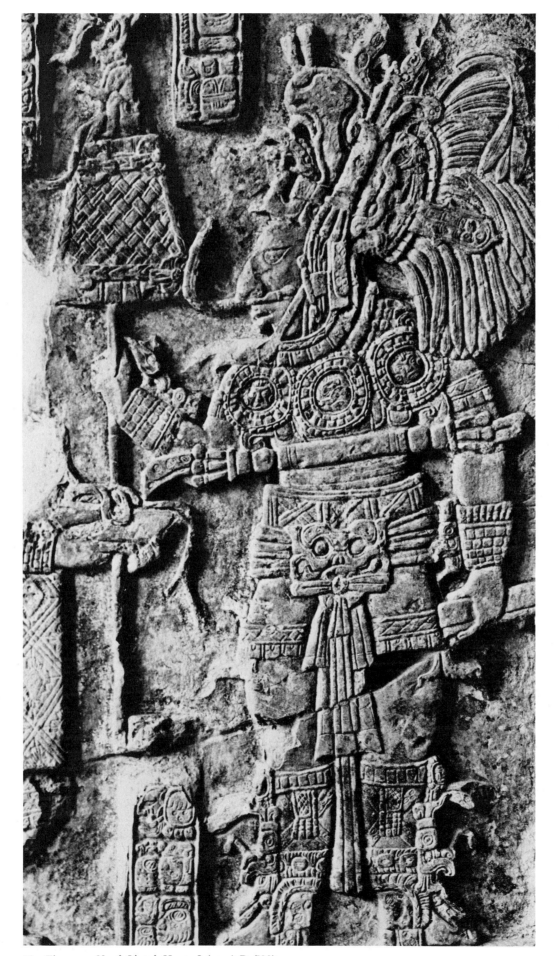

80 Figure on North Lintel, House L (ca. A.D. 720),
Yaxchilan, Chiapas, Mexico.

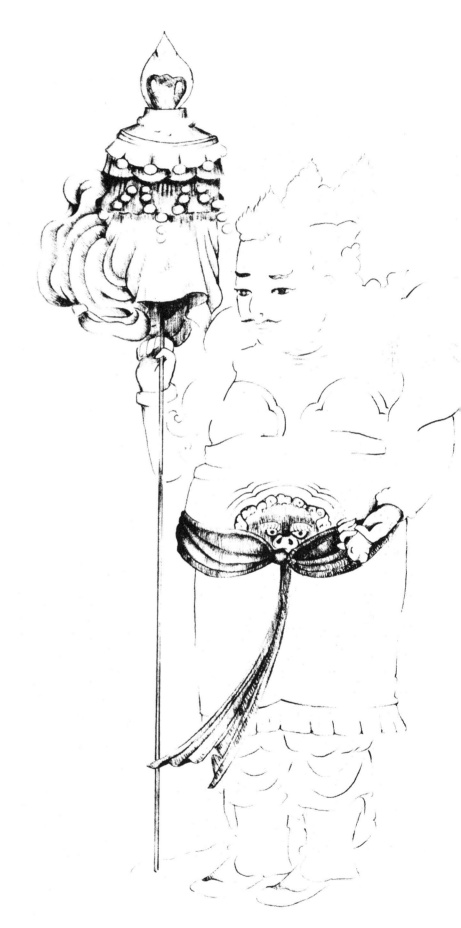

80A Drawing of the Guardian King with Irrelevant
Details Deleted (See Plate 79).

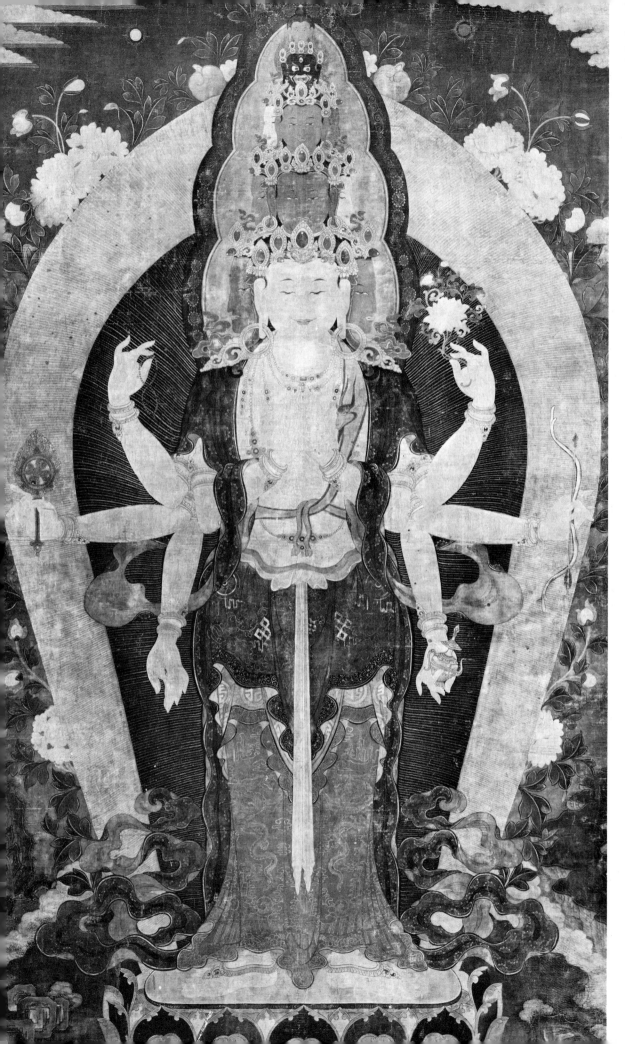

81 Eleven-Headed Kuan-Yin, Ming Dynasty, ca.
Sixteenth Century A.D., Tibet, China (Courtesy
of the Museum of Fine Arts, Boston).

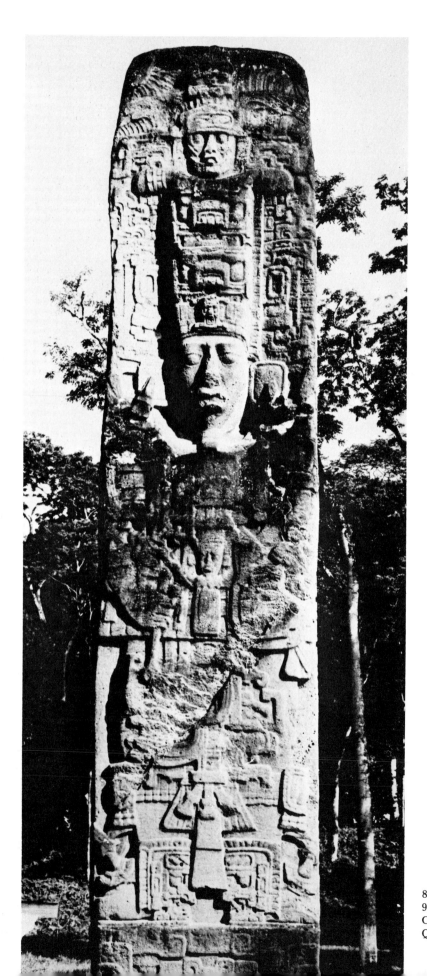

82 Stela E, Dated
9.17.0.0.0—13 Ahau 18
Cumhu (ca. A.D. 771),
Quirigua, Guatemala.

Another trait shared by only the Mayan and the East Asian is the vertical-stacked heads motif above the standing figure, with feet opened up 180 degrees in a straight line (Plate 81). In China, early examples of this motif can be found in the Tun-Huang Caves, dating back to the Tang (A.D. 618-907) period.

83 Chia-Lo God, Sung Dynasty, ca. Eleventh to Thirteenth Century A.D., China.

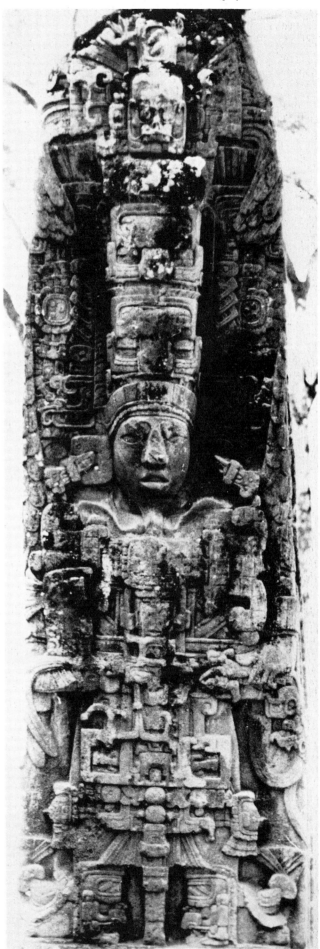

84 Stela D, Dated 9.16.15.0.0—7 Ahau 18 Pop (ca. A.D. 765), Quirigua, Guatemala.

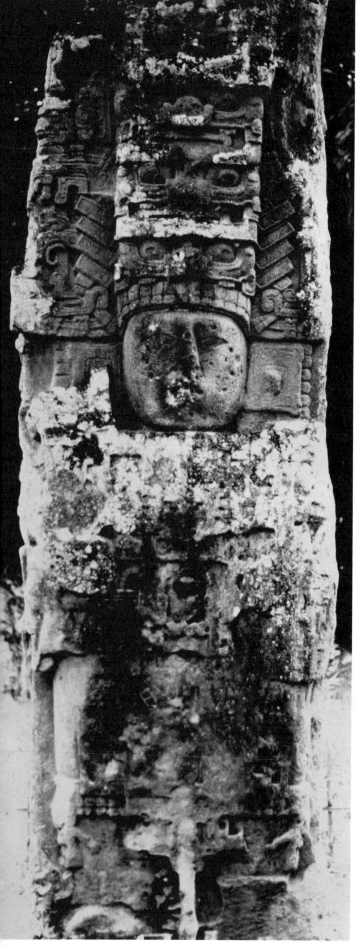

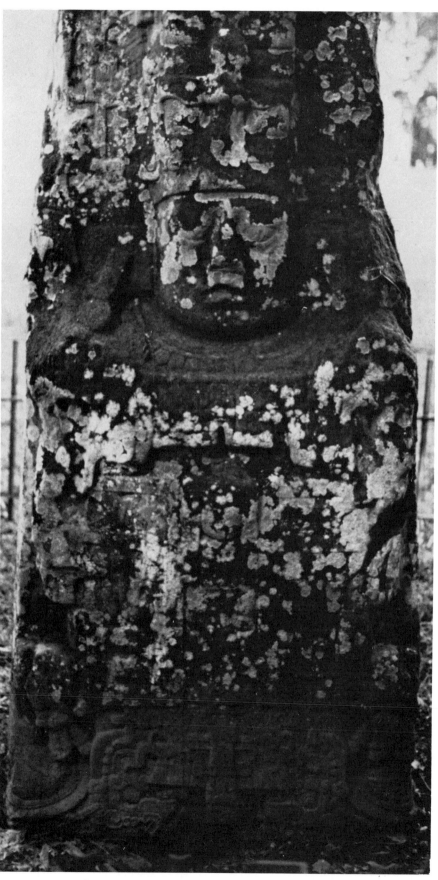

85 Stela J, Front, Dated 9.16.5.0.0—8 Ahau 8
Zotz (ca. A.D. 760), Quirigua, Guatemala.

86 Stela K, Dated 9.18.15.0.0—3 Ahau 3
Yax (ca. A.D. 800), Quirigua, Guatemala.

87 Tomb Guardian, ca. Third Century A.D., Chu-Fu, Shantung, China
(Courtesy Dr. Osvald Siren, National Museum of Stockholm).

A number of the principal figures in the stelae of Quirigua (Plates 85 and 86) were carved in unusual body proportions (the height of the head measures approximately one-fourth of the length of the body). Similar scale was used in the Shantung statues (Plate 87).

Masks were placed next to one another not only vertically (Plates 89-91) but also horizontally (Plates 88 and 92, top) in both Asian and Mayan artworks.

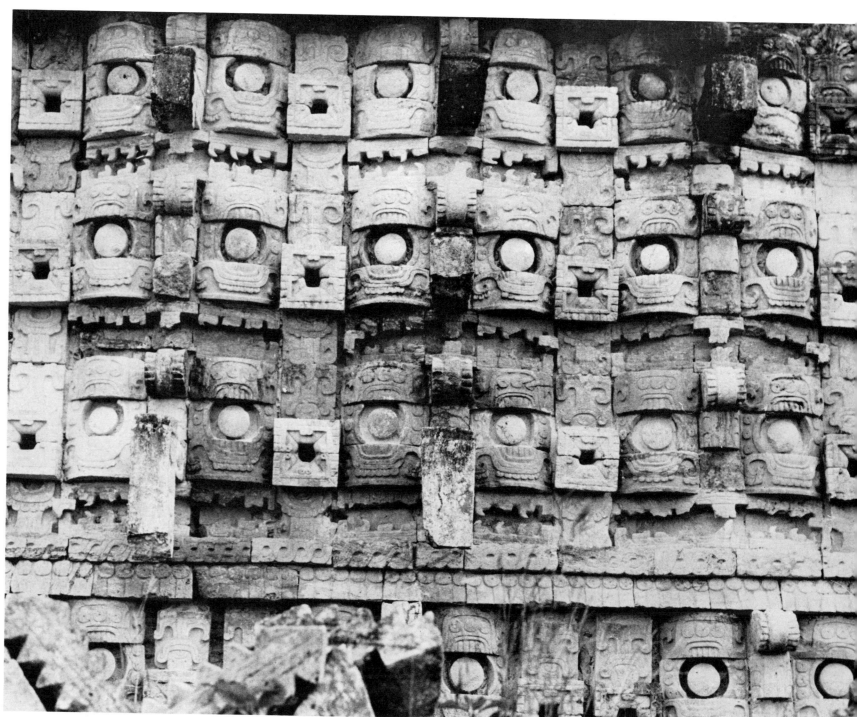

88 Facade, House of Masks, Dated Postclassic Period (ca. A.D. 900-1100), Kabah, Yucatan, Mexico.

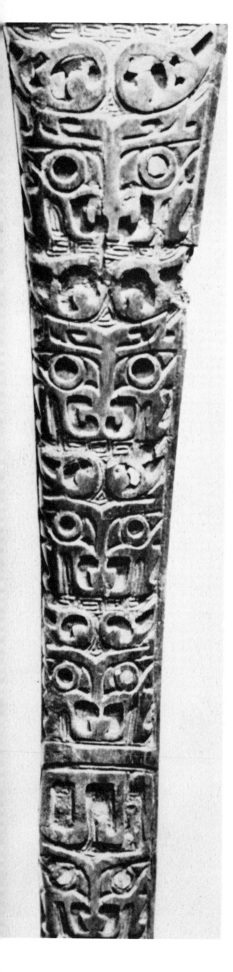

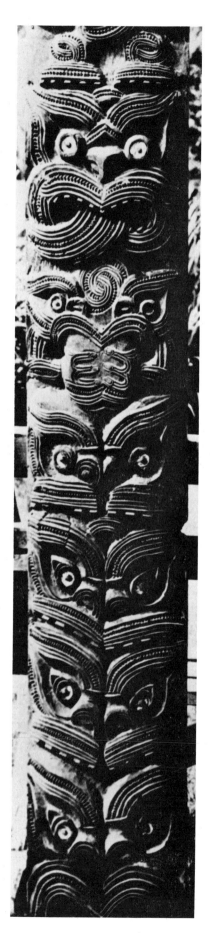

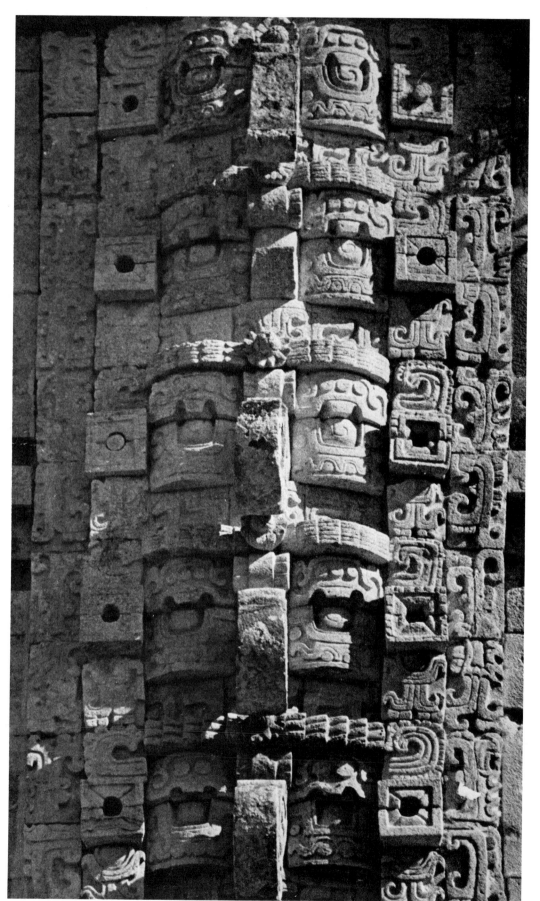

89 Tao-Tieh Masks on Bone, Shang Dynasty, ca. Fifteenth Century B.C., China (Courtesy of the Museum of Fine Arts, Boston).

90 Maori Masks on Posts, ca. Nineteenth Century A.D., New Zealand (Courtesy of the American Museum of Natural History).

91 Chac Masks, Postclassic Period (ca. A.D. 900-1100), Uxmal, Yucatan, Mexico.

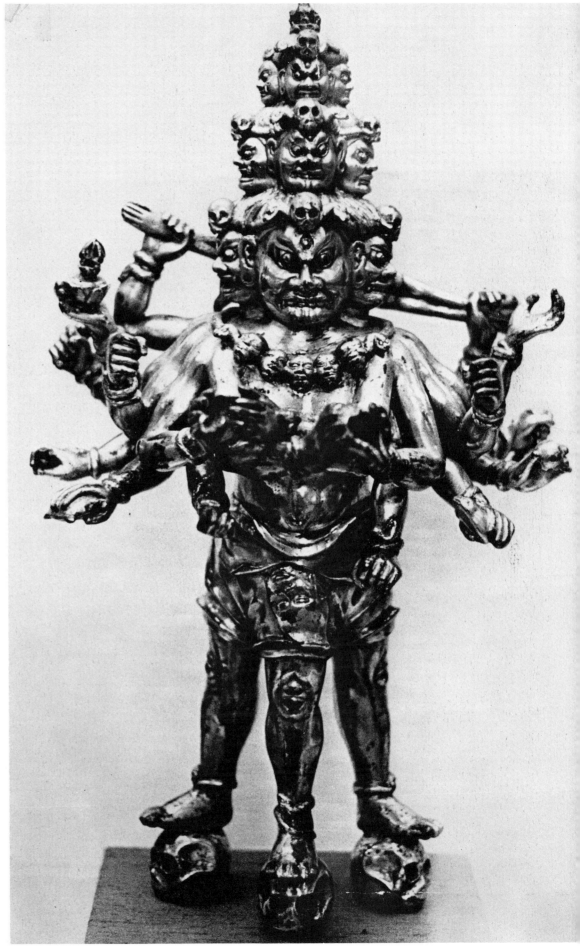

92 Chia-Lo God, ca. Seventeenth Century A.D., Tibet, China (Collection of the British Museum, London).

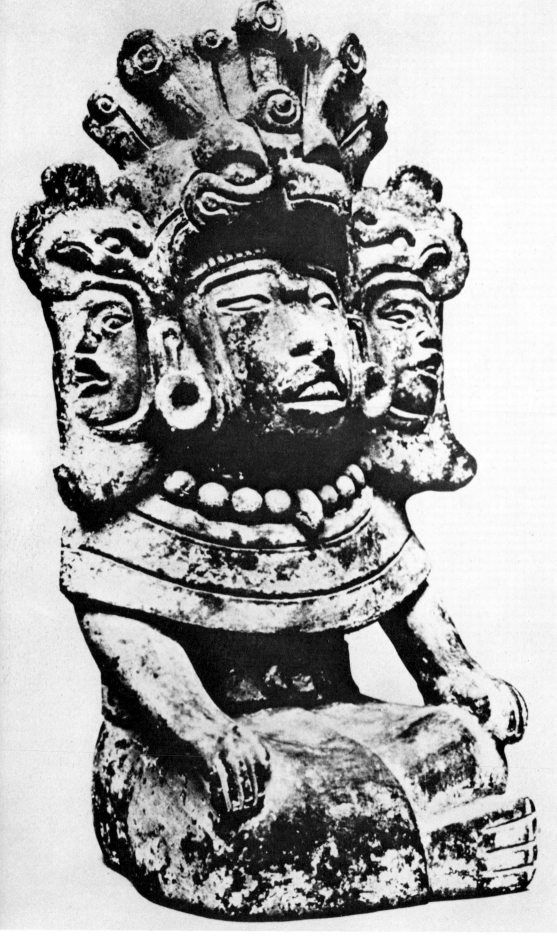

The cross-legged Zapotec deities in Plates 93 and 100 bear close resemblance to those of the Asian not only in general trait arrangement but also in specific attributes: the head emerging from the mouth of a bird (Plates 93, 97-100), in addition to having three faces.

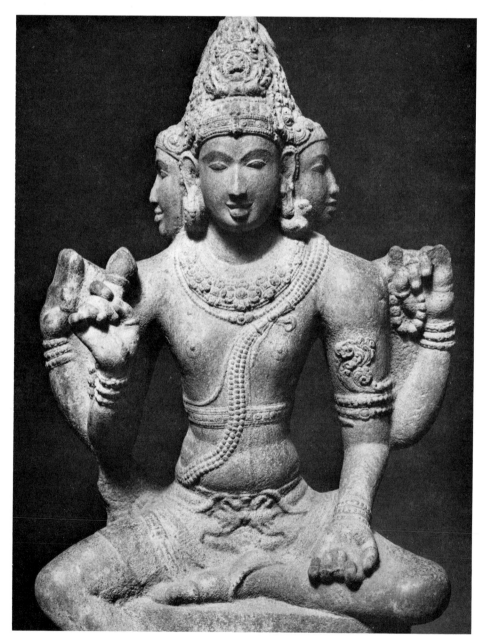

94 Brahma, Chola Dynasty, ca. Tenth Century A.D., Tanjore, India (The Metropolitan Museum of Art, Eggleston Fund, 1927).

93 Zapotec Three-Faced Deity (A Funerary Urn), ca. Eighth Century A.D., Oaxaca, Mexico (Collection of the British Museum, London).

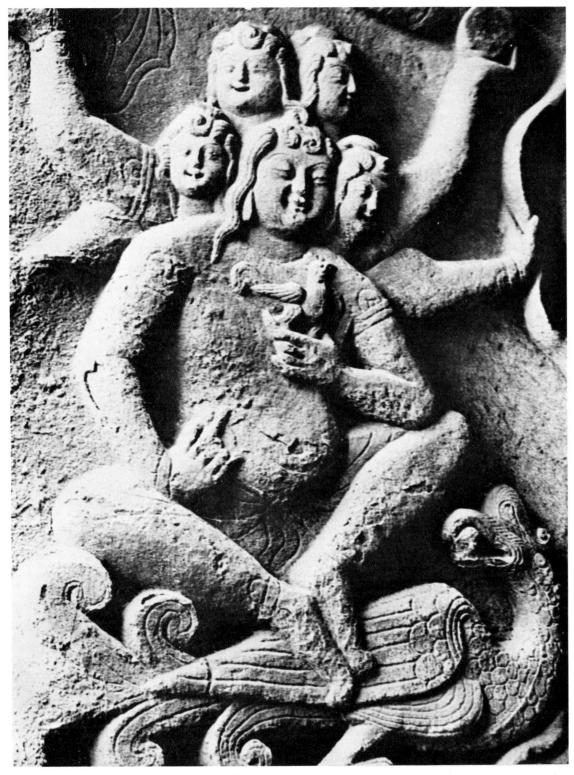

95 Multiple-Headed Deity, Northern Wei Dynasty,
ca. Fifth Century A.D., Yun-Kang Caves, Ta-Tung,
Shansi, China.

96 Brahma, ca. Fourteenth Century A.D., Cambodia
(Collection of the Musee Guimet, Paris).

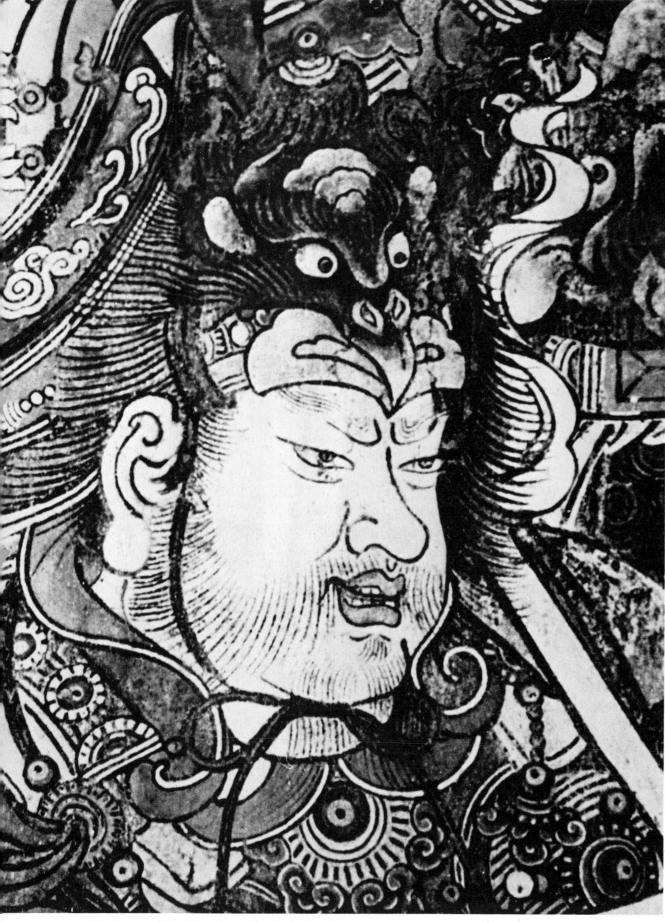

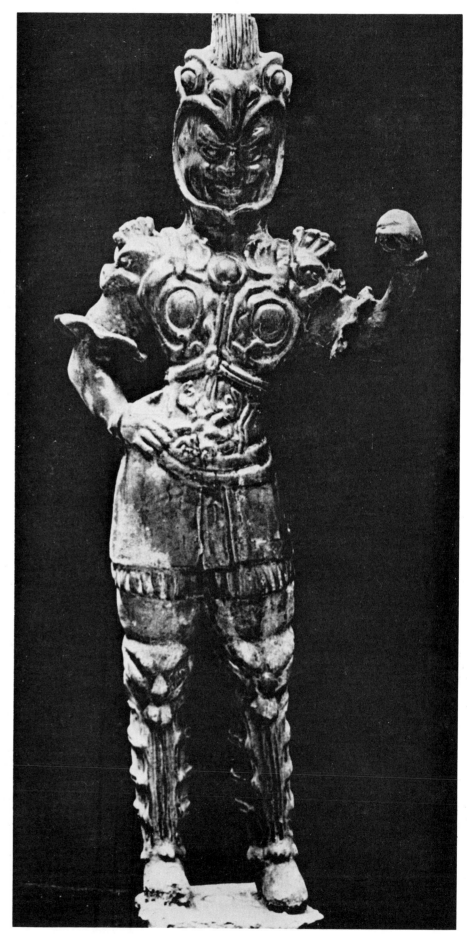

97 Deity with Bird Headdress (Detail of a Mural), ca.
Thirteenth Century A.D., Moon Hill Monastery, Shansi,
China (Collection of the University Museum, Philadelphia).

98 Guardian with Bird-Headdress (A Funerary Figurine),
Tang Dynasty (A.D. 618-907), China (Courtesy
of the Victoria and Albert Museum).

notice that in Plate 98, in addition to the bird-headdress, there are two birds' heads in profile facing opposite directions on the shoulders of the Tang guardian king. Similar elements can be observed in Plates 93 and 100.

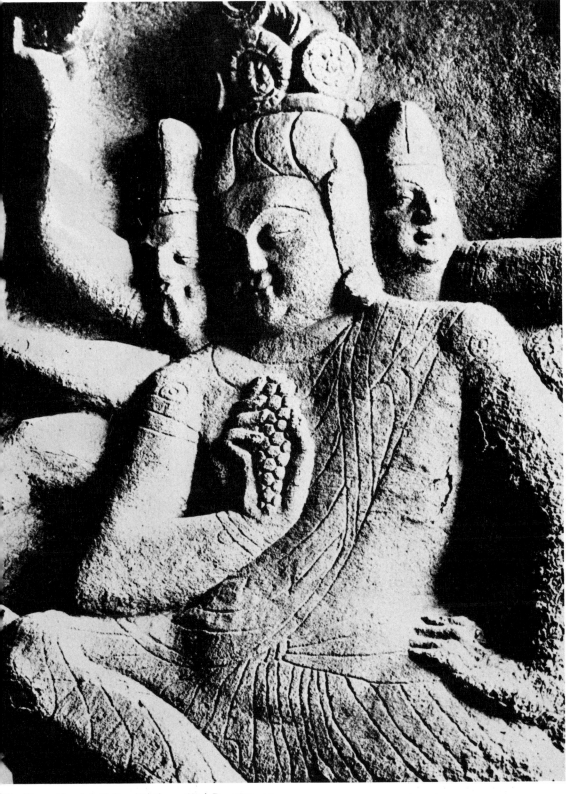

99 Three-Headed Deity, Northern Wei Dynasty, ca. Fifth Century A.D., Yun-Kang Caves, Ta-Tung, Shansi, China.

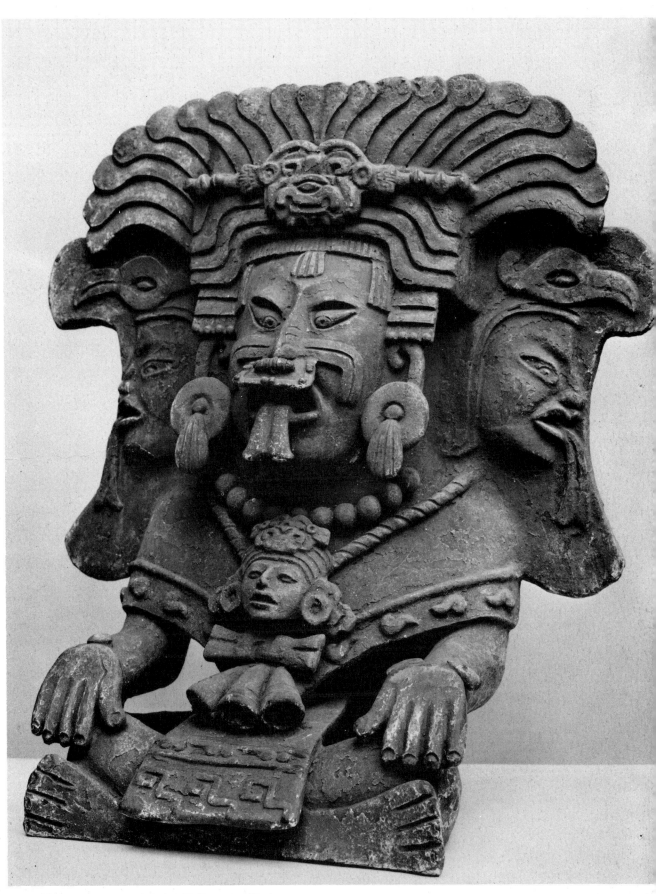

100 Zapotec Three-Faced Deity (A Funerary Urn), ca. Eighth Century A.D., Oaxaca, Mexico (Collection of the British Museum, London).

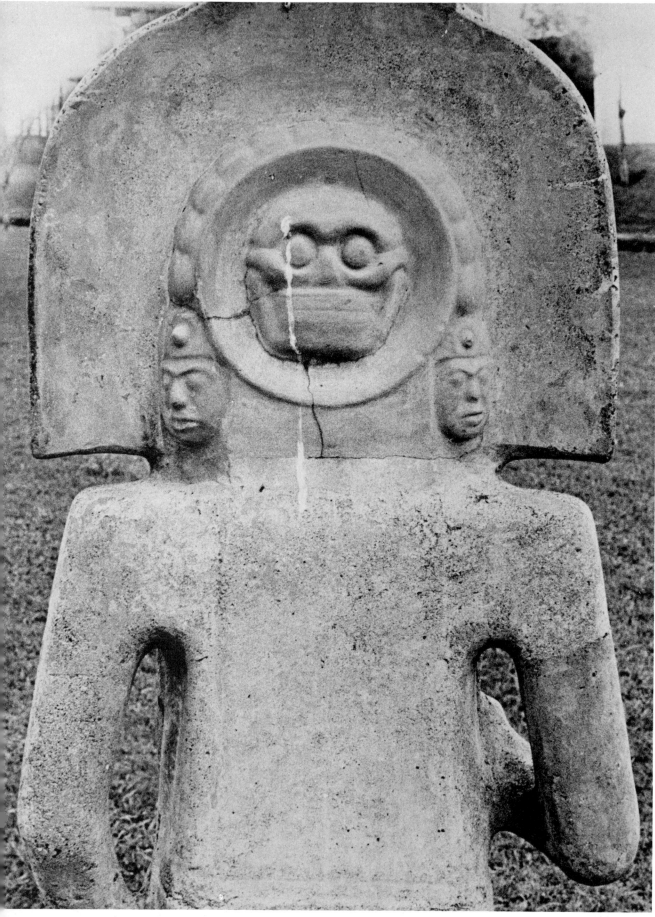

The side-faces of the three-faced Huastec deity (Plate 101) wear headdresses with round ornaments attached at the center. Similar facial features (the closed eyes, flat nose, thick lips, and the round face) and headdress can be observed in Plate 102. In Plates 101, 104, 106-108, the side-faces appear to have been purposefully reduced by both the Mayan and Asian artists to serve as ornaments to the ears of the main face.

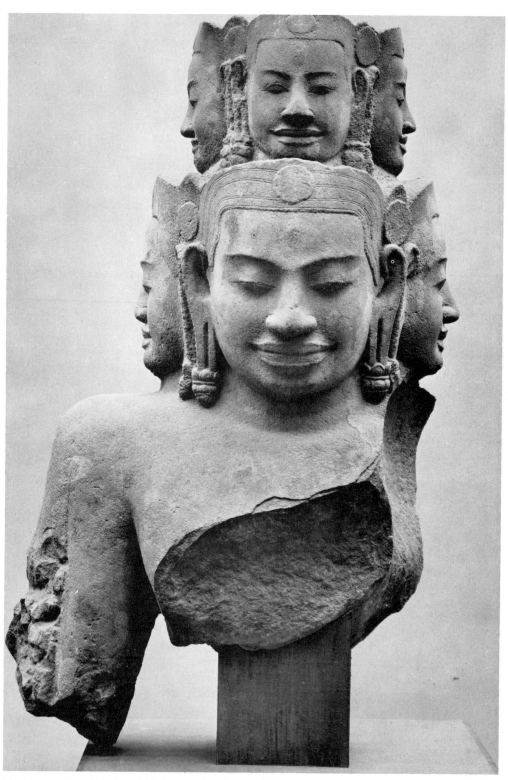

102 Eleven-Headed Avalokitesvara, Khmer Period, ca. Eleventh Century A.D., Angkor Thom, Cambodia (The Metropolitan Museum of Art, Fletcher Fund, 1935).

101 Huastec Three-Faced Deity, Postclassic Period (ca. A.D. 900-1200), Veracruz, Mexico (Collection of the University of Veracruz, Jalapa).

103 Three-Faced Deity (Detail of a Relief), Ming
Dynasty, ca. Fourteenth Century A.D., China.

104 Three-Faced Deity, ca. Eighth to Tenth Century A.D.,
Bezeklik, Turfan (Modern Hsinchiang Province, China)

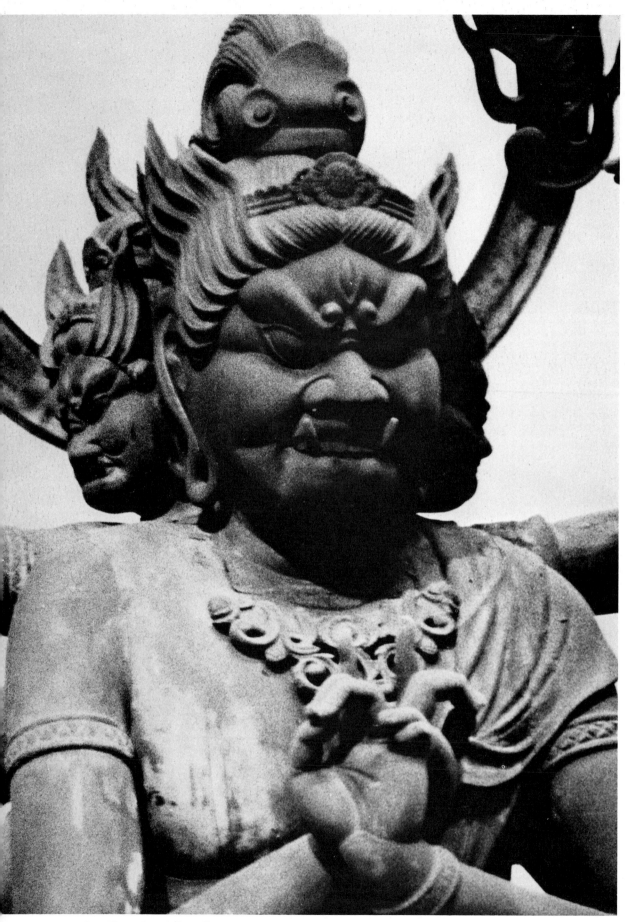

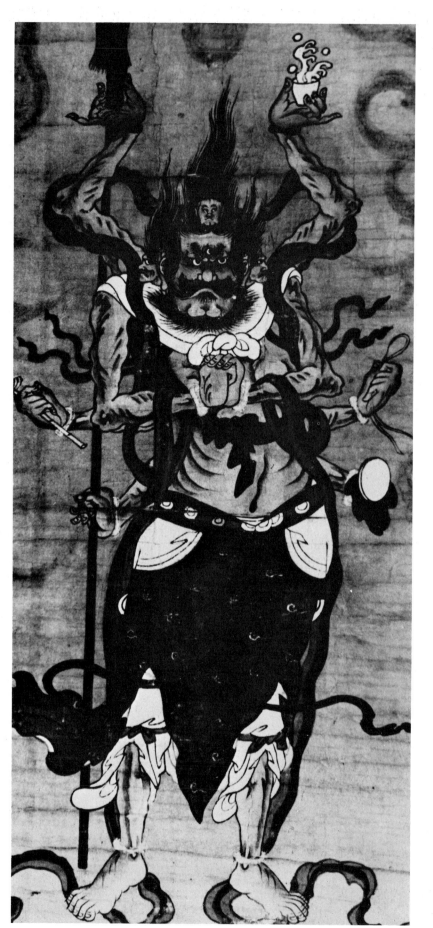

In addition to the flying hair, the figures in plates 106-108 are four-headed. The chronological problem of Plates 105-110 will be discussed in detail in a separate volume under preparation titled *The Origin of Ancient American Civilization.*

105 Three-Faced Guardian King, ca. Eleventh Century, Japan (Collection of the Tokyo National Museum, Tokyo).

106 Four-Faced Guardian King, ca. Ninth to Tenth Century A.D., China (Courtesy of the American Museum of Natural History).

107, 108 Four-Faced Olmec Stone Figure (Two Views), Attributed to
Preclassic Period (ca. 800 B.C.-A.D. 300), San Martin Pajapan, Veracruz,
Mexico (Collection of the Museum Park, Villahermosa).

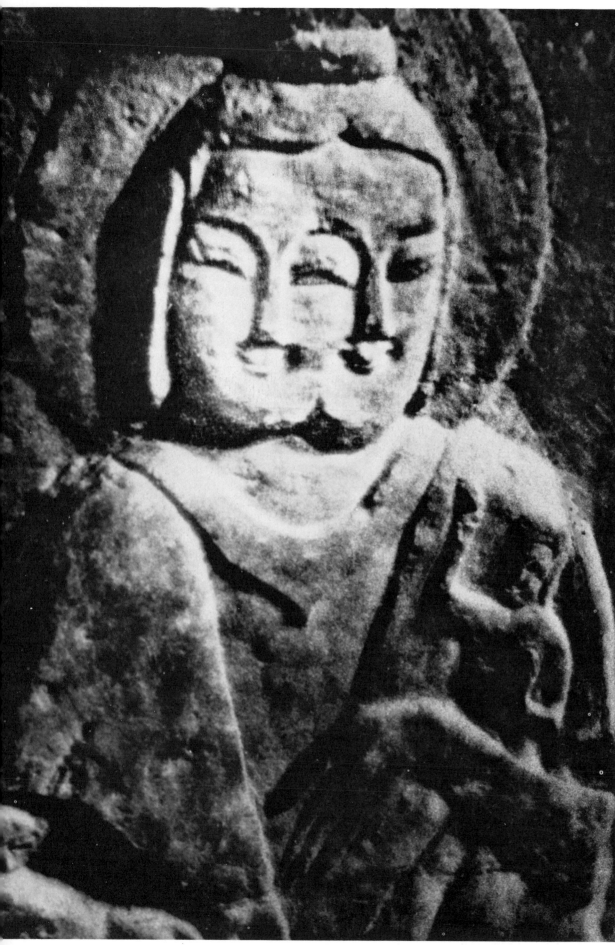

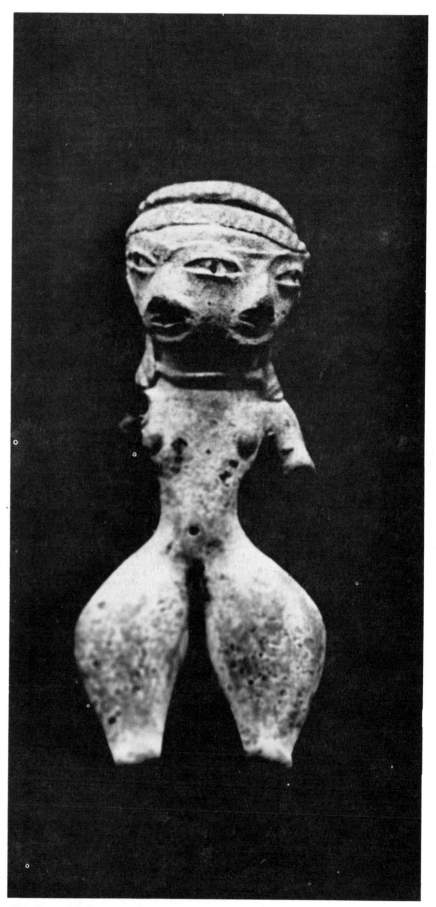

The figure in Plate 1[0]
has two faces which a[re]
resolved into one b[y]
sharing a common ey[e.]
The figure in Plate 11[0]
resembles that of Plat[e]
109 not only in th[is]
unusual attribute, b[ut]
also in the hair style—[a]
bun.

The half-kneelin[g]
worshipping figures i[n]
Plates 111 and 112 eac[h]
have five snakes comin[g]
out of their backs.

110 Two-Faced, Three-Eyed Lady, Middle
Preclassic Period (ca. 1000-300 B.C.), Tlatilco, Mexico
(Collection of the National Museum of Anthropology,
Mexico City).

109 Two-Faced, Three-Eyed Lady, Northern Wei
Dynasty, ca. Fifth Century A.D., Yun-Kang Caves,
Ta-Tung, Shansi, China.

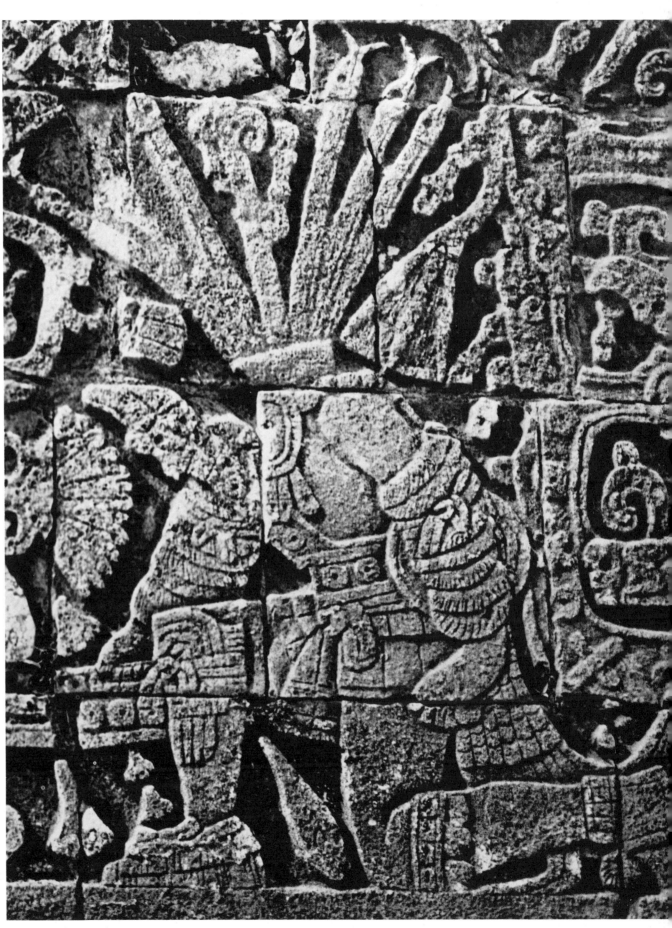

111 Worshipping Bodhisattva (Detail of a Stone Stela),
Dated Second Year of Tai-An, Northern Wei Dynasty
(A.D. 457), China.

112 Worshipping Ball-Player (Detail of the Center
Panel, East Bench of the Ball Court), Postclassic
Period (ca. A.D. 1000-1300), Chichen Itza, Yucatan,
Mexico.

3. SEATED FIGURES (PLATES 113-59)

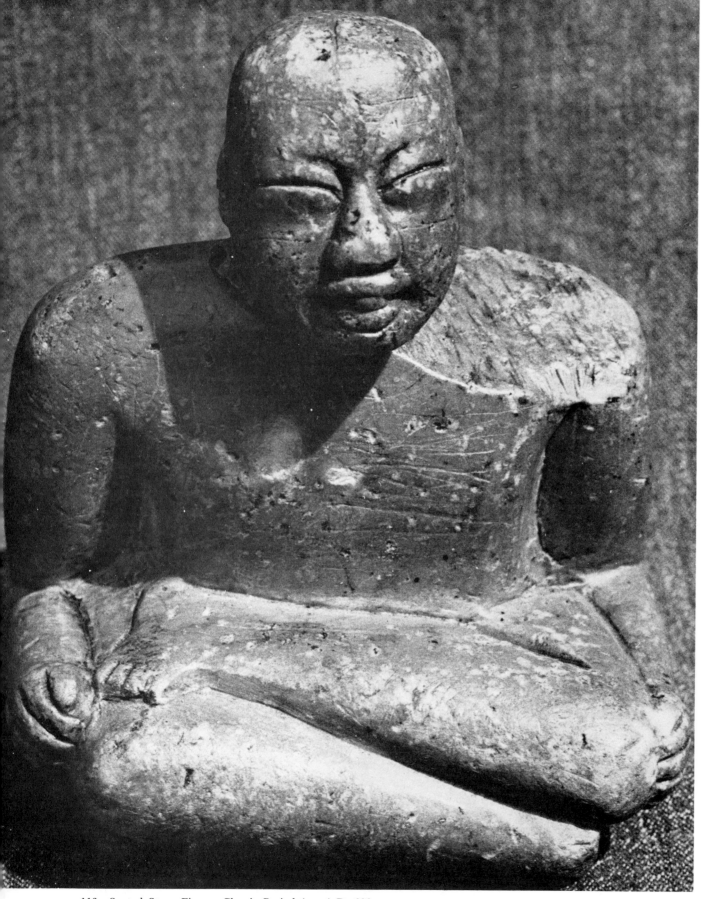

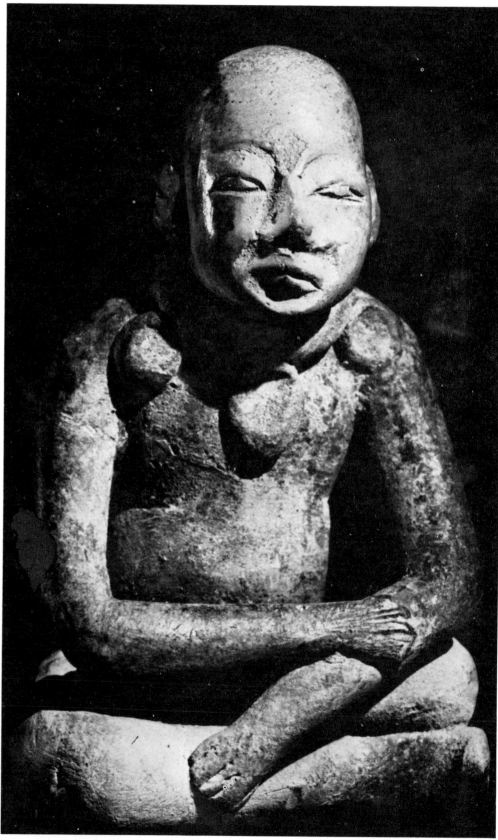

113 Seated Stone Figure, Classic Period (ca. A.D. 600-900), Santa Clara (Near Copan), Honduras (Collection of the Regional Museum of Mayan Archaeology, Copan).

114 Huastec Seated Figure, Postclassic Period (ca. A.D. 900-1200), Mexico (Courtesy of the American Museum of Natural History).

The stone figure in Plate 113 is one of the few Mayan cross-legged figures in the Copan area which escaped decapitation (Plates 245, 246, and 122). The shaven head, the narrow eyes, puffy cheeks, the general round quality of body modeling (characteristic of Buddhist sculptures depicting energy expanding within and related to the practice of breathing, see Plate 128), and the ''half lotus'' sitting posture (one leg on top of the other with bottom of the foot facing up—a posture not exactly natural and comfortable for the uninitiated), are traits taken together so unusual and foreign to the Mayans and yet so strikingly similar to those of the Buddhist (see Plates 115-117) that I was totally fascinated when I saw it. Of significance is the fact that it was found only a few miles from Copan, where the double-headed serpent, the elephantlike motifs and a whole conglomeration of other traits (Plates 3-32) converge to make it one of the most important Meso-American nuclei of possible Asiatic influence.

116 Buddhist Monk, Paekche Period, ca. Sixth Century A.D., Korea (Collection of Min Byong-Do, Courtesy of the National Museum of Korea, Seoul).

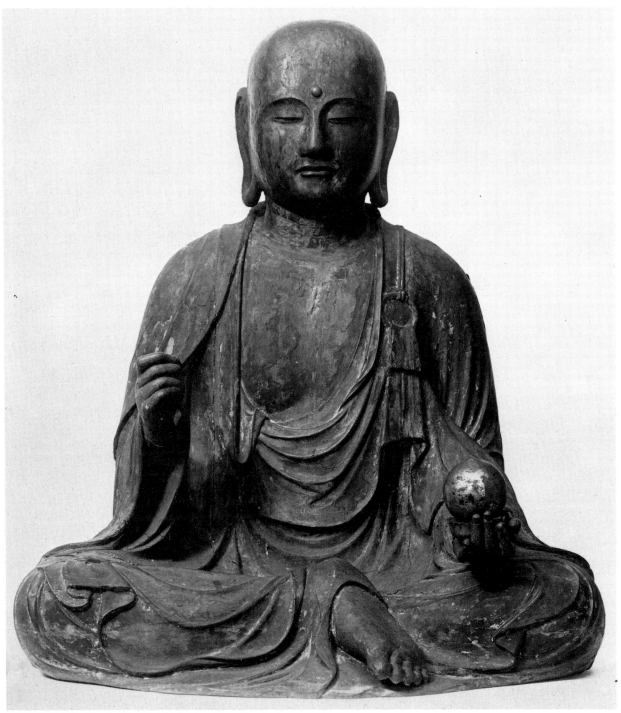

115 Seated Jizo, Kanakura Period (A.D. 1322), Japan (Courtesy of the Museum of Fine Arts, Boston).

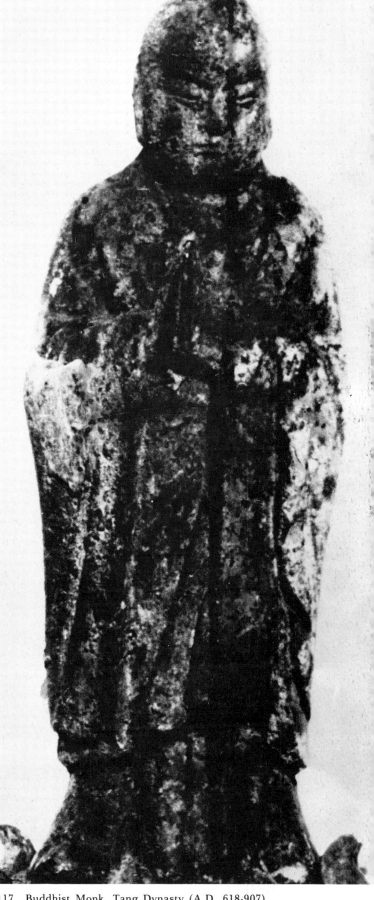

117 Buddhist Monk, Tang Dynasty (A.D. 618-907), China (Courtesy of the Smithsonian Institution, Freer Gallery of Art, Washington, D.C.).

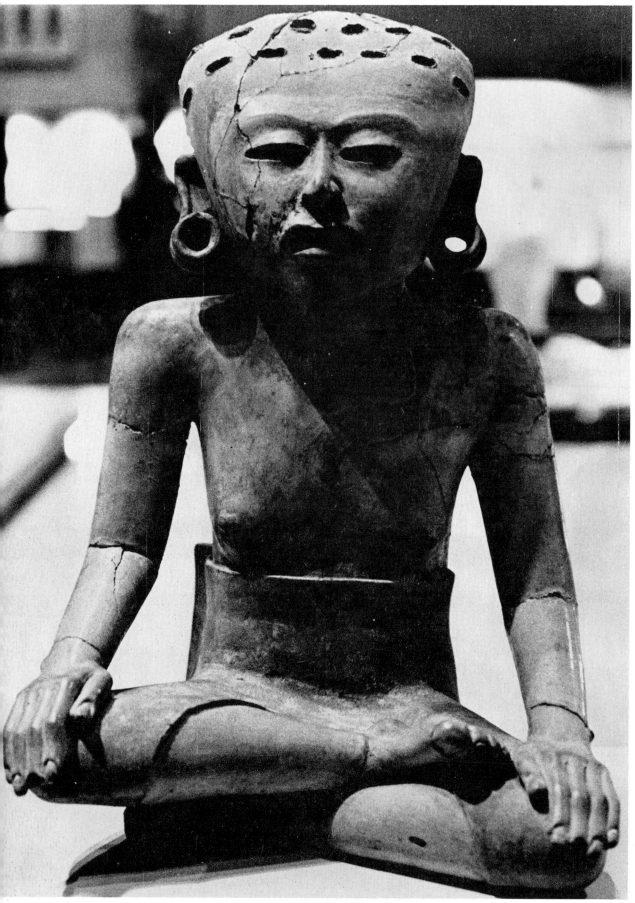

118 Seated Woman, Classic Period (ca. A.D. 600-900), Veracruz, Mexico (Collection of the National Museum of Anthropology, Mexico City).

Other cross-legged figures in Meso-America (Plates 118 and 120) were also frequently modeled with narrow eye features.

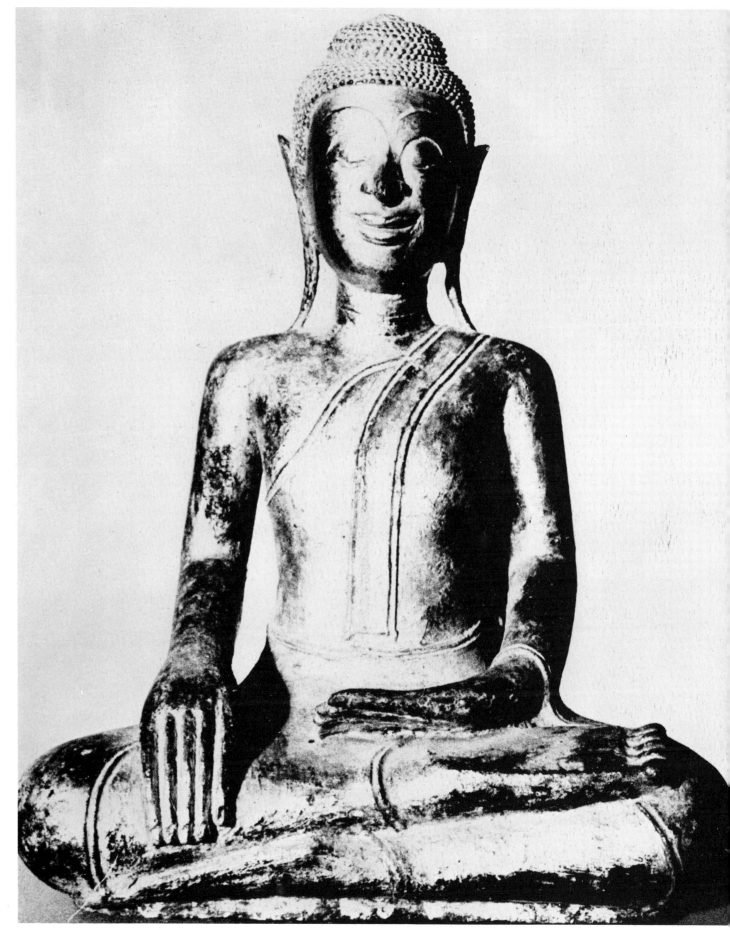

119 Seated Buddha, ca. Fourteenth Century A.D.,
Thailand.

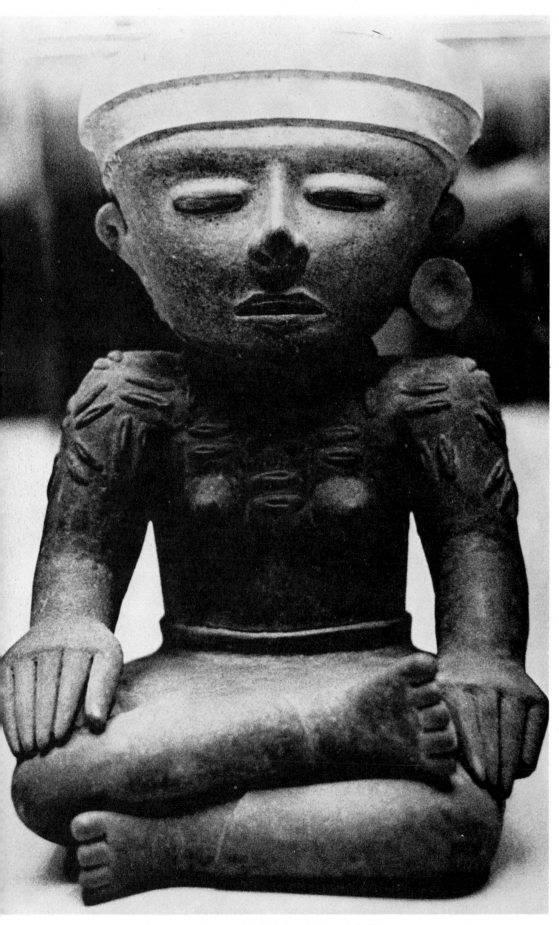

120 Seated Woman, Classic Period (ca. A.D. 600-900),
Mexico (Courtesy of the American Museum of
Natural History).

Curiously, today many natives of the Melanesia and Polynesia islands still sit in this unique posture (Plate 121).

121 Seated Woman, Samoa (South Pacific) Islands (Courtesy of the American Museum of Natural History).

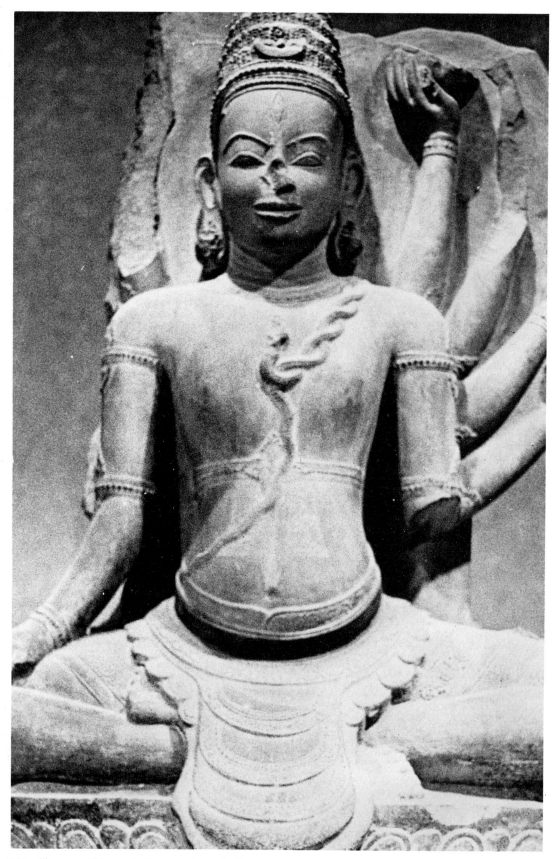

122 Seated Priest, ca. Eighth Century A.D., Copan,
Honduras (Collection of the British Museum, London).

123 Siva, ca. Thirteenth Century A.D., India
(Collection of the Musee Guimet, Paris).

Also found in Copan (lower chamber, Temple 16), the stone figure in Plate 122 is noteworthy not only on account of its sitting posture but also because of its slender proportions. Furthermore, observe the neatly placed loincloth apron on top of the crossed legs (Plates 122 and 123).

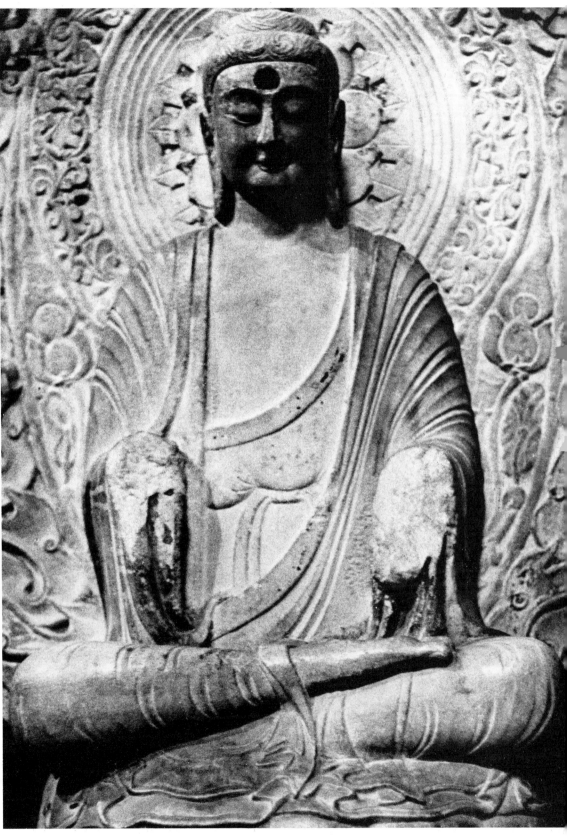

124 Seated Buddha, ca. Sixth Century A.D., China.
(Collection of the Musee Cernuschi, Paris).

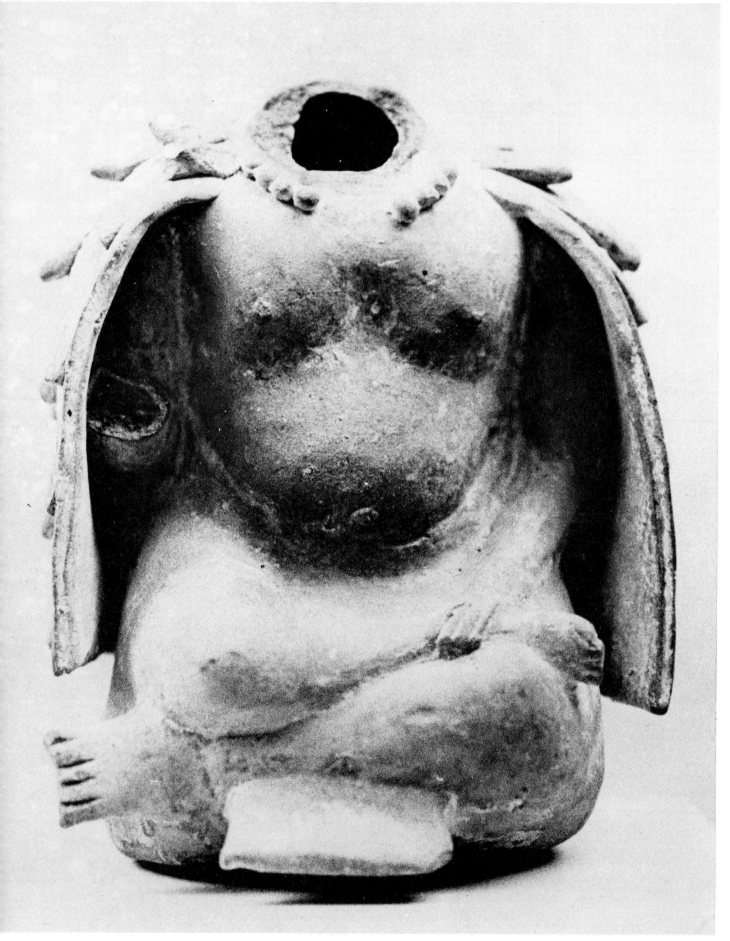

125 Seated Figure with Cloak (ca. A.D. 700-1000), Campeche, Mexico (Collection of the National Museum of Anthropology, Mexico City).

126 Seated Figure with Cloak (Detail), ca. Sixth Century A.D., China, Detail of Plate 275 (Courtesy of the Smithsonian Institution, Freer Gallery of Art, Washington, D.C.).

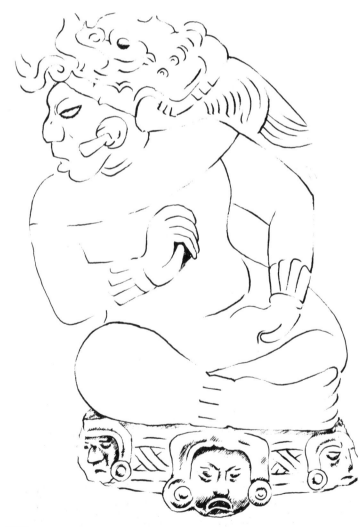

127A

The cross-legged figure in Plates 127A, 127B is seated on a round pedestal decorated with three faces. This motif was common in China during the South-North Dynasty (A.D. 420-589). See Plates 128 and 129.

129 Seated Buddha, ca. Sixth Century A.D., China (Detail of a Stone Stupa on loan to the Metropolitan Museum of New York City by the Tribner Family).

128 Seated Buddha, ca. Sixth Century A.D., China (Collection of the William Rockhill Nelson Gallery of Art, Kansas City).

127A, 127B Pendant, Dated Classic Period (ca. A.D. 600-1000), Nebaj, Guatemala (National Museum of Archaeology).

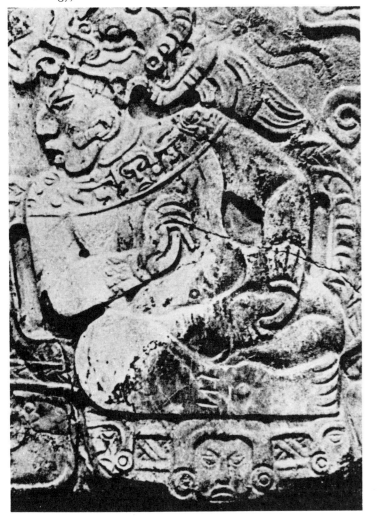

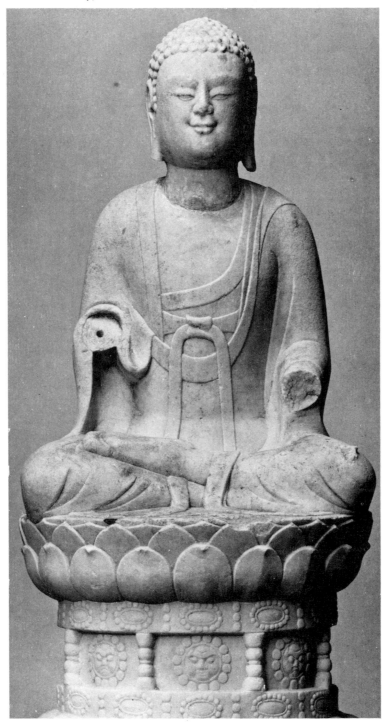

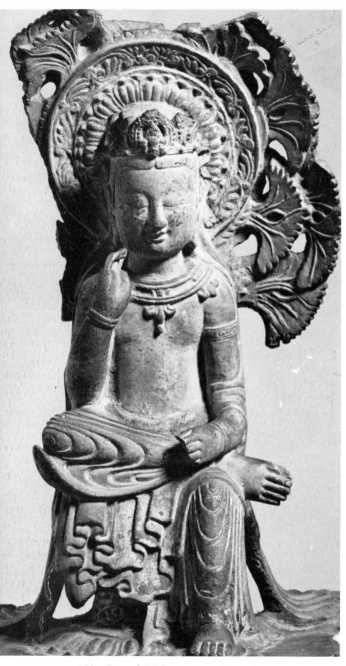

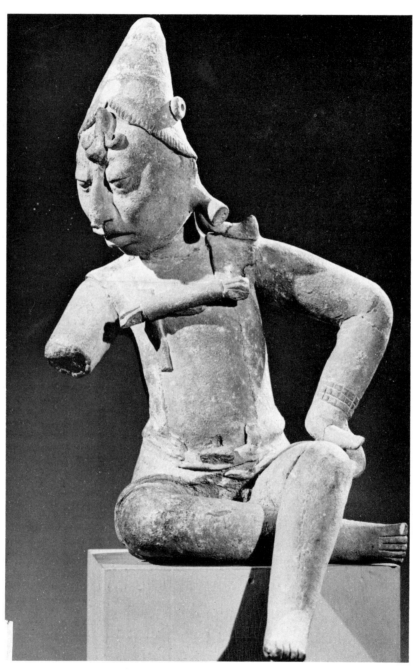

A variation of the "lotus" position, the sitting posture depicted in the figure in Plate 130 is an attribute of Bodhisattva and sometimes Kuan-Yin. Observe the similar posture and pensive attitude in the figure in Plate 131.

130 Seated Maitreya, ca. Seventh Century A.D., China (Courtesy of the Smithsonian Institution, Freer Gallery of Art, Washington, D.C.).

131 Seated Figure (ca. A.D. 700-900), Campeche, Mexico (Courtesy of the American Museum of Natural History).

The seated figure in Plate 133 was carved in low-relief within a frame similar to those in Plate 132. The figure is holding a lotus flower and a lotus leaf in the left hand, an attribute found also in Plate 132 (far upper left and far upper right). Note that the animal head headdresses worn by the two seated figures are similar in concept to those in Copan (Plates 219-221, 237, 238, and 245).

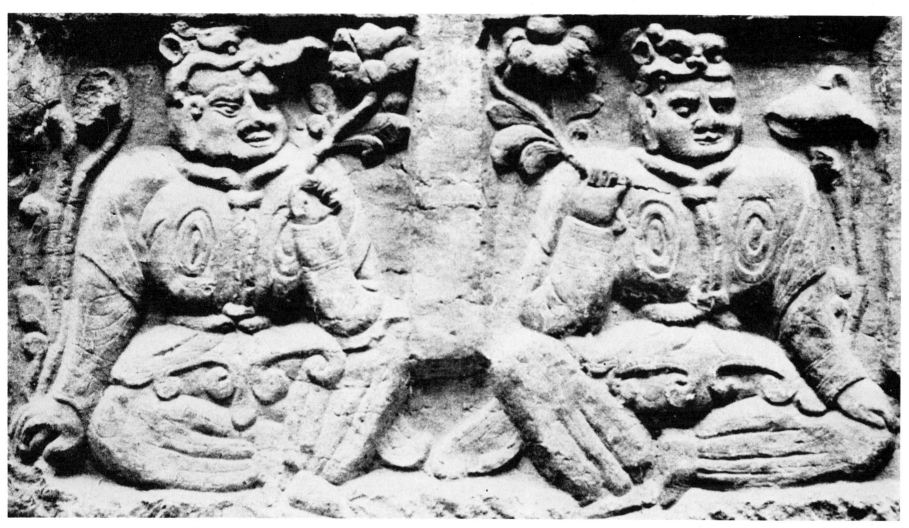

132 Seated Figure Holding Lotus Flower and Lotus Leaf (Detail), ca. Sixth Century A.D., China, Detail of Plate 250 (Collection of the Metropolitan Museum, New York City).

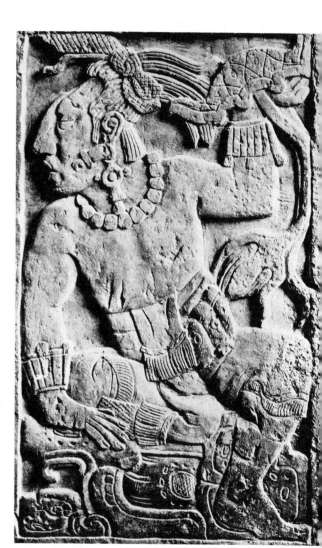

133 Seated Figures Holding Lotus Flower and Lotus Leaf (ca. A.D. 600-900), Palenque, Chiapas, Mexico (Collection of the Museo de America, Madrid).

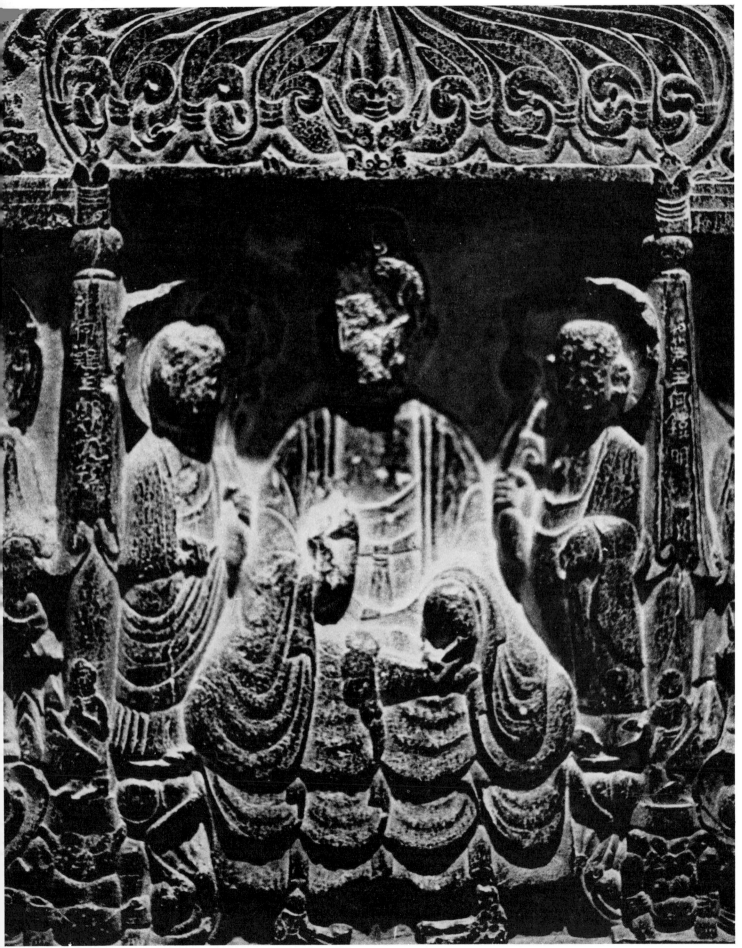

134 Buddha Seated on a Throne (Detail) Wei Dynasty (A.D. 554), China
(Courtesy of the Museum of Fine Arts, Boston).

The Buddhist throne in Plate 134 is similar in motif arrangement to the Mayan throne shown in Plate 136. Both thrones are flanked by two plump seated dwarfs and topped by winged creatures.

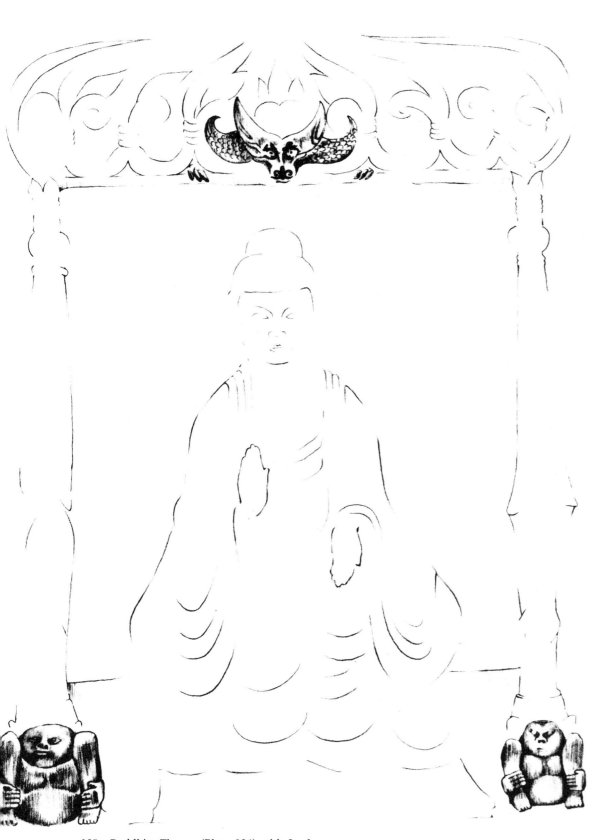

135 Buddhist Throne (Plate 134) with Irrelevant
Details Eliminated.

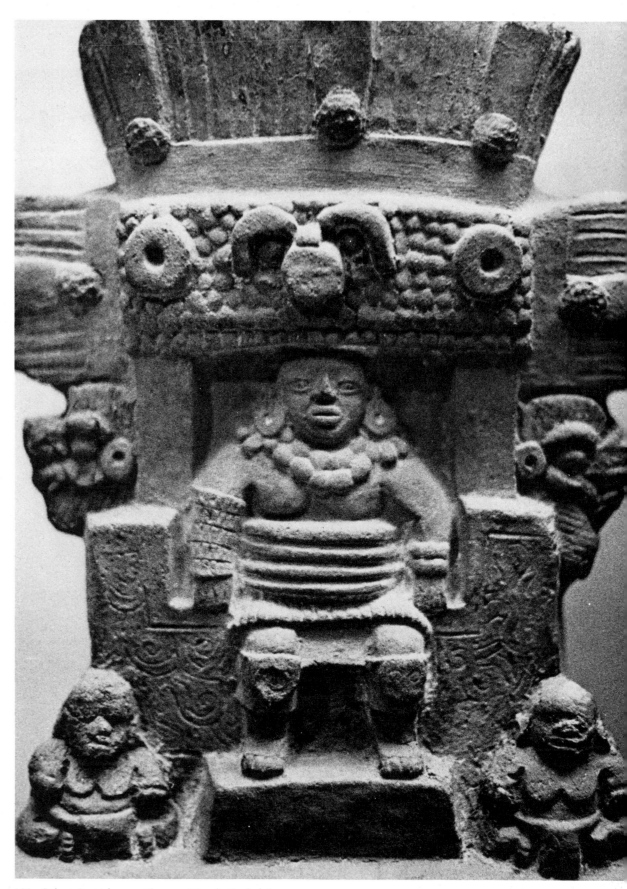

136 Priest Seated on a Throne, Classic Period (ca.
A.D. 600-900), Campeche, Mexico (Collection of the
National Museum of Anthropology, Mexico City).

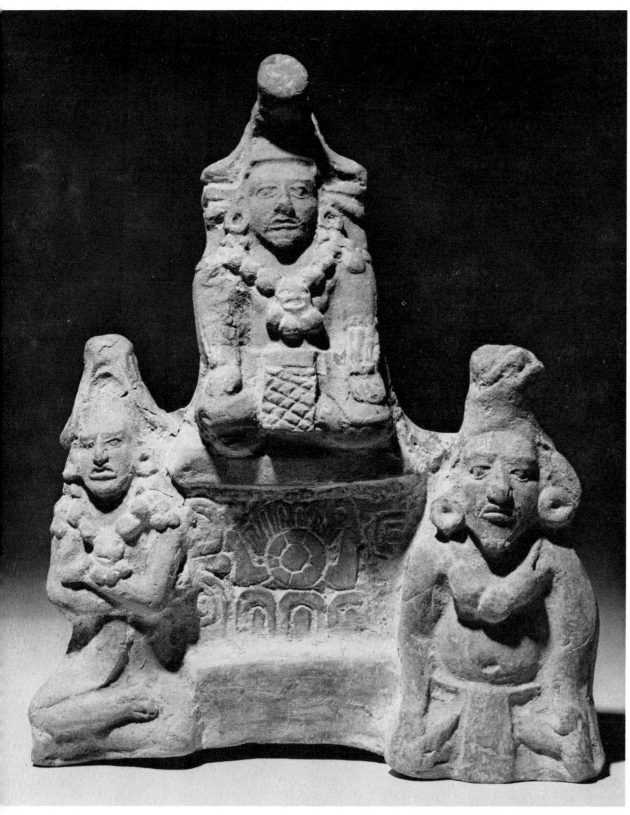

In Plate 137, a priest is seated on a flower-decorated throne, framed by two seated attendants (compare with Plate 138, lower portion). The petals on the lower portion of the Mayan throne are stylized in the manner of an I within an inverted U (see Chinese counterpart in Plates 139 and 140). In addition, the top view of an eight-petaled lotus flower can be observed directly below the principal cross-legged figure in both Plates 137 and 141.

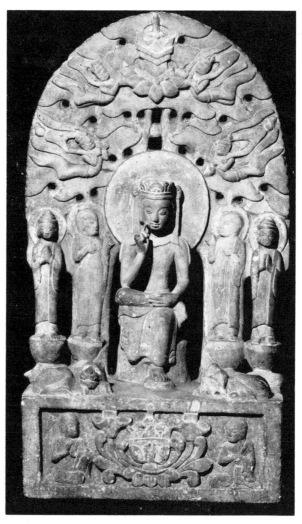

137 Priest Seated on a Throne, Dated Late Classic Period (ca. A.D. 700-1000), Jaina, Campeche, Mexico (Stendahl Collection).

138 Seated Maitreya with Attendants, ca. Sixth Century A.D., China (Courtesy Museum of Fine Arts, Boston).

139 Stylized Lotus Petal, Chou Dynasty, ca. Eighth
Century B.C., China (Courtesy of the Smithsonian
Institution, Freer Gallery of Art, Washington, D.C.).

140 Stylized Lotus Petal, Wei Dynasty, Sixth Century
A.D., China (Collection of the University Museum,
Philadelphia).

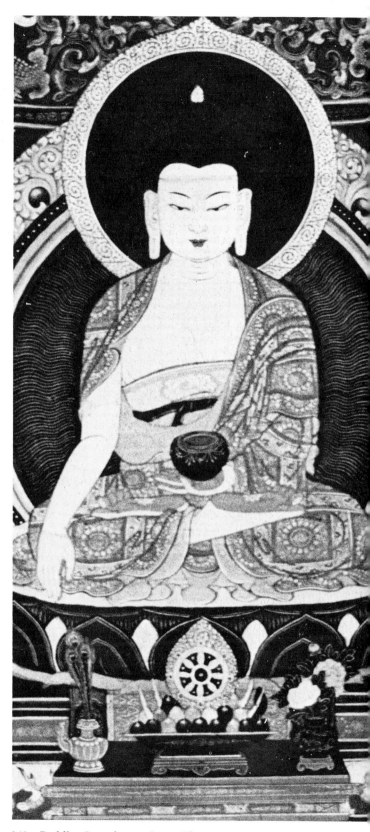

141 Buddha Seated on a Lotus Throne, ca.
Nineteenth Century A.D., Tibet, China.

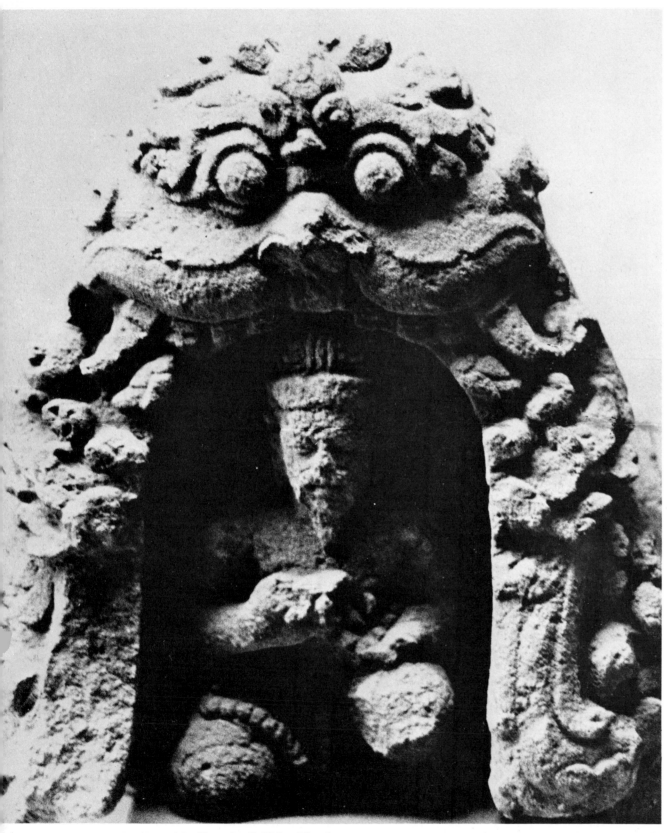

142 Man Seated Inside a Small Niche (The Open Mouth of a Monster), ca. Eleventh Century, Java (Royal Tropical Institute, Photografic-Archives, Amsterdam).

143 Winged-Monster-Head Headdress (Detail of a Stone Relief), Wei Dynasty, ca. Fifth Century A.D., Yuan-Kang Caves, Ta-Tung, Shansi, China.

In Plates 142 and 145, a man is seated inside a small niche as if he is inside the mouth of a monster (note the big monster-masks above the niches, complete with fangs). In addition, the Olmec figure in Plate 145 is wearing a winged animal-head headdress which bears striking resemblance to that of the Chinese figure in Plate 143. In spite of the fact that the La Venta altars and monuments have been attributed by most American archaeologists to the Preclassic Period (ca. 800 B.C.-A.D. 300), I have collected substantial evidence (I will explore this subject in detail in another monograph, *The Origin of Ancient American Civilization*) to support a later dating.

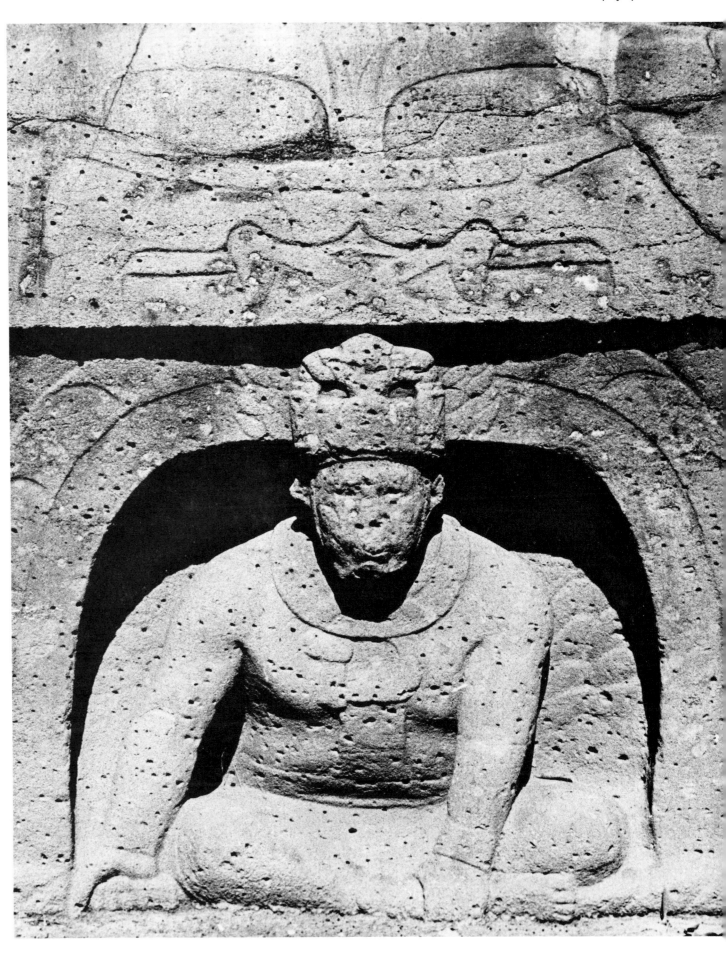

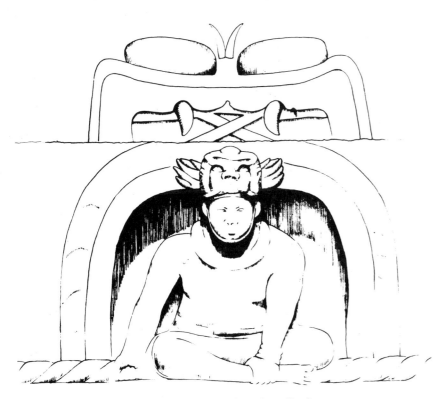

144, 145 Man Seated Inside a Small Niche (Detail of Altar 4), Attributed to Preclassic Period (ca. 800 B.C.-A.D. 300), La Venta, Mexico (Collection of the Museum Park, Villahermosa).

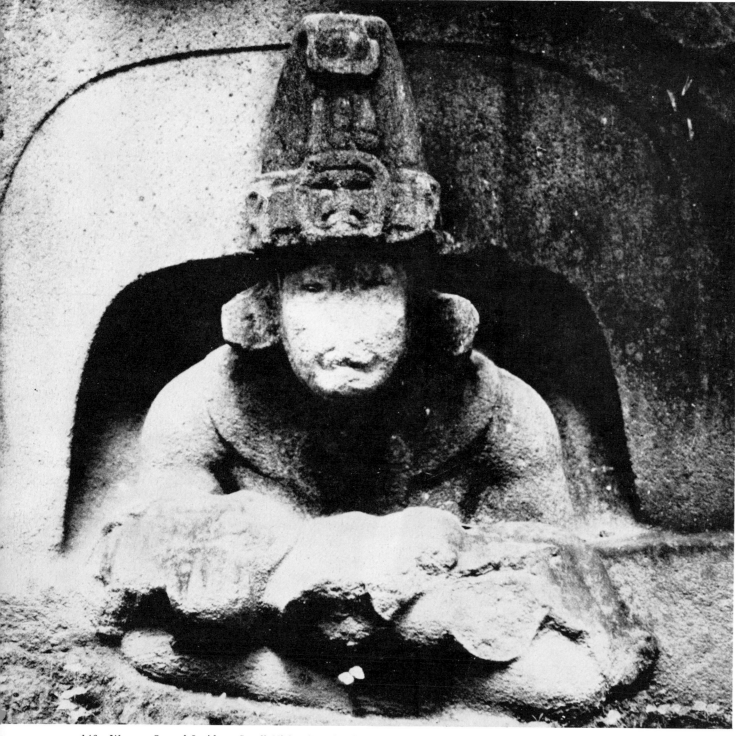

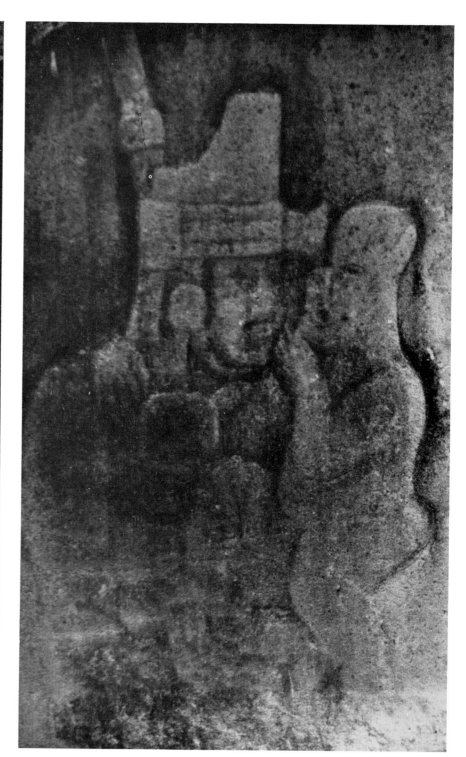

146 Woman Seated Inside a Small Niche (Detail of Altar 5, Front), Attributed to Preclassic Period (ca. 800 B.C.-A.D. 300), La Venta, Mexico (Collection of the Museum Park, Villahermosa).

147 Woman Talking to a Child (Detail of Altar 5, South Side).

In the front of Altar 5 (Plate 146), a person is seated inside a niche. On the south side of the same altar, a woman is portrayed talking to her child. A similar combination of these two motifs can be observed in Plate 148.

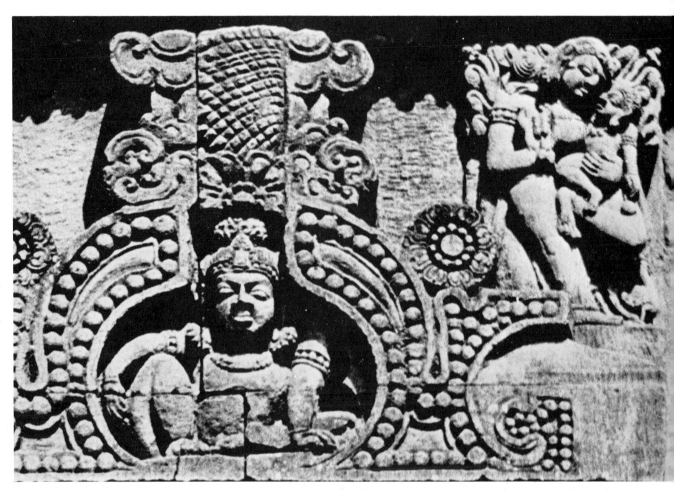

148 Facade (Detail) of Parasuramesvara Temple, (ca. A.D. 750), Bhuvanesvara, India.

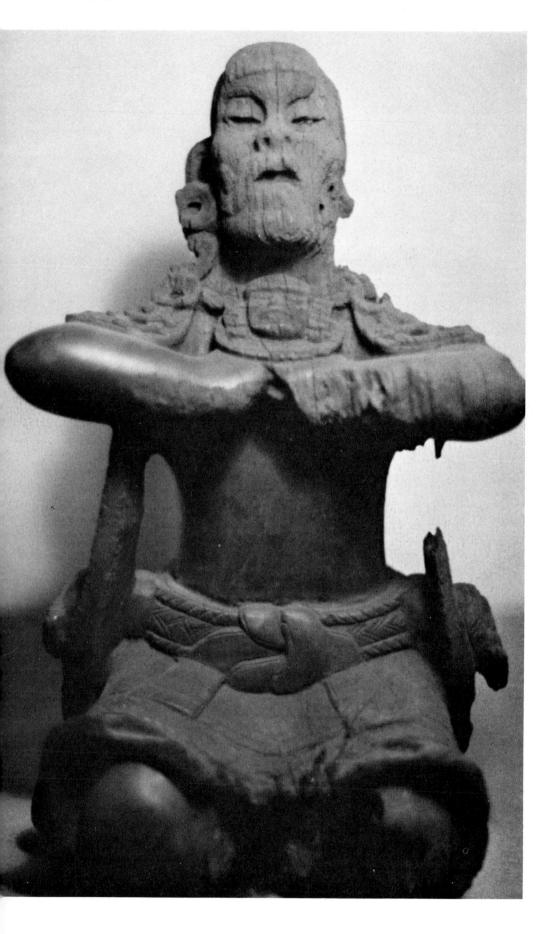
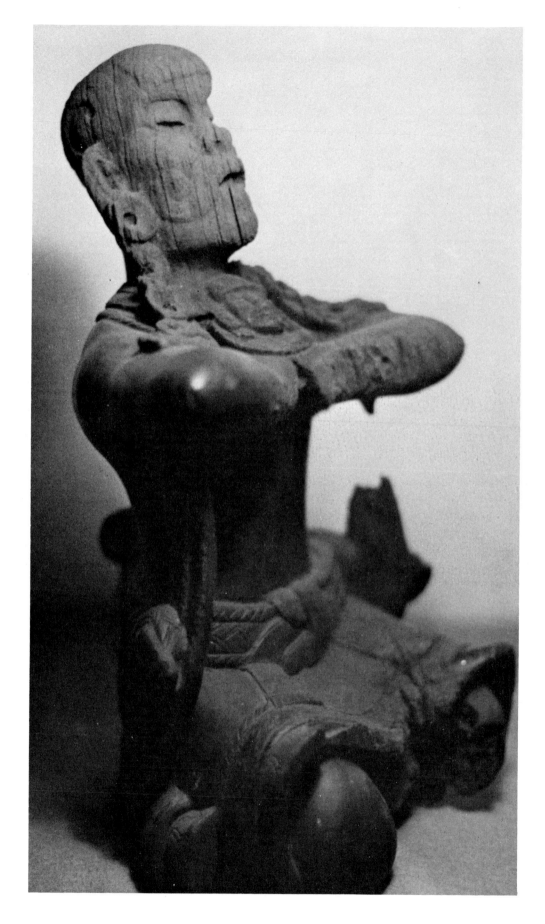

The figure in Plates 149-151 is the only surviving Meso-American wooden statue in the round. This figure is significant in that it depicts not only a posture common in Buddhist art (Plates 152, 156, and 157), but also unique Buddhist ceremonial attire: a wide ribbon draped around the neck, under the arm to the back of the body (usually with the upper portion of the body naked, see Plates 152-157).

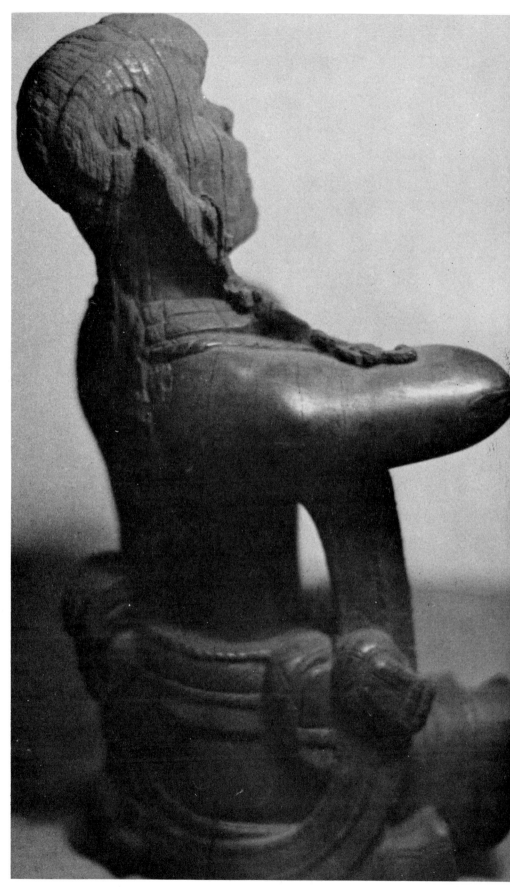

149, 150, 151 Worshipping Figure (Three Views) (ca. A.D. 600-1200), Tabasco, Mexico (Collection of the Museum of Primitive Art, New York City).

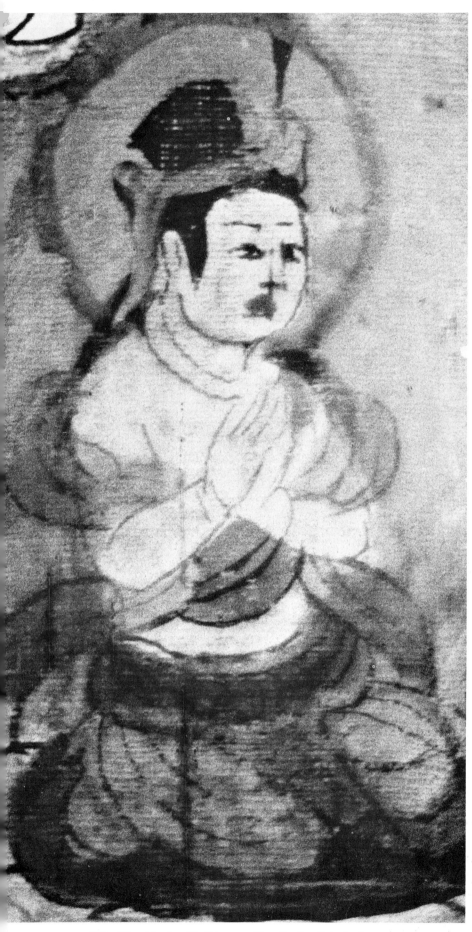

152 Worshipping Bodhisattva (Detail of a Painting),
Tang Dynasty (A.D. 618-907), Tun-Huang, Kansu,
China (Collection of the Musee Guimet, Paris).

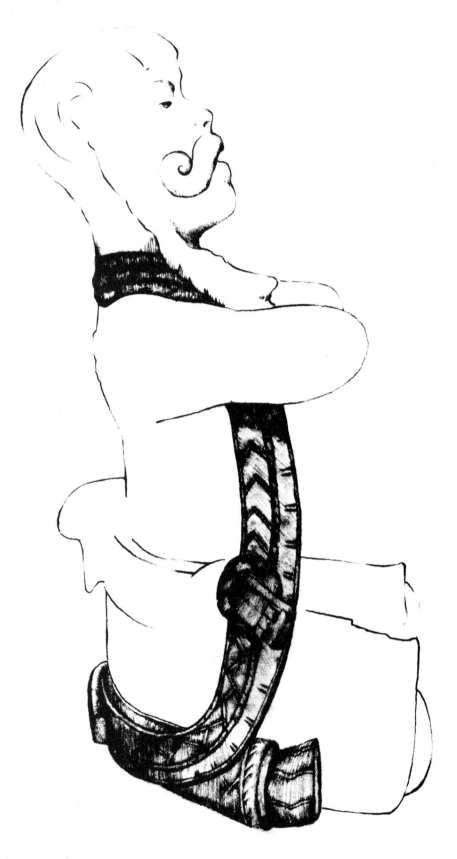

153, 154 Drawing of Plates 149 and 150, with
Irrelevant Elements Deleted.

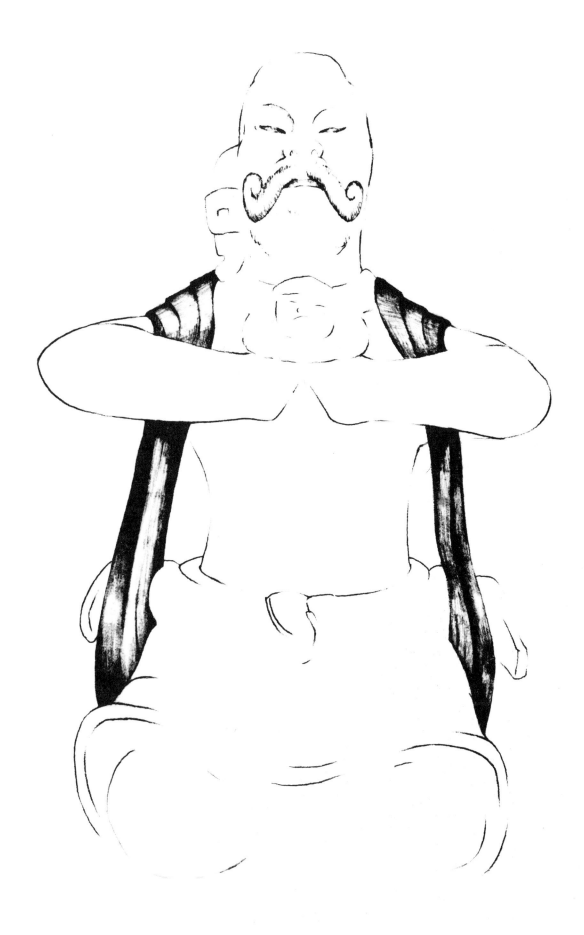

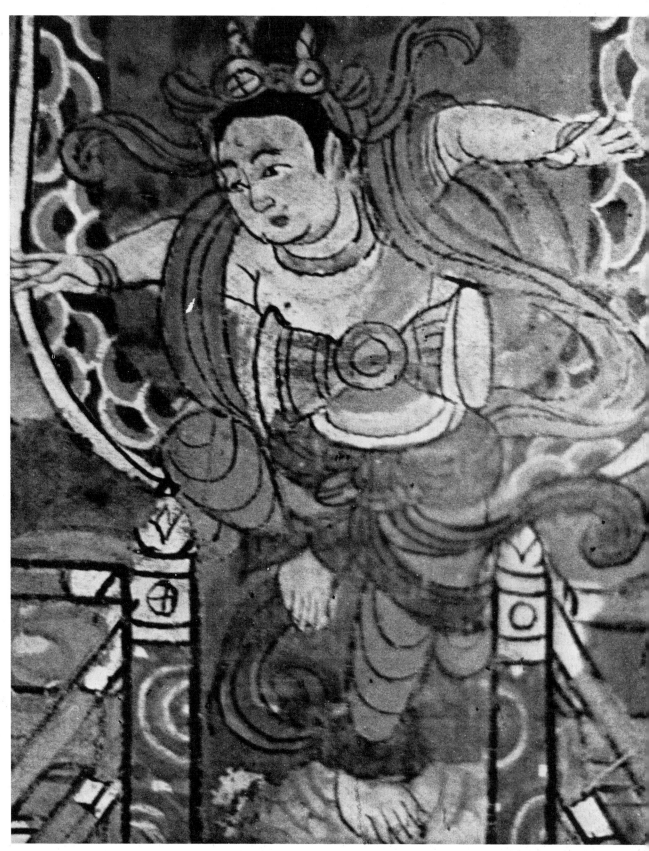

155 Dancer in the West Paradise (Detail of a Painting), Tang Dynasty (A.D. 618-907), Tun-Huang, Kansu, China (Collection of the Musee Guimet, Paris).

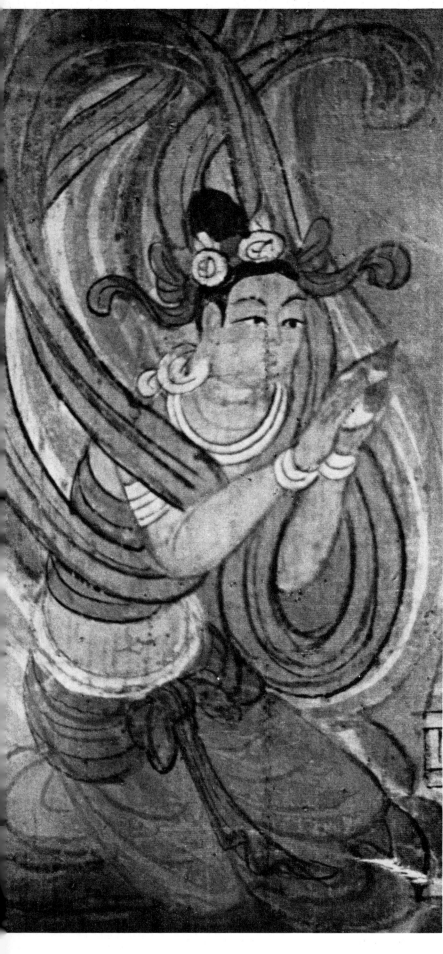

156 Worshipping Figure (Detail of a Painting), Tang Dynasty (A.D. 618-907), Tun-Huang, Kansu, China (Collection of the Musee Guimet, Paris).

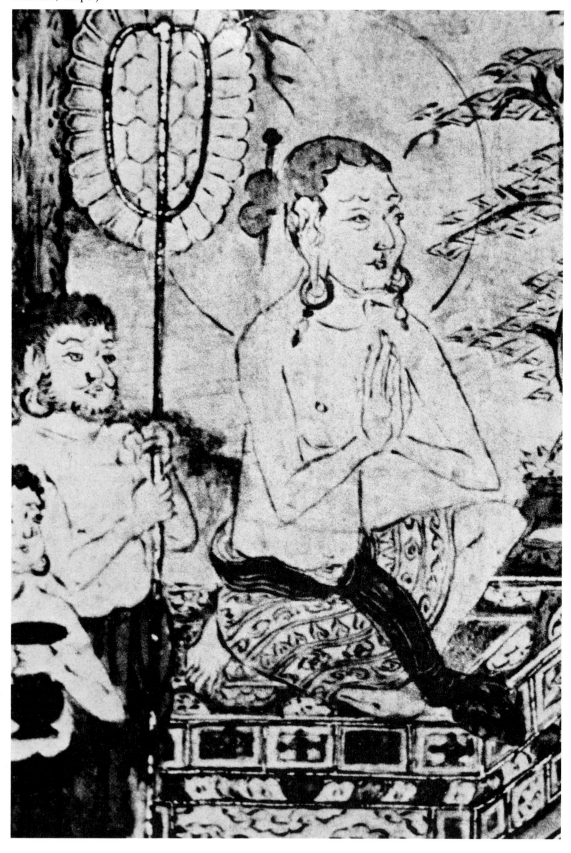

157 Worshipping Mo-Ho-Lo-Tso (A King of Nanchao-Modern Yunnan, Detail of a Painting), Sung Dynasty (A.D. 960-1278), China (Collection of the Chung-Shan Museum, Taipei).

Another foreign attribute of this wooden statue is its pronounced handlebar moustache, which is a feature often depicted on Tang funerary figurines (Plate 159).

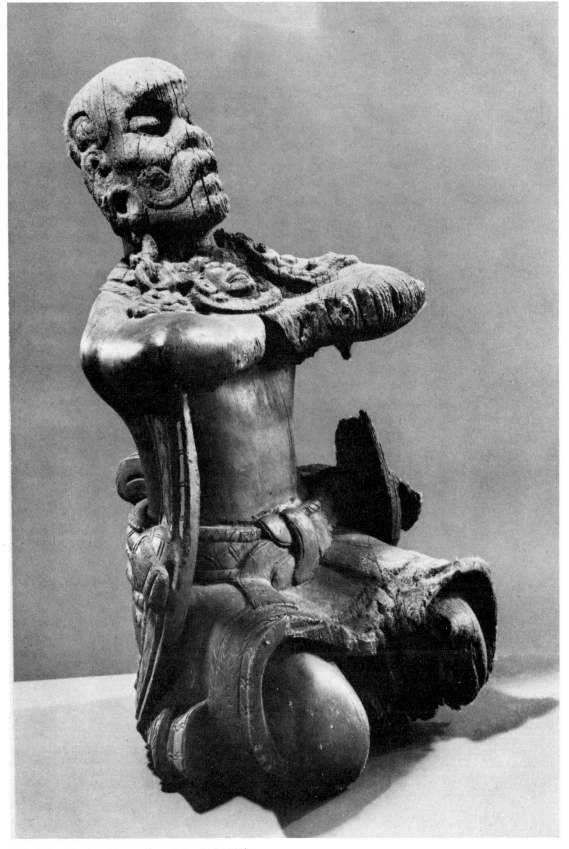

158 Worshipping Figure (ca. A.D. 600-1200), Tabasco, Mexico (Collection of the Museum of Primitive Art, New York City).

159 Figurine with Curled Moustache, Tang Dynasty (A.D. 618-907), China (Collection of Musee Cernuschi, Paris).

4. FIGURE STANDING ON FIGURE (PLATES 160-213)

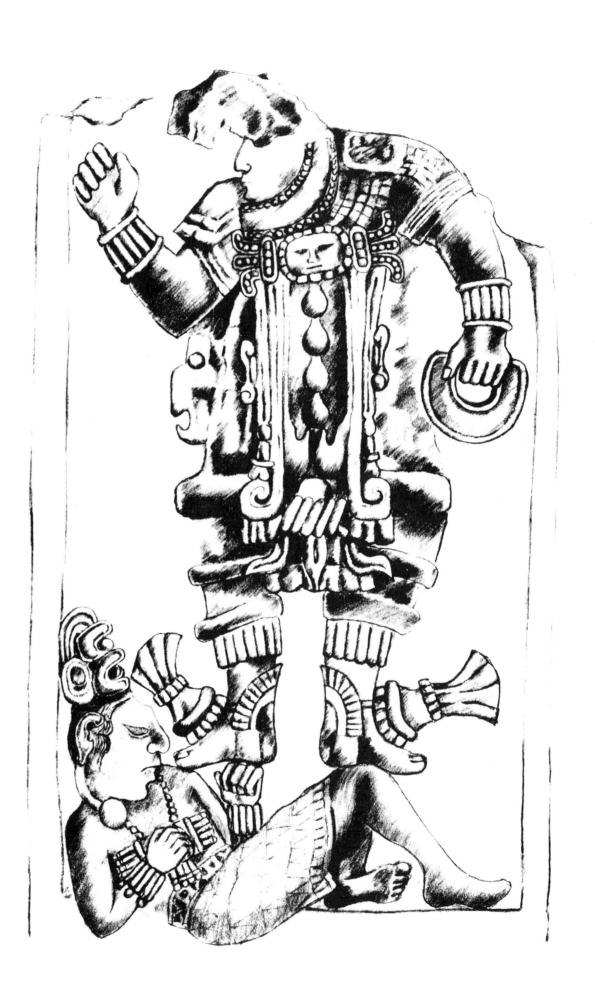

160, 161 Stela 7, Dated 9.15.10.0.0 (ca. A.D. 736),
Etzna, Campeche, Mexico (Courtesy of the
Peabody Museum, Harvard University).

In Plates 160 and 161, a priest or warrior, right hand raised and holding a perforated disk in the left hand, is standing on a half-reclining slave or demon who is facing up, his body partially supported by his forearms. Similar subject matters with almost identical postures are portrayed in Plate 162.

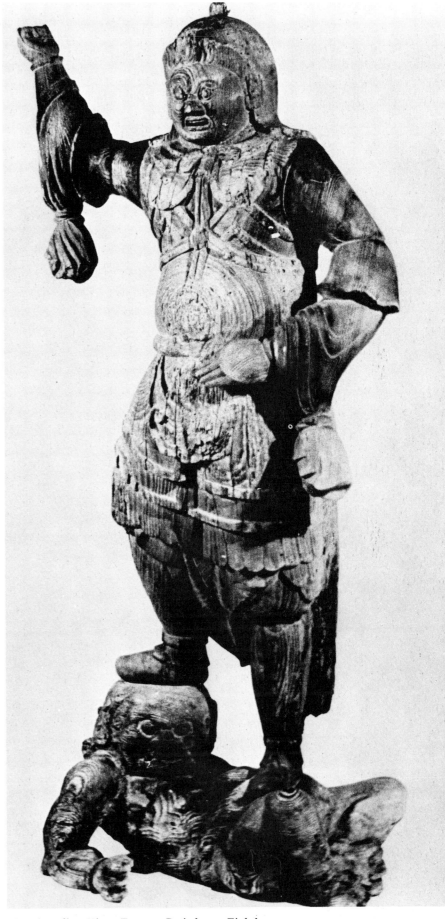

162 Guardian King, Tempyo Period, ca. Eighth Century A.D., Japan (Courtesy of the Fogg Art Museum, Harvard University).

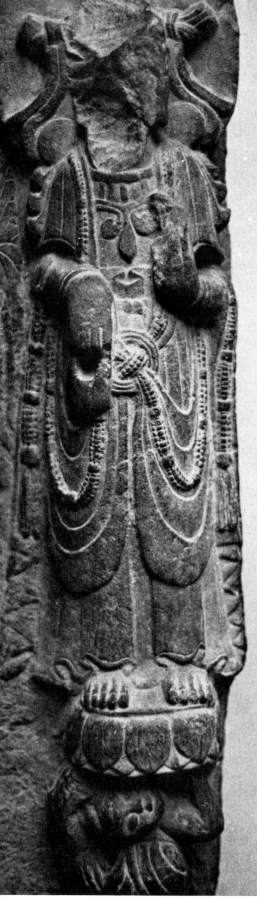

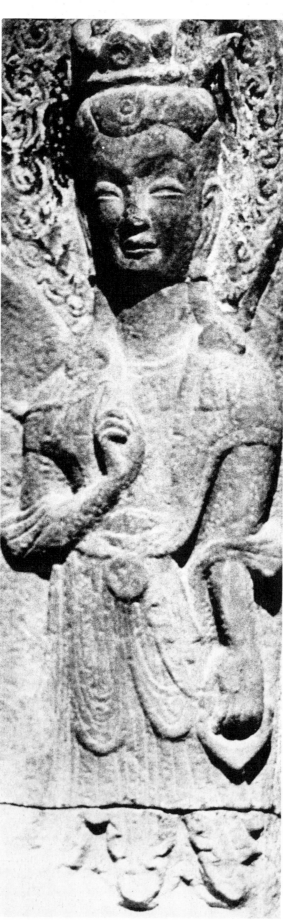

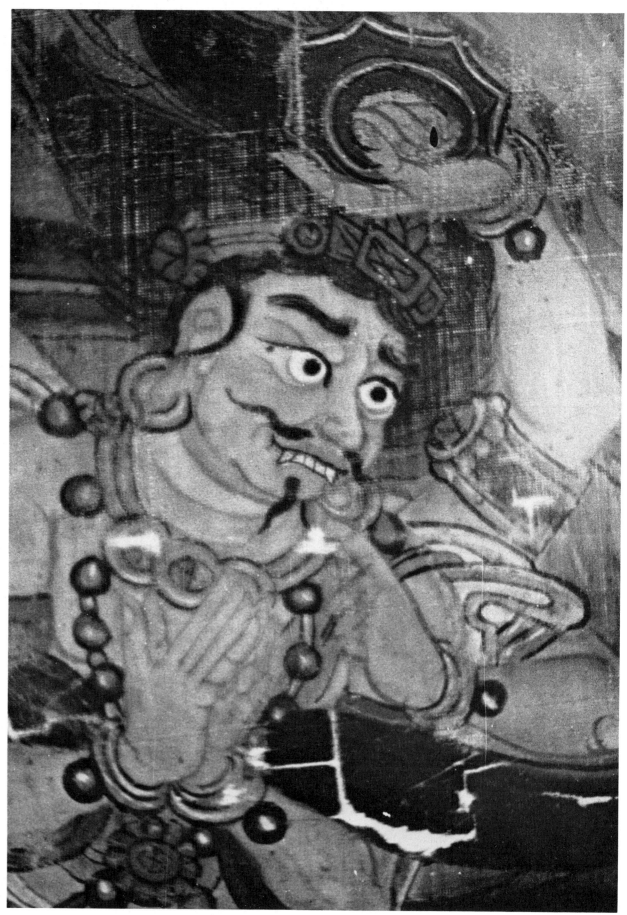

163 Attendant, ca. Sixth Century
A.D., China (Courtesy of the Smith-
sonian Institution, Freer Gallery of
Art, Washington, D.C.).

164 Buddha's Attendant, ca. Sixth
Century A.D., China.

165 Guardian King, Five Dynasty (Dated A.D. 943),
China (Collection of the Musee Guimet, Paris).

The perforated disk held in the left hand of the standing figure in Plate 161 is also a popular hand-held ceremonial object depicted in Buddhist artworks. It signifies the "Jewel of Buddha" (see Plates 249-252 for its relationship to the lotus flower). Plate 163 (right hand), Plate 164 (left hand), Plate 165 (upper left hand), and Plate 168 (left hand) are a few of the examples. A perforated disk almost identical to those in Plates 165 and 168 (note the ring around the perforation) can also be observed in Plate 167 (right hand).

The slaves or demons underneath the standing figures in Plates 166 and 167 were modeled in similar reclining posture—resting partially on the left arm with right arm raised and head facing upward.

166 Guardian King, Tang Dynasty (A.D. 618-907),
China (Collection of the University Museum, Philadelphia).

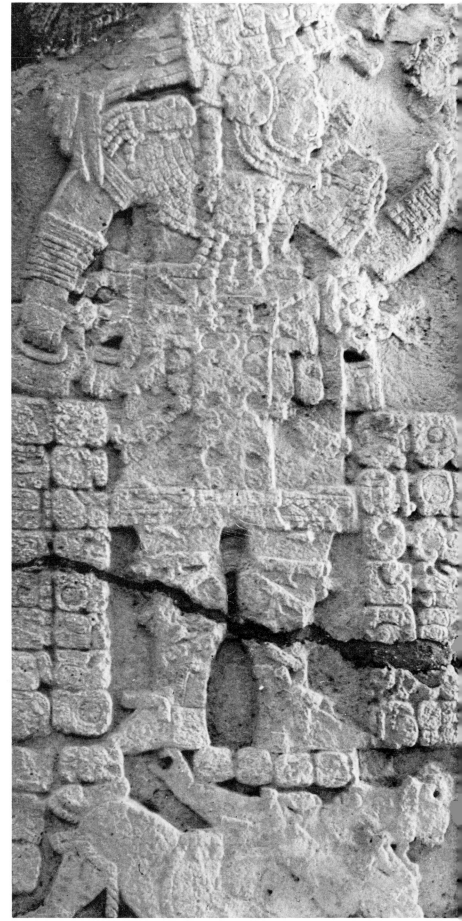

167 Stela 19, Dated 9.13.0.0.0 — 8 Ahau 7 Uo (A.D. 692), Etzna, Campeche, Mexico.

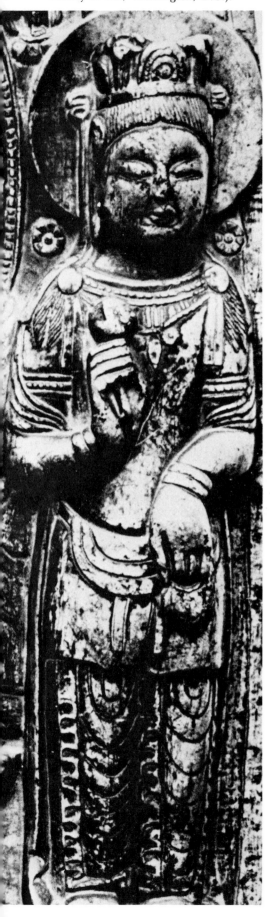

168 Attendant, ca. Sixth Century A.D., China, Detail of Plate 275 (Courtesy of the Smithsonian Institution, Freer Gallery of Art, Washington, D.C.).

169 Maori Wood-Carving, ca. Nineteenth Century A.D., New Zealand (Courtesy of the American Museum of Natural History).

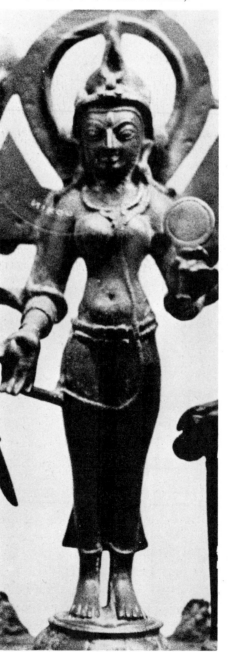

170 Buddha's Attendant, ca. Thirteenth Century A.D., India (Courtesy of the Victoria and Albert Museum).

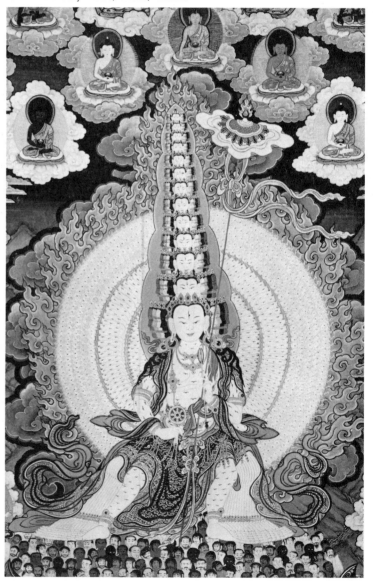

171 Thousand Headed Kuan-Yin, ca. Nineteenth Century A.D., Tibet, China.

In Plates 172-179 the figures are standing on the backs of slaves or demons who are in crouching positions. Note round fanlike object held in the left hand of the Mayan figure in Plate 172, which is also a common Buddhist ceremonial object. Compare it with the object held in the right hand of the figure in Plates 168, 169, 171 and in the left hand in Plate 170. Furthermore, the Mayan figure in Plate 172 holds a trident spear as does the Chinese figure in Plate 174 and the Japanese figure in Plate 181.

172 Stela 8, Dated 9.18.10.0.0 — 10 Ahau 8 Zac (Last Quarter of the Eighth Century A.D.), Naranjo, Peten, Guatemala.

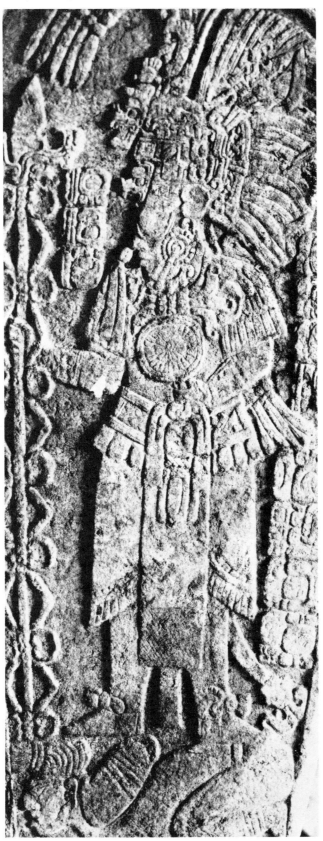

173 Guardian King of Heaven, Tang Dynasty (ca. A.D. 618-907), China, Detail of Plate 177 (Courtesy of the Museum of Fine Arts, Boston).

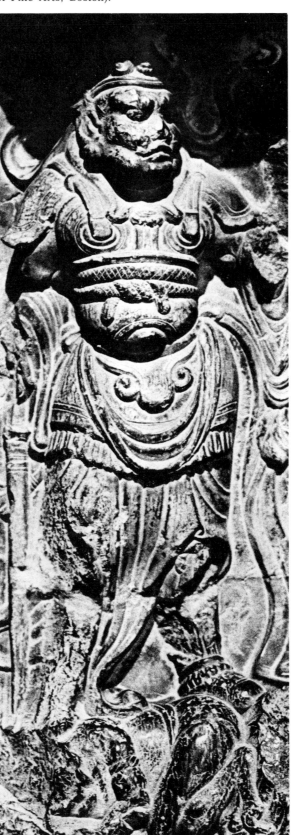

174 Guardian, ca. Sixth Century A.D., China (Detail of a Stone Stupa, on loan to the Metropolitan Museum of New York City by the Tribner family).

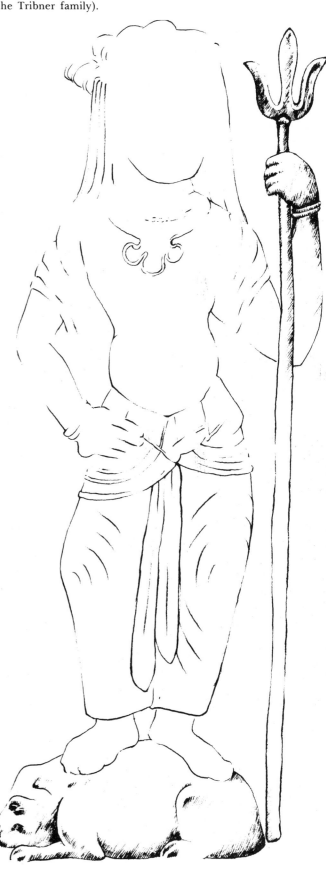

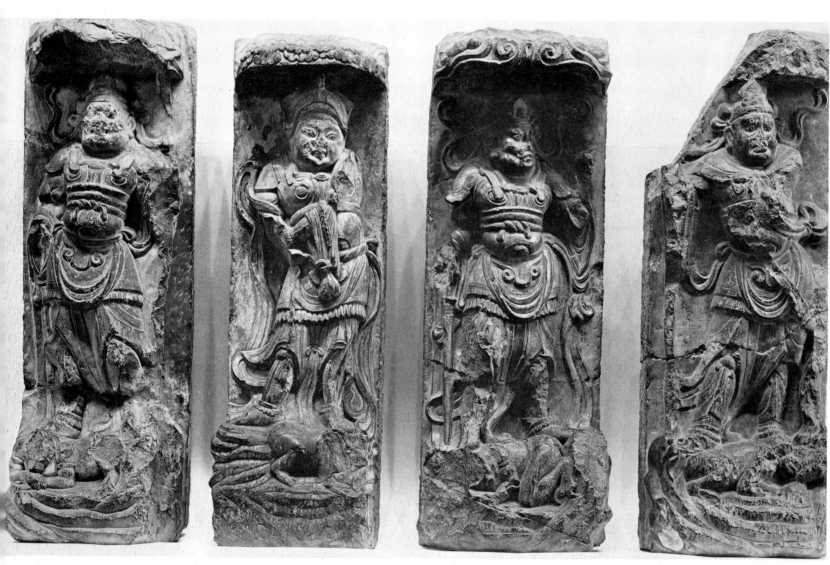

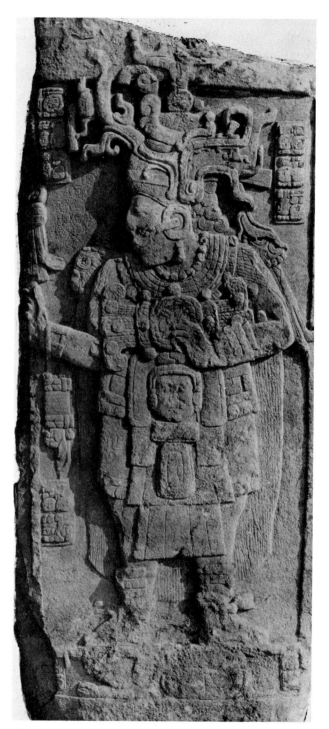

175, 176, 177, 178 The Four Guardian Kings of Heaven, Tang Dynasty (A.D. 618-907), China (Courtesy of the Museum of Fine Arts, Boston).

179 Stela 51, Dated 9.14.19.5.0—4 Ahau 18 Muan (ca. A.D. 731), Calakmul, Campeche, Mexico.

In Plates 181 and 182 the slave or demon underneath the principal figure is lying on its stomach, head facing the viewer. Note that both principal figures are decorated with a chinless animal mask on the stomach.

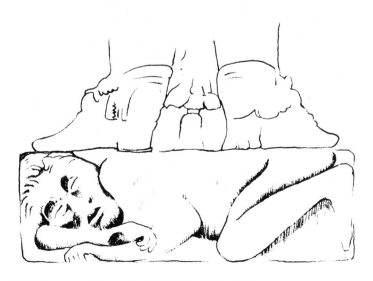

180 Demon or Slave, Stela 24 (See Plate 182).

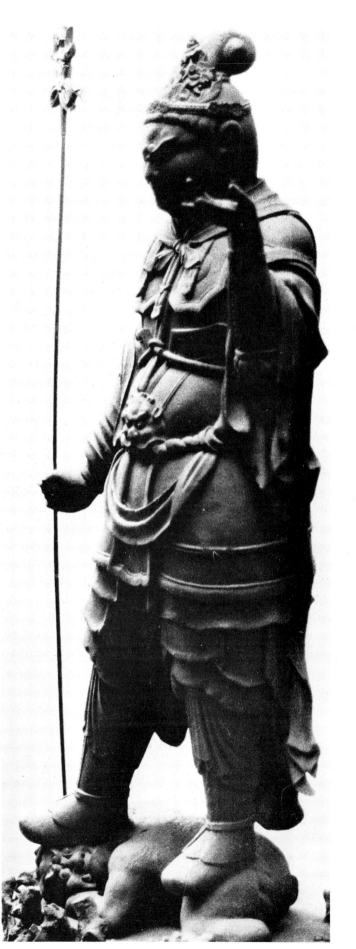

181 Guardian King, ca. Ninth Century A.D., Japan.

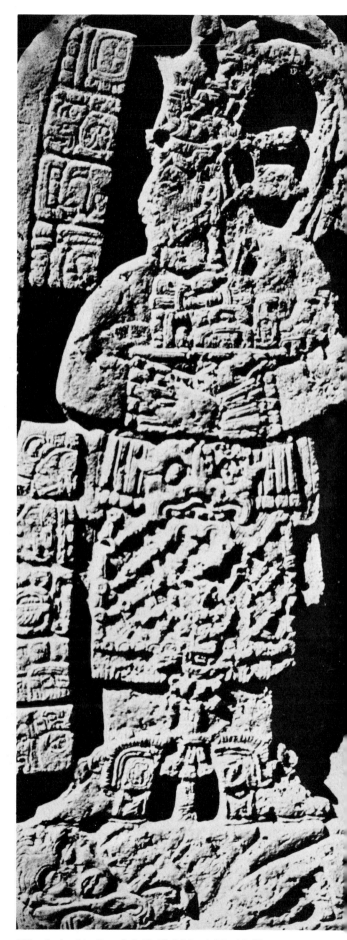

182 Stela 24, Dated 9.12.10.5.12—4 Eb 10 Yax (ca. A.D. 702), Naranjo, Peten, Guatemala.

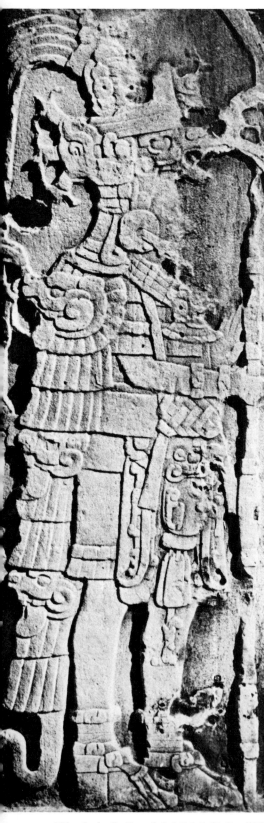

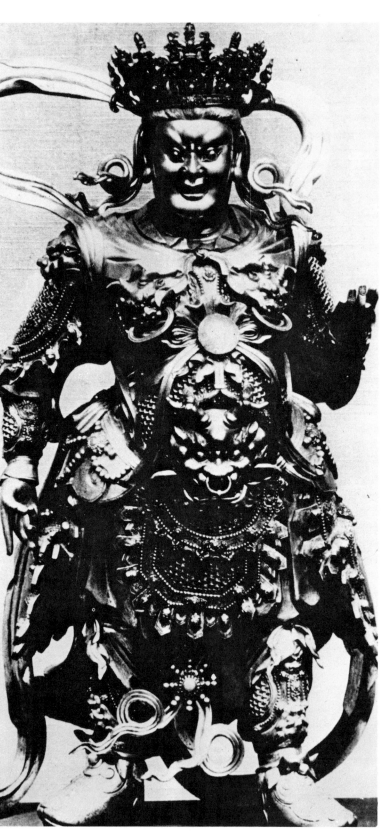

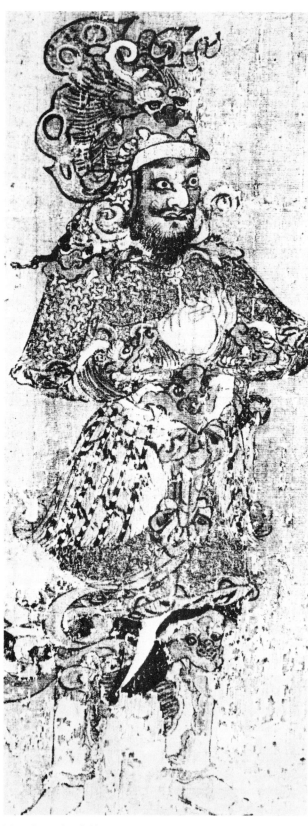

One of the attributes that characterized ancient Chinese martial attire was the extensive use of chinless monster masks (Plates 184 and 186). This custom first made its appearance in Chinese art works of the Shang Dynasty (ca. 1766-1154 B.C.) and was still in practice in the Ming Dynasty (A.D. 1368-1628). The chinless monster shoulder-guards of the Mayan warriors (Plates 183 and 188) resemble closely those of the Chinese (Plates 184, 186, and 189), as does the chinless monster-head headdresses (Plates 185-188). The slave underneath the Mayan warrior is lying flat, face down, with hair folding forward covering the head (Plates 187 and 188); its counterparts underneath the three figures in Plate 190 show a similar attribute.

183 Stela 9, Dated 9.2.0.0.0 (A.D. 475), Tikal, Peten, Guatemala.

184 Guardian King, Ming Dynasty, ca. Fourteenth Century A.D., China (Collection of the Seattle Art Museum).

185 Portrait of Chang Sun Sung—A General of Early Northern Wei Dynasty, During the Reign of Ming-Yuan Emperor (A.D. 409-424), Attributed to Chen Hung of Tang Dynasty (ca. A.D. 730), China, See Plate 10 (Collection of the Nelson Gallery and Atkins Museum of Fine Arts, Kansas City).

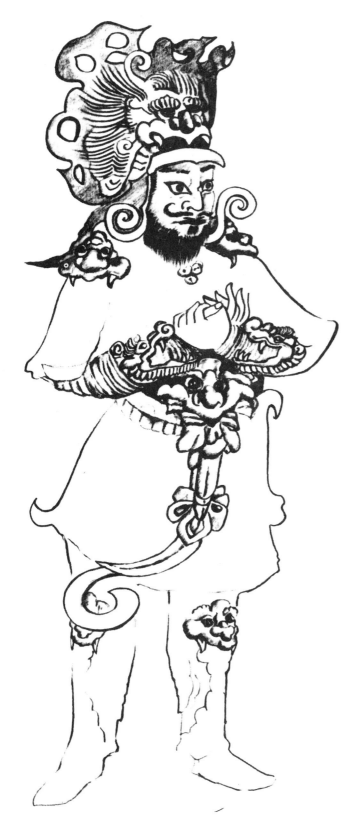

186 Portrait of Chang Sun Sung with Irrelevant Details Deleted.

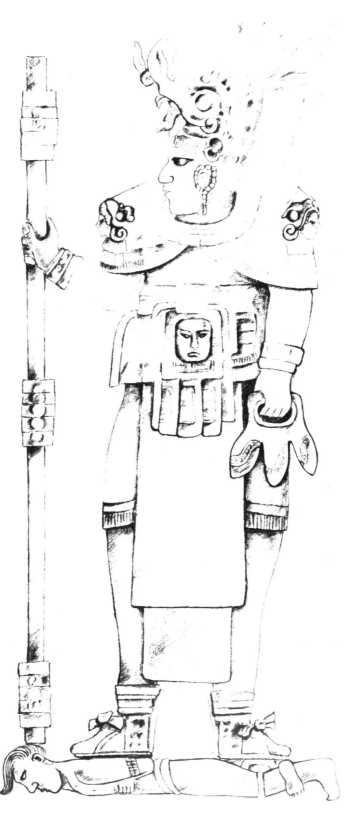

187 Stela 30 with Irrelevant Details Deleted.

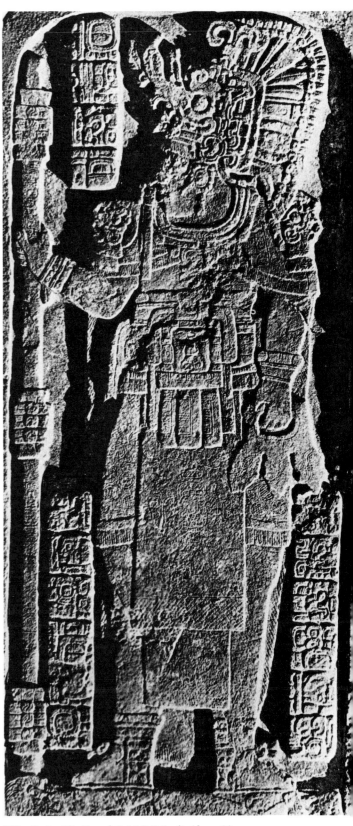

188 Stela 30, Dated 9.14.3.0.0—7 Ahau 18 Kankin (ca. A.D. 711), Naranjo, Peten, Guatemala.

189 Guardian King of Heaven, ca. Tenth Century A.D., China (Courtesy of the American Museum of Natural History).

190 Guardian Kings of Heaven, ca. Nineteenth Century A.D., Tibet (Courtesy American Museum of Natural History).

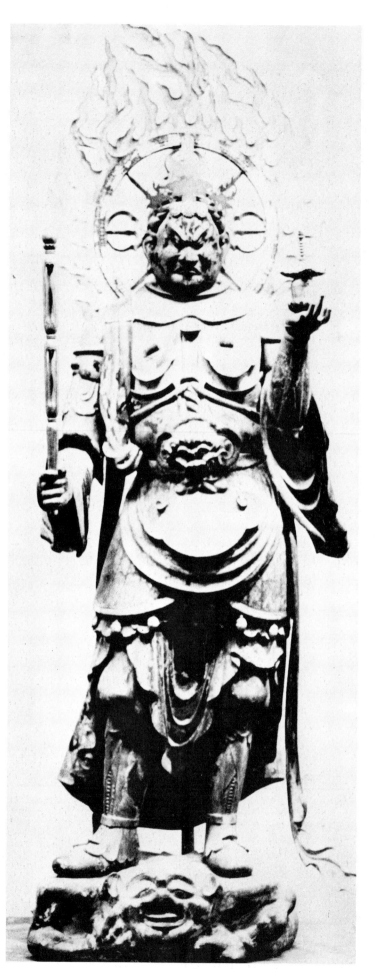

191 Guardian King of Heaven, ca. Ninth Century A.D., Japan.

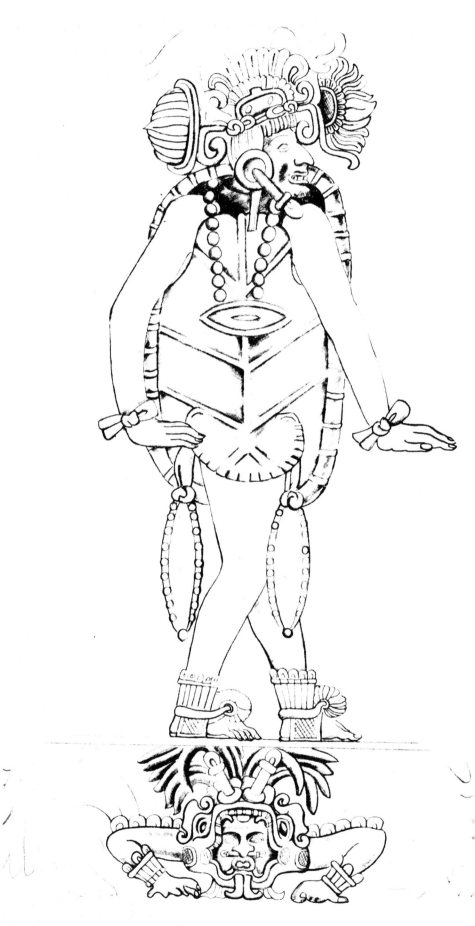

192 Stone Relief, Temple of the Jaguars, with Irrelevant Elements Deleted.

193 Stone Relief, Temple of the Jaguars, Dated Post-classic Period (ca. A.D. 1000-1300), Chichen Itza, Yucatan, Mexico.

Plates 191-195 depict kings or warriors standing on top of anthropomorphic creatures in frontal, "push-up" positions.

194 King of the Yakshas, Sunga Period, ca. First Century B.C., Bharhut, India.

195 Column, Temple of the Warrior, (ca. A.D. 1000-1300), Chichen Itza, Yucatan, Mexico.

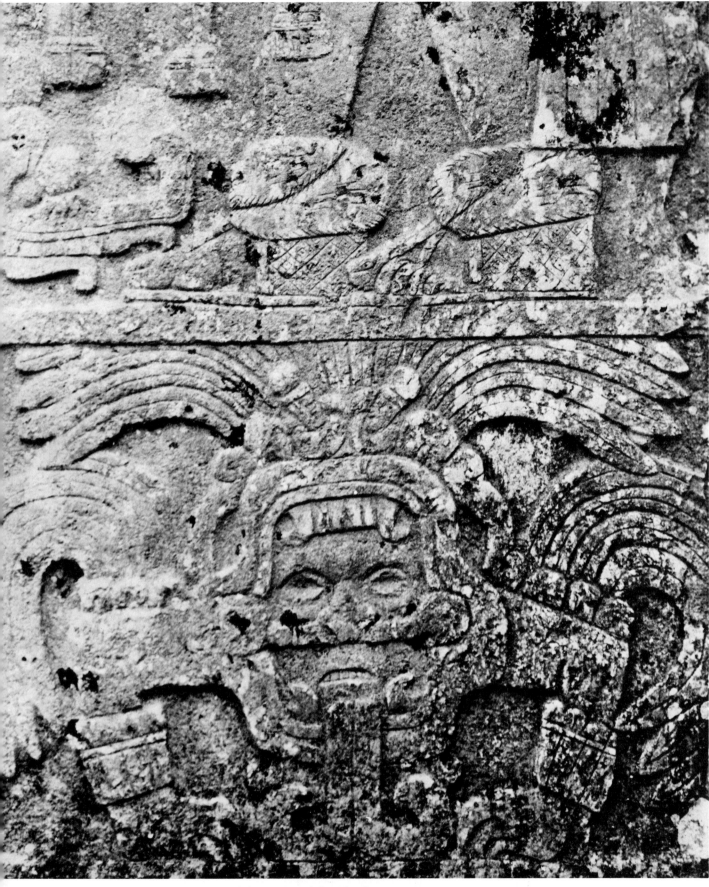

196 The Great Ball Court, Column, Dated Postclassic
Period (ca. A.D. 1000-1300), Chichen Itza, Yucatan,
Mexico.

197 Rubbing From a Stone Panel, Han
Dynasty, ca. Second Century A.D., I-Nan,
Shantung, China.

The anthropomorphic creatures in frontal "push-up" positions were often represented with a large double-hooked tongue in Meso-America (Plates 195 and 196) as well as in China (Plate 199). These creatures also often bear attributes of birds, portrayed with wings or feathers (Plates 196-199). In addition, Plates 192, 193, 195, and 196 depict the hands of this creature with claws and the head of the creature being inside the wide open mouth of a feline. Plate 197 portrays a similar creature—with claws and an unusually large mouth.

198 Rubbing From a Stone Panel, Han Dynasty, ca. First Century A.D., Shantung, China.

199 Rubbing From a Sarcophagus, Han Dynasty, ca. First Century A.D., Szechuan, China.

200 Column, Dated Late Classic Period (ca. A.D. 850), Glyphic Lintel Building, Xcochkax, Puuc, Mexico.

201 Guardian King of Heaven, Tang Dynasty (A.D. 618-907), China (Courtesy of the Museum of Fine Arts, Boston).

202 Durga, ca. Seventh Century A.D., Pallua, India (Courtesy of the Museum of Fine Arts, Boston).

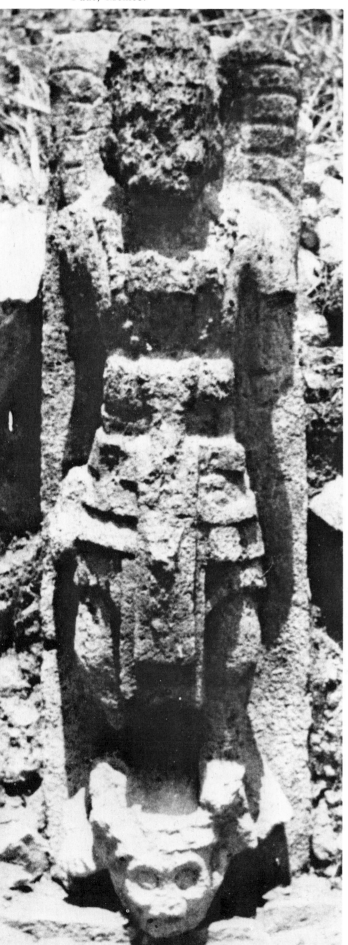

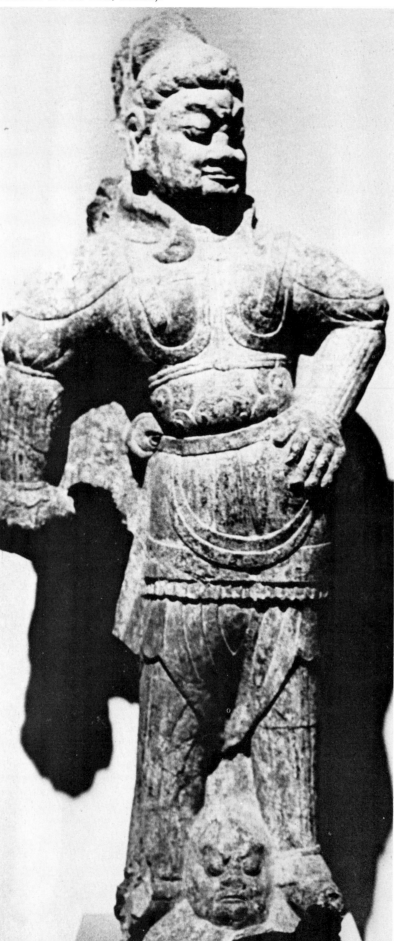

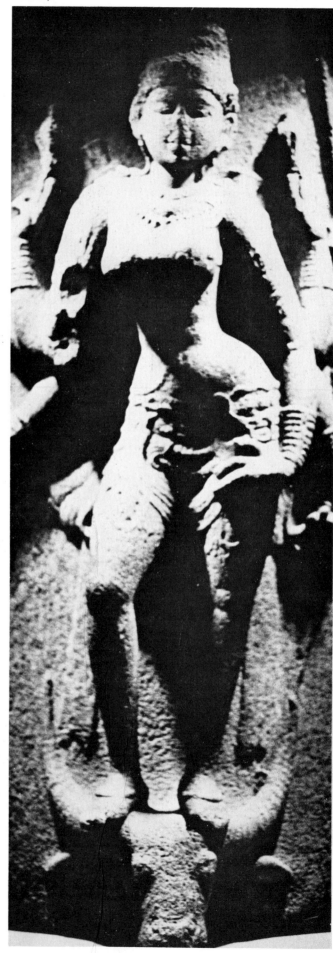

The principal figures in Plates 200-208 were all placed above the heads of monsters.

203 Maori Wood-Carving, Early Twentieth Century A.D., New Zealand (Courtesy of the American Museum of Natural History).

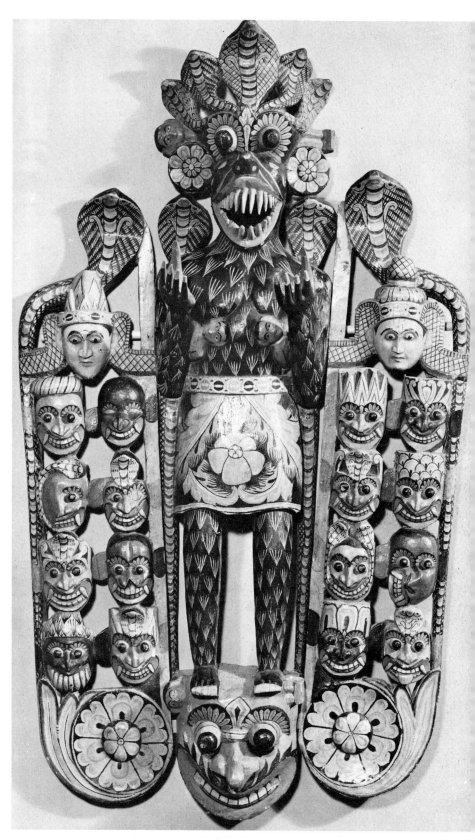

204 Wood-Carving, Early Twentieth Century A.D., Point de Calle, Ceylon (Courtesy of the American Museum of Natural History).

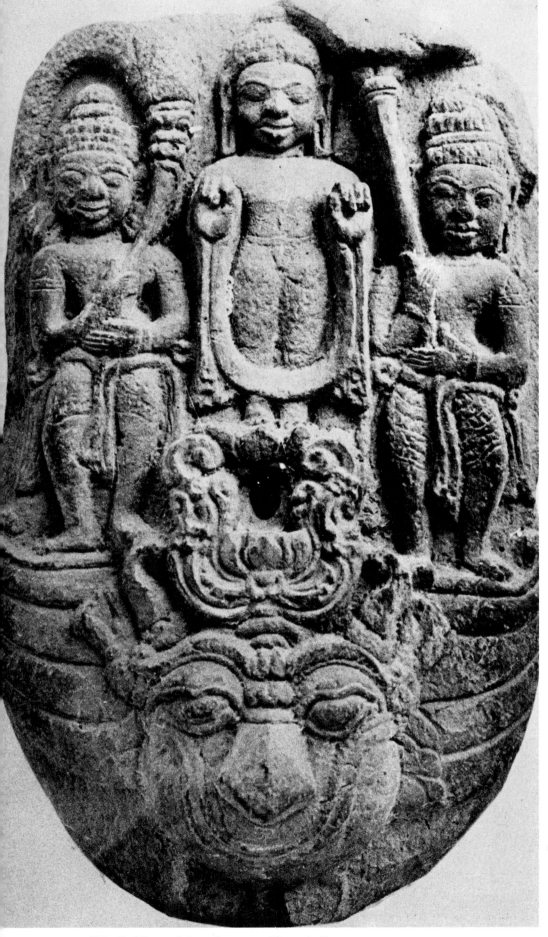

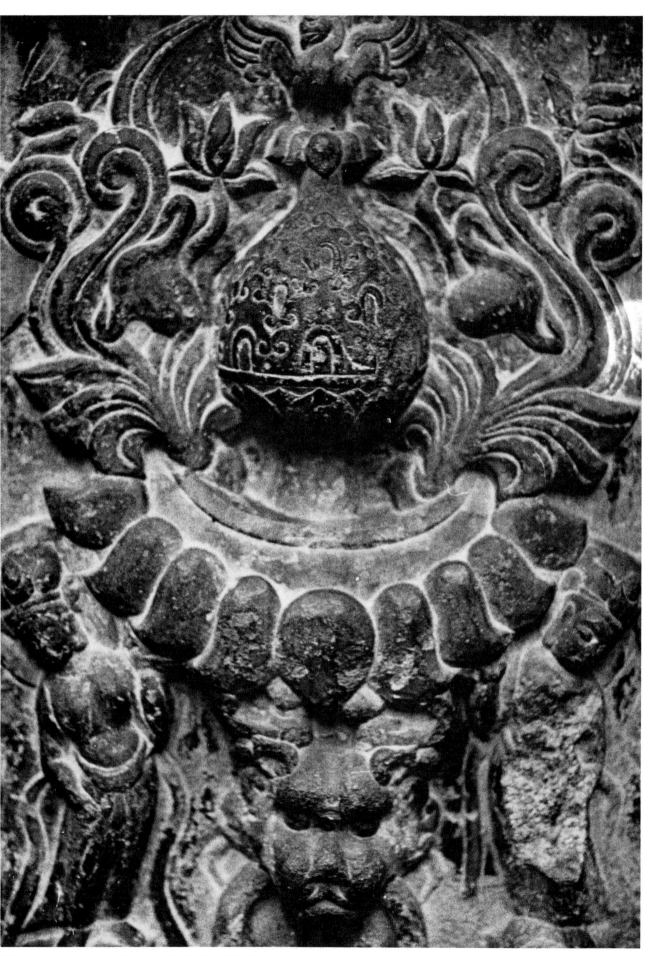

205 Buddha and Attendants, ca. Eleventh Century
A.D., Cambodia.

206 Stone Relief, Sui Dynasty (A.D. 581-618), China.

The anthropomorphic plants in Plates 206 and 207 are both crowned with a flower on which a bird perches. Underneath the plants is a monster mask with a vinelike element coming out from both corners of the mouth. Plate 208, bottom, shows a similar mask.

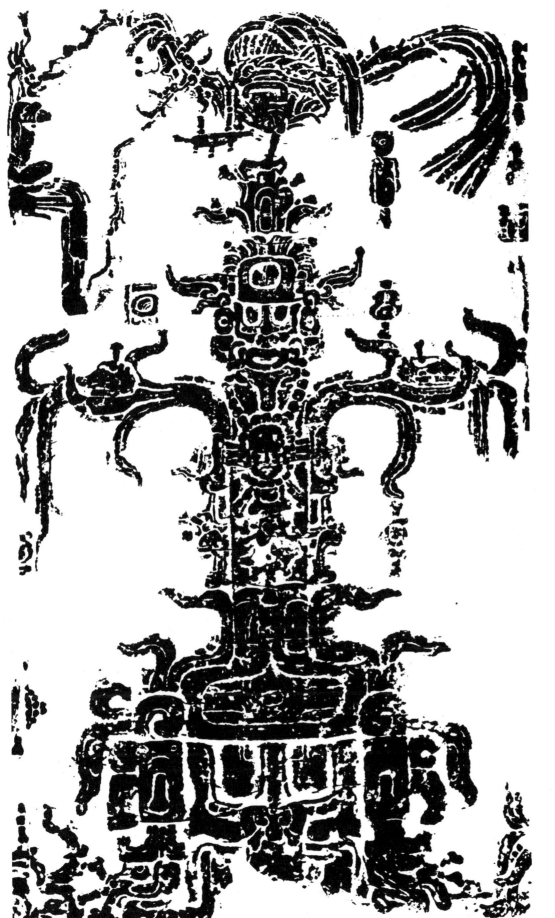

207 Rubbing from the Temple of the Foliated Cross, Classic Period (ca. A.D. 700), Palenque, Chiapas, Mexico.

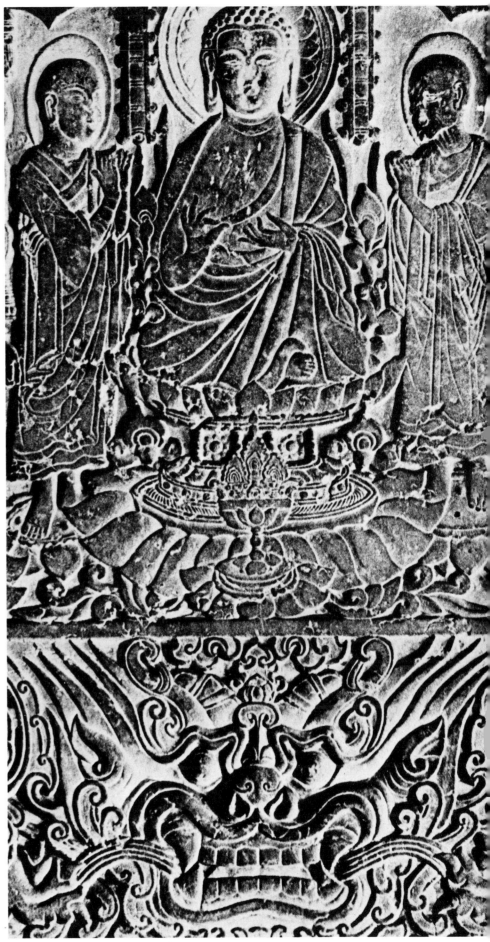

208 Stone Relief, Tang Dynasty (A.D. 618-907), China (Collection of the Art Institute of Chicago).

In both Meso-America and ancient China the beard of the monster mask was sometimes stylized in the form of a flower (Plates 209, 210, 211, 212, and 213 bottom).

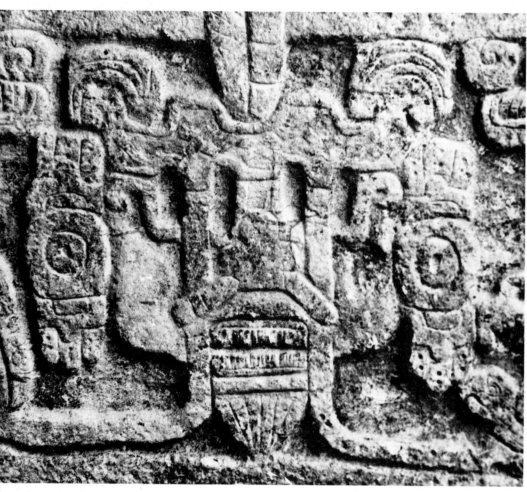

209, 210 Stylized Mask, Temple of the Jaguars,
Dated Postclassic Period (ca. A.D. 1000-1300),
Chichen Itza, Yucatan, Mexico.

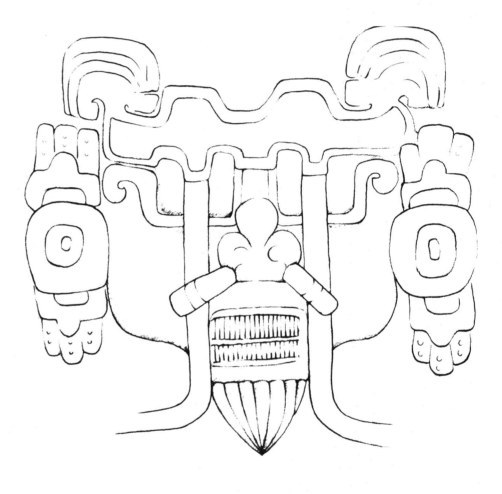

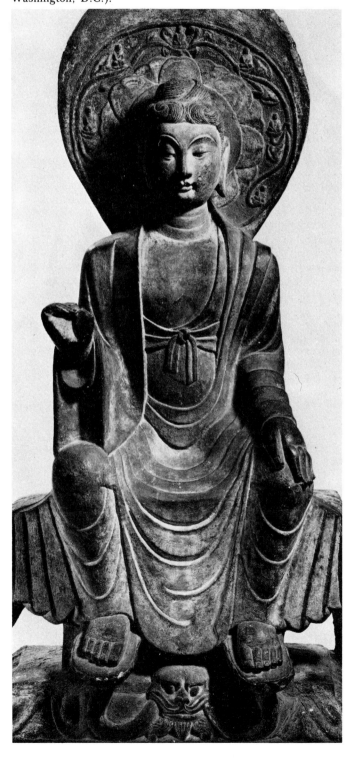

211 Bodhisattva, Tang Dynasty (A.D. 618-907), China (Courtesy of the Smithsonian Institution, Freer Gallery of Art, Washington, D.C.).

212 Human Headed Monster (Detail), Tang Dynasty (A.D. 618-907), China (Collection of the British Museum, London).

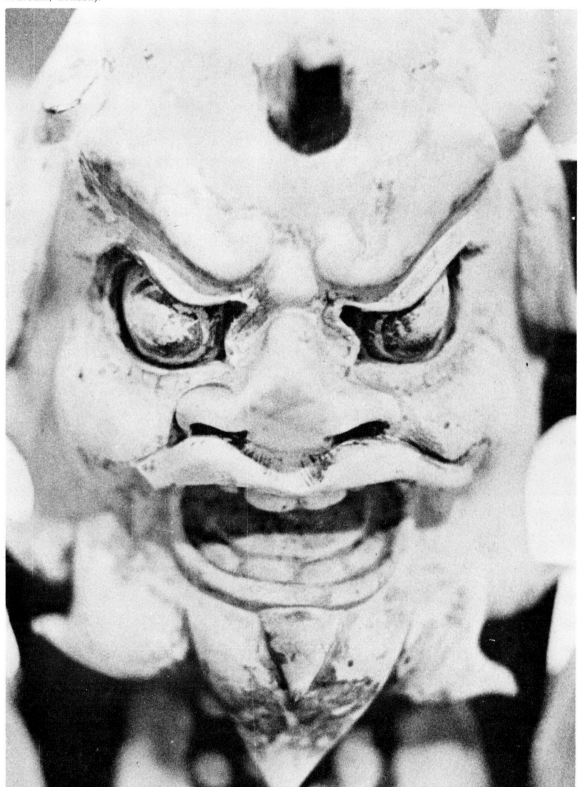

213 Stela E, Dated 9.17.0.0.0 — 13 Ahau 18 Cumhu (A.D. 771), Quirigua, Guatemala.

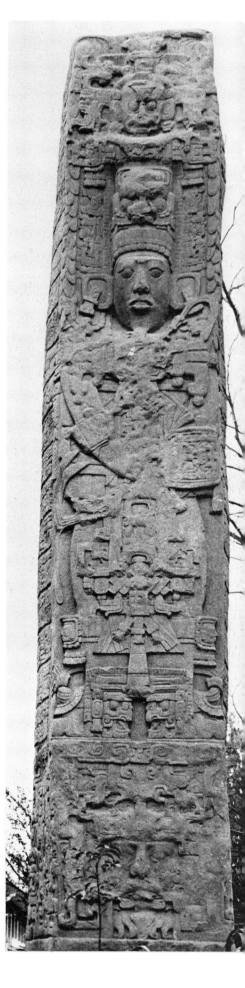

214 Asian Elephant.

Chac, the Mayan Rain God of the four quarters, is one of the most often depicted deities in Meso-American sculptures. It has been variously identified by Mayan scholars as the Long-Nose God, the God B, the Serpent Bird—Kukulcan or the Aztec Quetzalcoatl. Among the attributes of this god are the long nose, the long tusk at the corner of the mouth (see Plates 235-238), and the spiral marking in the eye. This Chac head I found on Stela C at Copan (Plate 215) is unusual in that it was represented as emerging from the mouth of an animal having two *huge wavy ears,* a feature not found in Mayan representation of an animal head in any other site. The nose of the animal was broken. Two curled tusks can be observed protruding from the mouth of Chac.

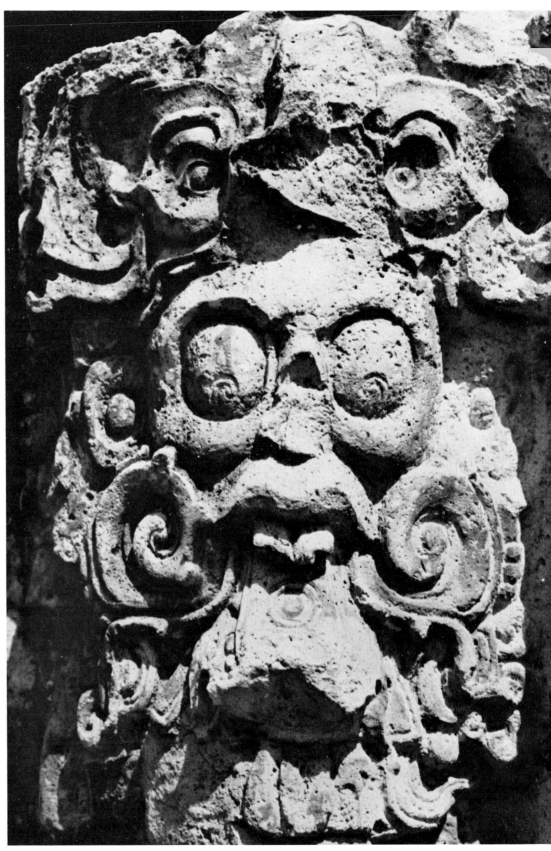

215 Head with Curled Tusks, Wearing an Elephant-like Headdress, Stela C (Detail), Dated 9.17.12.0.0—4 Ahau 18 Muan (A.D. 782), Copan, Honduras.

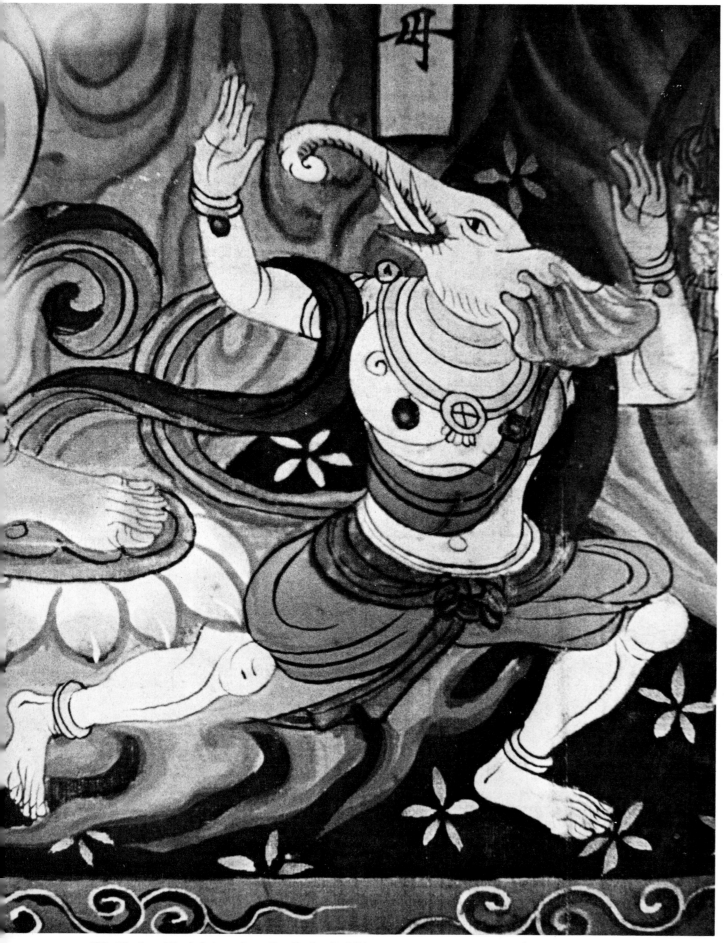

216 Elephant-Headed Attendant, Detail of a Buddhist Painting, Tang Dynasty (A.D. 618-907), Tun-Huang, China (Collection of the Musee Guimet, Paris).

In front of the hieroglyphic stairway at Copan I noticed another representation of this large-eared animal, this time complete with tusks (Plates 217, 219, and 220). Its nose is also broken, an indication that it once may have had a long, protruding snout. Plate 218 is a twelfth century Japanese representation of a Buddhist disciple after the Tang (A.D. 618-907) Tun-Huang prototype (notice the three tusks at the corner of the elephant's mouth in Plate 216 and Plate 218). The disciple is depicted in a typical oriental worshipping posture: with feet positioned apart forming a wide V and the two arms held horizontally in front of the breast. In addition to the elephantlike animal headdress, the standing figures in Plate 217 were modeled with almost identical ceremonial posture.

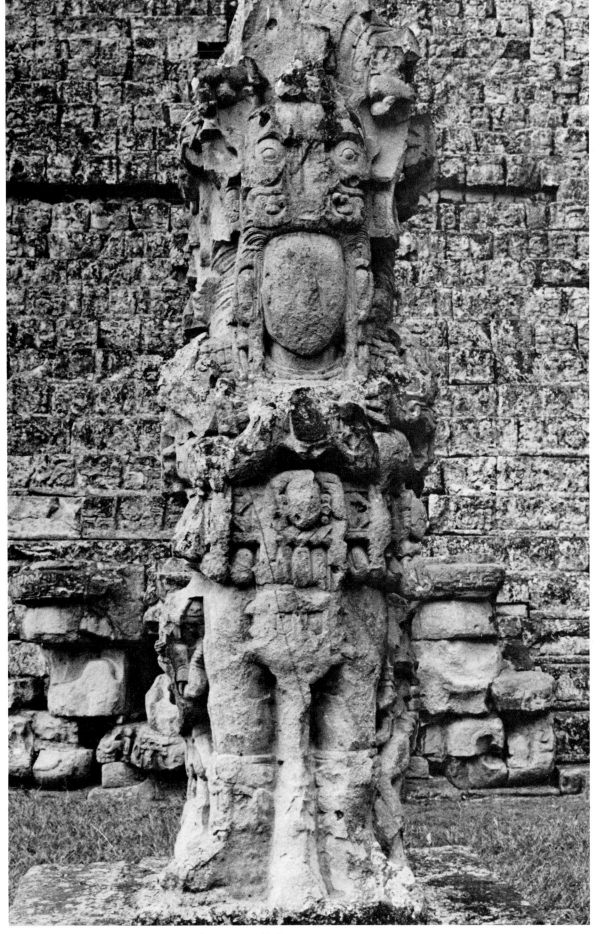

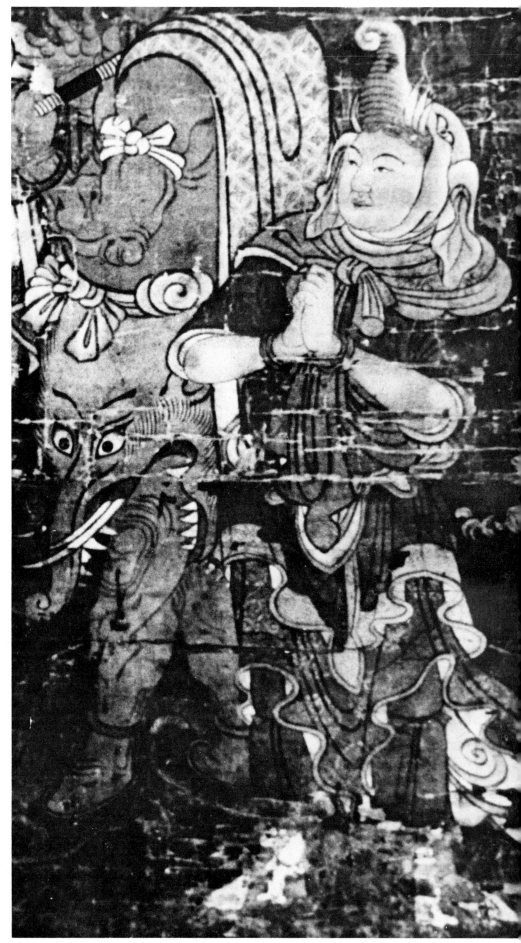

217 Stela M, Dated 9.16.5.0.0—8 Ahau 8 Zotz (A.D. 756), Copan, Honduras.

218 Yaksa with Elephant-Headdress (One of the Five Attendants of Bishamonten Mandara), Kamakura Period (ca. A.D. 1200), Japan (Courtesy of the Museum of Fine Arts, Boston).

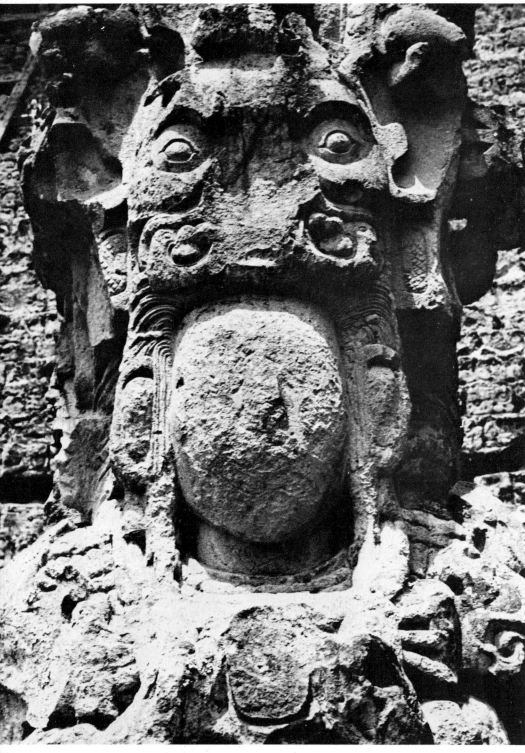

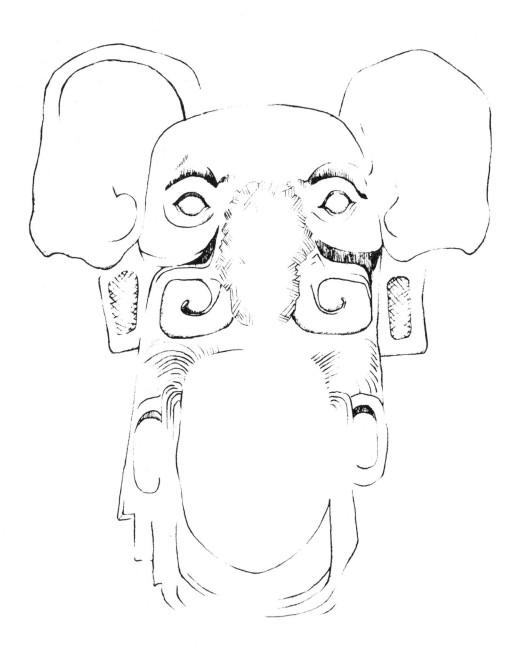

219, 220 Elephant-Headdress with Curled Tusks, and
Large Ears, Stela M (Detail), Dated A.D. 756, Copan,
Honduras (See Plate 217).

The curled element at the corner of Chac's mouth (Plate 221) is an attribute traceable to the elephantlike animal headdress (Plates 219 and 220).

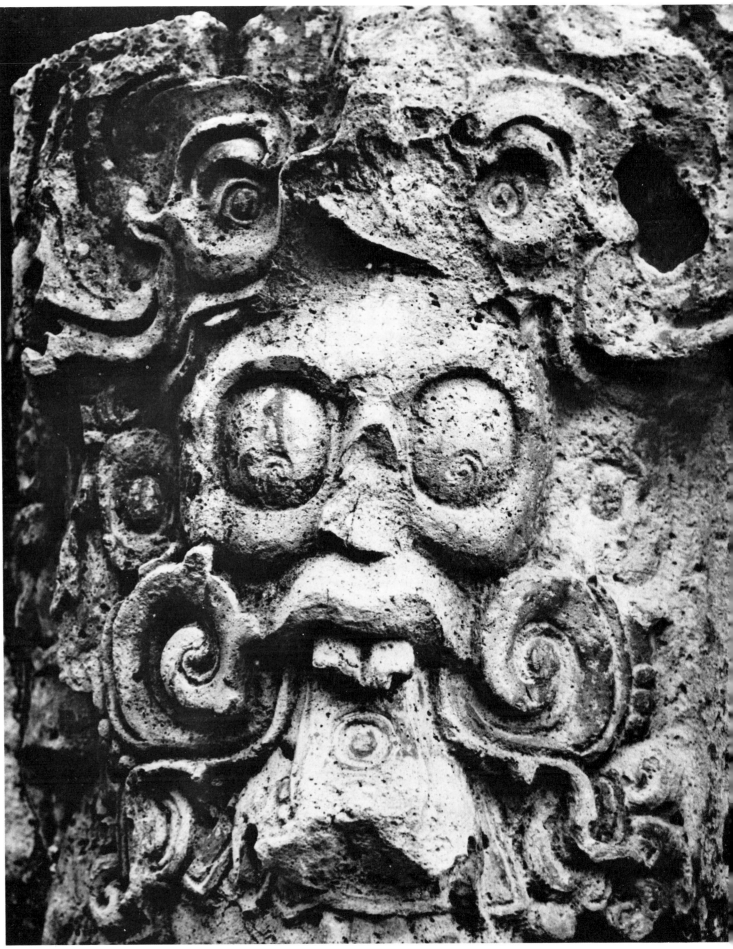

221 Head with Curled Tusks, Wearing an Elephant-like Headdress, Stela C (Detail), Dated 9.17.12.0.0 — 4 Ahau 18 Muan (A.D. 782), Copan, Honduras.

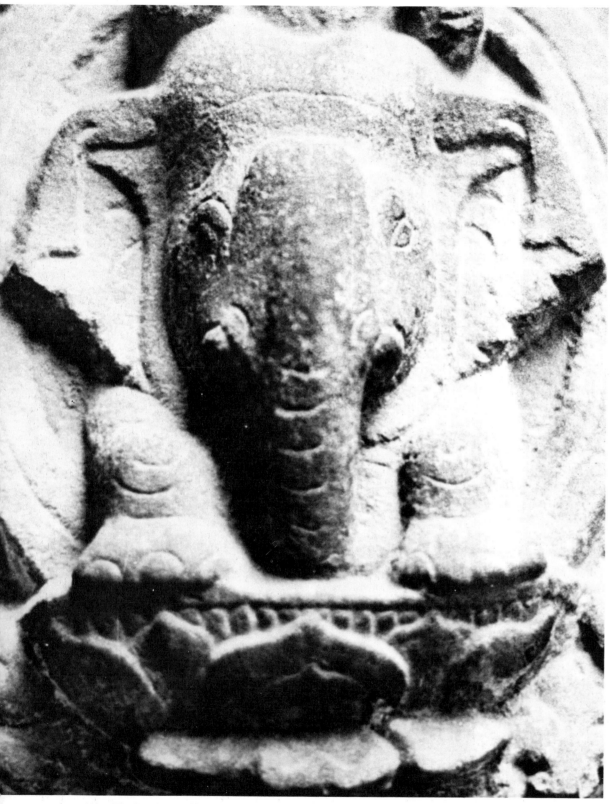

222 Elephant, Standing on a Lotus Flower, ca. Thirteenth Century A.D., Cambodia.

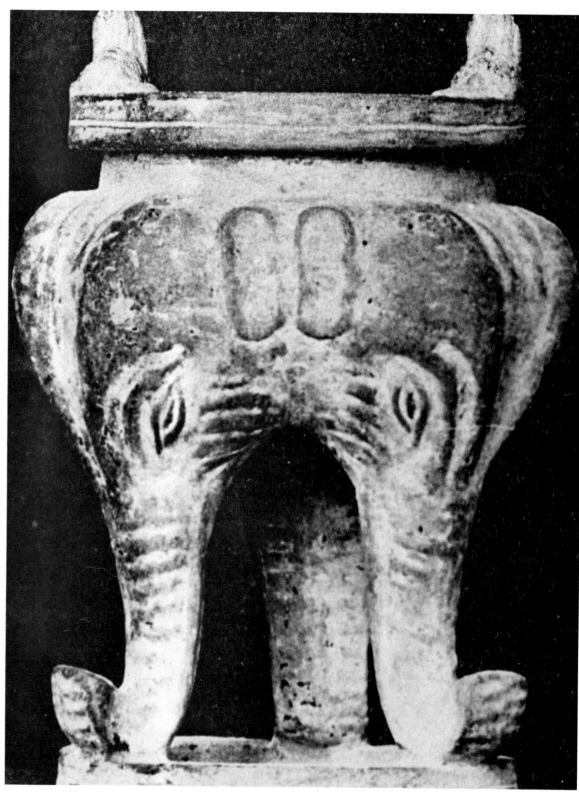

223 Tripod Vessel in the Form of Elephant Heads, Tang Dynasty (A.D. 618-907), China (Courtesy of the Victoria and Albert Museum).

Another Asiatic motif, two joined heads with long snouts facing opposite directions (Plate 223, top of Plate 225, and Plate 226), also occurred at Copan, Honduras. On the upper portion of Plate 224, this motif can be observed perching on top of the principal Mayan figure. Also noteworthy is the fact that the arms and lower legs of both principal figures in Plates 224 and 225 were decorated with animal heads with large, oval-shaped eyes.

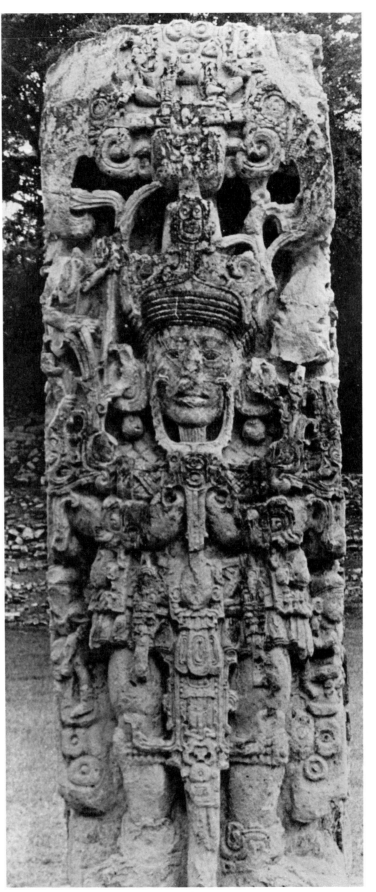

224 Stela B, Dated 9.15.0.0.0—4 Ahau 13 Yax (A.D. 731), Copan, Honduras.

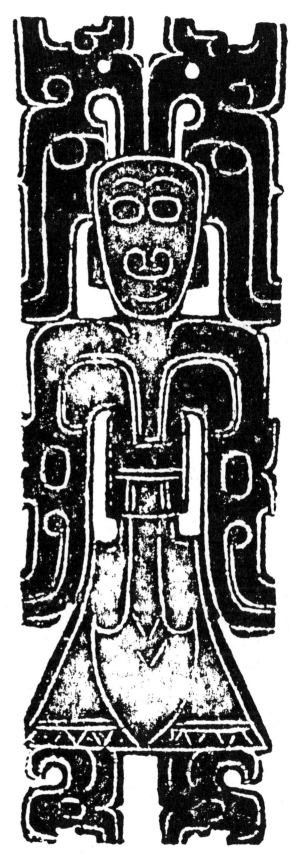

225 Jade Pendant (Rubbing), Warring State Period (403-221 B.C.), China (After *Wen-Wu,* No. 7, 1959, P. 65, Courtesy of the People's Republic of China).

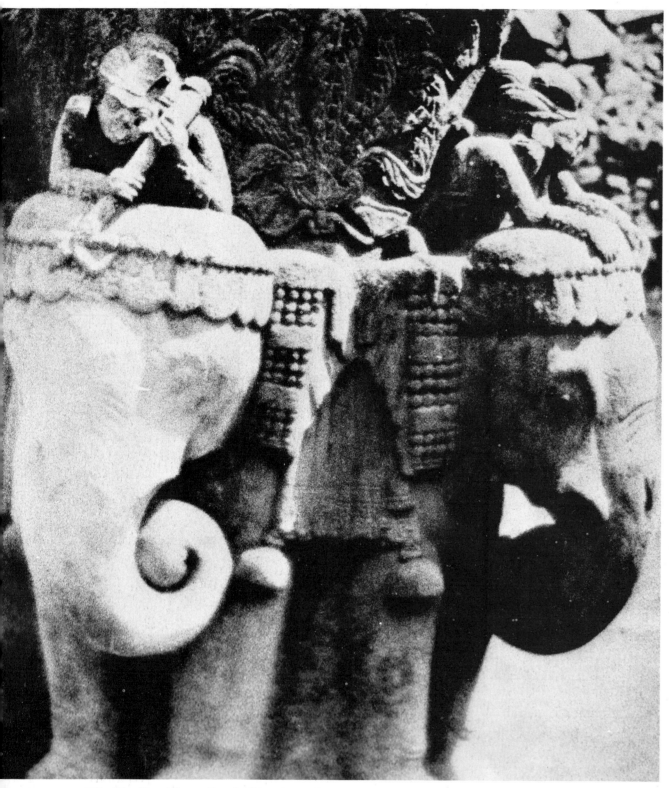

226 The Great Stupa (Detail of North Gate), Early Andhra Period (First Century B.C.), Sanci, India.

When the great English archaeologist Alfred Maudslay conducted the first intensive study of Copan in 1885, the upper left corner of Stela B was relatively intact (see Maudslay, *Biologia Centrali Americana,* Plate Volume 1, Plate 34). Today there is a large cavity there. Since we know this Stela has never fallen down and since we know of no stone-boring insects nor stone-pecking birds in Central America, it would be interesting to find out exactly what happened to it. Disfigurement of this kind is not confined to Mayan artifacts. Quite a number of Olmec monuments and sculptures from La Venta and San Lorenzo (now at Museum Park, Villahermosa, and at the University of Veracruz, Jalapa) seem to have shared the same fate. Plate 227 is based on Maudslay's Plate Volume 1, Plate 34. The long, inward-curling snouts, the contours of the foreheads and the turbanned squatting figures next to them, resemble strikingly the pair of elephants depicted on the north gate of the Great Stupa, Sanci, India (Plate 226). Note that the cross-hatched markings on the snouts of Stela B also occurred on Stela M (Plates 219 and 220, next to the curled tusks). These markings could be a symbolic expression of skin texture. Careful examination of Plate 214 will show that the giant creature is textured all over with cross-hatched lines.

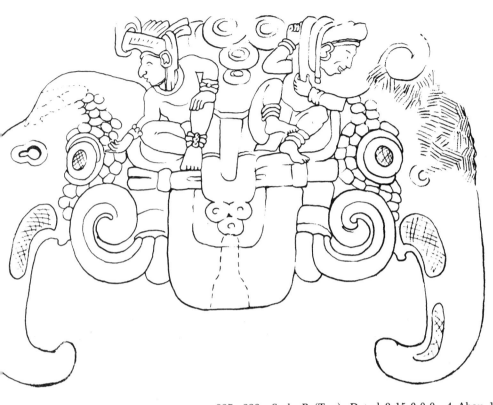

227, 228 Stela B (Top), Dated 9.15.0.0.0—4 Ahau 13
Yaz (A.D. 731), Copan, Honduras.

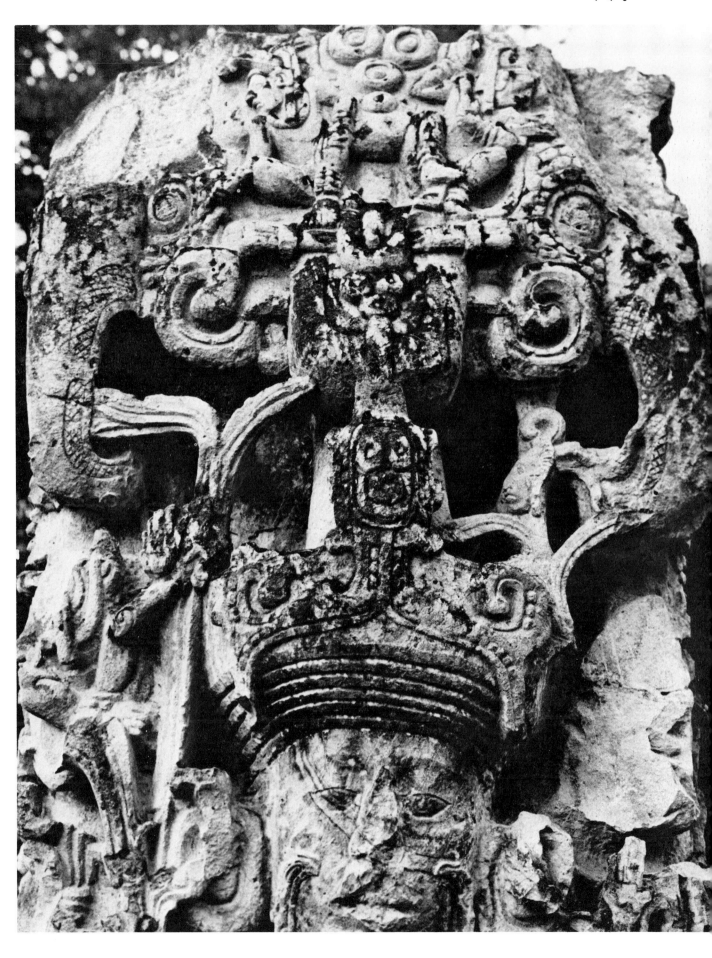

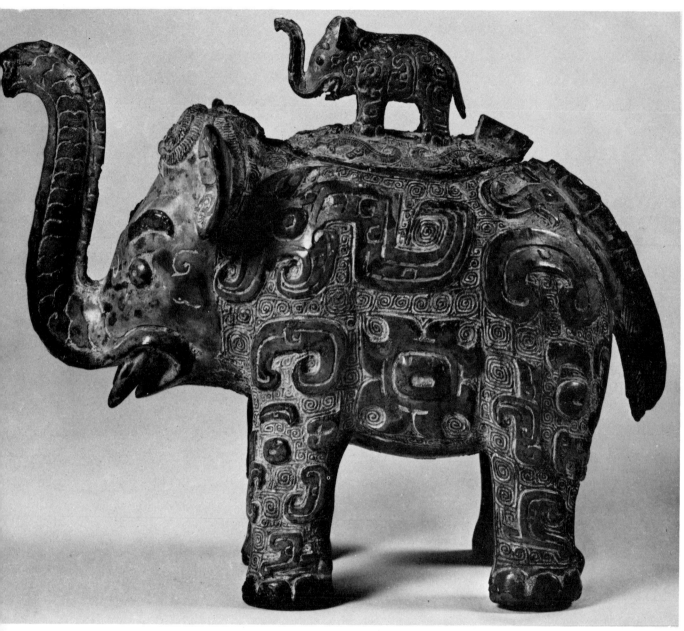

229 Huo (Bronze Ceremonial Vessel) in the Form of an Elephant, Early Chou Dynasty, ca. Eleventh Century B.C., China (Courtesy of the Smithsonian Institution, Freer Gallery of Art, Washington, D.C.).

The long snouts of the stacked Chac masks (Plates 230 and 234) are proudly and defiantly erect on the façades of Uxmal as if endeavoring to reveal the hidden story concerning their origin.

230 Masks of Rain God Chac, Post-classic Period (ca. A.D. 900-1100), Uxmal, Yucatan, Mexico.

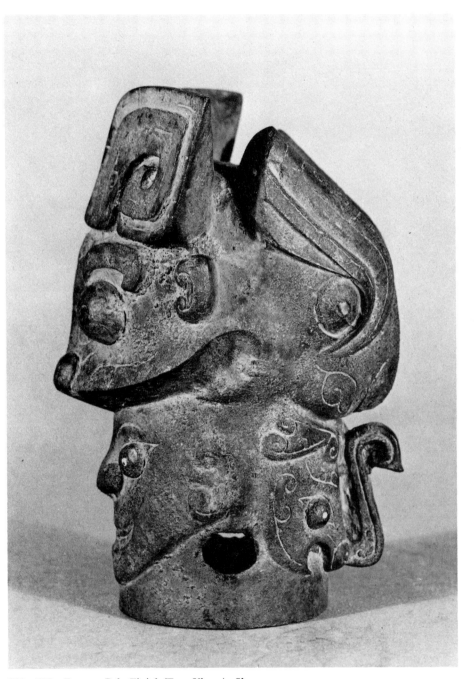

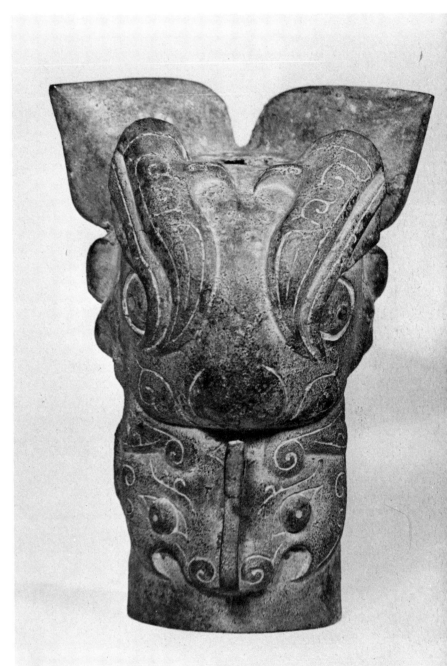

231, 232 Bronze Pole-Finial (Two Views), Shang Dynasty, ca. Thirteenth Century B.C., China (The Minneapolis Institute of Arts).

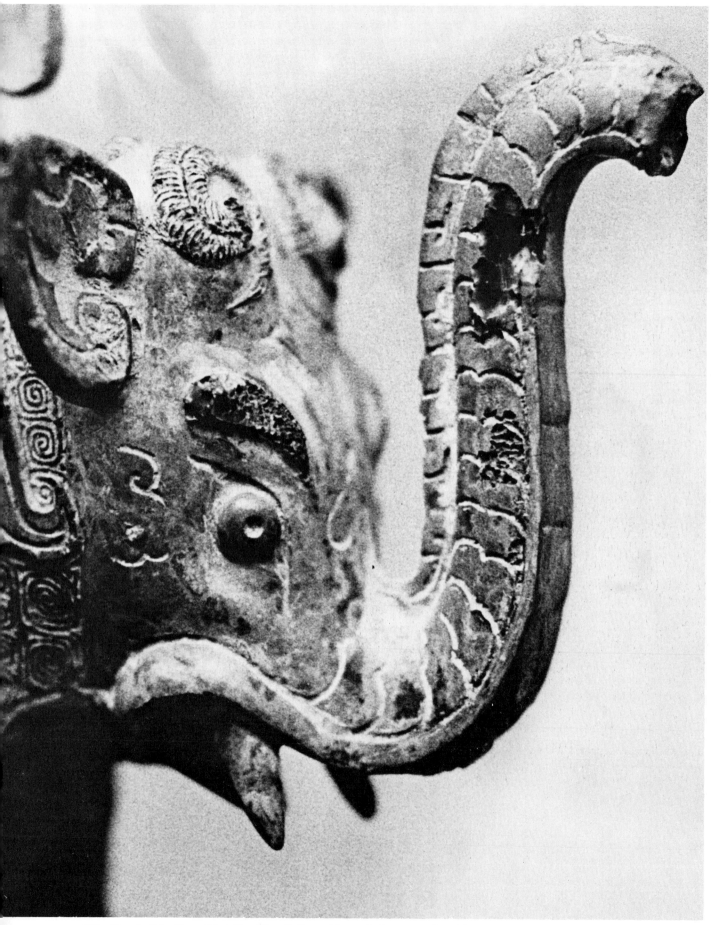

233 Detail of the Shang Huo (See Plate 229), ca. Eleventh Century B.C., China.

The Chac masks of the Mayan were sometimes carved without chins (Plate 234). This is also a common attribute of the Chinese Tao-Tieh masks (Plates 89, 91, 231, and 232).

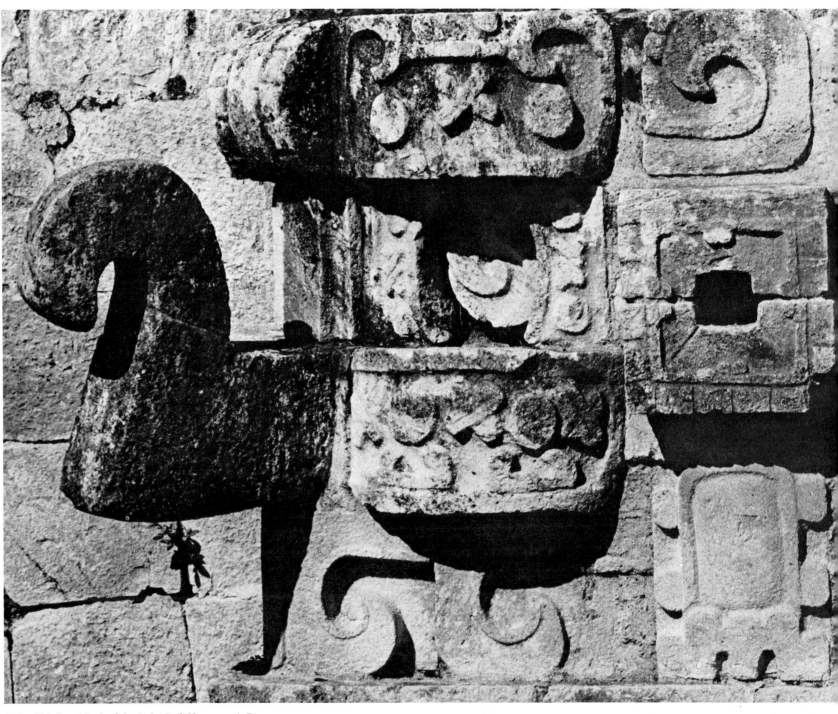

234 Chinless Mask of the Rain God Chac, ca. A.D. 900-1100, Uxmal, Yucatan, Mexico.

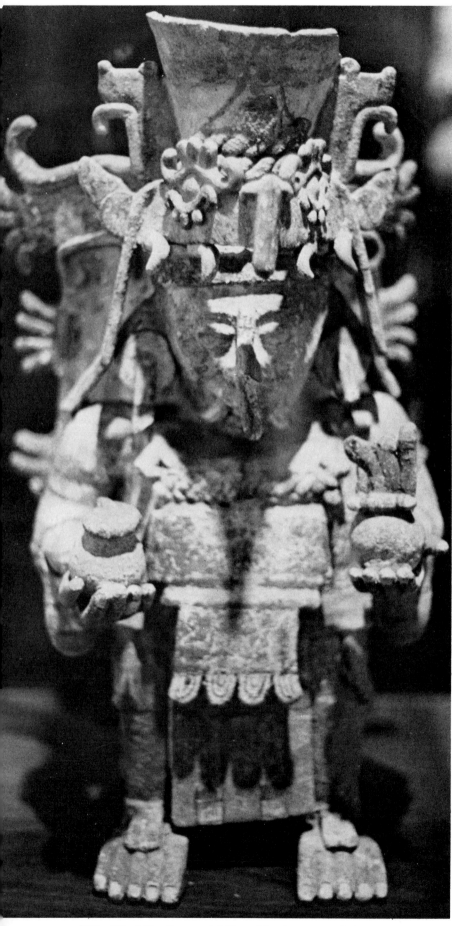
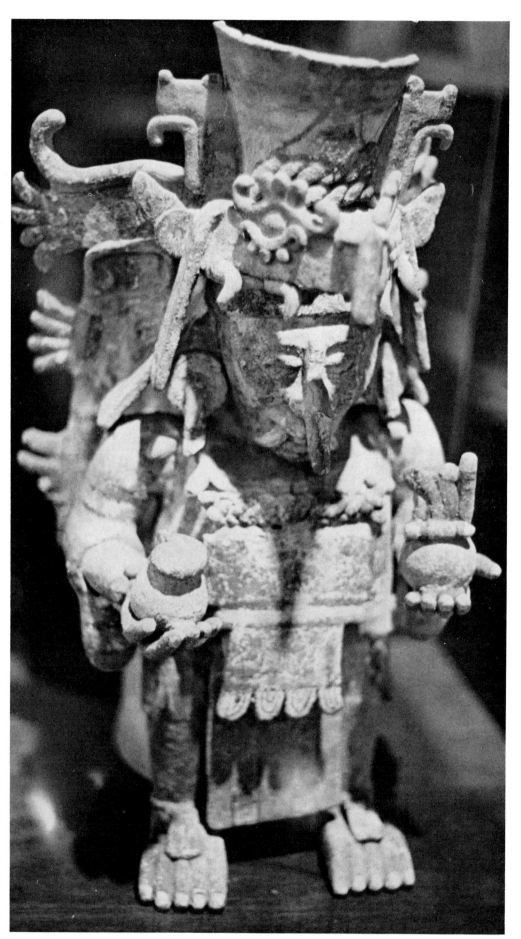

This Chac vessel in th collection of the Nation Museum of Anthropolog in Mexico City, is mo revealing in that it clear depicts elephantlike tusl protruding, at an angl from the corners of Chac mouth (see Plates 21 218, and 233 for con parison). This, togeth with the snoutlike nose ar the animal headdres represents a schem tization similar in conce to that of the Chine (Plates 185, 186, 216-21 229, 231, and 232).

235, 236, 237 Ceremonial Vessel in the Form of the Rain God Chac, Postclassic Period, ca. Eleventh to Fourteenth Century A.D., Mayanpan, Yucatan, Mexico (Collection of the National Museum of Anthropology, Mexico City).

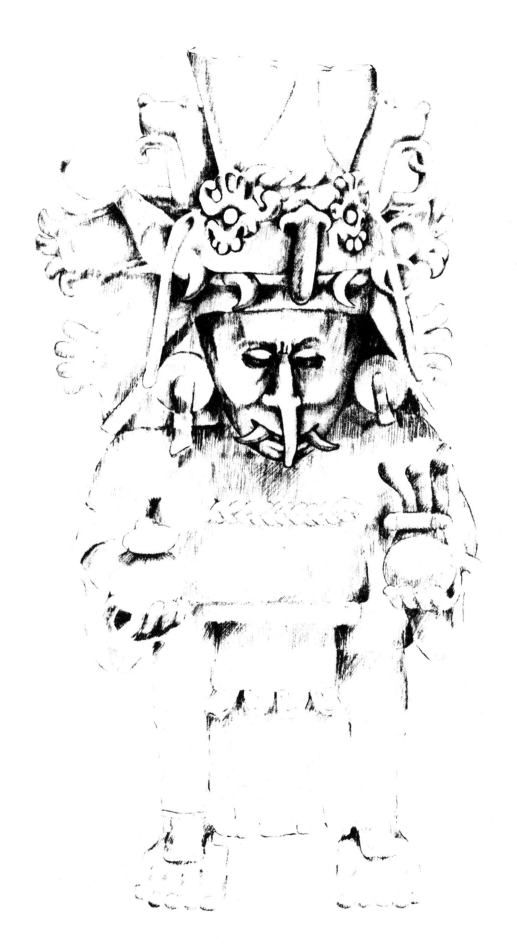

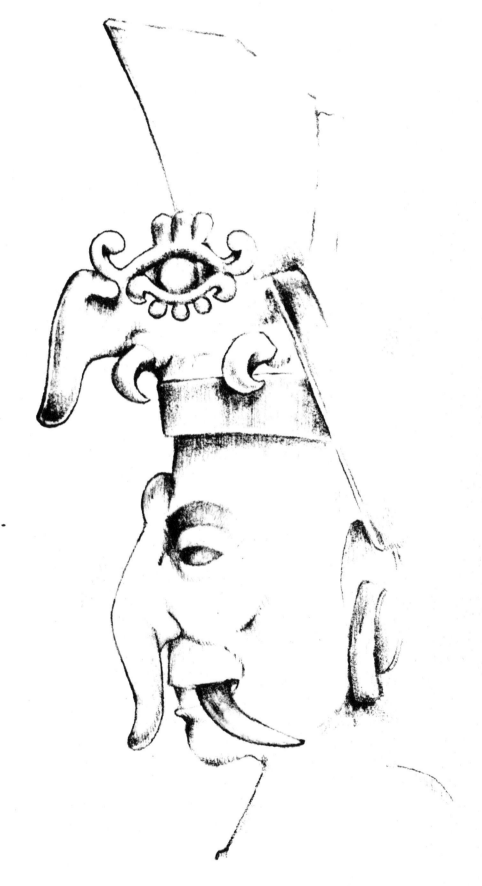

238 Profile of the Head of Chac.

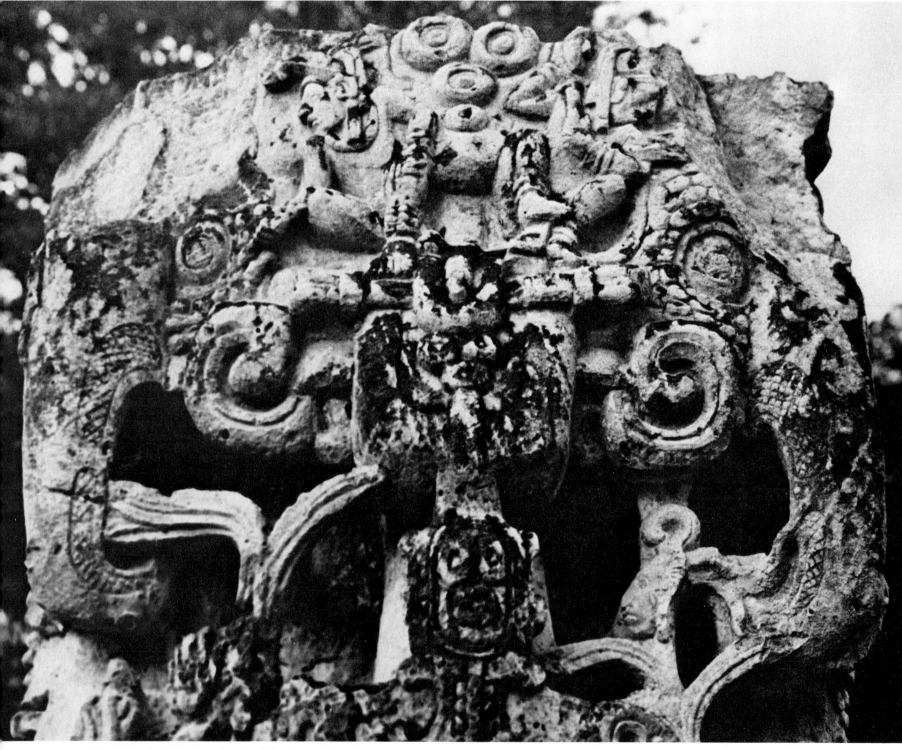

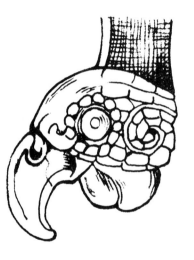

239 Stela B (Top), Dated A.D. 731, Copan, Honduras.

240 Tenoned Stone Facade Decoration in the Form of a Macaw-Head, ca. Eighth Century A.D., Copan, Honduras (After Herbert Spinden, *Nature,* No. 2413, Vol. 96, January 27, 1916, P. 593).

In order to prove the identity of the long-snout head on Stela B to be that of a macaw, Dr. Spinden illustrated a tenoned stone macaw head in a vertical position (Plate 240) in both his article in *Nature* and his book, *Mayan Art and Civilization*—despite the clear intention of the Mayan artist that it be assembled and viewed in horizontal position (Plate 241, the Mayans never hung stone sculpture from the ceiling). That the two much-discussed creatures on the upper portion of Stela B bear some attributes of the macaw is indisputable. However, to argue that they are one hundred percent macaw-inspired is just as prejudiced and unobserving as to contend that they are completely derived from Asian elephant (as Elliot Smith did). The trait-complex (general concept of composition) of Stela B might have been borrowed from Asia, but local elements had definitely been added on, or merged with, borrowed traits. A typical Mayan representation of blue macaw (Plates 241-242) differs from the two long-snouted animals on Stela B (Plates 227 and 228) in that: 1) its head is usually of the same length as its bill, whereas the two animals on Stela B have snouts twice as long as the heads; 2) no cross-hatched markings have ever been used to decorate its bill, or any other part of its head; and 3) the contour of the macaw head generally fits into a square (Plate 242) whereas that of the creature on Stela B undulates on the forehead (Plate 227).

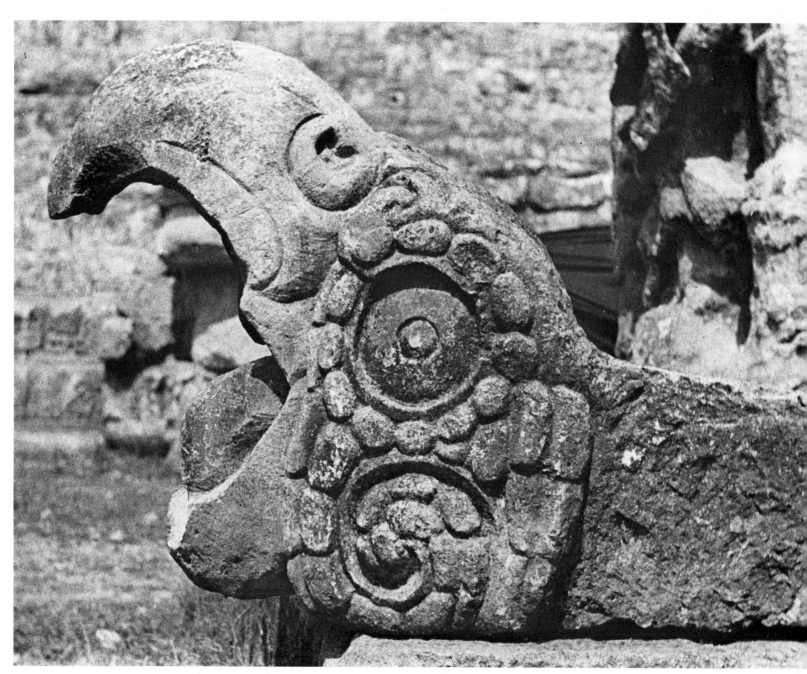

241 Tenoned Stone Macaw-Head in Proper Position.

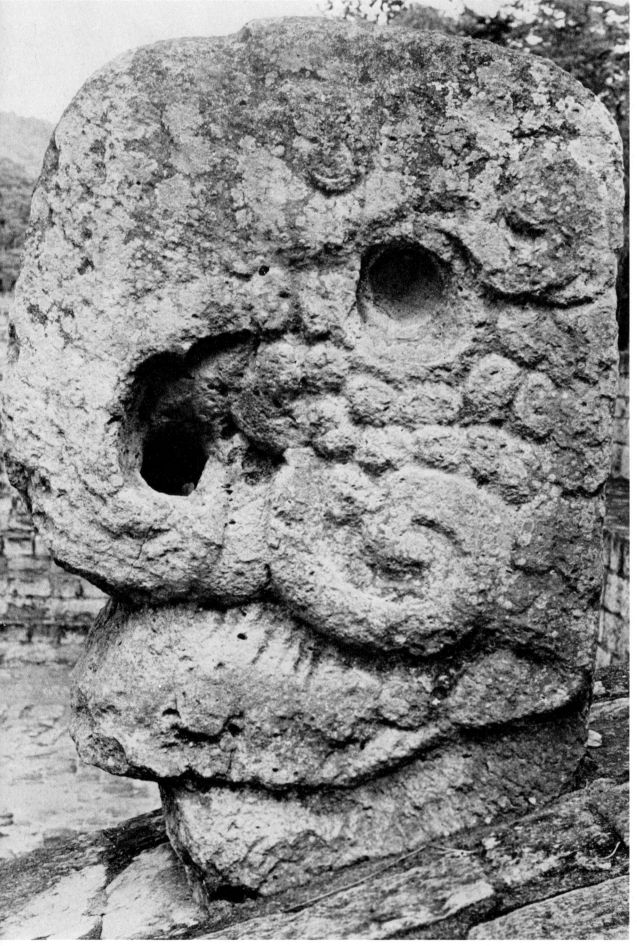

242 Tenoned Stone Macaw-Head, ca. Eighth Century
A.D., The Ball Court, Copan, Honduras.

Six hundred seventy-five feet from Stela B in the Court of Hieroglyphic Stairway, stands Stela N (Plates 243 and 244), which also bears traits uniquely Asiatic. On top of the head, a cross-legged, figure sits behind a flower (Plates 245 and 246), which is also one of the common head treatments in Buddhist art (Plates 247 and 248).

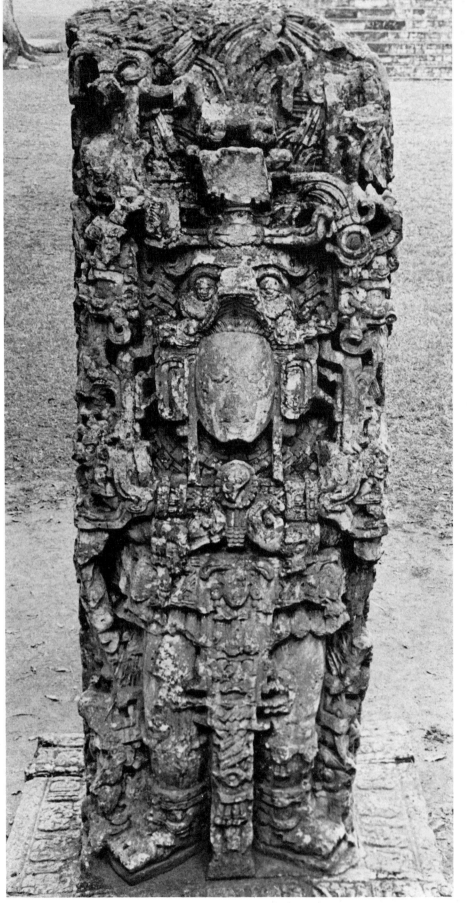

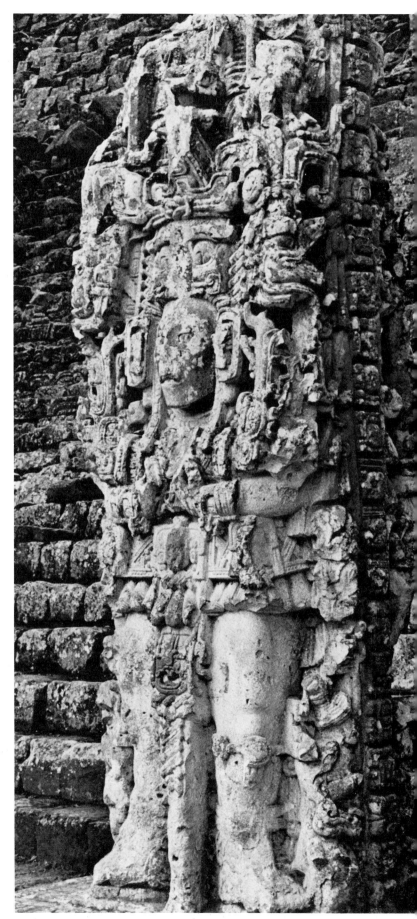

243 Stela N, Back, Dated 9.16.10.0.0 — 1 Ahau 3 Zip (A.D. 761), Copan, Honduras.

244 Stela N, Front, Dated 9.16.10.0.0 — 1 Ahau 3 Zip (A.D. 761), Copan, Honduras.

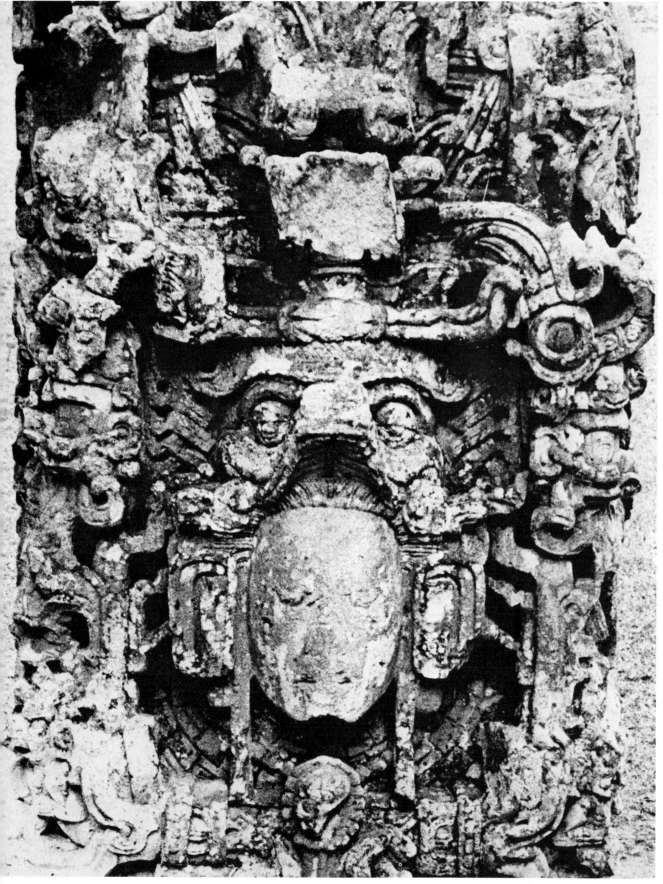

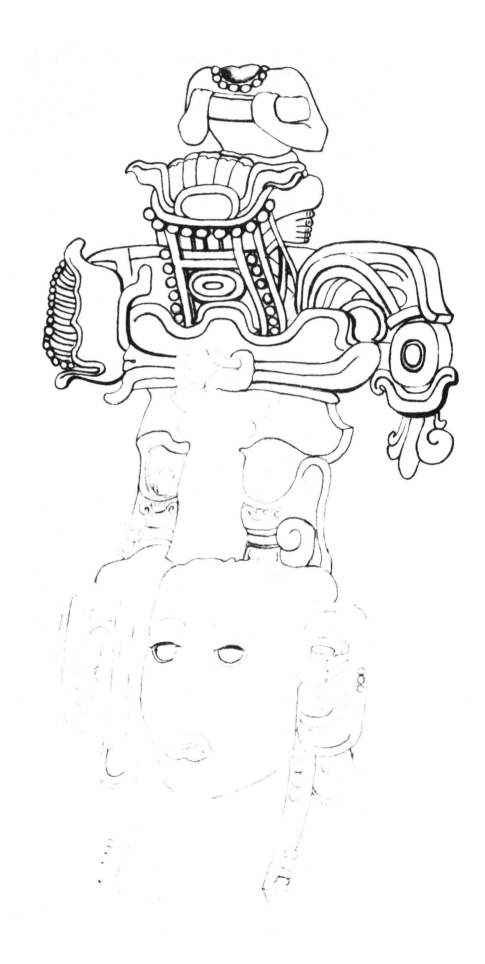

245, 246 Stela N (Top), Dated A.D. 761, Copan, Honduras (Drawing Based on Maudslay's *Biologia Centrali Americana,* Plate Vol. 1, Plate 77).

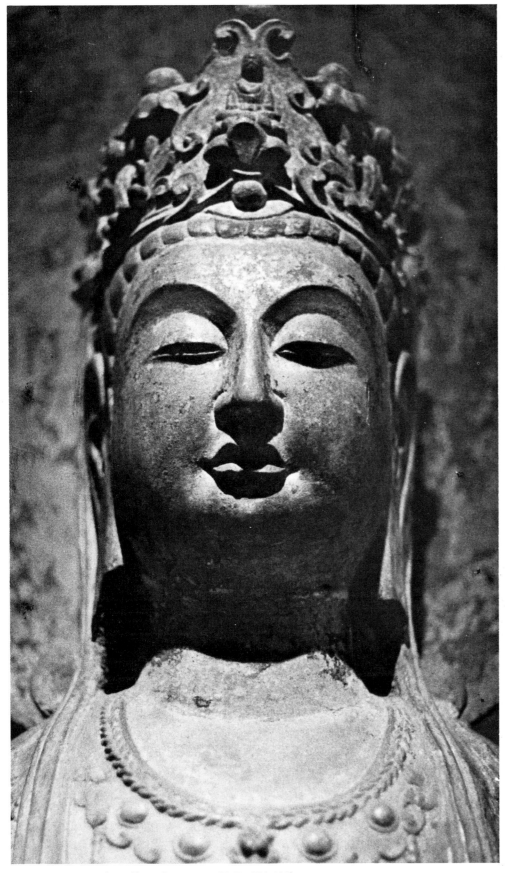

247 Bodhisattva (Detail), Sui Dynasty (A.D. 589-618), China (Collection of the Fogg Art Museum, Harvard University).

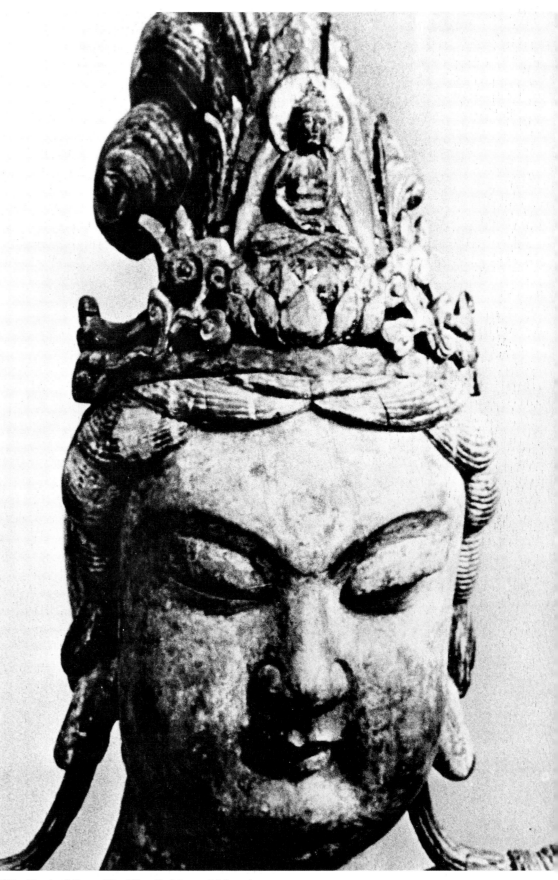

248 Head of Kuan-Yin (The Goddess of Mercy), Sung Dynasty, ca. Eleventh Century A.D., China, Detail of Plate 280 (Collection of the Metropolitan Museum, New York City).

One of the trademarks of Buddhist lotus stylization is the double-line ring at the center of the flower which symbolizes the so-called ''jewel of Buddha'' (top center, Plate 250; right hand of the standing attendant, Plates 251 and 252). The flower in front of the seated figure on top of Stela N (Plates 245, 246, and 249) bears a similar attribute. Note also the two ribbonlike elements flanking the heads on Plates 245-248.

249 Representation of the Lotus Flower, Stela N (Top), Dated A.D. 761, Copan, Honduras.

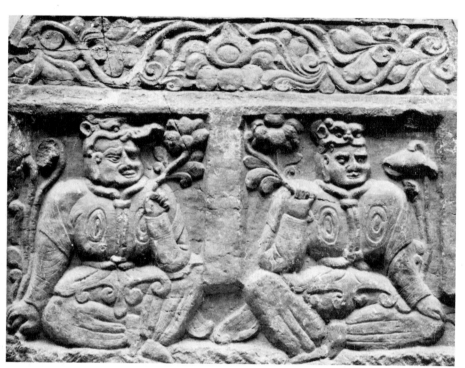

250 Representation of the Lotus Flower, Base of the ''Tribner'' Stela, Wei Dynasty, ca. Sixth Century A.D., China (The Metropolitan Museum of Art, Rogers Fund, 1930).

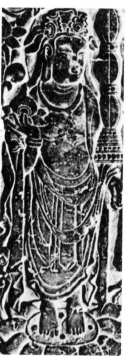

251, 252 Representation of the Lotus Flower, Detail of a Stone Tympanum, Tang Dynasty (A.D. 618-907), China, See Plate 208 (Collection of the Art Institute of Chicago).

6. CEREMONIAL GESTURES (PLATES 253-305)

A free-standing human figure carved in the full round is a rare occurrence in Mayan art. Quite a number of these figures, however, have been found in Copan, which is to the Mayan art world as New York or Paris is to the contemporary art scene. The following photographs illustrate the parallels in ceremonial hand gestures in Mayan and Asian art.

253, 254, 255 Fragments from Free-Standing Sculptures of Copan, Classic Period (ca. A.D. 700-800), Copan, Honduras (Collection of the Peabody Museum, Harvard University).

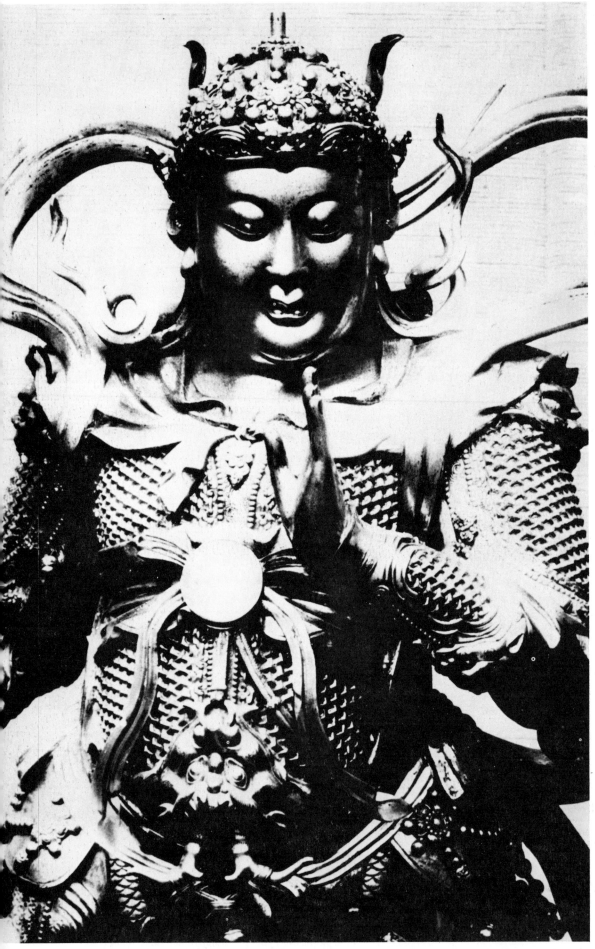

256 Guardian King (Detail), Early Ming Dynasty, ca. Fourteenth
Century A.D., China (Collection of the Seattle Art Museum).

The left hands of the figures in Plates 256 and 259 are held vertically at
the level of the breast, perpendicular to the chest, palms facing right.

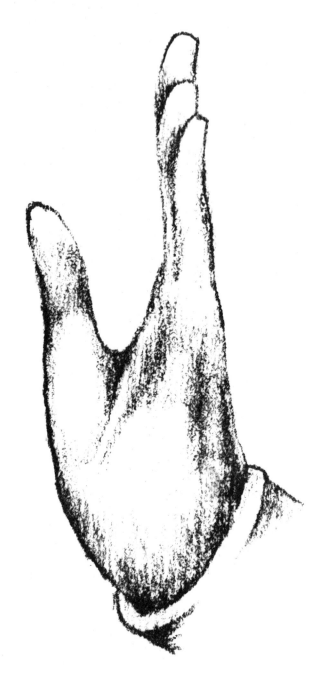

257 Mahayana Buddhist Mudra (Symbolic Gesture)
of Nan-Wu-Ho-Mi-To-Fu (Adoration of Amitabha).

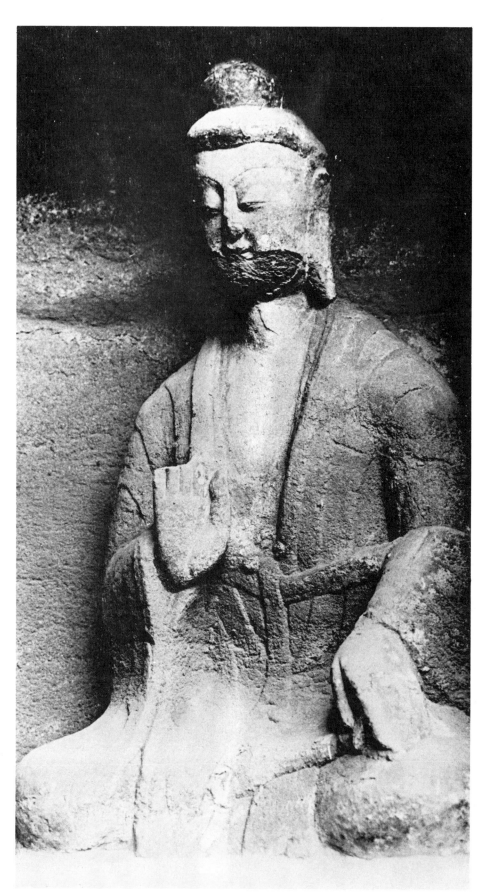

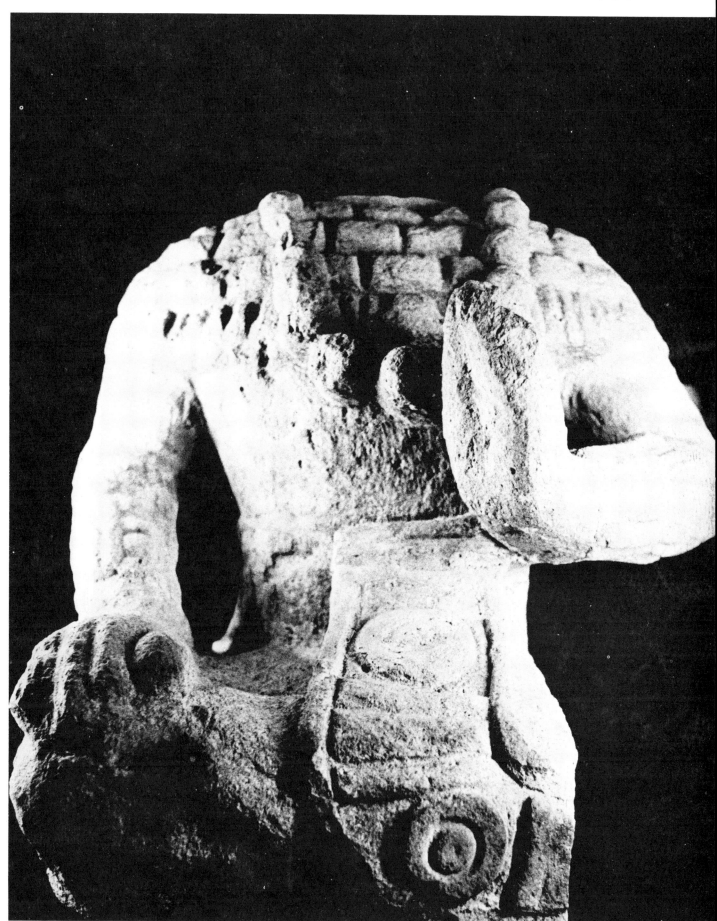

258 Cross-legged Stone Figure, Northern Wei
Dynasty, ca. Fifth Century A.D., Yun-Kang Caves,
Ta-Tung, Shansi, China.

259 Cross-legged Stone Figure, Classic Period (ca.
A.D. 700-800), Copan, Honduras (Collection of the
Peabody Museum, Harvard University).

260 Sakyamuni, Wei Dynasty, ca. Sixth Century
A.D., China (Collection of the Metropolitan Museum,
New York City).

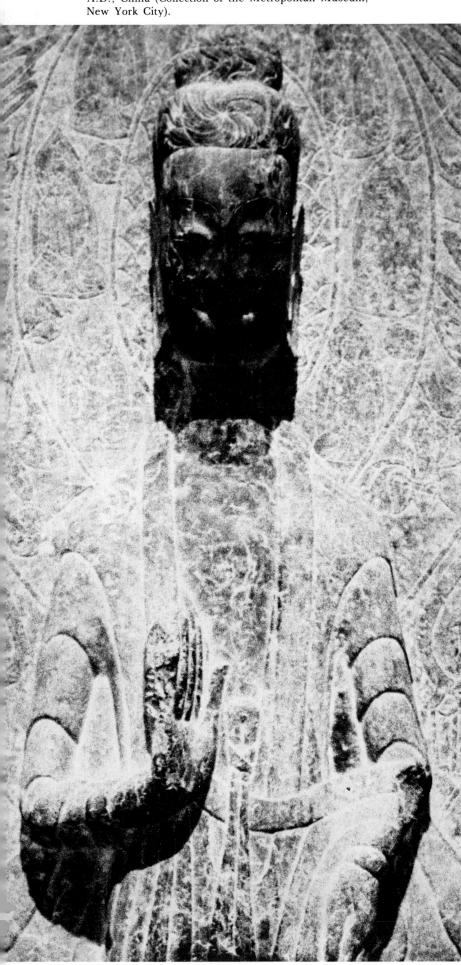

261 Clay Figurine, Classic Period (ca. A.D. 800),
Campeche, Mexico (Courtesy of the American
Museum of Natural History).

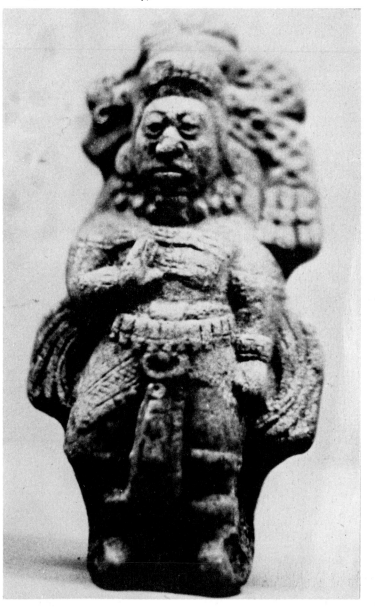

The right hands of these two
standing figures (Plates 260
and 261) are held vertically in
front of the breast, palm
facing left.

Plates 262, 269, 270, and 273-277 represent one of the most frequently depicted gestures in Chinese Buddhist art of the South-North Dynasty (A.D. 420-589). One hand is lowered, palm facing front; the other hand is raised at breast level, palm outward. This combination of hand gestures is known as Shih-Yuan-Wu-Wei. Shih-Yuan, referring to the lowered hand, signifies the "granting of the wish." Wu-Wei, literally means "fear not." Legend has it that the devilish Devadatta intoxicated an elephant which went berserk and attacked Sakyamuni. The Buddha raised his hand, palm outward (as if attempting to stop the animal), and five rays of colored light emitted from the tips of his upright fingers. The frenzied animal was allegedly subdued. An almost identical combination of hand gestures can be observed in Plates 263, 264, 268, 271, 272, 278, and 279. Note that the Mayan figure in Plate 264 wears a ceremonial belt which, protruding at the waistline, appears to be too loose to be of practical use. The Chinese had a long tradition of decorating their officials (Plates 265 and 266) with ceremonial belts of this kind (a belt was often given to an official by the emperor as a reward for distinguished service).

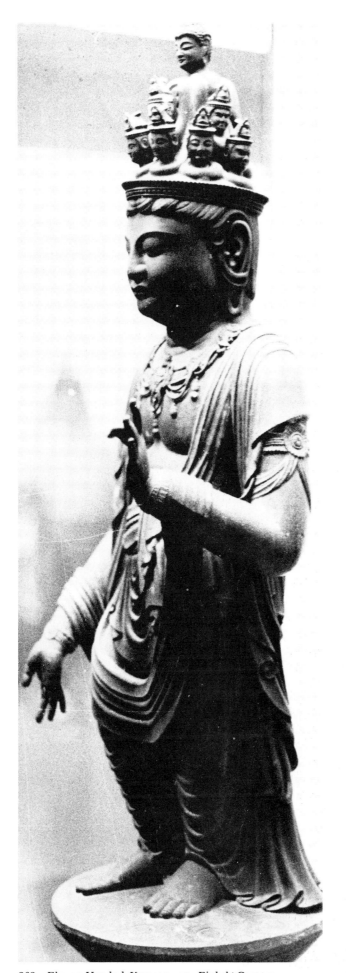

262 Eleven-Headed Kannon, ca. Eighth Century A.D., Japan.

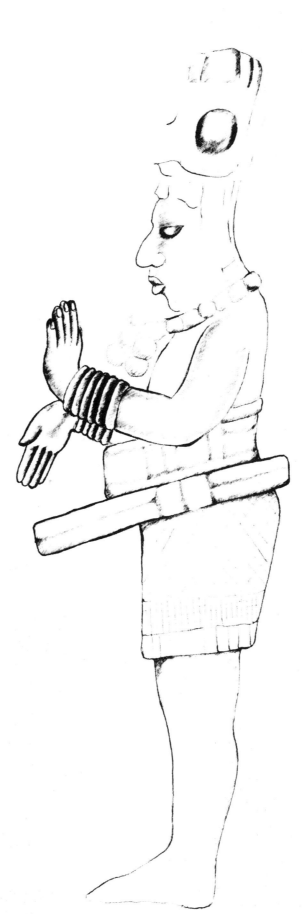

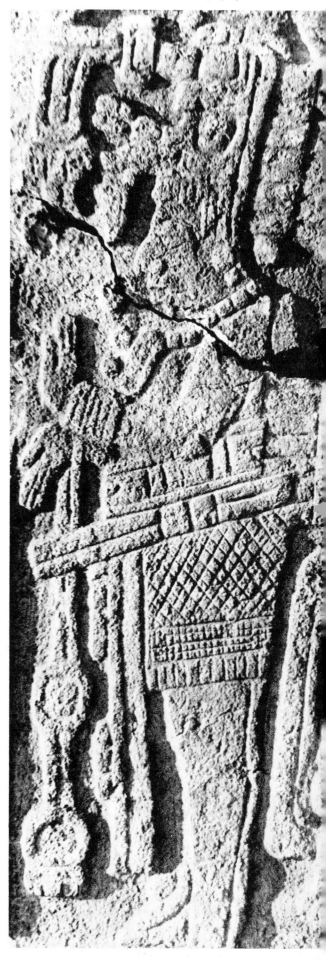

263, 264 Sculptured Column Building, North Lintel, Dated Late Classic Period (ca. A.D. 850), Xculoc, Puuc, Mexico.

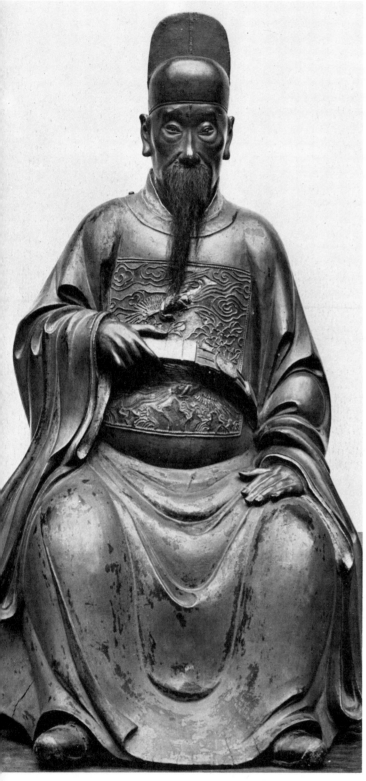

265 Portrait-Figure of a Ming Official Holding a Ceremonial Jade Belt, Ming Dynasty (ca. Fourteenth Century A.D.), China (The Metropolitan Museum of Art, Fletcher Fund, 1934).

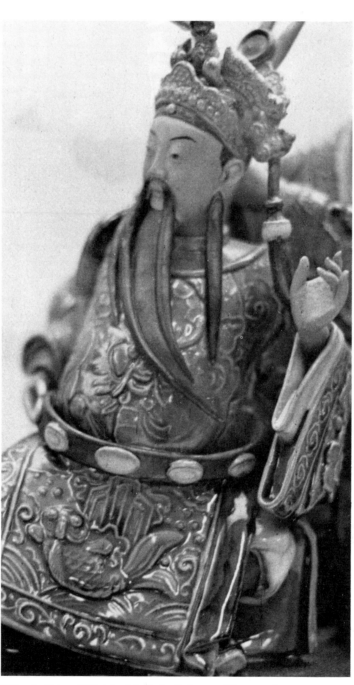

266 A Ching Official with Jade Belt, ca. Nineteenth Century A.D., China (From the Collection of the City Museum & Art Gallery, Urban Council, Hong Kong).

267 Stone Belt, ca. Thirteenth Century A.D., West Indies (Courtesy of the American Museum of Natural History, New York City).

In Plate 268, a Mayan long-nosed god is represented in low relief profile. The left hand is raised, the right hand lowered, and both palms face front. The Chinese and Korean equivalents of this ceremonial gesture is shown in Plates 269 and 270.

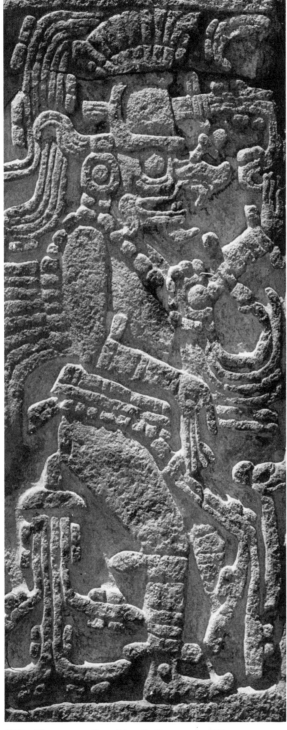

268 Figure on East Lintel, Structure 4B1. Late Classic Period, (ca. A.D. 850), Sayil, Yucatan, Mexico.

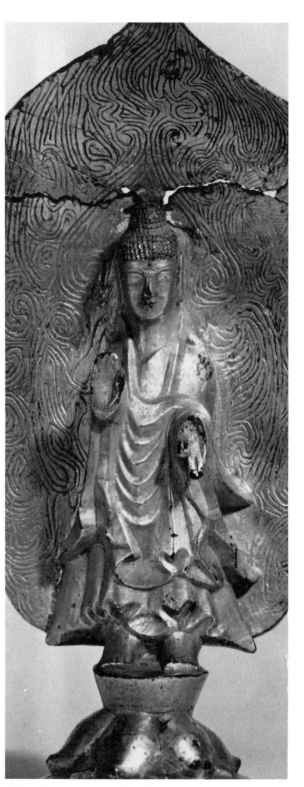

269 Gilt-Bronze Buddha, Koguryo Period, ca. Sixth Century A.D., Korea (Collection of the National Museum of Korea, Seoul).

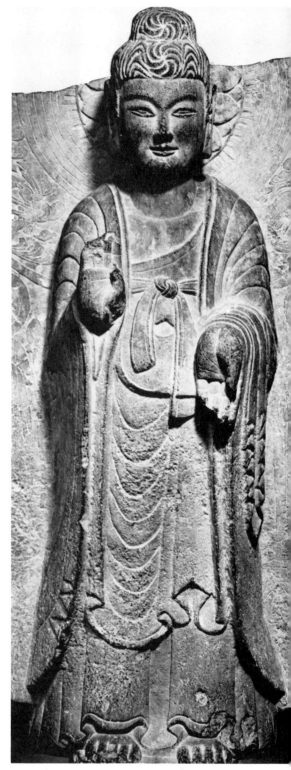

270 Stone Buddha, ca. Sixth Century A.D., China (Courtesy of the Smithsonian Institution, Freer Gallery of Art, Washington, D.C.).

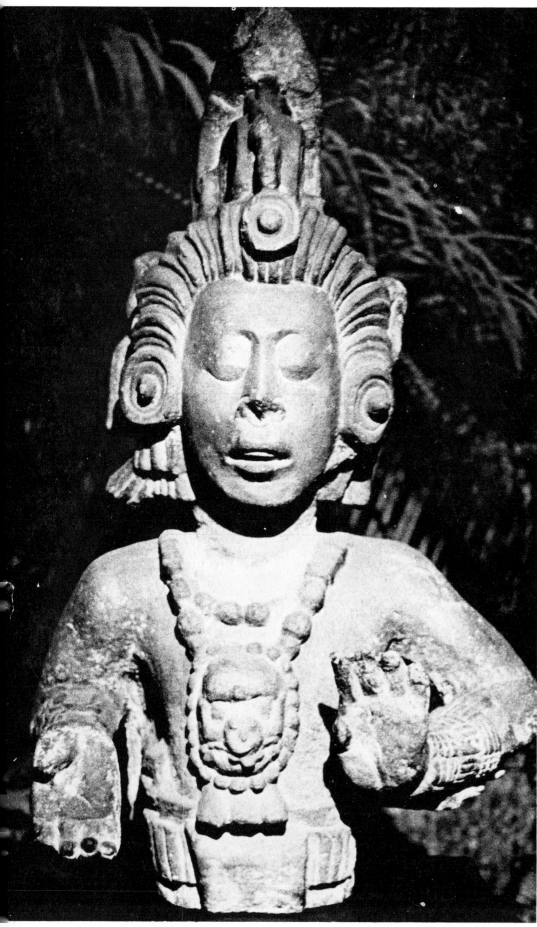

271 The Maize God, (ca. A.D. 700), Copan, Honduras
(Collection of the Museum of Mankind, British Museum, London).

A variation of the standard Shih-Yuan-Wu-Wei gesture, confined mostly to the Chinese, Korean, and Japanese, is the bending of three fingers of the lowered hand with the thumb and the index finger remaining extended (Plate 273 and the Mayan counterpart, Plates 271 and 272). Note however, that the Shih-Yuan gesture was made invariably with the left hand and the Wu-Wei gesture with the right hand in Chinese Buddhist art; whereas in Japan, sometimes the right hand was used to form the Shih-Yuan gesture and the left, the Wu-Wei gesture (Plate 262). All the Mayan counterparts of this motif belong to the latter variation—left hand up, right hand down (Plates 264, 268, and 271).

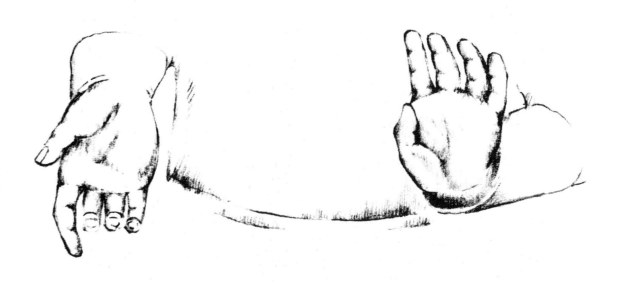

272 The Shih-Yuan and Wu-Wei Mudra (The ''Granting of Wish'' and ''Granting of Courage'' Gesture).

The buttonlike (flower) decorations above the foreheads of the figures in Plates 271 and 274 are almost identical. The eyes of the figures were also modeled in a similar manner: the upper eyelid meets the lower at a line, resembling the bottom of a boat. Since both deities being portrayed are anything but senile, it seems rather unusual that they were represented with eyes closed and with hands posed in none other than the Shih-Yuan-Wu-Wei gesture (Plates 271, 274-276, 278, and 279).

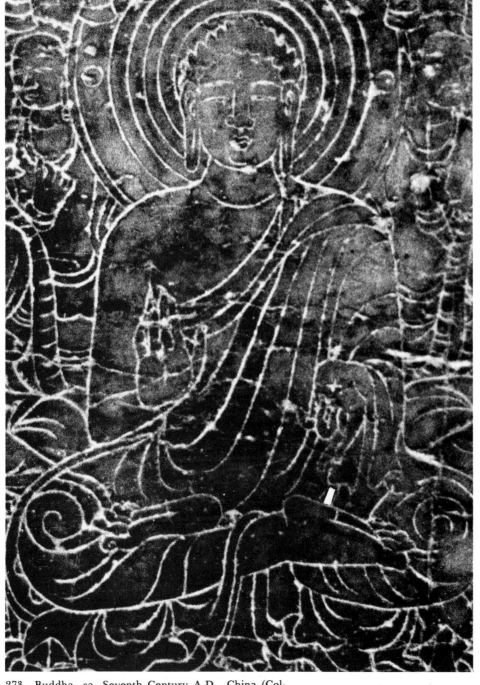

273 Buddha, ca. Seventh Century A.D., China (Collection of the University Museum, Philadelphia).

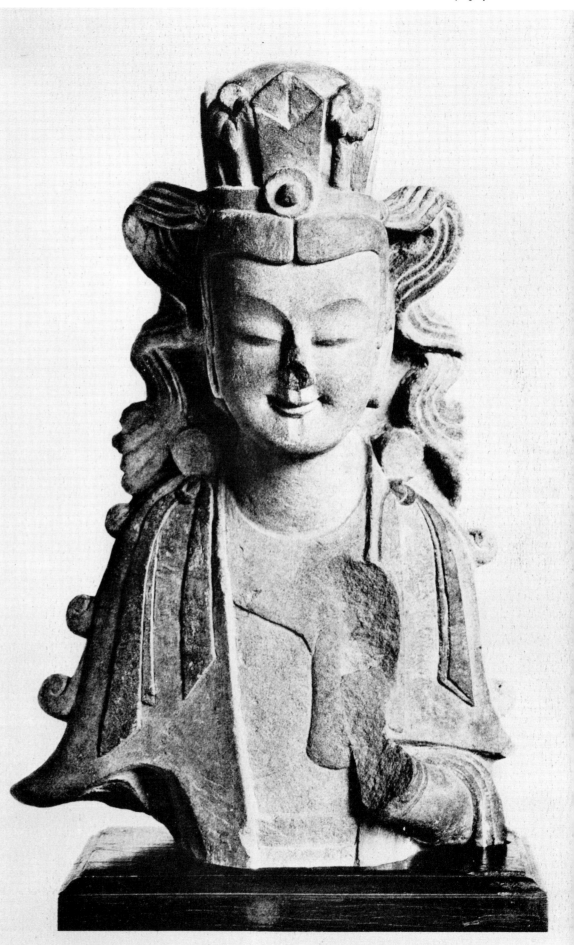

274 Bodhisattva, ca. Sixth Century, China (Collection of Mr. Schieper of Berlin, Courtesy of Dr. Otto Kummel).

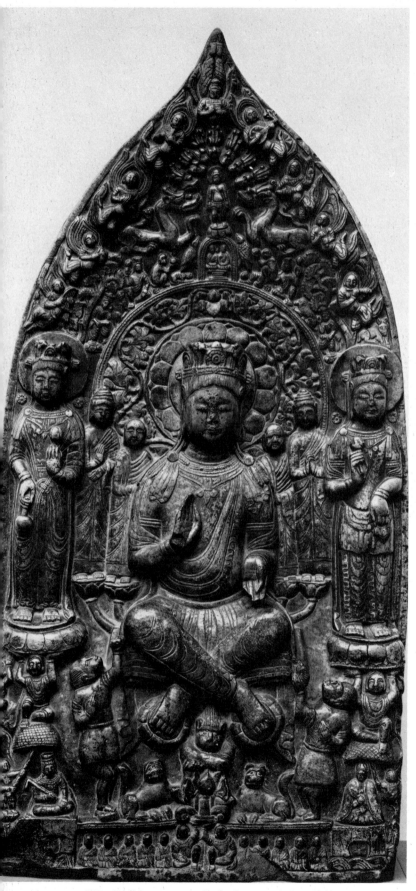

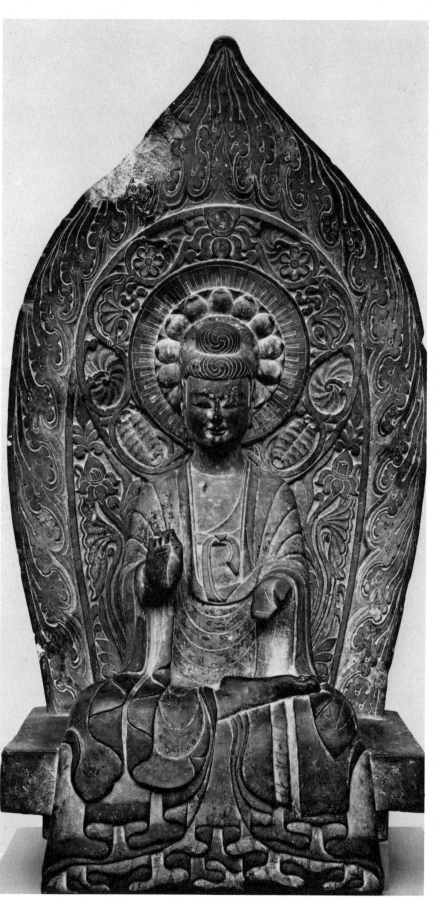

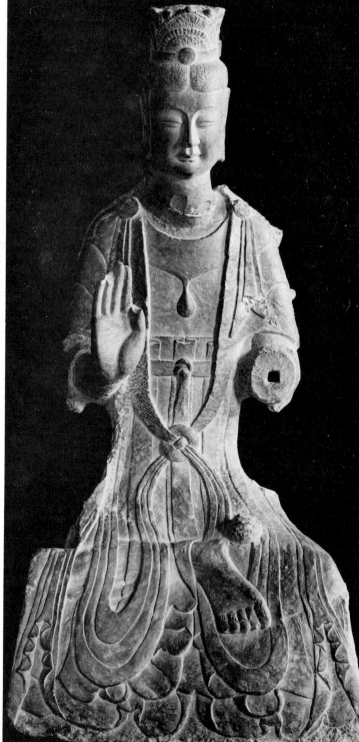

275 Bodhisattva, ca. Sixth Century A.D., China (Courtesy of the Smithsonian Institution, Freer Gallery of Art, Washington, D.C.).

276 Buddha, ca. Sixth Century A.D., China (Courtesy of the Smithsonian Institution, Freer Gallery of Art, Washington, D.C.).

277 Maitreya, Northern Wei Dynasty, Fifth Century A.D., China (Courtesy of the Museum of Fine Arts, Boston).

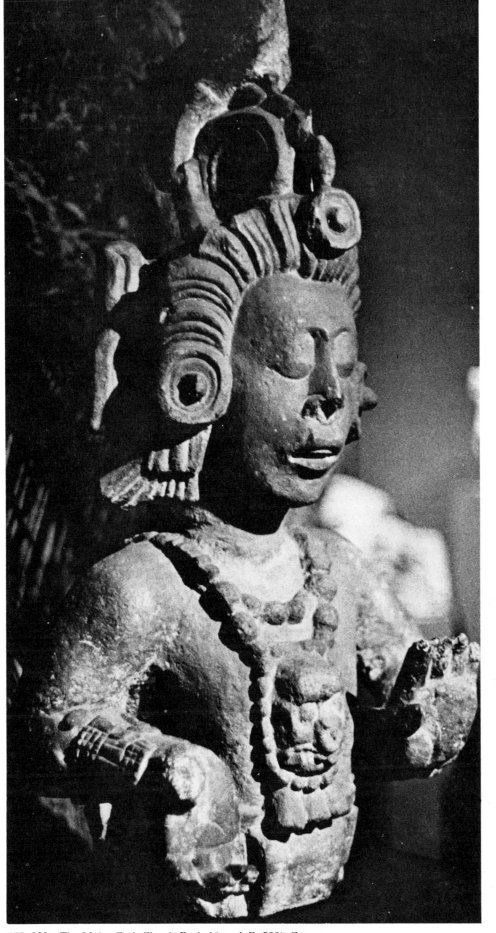
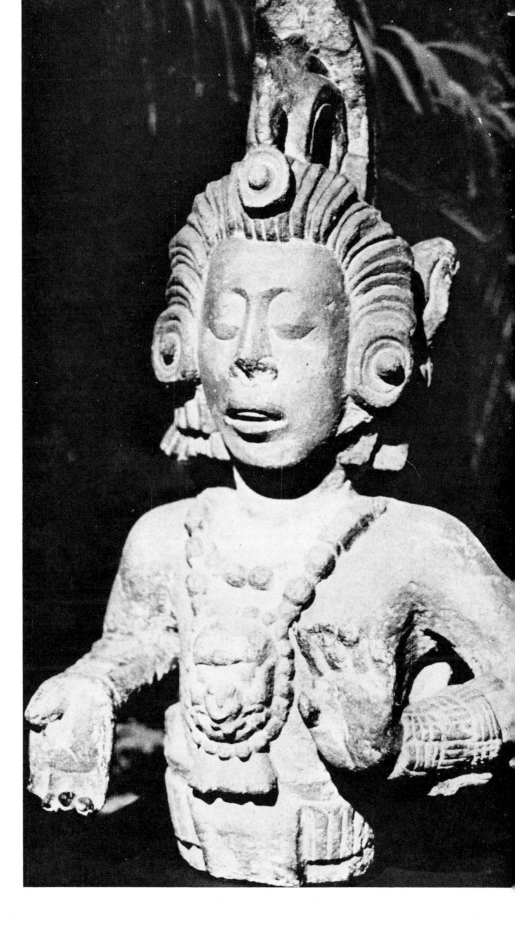

278, 279 The Maize God, Classic Period (ca. A.D. 700), Copan,
Honduras, See Plate 271 (Collection of the British Museum, London).

1 7 0

The "Young Maize Gods" of Copan (Plates 278, 279, 282, and 283) also were portrayed with a distinct hair fashion—the hair combed toward the back of the head where a loop rises high above the head. One of the most popular Mahayana Buddhist deities, Kuan Yin, was always represented with a high hair style.

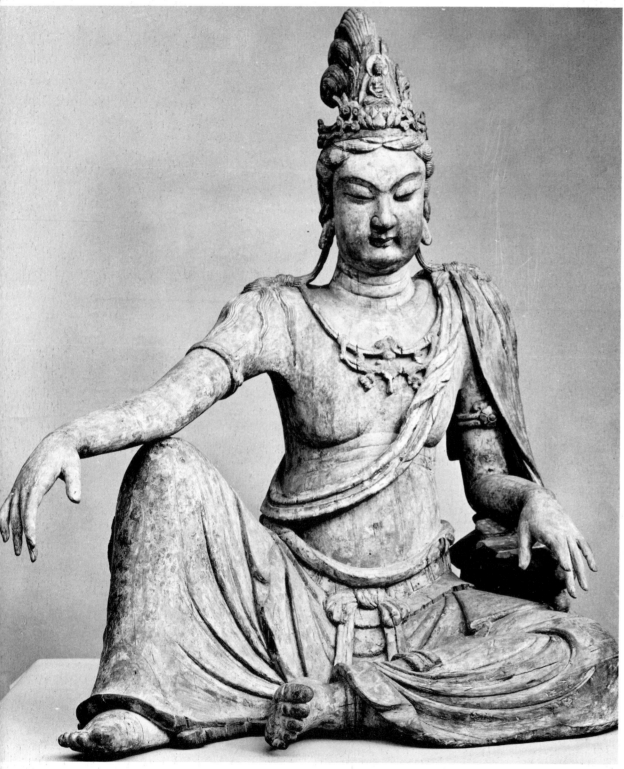

280 Kuan-Yin, Sung Dynasty, ca. Eleventh Century A.D., China (The Metropolitan Museum of Art, Fletcher Fund, 1928).

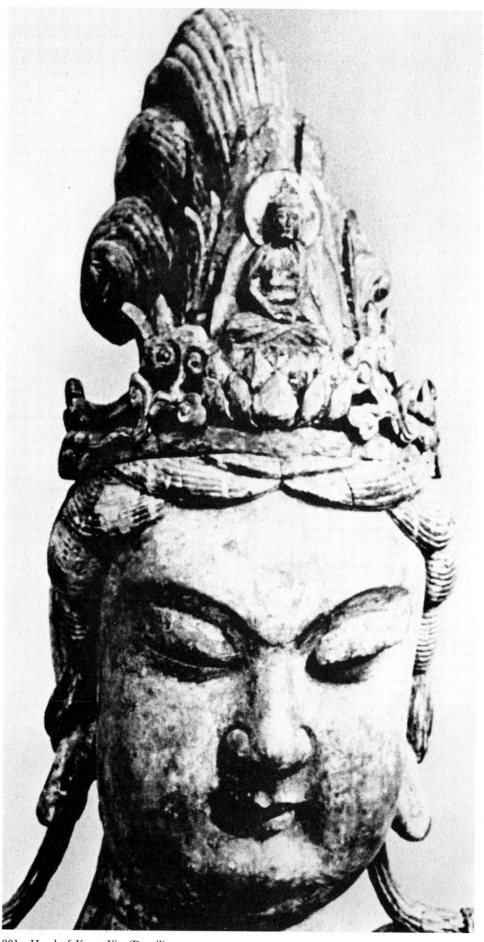

281 Head of Kuan-Yin (Detail).

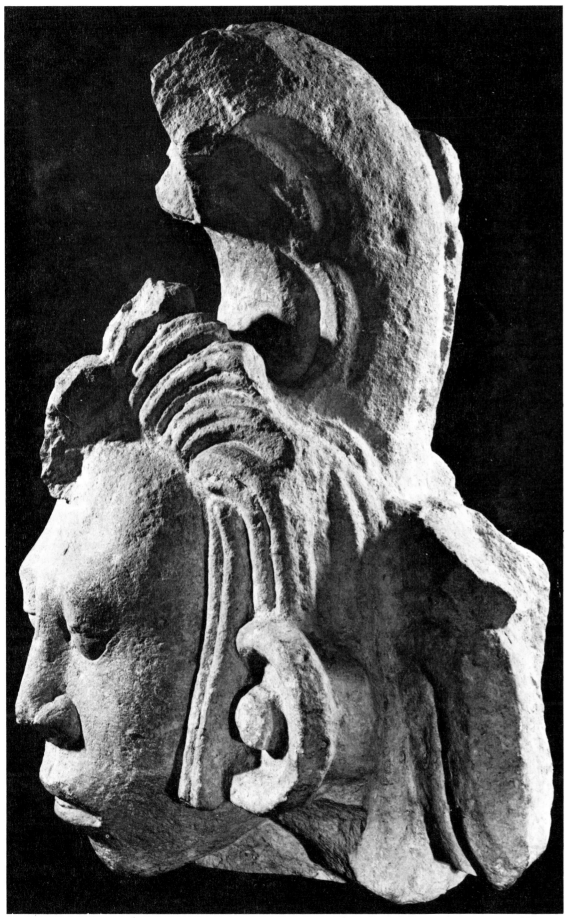
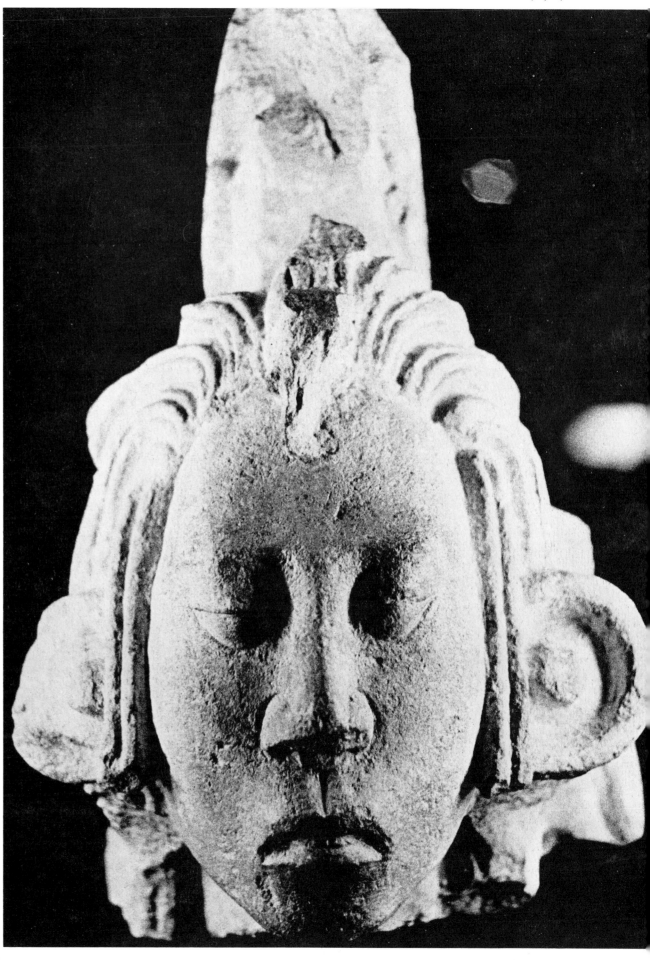

282, 283 Head of Maize God, Classic Period (ca. A.D. 700-800),
Copan, Honduras (Courtesy of the Peabody Museum, Harvard University).

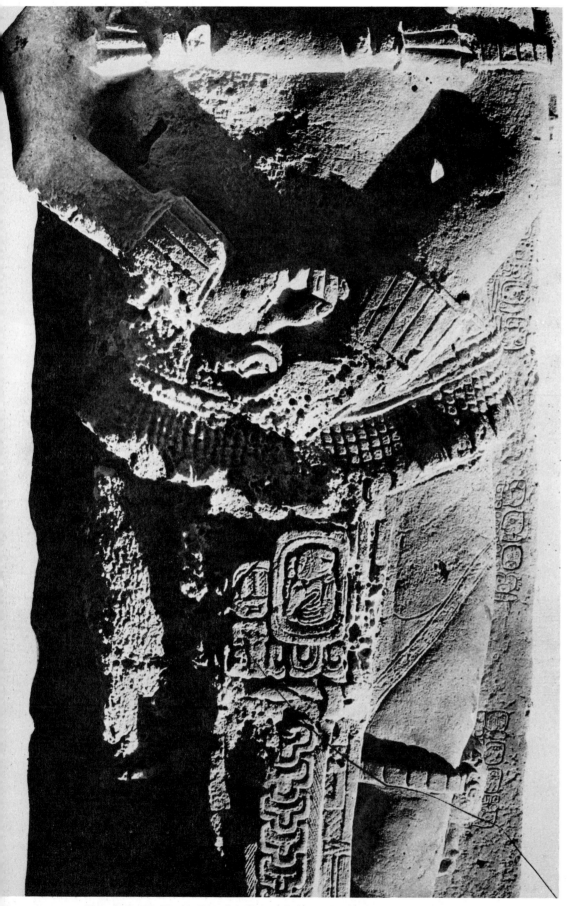

284 Stela 15, Front, Dated 9.17.15.0.0 (ca. A.D. 780), Piedras Negras, Peten, Guatemala (Courtesy of the Peabody Museum, Harvard University).

285 Chuan-Fa-Lun Mudra (The ''Turning the Wheel of the Law'' Gesture).

The hands of the Buddha in Plate 286 were portrayed in the Chuan Fa-Lun (Turning the Wheel of Law) configuration: the palm of the right hand facing downward, *middle finger touching the thumb at the tip;* left palm facing up at the level of the abdomen supporting the wheel. The Wheel of Law, symbolizing cosmic forces in continual centripetal movement, is associated by the Buddhist with the sun and is sometimes stylized in the form of a lotus flower viewed from the top. The gesture of Chuan Fa-Lun supposedly describes the act of Buddha's setting the Wheel of Law in constant motion throughout the cosmos, saving man from evil elements, thus facilitating the achievement of salvation. It also signifies the on-going dispensation and propagation of the Buddhist doctrine. The Mayan priest in Plate 284 assumes a strikingly similar gesture. Note that the middle finger of the upper hand also touches the thumb at the tip.

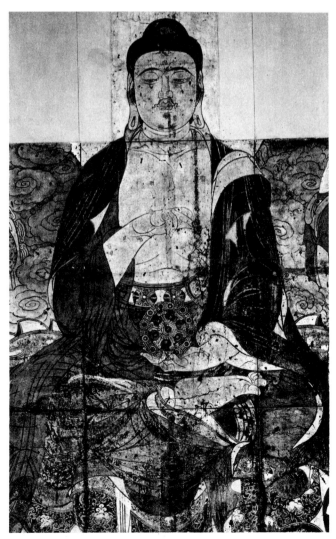

286 Buddha, Mural in Tang Style (A.D. 618-907), ca. Thirteenth Century A.D., Shansi, China (Collection of the University Museum, Philadelphia).

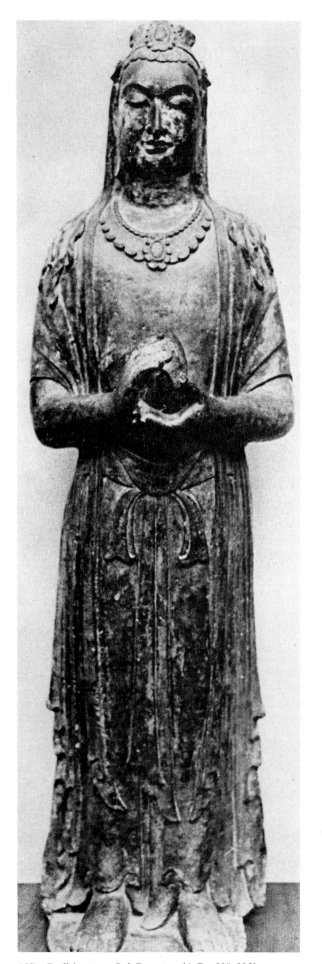

287 Bodhisattva, Sui Dynasty (A.D. 605-618), China (Courtesy of the Smithsonian Institution, Freer Gallery of Art, Washington, D.C.).

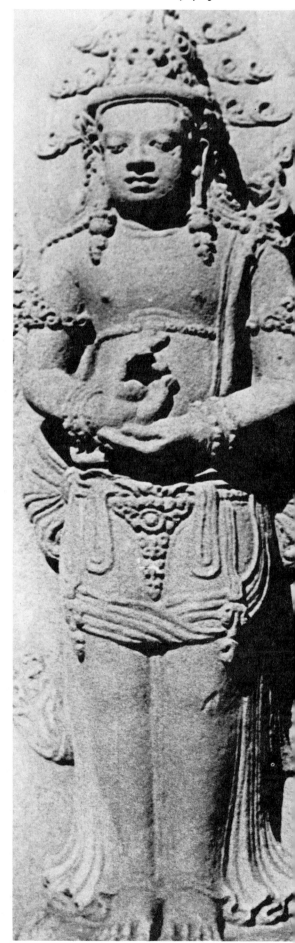

288 Bodhisattva, ca. Eighth Century A.D., India.

One of the most typical Southeast Asian dancing positions, extreme backward bending of the hand decorated with long artificial fingernails (Plate 291), also finds its counterpart in Meso-America (Plate 290). Note the flying strips tied around the waist in Plates 290-292.

289 Traditional Indonesian Dancer, Modern.

290 Painted Figure, Dated Late Classic Period (ca. A.D. 600-675), Uaxactun, Peten, Guatemala (National Museum of Archaeology).

291 Wayang Purwa Puppets, Modern.

292 Apsaras, ca. Twelfth Century A.D., Cambodia
(Collection of the Musee Guimet, Paris).

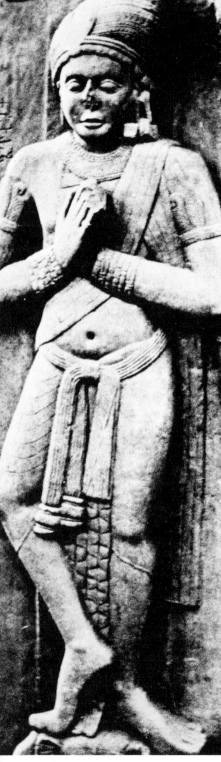

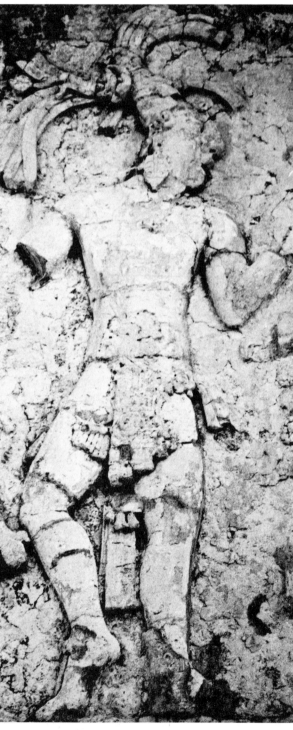

Differing from their contemporaries in Copan whose sculptures stressed the formal quality of rigid axial symmetry, the Mayans in Chiapas subtly infused movement in the portrayal of their priest-kings (Plates 294 and 297). The body weight of this type of figure was characteristically placed on one leg, with the other leg slightly raised, resting on the ball of the foot. Identical posture was extensively and consistently employed in the depiction of kings and religious personages in Asia (Plates 293, 296, and 298).

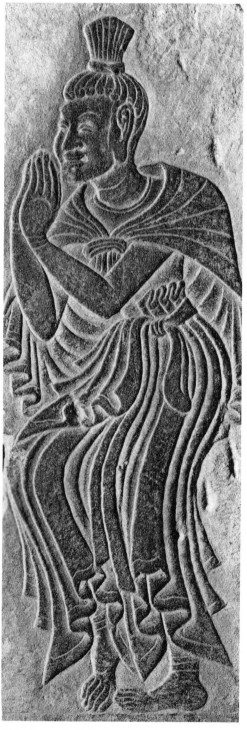

293 King of the Yakshas, Sunga Period, ca. First Century B.C., Bharhut, India.

294 Stucco Relief, Palace House, Western Corridor (ca. A.D. 650-750), Palenque, Chiapas, Mexico.

295 One Foot in Vertical Position Motif.

296 Stone Relief of an Adoring Figure, Northern Chi Dynasty (A.D. 550-577), Tien Lung Shan Cave, China (Courtesy of the Fogg Art Museum, Harvard University).

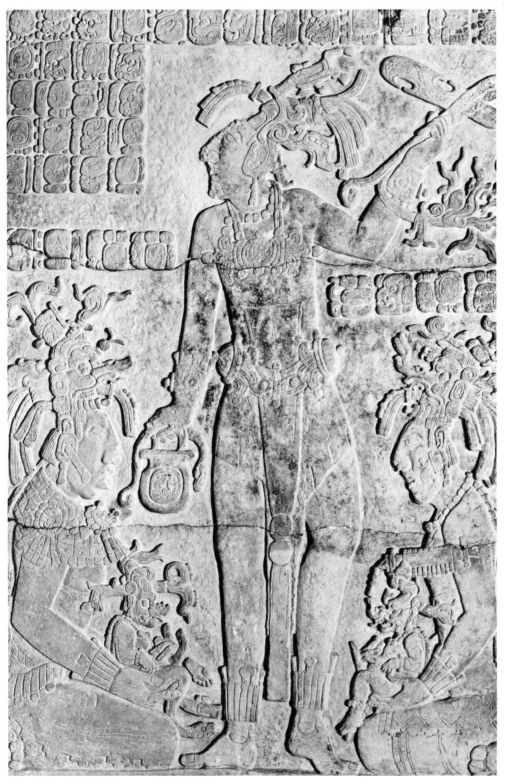

297 Relief Panel, Dated Late Classic Period (ca. A.D. 800), Chiapas, Mexico (Robert Woods Bliss Collection, Dumbarton Oaks).

298 Dancer, ca. Thirteenth Century A.D., Cambodia (Collection of the Musee Guimet, Paris).

The Mayan articulation of dynamism in art during the Classic period was always restrained. One of the exceptions is Stela 9 at Oxkintok. The Stela is framed by intertwining, vinelike elements. In the lower portion of the Stela (Plate 301), two figures are depicted: the figure on the left appears to be attentively observing a demonstration given by the figure on the right who bears traits foreign to the local Mayans. In addition to the conical hat, the long beard and the booklike object held on his left arm, the figure is dancing on the toes of one bended leg, with the other leg raised in front of it above the knee. Interestingly enough this is a standard pose assumed by the Apsaras who are frequently depicted in Asian artworks dancing on the petals of lotus flowers (Plates 299 and 300). Since the lotus flowers on which the Apsaras dance in Plates 299 and 300 would not be, in reality, stable enough to support the body load, their use as a dance pedestal appears to be arbitrary and symbolic in nature. It is significant that we find an unstable object of similar configuration underneath the Mayan dancing figure in Plate 301.

299 Dancing Apsaras, Khmer Period, ca. Twelfth to Thirteenth Century A.D., Bayon, Cambodia (The Metropolitan Museum of Art, Fletcher Fund, 1935).

300 Dancing Figure (Detail of a Stone Stupa), Tang Dynasty (ca. A.D. 700), China (Collection of the William Rockhill Nelson Gallery, Kansas City).

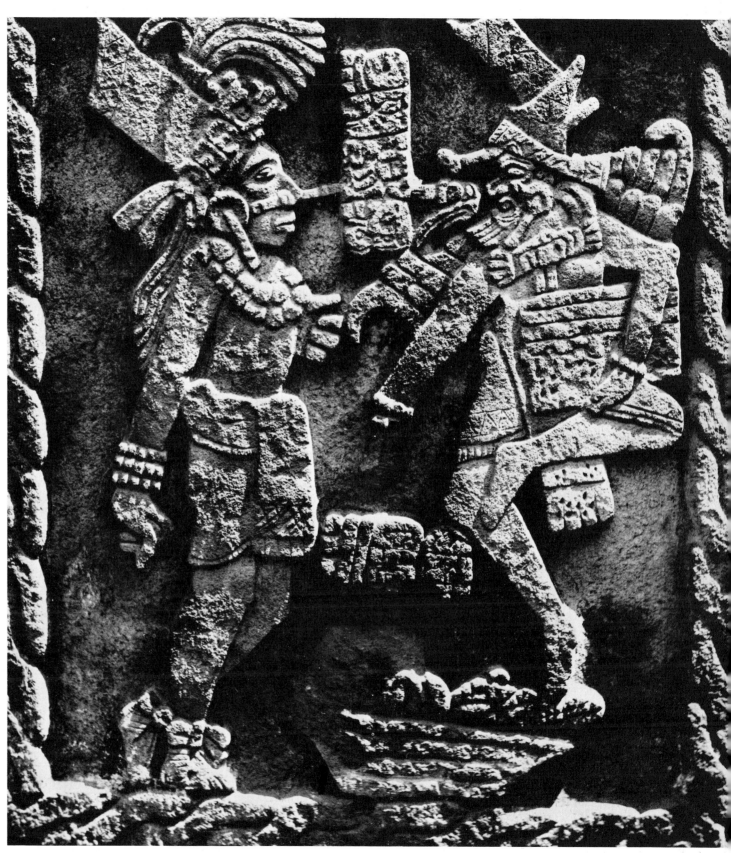

301 Dancing Figure (Detail of Stela 9), Late Classic Period (ca. A.D. 850), Oxkintok, Yucatan, Mexico.

Another characteristic attribute the Asian Apsaras (emerging fr a flower) also finds its almost ex counterpart in Jaina, Mexico, miles from Oxkintok, where St 9 is located. Plates 302 and correspond to Plates 303 and (note also the "sleepy-hea attribute of the figures inside flower), not only in iconograp concept but also in formal ticulation.

302 Apsara Emerging from a Lotus Flower, Northern Wei Dynasty, ca. Fifth Century A.D., Yuan-Kang Caves, Ta-Tung, Shansi, China.

303 Deity Emerging from a Flower, ca. Seventh to Ninth Century A.D., Jaina, Campeche, Mexico (Collection of the Museum of Primitive Art, New York City).

304 Apsara Emerging from a Lotus Flower, ca.
Seventh Century A.D., China (Courtesy of the Fogg
Art Museum, Harvard University).

305 Deity Emerging from a Lotus Flower, ca, Seventh
to Ninth Century A.D., Jaina, Campeche, Mexico
(Courtesy of the American Museum of Natural History).

Chan Kuo Tse [The Records of the Warring States], ca. 3rd century B.C.

Chen-La Feng Tu Chi [The Geography of Cambodia], by Chou Ta-Kuan, ca. A.D. 1287.

Chien Han Shu [The History of Former Han Dynasty], by Pan Ku and Pan Chao, ca. 1st century A.D.

Ching Chu Li Chi Hsien Sheng Chi Shih Sui Lun Wen Chi [Symposium in Honor of Dr. Chi on His Seventieth Birthday], Tsing Hua Journal: Taipei, 1965.

Chin Kang Ching [The Vajracchedika Sutra], by Kumarajiva, ca. A.D. 405.

Chin Tang Shu [The Old History of Tang Dynasty], by Liu Hsu, ca. A.D. 945.

Chu Fan Chih [The Records of Foreign Peoples], by Chao Ju-Kua, ca. 13th century A.D.

Chun Chiu [The Spring and Autumn Annals], ca. 8th-5th century B.C.

Chung-Kuo Ku Tai Yu Mei-Chou Chiao Tung Kao [China and America; A Study of Ancient Communication Between the Two Lands], by Wei Chu-Hsien, Shou Wen Society: Hong Kong, 1970-71.

Chu Shu Chi Nien [The Bamboo Annals of the Wei State], ca. 3rd century A.D.

Fo Kuo Chi [The Records of Buddhist Countries], by Fa-Hsien, ca. A.D. 416.

Hai Nei Shih Chou Chi [The Ten Continents in the Sea], by Tung-Fang Shuo, ca. 4th-5th century A.D.

Hai Tao Ching [The Book of Sea Ways], ca. 14th century A.D.

Hou Han Shu [The History of the Later Han Dynasty], Fan Yeh, ca. A.D. 450.

Hsin Tang Shu [The New History of Tang Dynasty], by Ou-Yang Hsiu and Sung Chi, ca. A.D. 1061.

Hsi-Yang Chao-Kung Tien-Lu [The Records of the Tributary Countries of the Western (South) Seas], by Huang Sheng Tseng, ca. A.D. 1520.

Hsi-Yang Fan Kuo Chi [Records of the Foreign Countries in the Western (South) Seas], by Kung Chen, ca. A.D. 1454.

Huai Nan Tzu [The Natural History of Prince Huai Nan], by Liu An's court scholars, ca. 2nd century B.C.

Hua Yen Ching [The Buddha-Avatamsaka Sutra], ca. 6th century A.D.

I Yu Chih [The Records of Foreign Territories], by Chou Chih-Chung, ca. 14th century A.D.

I Yu Tu Chih [The Illustrated Records of the Foreign Territories], compiled by Chu Chuan, ca. 14th century A.D.

Ju Shu Chi [The Journey into Szechuan], by Lu Yu, ca. A.D. 1170.

Kao Ku [Archaeology], Peking, 1955-

Kung Tzu Chia Yu [The Family Sayings of Confucius], edited by Wang Su, ca. 3rd century A.D.

Lai Nan Lu [The Journey to the South], by Li Ao, ca. A.D. 809.

Liang Shu [The History of the Liang Dynasty], by Yao Cha and Yao Sze-Lien, ca. A.D. 629.

Liang Szu Kung Chi [Tales of the Four Dukes of Liang Dynasty], by Chang Yueh, ca. A.D. 695.

Liao Shih [The History of Liao Dynasty], by To-To and Ou-Yang Hsuan, ca. A.D. 1350.

Ling Piao Lu I [The Natural History of Kuangtung Province], by Liu Hsun, ca. A.D. 895.

Lun Yu [The Confucian Analects], compiled by disciples of Confucius, ca. 450 B.C.

Lung Chiang Chuan Chang Chih [The Shipyards of the Dragon River], by Li Chao-Hsiang, ca. A.D. 1553.

Nan Chao Yeh Shih [The History of Yunan], by Yang Shen, ca. A.D. 1550.

Nan Chi Shu [The History of the Southern Chi Dynasty], by Hsiao Tzu-Hsien, ca. A.D. 520.

Nan Chou I Wu Chih [The Foreign Objects of the Southern Continents], by Wan Chen, ca. 3rd-4th century A.D.

Nan Chuan Chi [The Ships of the South], by Shen Tai, ca. 15th century A.D.

Pei Chi Shu [The History of Northern Chi Dynasty], by Li Te-Lin and Li Pai-Yao, ca. A.D. 640.

San Kuo Chih [The History of Three Kingdoms], by Chen Shou, ca. 3rd century A.D.

San Tsai Tu Hui [The Universal Encyclopedia], by Wang Chi, ca. A.D. 1609.

Shan Hai Ching [The Book of Mountain and Sea], ca. Han Dynasty (206 B.C.-A.D. 220).

Shih Chi [The Historical Records], by Szu-Ma Chien and Szu-Ma Tan, ca. A.D. 90.

Shu Ching [Book of Historical Documents], ca. 10th-5th century B.C.

Shui Ching [The Book of Rivers and Canals], by Sang Chin, ca. 3rd century A.D.

Shui Ching Chu [Commentary on the Books of Rivers and Canals], by Li Tao-Yuan, ca. 5th-6th century A.D.

Sui Shu [The History of Sui Dynasty], by Wei Cheng, ca. A.D. 636-656.

Sung Shih [The History of Sung Dynasty], by To-To and Ou-Yang Hsuan, ca. A.D. 1345.

Sung Shu [The History of Liu Sung of the South-North Dynasty], by Shen Yo, ca. 5th century A.D.

Tai-Ping Yu Lan [The Imperial Encyclopedia of Tai Ping], edited by Li Fang, ca. A.D. 985.

Tao I Chih Lueh [Journey to the Barbarian Islands in the South Seas], by Wang Ta-Yuan, ca. A.D. 1350.

Ta Tang Hsi Yu Chi [Journey to the Western Countries by Hsuan-Chuang of the Tang Dynasty], narrated by Hsuan-Chuang and written by Pien-Chi, ca. A.D. 646.

Ta Yuan Hai Yun Chi [The Records of Sea Transportation of the Yuan Dynasty], by Hu Ching, ca. A.D. 1331.

Tien Kung Kai Wu [The Works of Nature], by Sung Ying-Hsing, ca. A.D. 1637.

Tsin Shu [The History of Tsin Dynasty], by Fang Hsuan-Ling, ca. A.D. 635.

Tso Chuan [Tso's Enlargement of the Spring and Autumn Annals], by Tso Chiu Ming, ca. 5th-6th century A.D.

Tung Hsi Yang Kao [The Studies on Seas of the East and West], by Chang Hsieh, ca. A.D. 1618.

Tung Chien Kang Mu [The Outlines of Universal History], by Chu Hsi et al., ca. A.D. 1189.

Tu Shu Chi Cheng [Imperial Encyclopedia of Ching Dynasty], edited by Chen Meng-Li et al., ca. A.D. 1726.

Wen Wu [Cultural Relics], Peking, 1950.

Wei Shu [The History of Northern Wei Dynasty], by Wei Shou, ca. 6th century A.D.

Wu Pei Chih [The Journal of Martial Provisions], by Mao Yuan-I, ca. A.D. 1628.

Wu Shih Wai Kuo Chuan [The Records of Foreign Countries in the Time of Wu], by Kang Tai, ca. A.D. 260.

Wu Yueh Chun Chiu [The Annals of the Kingdoms of Wu and Yueh], by Chao Yeh, ca. 1st-2nd century A.D.

Ying Yai Sheng Lan [The Voyages of Cheng Ho to the South Seas], by Ma Huan, ca. A.D. 1451.

Yuan Hai Yun Chih [Sea Transportation of the Yuan Dynasty], by Wei Su, ca. 14th century A.D.

Yu Chi Tung Shih [General Guide for Ancient Jade Objects], by Na Chih-Liang, vols. 1 and 2, Hong Kong, Kai-Fa Co.: 1964-70.

Yueh Chueh Shu [The Lost Records of the State of Yueh], by Yuan Kang, ca. A.D. 52.

Yu Ti Chi Sheng [World Geography], by Wang Hsiang-Chih, ca. A.D. 1221.

Yu Ti Tsung Tu [General Atlas of the World], by Shih Ho-Chi, ca. A.D. 1564.

Acosta, Joseph de
 1590 *The Natural and Moral History of the Indies,* translated by Edward Grimston in 1604. New York: Burt Franklin. 1970 reprint.
Adair, James
 1775 *The History of the American Indians.* London: E. and C. Dilly.
Adams, Robert McC.
 1966 *The Evolution of Urban Society: Early Mesopotamia and Prehispanic Mexico.* Chicago: Aldine Publishing Co.
Anton, Ferdinand
 1970 *Art of the Maya.* New York: G. P. Putnam's Sons.
Arnold, Channing, and Frost, Frederick
 1909 *The American Egypt: A Record of Travel in Yucatan.* New York: Doubleday, Page and Co.
Barnard, Noel
 1972 *Early Chinese Art and Its Possible Influence in the Pacific Basin,* vols. 1, 2, and 3. New York: Intercultural Arts Press.
Bastian, Adolf
 1869 *Die Völker des Östlichen Asien.* Leipzig: O. Wigand.
 1881 *Der Völkergedanke im Aufbau einer Wissenschaft vom Menschen und seine Begründung auf Ethnologische Sammlungen.* Berlin: Dummler.
Bennett, John W.
 1974 Middle American Influences on Cultures of Southeastern United States. *Acta Americana* 22: 25-50.
Boas, Franz
 1940 *Race, Language and Culture.* New York: Macmillan.
 1966 *The Ceramic Sculptures of Ancient Oazaca.* South Brunswick, New Jersey: A. S. Barnes and Co.
Borovka, Gregory
 1928 *Scythian Art.* New York: Frederick A. Stokes Co.
Carter, Dagny
 1948 *Four Thousand Years of China's Art,* New York: Ronald Press Co.
Churchward, James
 1932 *The Cosmic Forces of Mu.* New York: Ives Washburn.
Chamberlain, Robert S.
 1948 *The Governorship of the Adelantado Francisco De Montejo in Chiapas, 1539-1544,* Contributions to American Anthropology and History, vol. IX, no. 46. Washington, D.C.: Carnegie Institution of Washington.

Cheng, Te-Kun
 1960 *Archaeology in China,* vols. 1, 2, and 3. Cambridge, England: W. Heffer and Sons Ltd.
Ciudad Real, Antonio de
 1932 *Fray Alonso Ponce on Yucatan,* translated and annotated by Earnest Noyes, *Middle American Research Series,* vol. 4: 314. New Orleans: Tulane University Press.
Coe, William R.
 1965 Tikal: ten years of study of a Maya ruin in the lowlands of Guatemala. *Expedition* 8:50-56.
 1968 San Lorenzo and the Olmec Civilization. *Proceedings, Dumbarton Oaks Conference on the Olmec.* Washington, D.C.: Dumbarton Oaks.
Cogolludo, Diego Lopez
 1688 *Historia de Yucatan.* Madrid: J. Garcia Infanzon.
 1842 *Historia de Yucatan.* 2nd edition, appendix by Justo Sierra, Campeche.
Coomaraswamy, Ananda K.
 1927 *History of Indian and Indonesian Art.* London: Edward Goldston.
Covarrubias, Miguel
 1954 *The Eagle, the Jaguar and the Serpent.* New York: Alfred A. Knopf.
Dixon, Roland B.
 1928 *The Building of Cultures.* New York: Charles Scribner's Sons.
 1954 *Historia de los Indias de Nueva España* (The History of the Indies of New Spain), first published in 1585. Translated in English by Heyden and Horcasitas. New York: Orion Press.
Ekholm, Gordon
 1946 Wheeled Toys in Mexico. *American Antiquity.* 2:222-28.
 1953 A Possible Focus of Asiatic Influence in the Late Classic Cultures of Mesoamerica. *Asia and North America: Transpacific Contacts* Memoir 9, Society of American Archeology.
 1955 The New Orientation Toward Problems of Asiatic-American Relationships. *New Interpretations of Aboriginal American Culture History.* Anthropology Societies, Washington, 75th Anniversary Volume, Anthropology Society.
 1964 Transpacific Contacts. *Pre-Historic Man in the New World.* Edited by J. D. Jennings and Edward Norbeck. Chicago: University of Chicago Press.

1971 Diffusion and Archaeological Evidence. *Man Across the Sea.* Edited by Carroll Riley, J. C. Kelley, C. W. Pennington and R. S. L. Rands. Austin: University of Texas Press.

Estrada, Emilio, and Meggers, Betty J.
1961 A Complex of Traits of Probable Transpacific Origin on the Coast of Ecuador. *American Anthropologist* 63:913-39.

Estrada, Emilio; Meggers, Betty J.; and Evans, Clifford, Jr.
1962 Possible Transpacific Contact on the Coast of Equador. *Science* 135(3501):371-72.

Flannery, Kent V.
1968 Archaeological Systems Theory and Early Mesoamerica. *Anthropological Archaeology in the Americas.* Edited by B. J. Meggers. Washington, D.C.: Anthropological Society of Washington.
1968 The Olmec and the Valley of Oaxaca: a model for inter-regional interaction in formative times. *Dumbarton Oaks Conference on the Olmec.* Edited by E. P. Benson. Washington, D.C.: Dumbarton Oaks.

Gladwin, Harold S., *et al.*
1937 *Excavations at Snaketown: Material Culture,* Medallion Papers, no. 25, vol. 1. Globe, Arizona: Private Printing for Gila Pueblo.
1947 *Men Out of Asia.* New York: McGraw-Hill Book Co., Inc.

Graebner, Fritz
1903 Kulturkreise und Kulturschichten in Ozeanien. *Zeitschrift für Ethnologie,* 1905, 37:28-53.

Heine-Geldern, Robert von
1954 Die Asiatische Herkunft der Sudamerikanischen Metalltechnik. *Paideuma* 5:347-423.
1959 Chinese Influence in Mexico and Central America: the Tajin Style of Mexico and the Marble Vases from Honduras. *Actas del 33rd Congreso Internacional de Americanistas.* San Jose: Lehmann.
1959 Representations of the Asiatic Tiger in the Art of the Chavin Culture: a proof of early contacts between China and Peru. *Actas del 33rd Congreso Internacional de Americanistas.* San Jose: Lehmann.
1966 The Problem of Transpacific Influences in Meso-America. *Handbook of Middle American Indians.* Edited by R. Wauchope et al. Austin: University of Texas Press.
1966 Some Tribal Art Styles of Southeast Asia: An Experiment in Art History. *The Many Faces of Primitive Art* by Douglas Fraser. Englewood Cliffs: Prentice Hall.

Heine-Geldern, Robert, and Ekholm, Gordon E.
1951 Significant Parallels in the Symbolic Arts of Southern Asia and Middle America. *The Civilizations of Ancient America.* Edited by Sol Tax. Chicago: University of Chicago Press.

Heyerdahl, Thor
1950 *Kon-Tiki.* Chicago: Rand-McNally and Co.
1952 *American Indians in the Pacific: The Theory Behind the Kon-Tiki Expedition.* London: George Allen and Unwin.
1958 *Aku-Aku: The Secret of Easter Island.* Chicago: Rand McNally and Co.

Howard, E. B.
1935 Evidence of Early Man in America. *The Museum Journal* 24:53-171.

Hrdlicka, Ales; Holmes, W. H.; Willis, B.; Wright, F.; Fenner, C.
1912 *Early Man in South America.* Washington, D.C.: Bureau of American Ethnology.

Humboldt, Alexander von
1885 Views of the Cordilleras and Monuments of the Indigenous Nations of America. In Vining, Edward P. *An Inglorious Columbus.* New York: Appleton and Co.

Jennings, Jesse D., and Norbeck, Edward
1964 *Prehistoric Man in the New World.* Chicago: University of Chicago Press.

Kampen, Michael Edwin
1972 *The Sculptures of El Tajin Veracruz, Mexico.* Gainesville: University of Florida Press.

Kempers, A. J. Bernet
1959 *Ancient Indonesian Art.* Amsterdam: C. P. J. Van Der Peet.

Kidder, Alfred V.
1936 Speculations on New World Prehistory. *Essays in Anthropology.* Berkeley: University of California Press.
1947 *The Artifacts of Uaxactun, Guatemala.* Washington, D.C.: Carnegie Institution of Washington.

Kingsborough, Edward
1831-1848 *Antiquities of Mexico.* London: Robert Havell and Colnaghi, Son, and Co.

Koop, Albert J.
1924 *Early Chinese Bronzes.* New York: Charles Scribner's Sons.

Kroeber, Alfred L.
1909 The Archaeology of California. *Putnam Anniversary Volume.* New York: G. E. Stechert and Co.
1925 Archaic Culture Horizons in the Valley of Mexico. *University of California Publications in American Archaeology and Ethnology* 17:373-408.
1930 Cultural Relations Between North and South America. *Proceedings of the 23rd International Congress of Americanists.*
1948 *Anthropology.* New York: Harcourt, Brace and Co.

Ku, Pan
1938 *The History of the Former Han Dynasty,* vol. 1, 2, and 3. Baltimore: Waverly Press, Inc.

Landa, Diego de
1556 *Relación de las cosas de Yucatan.* Edited with notes by Alfred Tozzer, *Papers of the Peabody Museum of American Archaeology and Ethnology,* Harvard University, Cambridge, Massachusetts, 1966 reprint, vol. XVIII.

Larkin, Frederick
1880 *Ancient Man in America.* New York: Randolph.

Lathrap, Donald W.
1971 The Tropical Forest and the Cultural Context of Chavin. *Dumbarton Oaks Conference on Chavin.* Edited by E. P. Benson. Washington, D.C.: Dumbarton Oaks.

Legge, James
1893-95 *The Chinese Classics,* vols. 1, 2, 3, 4, and 5. Oxford: Clarendon Press.

Leland, Charles G.
1875 *The Discovery of America.* London: Curzon Press Ltd.

Li, Chi
1928 *The Formation of the Chinese People.* New York: Russel & Russel.
1957 *The Beginnings of Chinese Civilization.* Seattle: University of Washington Press.

Lizana, Bernardo de
1893 *Historia de Yucatan.* Mexico: Museum Nacional.

Lowie, Robert
1966 *The History of Ethnological Theory.* New York: Holt, Reinhart, and Winston.

McGovern, William Montgomery
1939 *The Early Empires of Central Asia.* Chapel Hill: University of North Carolina Press.

Maudslay, Alfred
1889-1920 *Biologia Central Americana.* London: Porter and Dulay.

Meggers, Betty J., and Evans, Clifford
1957 *Archaeological Investigations at the Mouth of the Amazon.* Washington, D.C.: Bureau of American Ethnology.
1961 An Experimental Formulation of Horizon Styles in the Tropical Forest Area of South America. *Essays in Pre-Columbian Art and Archaeology.* Edited by S. K. Lothrop et al. Cambridge: Harvard University Press.
1963 *Aboriginal Cultural Development in Latin America: An Interpretive Review.* Washington, D.C.: Smithsonian Miscellaneous Collection, vol. 146, no. 1.

Meggers, Betty J.; Evans, Clifford; and Estrada, Emilio
1965 *Early Formative Period of Coastal Ecuador,* Smithsonian Contributions to Anthropology, vol. 1. Washington, D.C.: Smithsonian Institution.

Mertz, Henriette
1972 *Pale Ink, Two Ancient Records of Chinese Exploration in America.* Chicago: Swallow Press.

Morgan, Lewis
1878 *Ancient Society.* New York: Henry Holt.

Morley, Sylvanus
1920 *The Inscriptions at Copan.* Washington, D.C.: Carnegie Institution of Washington.
1937 *The Inscriptions of Peten.* Washington, D.C.: Carnegie Institution of Washington.
1946 *The Ancient Mayan.* Palo Alto: Stanford University Press.

Needham, Joseph
1971 *Science and Civilization in China.* Cambridge: Cambridge University Press.

O'Neale, Lila M.
1948 *Textiles of Pre-Columbian Chihuahua,* Contributions to American Anthropology and History, vol. IX, no. 45. Washington, D.C.: Carnegie Institution of Washington.

Paravey, Charles H. de
1835 *Mémoire de M. de Paravey sur l'Origine Japonaise, Arabe, et Basque de la Civilisation des Peuples du Plateau de Bogota.* Paris: Dondey-Dupré.

Parker, E. H.
1924 *A Thousand Years of the Tartars.* New York: Alfred A. Knopf, Inc.

Patterson, T. C.
1971 Chavin: an interpretation of its spread and influence, *Dumbarton Oaks Conference on Chavin.* Edited by E. P. Benson. Washington, D.C.: Dumbarton Oaks.

Phillips, Philip
1940 Middle American Influences on the Archaeology of the Southwestern United States, *The Maya and Their Neighbors.* Edited by C. L. Hay et al. New York: D. Appleton-Century Co., Inc.
1966 The Role of Transpacific Contacts in the Development of New World Pre-Columbian Civilizations. *Handbook of Middle American Indians.* Edited by R. Wauchope et al. Austin: University of Texas Press.

Phillips, Philip, and Willey, Gordon R.
1953 Method and Theory in American Archaeology: an operational basis for culture-historical integration. *American Anthropologist* 55:615-33.

Pope, John A.
1967 *The Freer Chinese Bronze.* Washington D.C.: Freer Gallery of Art.

Proskouriakoff, Tatiana
1950 *A Study of Classic Maya Sculpture.* Washington, D.C.: Carnegie Institution of Washington.
1963 Historical Data in the Inscriptions of Yaxchilan, Part I. Universidad Nacional Autonoma de Mexico. *Estudios de Cultura Maya.* 3:149-67.
1964 Historical Data in the Inscription of Yaxchilan, Part II. Universidad Nacional Autonoma de Mexico. *Estudios de Cultura Maya.* 4:177-201.

Riley, Carroll L.; Kelley, J. Charles; Pennington, Campbell W.; and Rands, Robert L.
1971 *Man Across the Sea.* Austin: University of Texas Press.

Rowe, John H.
1960 Cultural Unity and Diversification in Peruvian Archaeology. *Men and Culture.* Edited by A. F. Wallace. Selected Papers of the 5th International Congress of Anthropological and Ethnological Sciences. Philadelphia: University of Pennsylvania Press.
1966 Diffusionism and Archaeology. *American Antiquity.* 31:334-38.

Rowland, Benjamin
1953 *The Art and Architecture of India.* Baltimore: Penguin Books.

Sanders, W. T., and Merino, Joseph
 1970 *New World Prehistory; archaeology of the American Indian.* Foundations of Modern Anthropology Series. Englewood Cliffs: Prentice-Hall.

Saville, Marshall H.
 1892 Explorations on the Main Structure of Copan, Honduras. *Proceedings of the American Association for the Advancement of Science.* 41:271-75.

Schmidt, Wilhelm
 1939 *The Culture Historical Method of Ethnology.* Translated by S. A. Sieber. New York: Fortuny's.

Scholes, France, and Adams, Eleanor
 1938 *Don Diego Quijada, Alcalde Mayor de Yucatán, 1561-1565. Documentos sacados de los archivos de España,* vol. 1, p. xli and vol. 2, Mexico: Antiqua Liberia Robredo, de J. Porrúa e hijos.

Shepard, Anna O.
 1948 *The Symmetry of Abstract Design with Special Reference to Ceramic Decoration,* Contributions to American Anthropology and History, vol. IX, no. 47. Washington, D.C.: Carnegie Institution of Washington.

Siren, Osvald
 1929-30 *A History of Early Chinese Art,* vols. 1, 2, 3, and 4. London: Ernest Benn, Limited.

Smith, Elliot
 1915 Pre-Columbian Representations of Elephants in America. *Nature* 96 (2404): 340.
 1924 *Elephants and Ethnologists.* New York: E. P. Dutton and Co.
 1933 *The Diffusion of Culture.* London: Watts and Co.

Spencer, Herbert
 1850 *Social Statics.* New York: D. Appleton.
 1876 *Principles of Sociology.* New York: D. Appleton.
 1913 A Study of Mayan Art. *Memoirs of the Peabody Museum.* Cambridge: Harvard University Press.
 1916 *Nature* 96(2413):593.
 1957 *Maya Art and Civilization.* Indian Hills, Colorado: The Falcon's Wing Press.

Stephens, John Lloyd
 1841 *Incidents of Travel in Central America, Chiapas and Yucatan.* New York: Harper & Brothers.

Steward, Julian H.
 1948 A Functional-Developmental Classification of American High Cultures. *A Reappraisal of Peruvian Archaeology.* Edited by W. C. Bennet. Memoir 4, Society for American Archaeology.

Tax, Sol
 1951 *The Civilizations of Ancient America.* Chicago: University of Chicago Press.

Thompson, J. Eric S.
 1948 *An Archaeological Reconnaissance in the Cotzumalhuapa Region, Escuintla, Guatemala.* Contributions to American Anthropology and History, vol. IX, no. 44. Washington D.C.: Carnegie Institution of Washington.

Tozzer, Alfred
 1910 The Animal Figures in Mayan Codices. *Peabody Museum Papers.* Cambridge: Harvard University Press.
 1911 A Preliminary Study of the Prehistoric Ruins of Tikal, Guatemala. *Memoirs of the Peabody Museum.* 5:93-135.
 1941 Landa's Relación de las Cosas de Yucatan, Papers of the Peabody Museum of American Archaeology and Ethnology, vol. 18. Cambridge: Harvard University Press, 1966 reprint.

Tylor, Edward
 1865 *Researches Into the Early History of Mankind and the Development of Civilization.* New York: Henry Holt.
 1871 *Primitive Culture.* New York: Harper Torchbook.

Vining, Edward P.
 1885 *An Inglorious Columbus.* New York: Appleton and Co.

Wauchope, Robert
 1962 *Lost Tribes and Sunken Continents.* Chicago: University of Chicago Press.
 1971 *Handbook of Middle American Indians,* vols. 2, 3, 4, 10, and 11. Austin: University of Texas Press.

Wiens, Herold J.
 1967 *Han Chinese Expansion in South China.* Hamden, Conn.: The Shoe String Press, Inc.

Willey, Gordon R.
 1945 Horizon Styles and Pottery Traditions in Peruvian Archaeology. *American Antiquity.* 2:49-56.
 1953 A Pattern of Diffusion-Acculturation. *Southwestern Journal of Anthropology.* 9:369-84.
 1956 *Prehistoric Settlement Patterns in the New World.* Viking Fund Publications in Anthropology, no. 23. New York: Wenner-Gren Foundation for Anthropological Research.
 1958 Estimated Correlations and Dating of South and Central American Culture Sequences. *American Antiquity.* 23:353-78.
 1966-71 *An Introduction to American Archaeology.* Englewood Cliffs: Prentice-Hall.
 1971 Commentary on: The Emergence of Civilizations in the Maya Lowlands. *Observations on the Emergence of Civilization in Mesoamerica.* Edited by R. F. Heizer and J. A. Graham. Contributions of the University of California Archaeological Research Facility, no. 11. Berkeley: University of California Press.
 1974 *A History of American Archaeology.* London: Thames and Hudson.

Willey, Gordon R. and others
 1965 *Prehistoric Maya Settlements in the Belize Valley,* Papers of the Peabody Museum, vol. 54. Cambridge: Peabody Museum.

43 Shoulder Decoration, Guardian King, Tang Dynasty (A.D. 618-907), China (Collection of the National Museum of History, Taipei).

44 Stela 5, East Side, ca. A.D. 706, Copan, Honduras (See Plate 47).

45 Guardian King, Tang Dynasty (A.D. 618-907), China (Collection of the National Museum of History, Taipei).

46 Guardian King, Tang Dynasty (A.D. 618-907), China (Courtesy of the Victoria and Albert Museum).

47 Stela 5, East Side, Dated 9.13.15.0.0—13 Ahau 18 Pax (ca. A.D. 706), Copan, Honduras.

48 Stela 5, West Side, Dated 9.13.15.0.0—13 Ahau 18 Pax (ca. A.D. 706), Copan, Honduras.

49 Relief on Limestone Lintel (Detail), Late Classic Period (ca. A.D. 800), Chiapas, Mexico (The Robert Woods Bliss Collection, Dumbarton Oaks).

50 Dragon, Detail of a Crown, Liao Dynasty (A.D. 907-1125), China (Courtesy of the Museum of Fine Arts, Boston).

51 Long-Nose God, Late Classic Period (ca. A.D. 800), Chiapas, Mexico (Collection of the Museum of Mankind, London).

52 Long-Snouted Dragon Head, Shoulder Decoration of a Guardian King, Tang Dynasty (A.D. 618-907), China (Collection of the British Museum, London).

53 Long-Snouted Dragon Head, Detail of a Bronze Bell, Koryo Period (A.D. 1048), Kyonggi-Do, Korea (Collection of the National Museum of Korea).

54 Makara, ca. Thirteenth Century A.D., Java (Collection of the Musee Guimet, Paris).

55 Makara, ca. Tenth Century A.D., Prambanan, Java (Collection of the Rijksmuseum, Amsterdam).

56 Altar G, Left Side (ca. A.D. 800), Copan, Honduras.

57 Altar G, Right Side (ca. A.D. 800), Copan, Honduras.

58 Altar G, Dated 9.18.10.0.0—10 Ahau 8 Zac (A.D. 800), Copan, Honduras.

59 Altar G1, Dated 9.17.0.0.0—4 Ahau 13 Ceh (A.D. 771), Copan, Honduras.

60 Double-Headed Dragon on Wooden Lintel of Temple IV with Irrelevant Elements Deleted (ca. A.D. 600-800), Tikal, Petan, Guatemala.

61 Double-Headed Dragon Bronze Plate, Chou Dynasty (ca. 500 B.C.), China (Collection of the Rijksmuseum, Amsterdam).

62 Double-Headed Makara (Irrelevant Elements Deleted), Stone Relief on Terrace of Borobudur (ca. A.D. 800-900), Java.

63 Detail of Stela I, Back Side, Dated 9.18.10.0.0—10 Ahau 8 Zac (ca. A.D. 800), Quirigua, Guatemala.

64 Stone Relief on Terrace of Borobudur (ca. A.D. 800-900), Java.

65 Double-Headed Dragon on Stela I, ca. A.D. 800, with Irrelevant Elements Deleted, Quirigua, Guatemala.

66 Double-Headed Dragon on Bronze Yu, Shang Dynasty (1766-1154 B.C.), China (Collection of Musee Cernuschi, Paris).

67 Double-Headed Makara, Gateway in the Fourth Gallery (ca. A.D. 800-900), Borobudur, Java.

68 Human Head Emerging from the Mouths of Two Tigers, Rubbing from a Fang Ting (Square Cauldron Dedicated to King Wen Ting's Mother, Muwu) of Shang Dynasty (1766-1154 B.C.), Honan, China (Collection of the People's Republic of China).

69 Stela D, Dated 9.15.5.0.0—10 Ahau 15 Chen (A.D. 736), Copan, Honduras.

70 Tibetan Deity, ca. Nineteenth Century A.D., China.

71 Figure on a Han Relief (ca. A.D. 100), China.

72 Black Deity, ca. Nineteenth Century A.D., Tibet, China.

73 Stela H, Dated 9.16.0.0.0—2 Ahau 13 Tzec (A.D. 751), Quirigua, Guatemala (Courtesy Peabody Museum, Harvard University).

74 Guardian King, Yuan Dynasty (Thirteenth Century), Detail of a Mural in Yung-Lo Kung, Shansi, China.

75 Guardian Wei-To, ca. Seventeenth Century A.D., China (Courtesy of the Museum of Fine Arts, Boston).

76 Stela 16, Dated 9.14.0.0.0 (A.D. 711), Tikal, Peten, Guatemala.

77 Avalokitesvara, Sixth Century A.D., China (Courtesy of the Metropolitan Museum of Art, New York).

78 Figure on South Lintel of Structure 3C10, Late Classic Period (ca. A.D. 800), Oxkintok, Yucatan, Mexico (Courtesy of the Peabody Museum, Harvard University).

79 Guardian King, Detail of a Buddhist Painting in Tang (A.D. 618-907), Style, ca. Thirteenth Century A.D., China.

80 Figure on North Lintel, House L, ca. A.D. 720, Yaxchilan, Chiapas, Mexico.

80A Drawing of the Guardian King with Irrelevant Details Deleted (See Plate 79).

81 Eleven-Headed Kuan-Yin, Ming Dynasty, ca. Sixteenth Century A.D., Tibet, China (Courtesy of the Museum of Fine Arts, Boston).

82 Stela E, Dated 9.17.0.0.0—13 Ahau 18 Cumhu (ca. A.D. 771), Quirigua, Guatemala.

83 Chia-Lo God, Sung Dynasty, ca. Eleventh to Thirteenth Century A.D., China.

84 Stela D, Dated 9.16.15.0.0—7 Ahau 18 Pop (ca. A.D. 765), Quirigua, Guatemala.

85 Stela J, Front, Dated 9.16.5.0.0—8 Ahau 8 Zotz (ca. A.D. 760), Quirigua, Guatemala.

86 Stela K, Dated 9.18.15.0.0—3 Ahau 3 Yax (ca. A.D. 800), Quirigua, Guatemala.

87 Tomb Guardian, ca. Third Century A.D., Chu-Fu, Shantung, China (Courtesy Dr. Osvald Siren, National Museum of Stockholm).

88 Facade, House of Masks, Dated Postclassic Period (ca. A.D. 900-1100), Kabah, Yucatan, Mexico.

89 Tao-Tieh Masks on Bone, Shang Dynasty (ca. Fifteenth Century B.C.), China (Courtesy of the Museum of Fine Arts, Boston).

90 Maori Masks on Posts, ca. Nineteenth Century A.D., New Zealand (Courtesy of the American Museum of Natural History).

91 Chac Masks, Postclassic Period (ca. A.D. 900-1100), Uxmal, Yucatan, Mexico.

92 Chia-Lo God, ca. Seventeenth Century A.D., Tibet, China (Collection of the British Museum, London).

93 Zapotec Three-Faced Deity (A Funerary Urn), ca. Eighth Century A.D., Oaxaca, Mexico (Collection of the British Museum, London).

94 Brahma, Chola Dynasty (ca. Tenth Century A.D.), Tanjore, India (The Metropolitan Museum of Art, Eggleston Fund, 1927).

95 Multiple-Headed Deity, Northern Wei Dynasty, ca. Fifth Century A.D., Yun-Kang Caves, Ta-Tung, Shansi, China.

96 Brahma, ca. Fourteenth Century A.D., Cambodia (Collection of the Musee Guimet, Paris).

97 Deity with Bird Headdress (Detail of a Mural), ca. Thirteenth Century A.D., Moon Hill Monastery, Shansi, China (Collection of the University Museum, Philadelphia).

98 Guardian with Bird-Headdress (A Funerary Figurine), Tang Dynasty (A.D. 618-907), China (Courtesy of the Victoria and Albert Museum).

99 Three-Headed Deity, Northern Wei Dynasty, ca. Fifth Century A.D., Yun-Kang Caves, Ta-Tung, Shansi, China.

100 Zapotec Three-Faced Deity (A Funerary Urn), ca. Eighth Century A.D., Oaxaca, Mexico (Collection of the British Museum, London).

101 Huastec Three-Faced Deity, Postclassic Period (ca. A.D. 900-1200), Veracruz, Mexico (Collection of the University of Veracruz, Jalapa).

102 Eleven-Headed Avalokitesvara, Khmer Period, ca. Eleventh Century A.D., Angkor Thom, Cambodia (The Metropolitan Museum of Art, Fletcher Fund, 1935).

103 Three-Faced Deity (Detail of a Relief), Ming Dynasty, ca. Fourteenth Century A.D., China.

104 Three-Faced Deity, ca. Eighth to Tenth Century A.D., Bezeklik, Turfan, Chinese Turkestan (Modern Hsinchiang Province, China).

105 Three-Faced Guardian King, ca. Eleventh Century, Japan (Collection of the Tokyo National Museum, Tokyo).

106 Four-Faced Guardian King, ca. Ninth to Tenth Century A.D., China (Courtesy of the American Museum of Natural History).

107, 108 Four-Faced Olmec Stone Figure (Two Views), Attributed to Preclassic Period (ca. 800 B.C.-A.D. 300), San Martin Pajapan, Veracruz, Mexico (Collection of the Museum Park, Villahermosa).

109 Two-Faced, Three-Eyed Lady, Northern Wei Dynasty, ca. Fifth Century A.D., Yun-Kang Caves, Ta-Tung, Shansi, China.

110 Two-Faced, Three-Eyed Lady, Middle Preclassic Period (ca. 1000-300 B.C.), Tlatilco, Mexico (Collection of the National Museum of Anthropology, Mexico City).

111 Worshipping Bodhisattva (Detail of Stone Stela), Dated Second Year of Tai-An, Northern Wei Dynasty (A.D. 457), China.

112 Worshipping Ball-Player (Detail of the Center Panel, East Bench of the Ball Court), Postclassic Period (ca. A.D. 1000-1300), Chichen Itza, Yucatan, Mexico.

113 Seated Stone Figure, Classic Period (ca. A.D. 600-900), Santa Clara (Near Copan), Honduras (Collection of the Regional Museum of Mayan Archaeology, Copan).

114 Huastec Seated Figure, Postclassic Period (ca. A.D. 900-1200), Mexico (Courtesy of the American Museum of Natural History).

115 Seated Jizo, Kanakura Period (A.D. 1322), Japan (Courtesy of the Museum of Fine Arts, Boston).

116 Buddhist Monk, Paekche Period, ca. Sixth Century A.D., Korea (Collection of Min Byong-Do, Courtesy of the National Museum of Korea, Seoul).

117 Buddhist Monk, Tang Dynasty (A.D. 618-907), China (Courtesy of the Smithsonian Institution, Freer Gallery of Art, Washington, D.C.).

118 Seated Woman, Classic Period (ca. A.D. 600-900), Veracruz, Mexico (Collection of the National Museum of Anthropology, Mexico City).

119 Seated Buddha, ca. Fourteenth Century A.D., Thailand.

120 Seated Woman, Classic Period (ca. A.D. 600-900), Mexico (Courtesy of the American Museum of Natural History).

121 Seated Woman, Samoa (South Pacific) Islands (Courtesy of the American Museum of Natural History).

122 Seated Priest, ca. Eighth Century A.D., Copan, Honduras (Collection of the British Museum, London).

123 Siva, ca. Thirteenth Century A.D., India (Collection of the Musee Guimet, Paris).

124 Seated Buddha, ca. Sixth Century A.D., China. (Collection of the Musee Cernuschi, Paris).

125 Seated Figure with Cloak (ca. A.D. 700-1000), Campeche, Mexico (Collection of the National Museum of Anthropology, Mexico City).

126 Seated Figure with Cloak (Detail), ca. Sixth Century A.D., China, Detail of Plate 275 (Courtesy of the Smithsonian Institution, Freer Gallery of Art, Washington, D.C.).

127A, 127B Pendant, Dated Classic Period (ca. A.D. 600-1000), Nebaj, Guatemala (National Museum of Archaeology).

128 Seated Buddha, ca. Sixth Century A.D., China (Collection of the William Rockhill Nelson Gallery of Art, Kansas City).

129 Seated Buddha, ca. Sixth Century A.D., China (Detail of a Stone Stupa on loan to the Metropolitan Museum of New York City by the Tribner family).

130 Seated Maitreya, ca. Seventh Century A.D., China (Courtesy of the Smithsonian Institution, Freer Gallery of Art, Washington, D.C.).

131 Seated Figure (ca. A.D. 700-900), Campeche, Mexico (Courtesy of the American Museum of Natural History).

132 Seated Figure Holding Lotus Flower and Lotus Leaf (Detail), ca. Sixth Century A.D., China, Detail of Plate 250 (Collection of the Metropolitan Museum, New York City).

133 Seated Figures Holding Lotus Flower and Lotus Leaf, ca. A.D. 600-900, Palenque, Chiapas, Mexico (Collection of the Museo de America, Madrid).

134, 135 Buddha Seated on a Throne (Detail) Wei Dynasty (A.D. 554), China (Courtesy of the Museum of Fine Arts, Boston).

136 Priest Seated on a Throne, Classic Period (ca. A.D. 600-900), Campeche, Mexico (Collection of the National Museum of Anthropology, Mexico City).

137 Priest Seated on a Throne, Dated Late Classic Period (ca. A.D. 700-1000), Jaina, Campeche, Mexico (Stendahl Collection).

138 Seated Maitreya with Attendants, ca. Sixth Century A.D., China (Courtesy Museum of Fine Arts, Boston).

139 Stylized Lotus Petal, Chou Dynasty, ca. Eighth Century B.C., China (Courtesy of the Smithsonian Institution, Freer Gallery of Art, Washington, D.C.).

140 Stylized Lotus Petal, Wie Dynasty, Sixth Century A.D., China (Collection of the University Museum, Philadelphia).

141 Buddha Seated on a Lotus Throne, ca. Nineteenth Century A.D., Tibet, China.

142 Man Seated Inside a Small Niche (The Open Mouth of a Monster), ca. Eleventh Century, Java (Royal Tropical Institute, Photografic-Archives, Amsterdam).

143 Winged-Monster-Head Headdress (Detail of a Stone Relief), Wei Dynasty, ca. Fifth Century A.D., Yuan-Kang Caves, Ta-Tung, Shansi, China.

144, 145 Man Seated Inside a Small Niche (Detail of Altar 4), Attributed to Preclassic Period (ca. 800 B.C.-A.D. 300), La Venta, Mexico (Collection of the Museum Park, Villahermosa).

146 Woman Seated Inside a Small Niche (Detail of Altar 5, Front), Attributed to Preclassic Period (ca. 800 B.C.-A.D. 300), La Venta, Mexico (Collection of the Museum Park, Villahermosa).

147 Woman Talking to a Child (Detail of Altar 5, South Side).

148 Facade (Detail) of Parasuramesvara Temple (ca. A.D. 750), Bhuvanesvara, India.

149, 150, 151 Worshipping Figure (Three Views) (ca. A.D. 600-1200), Tabasco, Mexico (Collection of the Museum of Primitive Art, New York City).

152 Worshipping Bodhisattva (Detail of a Painting), Tang Dynasty (A.D. 618-907), Tun-Huang, Kansu, China (Collection of the Musee Guimet, Paris).

153, 154 Drawing of Plates 149 and 150, with Irrelevant Elements Deleted.

155 Dancer in the West Paradise (Detail of a Painting), Tang Dynasty (A.D. 618-907), Tun-Huang, Kansu, China (Collection of the Musee Guimet, Paris).

156 Worshipping Figure (Detail of a Painting), Tang Dynasty (A.D. 618-907), Tun-Huang, Kansu, China (Collection of the Musee Guimet, Paris).

157 Worshipping Mo-Ho-Lo-Tso (A King of Nanchao-Modern Yunnan, Detail of a Painting), Sung Dynasty (A.D. 960-1278), China (Collection of the Chung-Shan Museum, Taipei).

158 Worshipping Figure (ca. A.D. 600-1200), Tabasco, Mexico (Collection of the Museum of Primitive Art, New York City).

159 Figurine with Curled Moustache, Tang Dynasty (A.D. 618-907), China (Collection of Musee Cernuschi, Paris).

160, 161 Stela 7, Dated 9.15.10.0.0 (ca. A.D. 736), Etzna, Campeche, Mexico (Courtesy of the Peabody Museum, Harvard University).

162 Guardian King, Tempyo Period, ca. Eighth Century A.D., Japan (Courtesy of the Fogg Art Museum, Harvard University).

163 Attendant, ca. Sixth Century A.D., China (Courtesy of the Smithsonian Institution, Freer Gallery of Art, Washington, D.C.).

164 Buddha's Attendant, ca. Sixth Century A.D., China.

165 Guardian King, Five Dynasty (Dated A.D. 943), China (Collection of the Musee Guimet, Paris).

166 Guardian King, Tang Dynasty (A.D. 618-907), China (Collection of the University Museum, Philadelphia).

167 Stela 19, Dated 9.13.0.0.0—8 Ahau 7 Uo (A.D. 692), Etzna, Campeche, Mexico.

168 Attendant, ca. Sixth Century A.D., China, Detail of Plate 275 (Courtesy of the Smithsonian Institution, Freer Gallery of Art, Washington, D.C.).

169 Maori Wood-Carving, ca. Nineteenth Century A.D., New Zealand (Courtesy of the American Museum of Natural History).

170 Buddha's Attendant, ca. Thirteenth Century A.D., India (Courtesy of the Victoria and Albert Museum).

171 Thousand Headed Kuan-Yin, ca. Nineteenth Century A.D., Tibet, China.

172 Stela 8, Dated 9.18.10.0.0—10 Ahau 8 Zac (Last Quarter of the Eighth Century A.D.), Naranjo, Peten, Guatemala.

173 Guardian King of Heaven, Tang Dynasty (ca. A.D. 618-907), China, Detail of Plate 177 (Courtesy of the Museum of Fine Arts, Boston).

174 Guardian, ca. Sixth Century A.D., China (Detail of a Stone Stupa, on loan to the Metropolitan Museum of New York City by the Tribner family).

175, 176, 177, 178 The Four Guardian Kings of Heaven, Tang Dynasty (A.D. 618-907), China (Courtesy of the Museum of Fine Arts, Boston).

179 Stela 51, Dated 9.14.19.5.0—4 Ahau 18 Muan (ca. A.D. 731), Calakmul, Campeche, Mexico.

180 Demon or Slave, Stela 24.

181 Guardian King, ca. Ninth Century A.D., Japan.

182 Stela 24, Dated 9.12.10.5.12—4 Eb 10 Yax (ca. A.D. 702), Naranjo, Peten, Guatemala.

183 Stela 9, Dated 9.2.0.0.0 (A.D. 475), Tikal, Peten, Guatemala.

184 Guardian King, Ming Dynasty, ca. Fourteenth Century A.D., China (Collection of the Seattle Art Museum).

185 Portrait of Chang Sun Sung—A General of Early Northern Wei Dynasty, During the Reign of Ming-Yuan Emperor (A.D. 409-424), Attributed to Chen Hung of Tang Dynasty (ca. A.D. 730), China, (Collection of the Nelson Gallery and Atkins Museum of Fine Arts, Kansas City).